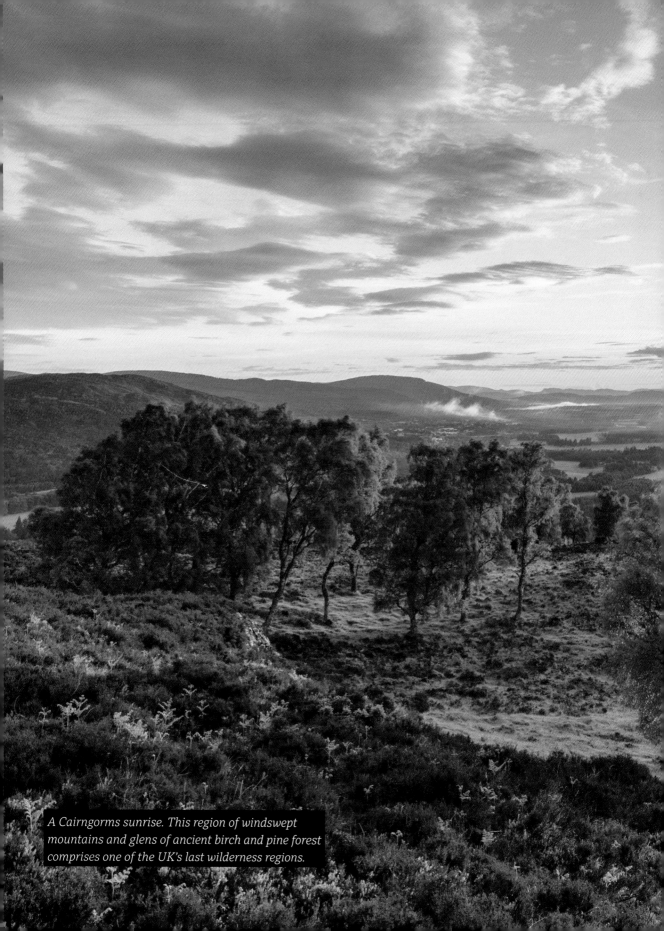

A Cairngorms sunrise. This region of windswept mountains and glens of ancient birch and pine forest comprises one of the UK's last wilderness regions.

Contents

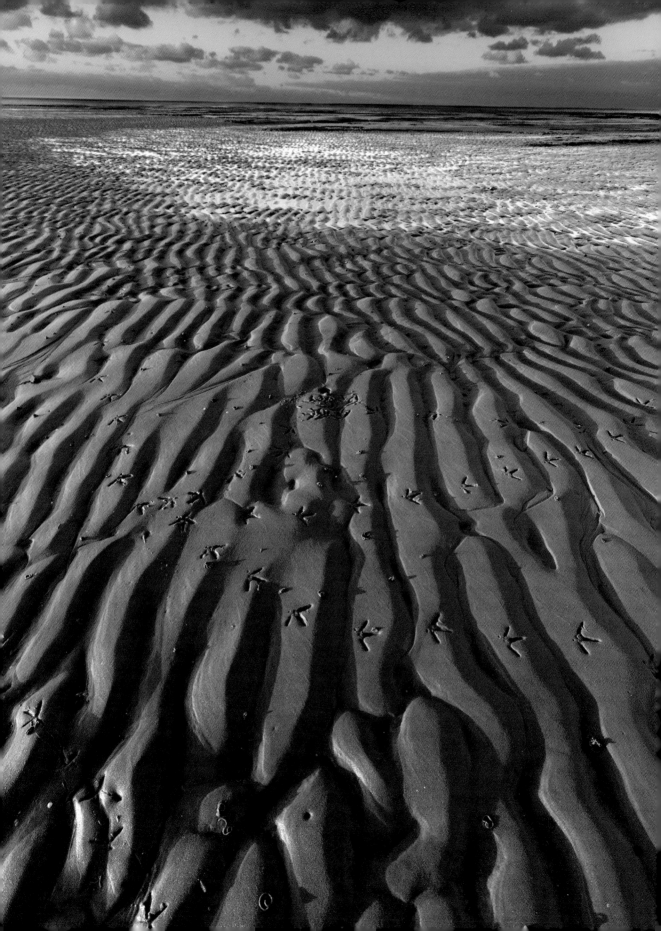

Introduction

For well over thirty years one of the nation's most popular television programmes, *Countryfile*, has been taking its viewers on a vicarious trip into the countryside every Sunday to reveal the delights and treasures of rural Britain; the beauty of its landscapes, the lives of its people and the diversity of its wildlife. In 2007 *Countryfile* welcomed a print companion in the form of the monthly BBC *Countryfile* Magazine, which, with its dazzling photographs, star features and best walks, added an extra dimension to our coverage of the UK's rural heartland.

Now, new to the *Countryfile* stable, comes this book that combines the best of both worlds, with the help of some of the best nature writing from BBC *Countryfile* Magazine. I've had the privilege of working for them since their early days and it is has become my conviction that we Brits, no matter what our roots, take a proprietorial attitude towards the countryside. We don't own it (at least most of us don't), but we behave as though we do and we want to protect it from harm. The UK landscape is the real star of *Countryfile*, which probably explains why the programme is regularly in the weekly Top 20 of TV shows.

Millions of us belong to conservation or environmental groups and millions more share the same desire to be out there in the fresh, invigorating air and the wide-open spaces. It is a passion unfettered by background, status, income or age. During the Covid-19 lockdowns, urbanites as well as country dwellers longed for the freedom to be roaming our green acres and made the most of them once restrictions were lifted, just as they did when the countryside re-opened after the disastrous epidemic of foot-and-mouth disease in 2001. In each case there was a massive outpouring of public support for our countryside, which is vitally important as tourism is part of the bedrock of the rural economy.

During my years presenting *Countryfile* I've been sent (sometimes more than once) to every rural corner of the UK in every season, mood and weather for well over 1,300 episodes and I have written about rural affairs in every edition of the magazine. Now here I am, making a contribution to a *Countryfile* book, which has month-by-month facts, observations and lyrical descriptions about what I consider to be the best place on Earth, the British countryside, by the magazine's dedicated writers. Many of you will be aware, of course, that this is not the first *Countryfile* book. That honour went to *Countryfile – A*

Oystercatcher footprints offer a tantalising sign of life in a vast area of sand exposed at low tide on the Norfolk coast.

Picture of Britain, a compilation of wonderful images sent in by viewers to our annual photographic competition. It proved to be so popular that it joined the *Sunday Times* list of bestsellers.

This one is much more than a simple yearbook. As you turn every page you will find fascinating, sometimes unexpected, details that are in some way relevant to the month in question. Here comes a spoiler alert – let's take a peep into just a couple of months.

In January you can become a galanthophile, a connoisseur of snowdrops; maybe take a more kindly view of that most unglamorous of vegetables, the swede – it comes from, guess where, Sweden, and is related to oilseed rape; go birdwatching in Norfolk – this month there could be 400,000 of them to spot – and, looking even further upwards, discover the secrets of stargazing; plus, for good measure, there are cows, beavers and Arctic landscapes.

June tells us that in medieval times poppies were called thundercups because, as they grew among crops, it was thought picking them would provoke damaging storms. Did you realise that it is thanks to the humble dung beetle that our countryside isn't buried beneath 200 million tonnes of number twos deposited every year by grazing farm animals? On a more bucolic note, June is a time for butterflies, glow-worms and red kites – and a visit to the Somerset Levels, which, according to legend, is the magic land of Avalon. That is just a taste of what is in store, and even though I like to think I am knowledgeable about country life, I learned a lot while leafing through the following pages. I hope you do, too.

As we know, life is not all a bed of roses for the people and wildlife that inhabit our countryside. For many folk – especially the elderly – it can feel an isolated and deprived place, heightened by the closure of shops, pubs, post offices and bus services. Lack of affordable homes and career opportunities is forcing younger people to move to the cities. And though visually stunning, ours is among the most nature-depleted countrysides on Earth. Our wildlife, though still diverse, is not as abundant as once it was. One in every six species is in danger of extinction and we have a chronic shortage of trees.

Farmers have been blamed for using industrialised methods that put wildlife at risk, but now many are attempting to make amends while at the same time battling to produce enough food for the nation. About 60 per cent of what we eat is home grown and that figure needs to be higher if we are to cut the bill for imports, although that could mean food being more expensive. These days we are well informed and we can make choices that help our economy, our farmers and the planet.

So let's bear the bigger picture in mind as we celebrate what we have – and it is bountiful. This book explores all aspects of life in our rural areas and emphasises, to me at least, how fortunate we still are to have all this on our doorsteps.

RIGHT: *Highland cattle are 'conservation grazers', used throughout the UK to maintain or increase the biodiversity of many habitats.*

OVERLEAF: *A pair of short-eared owls tussle as the sun sets in Lincolnshire.*

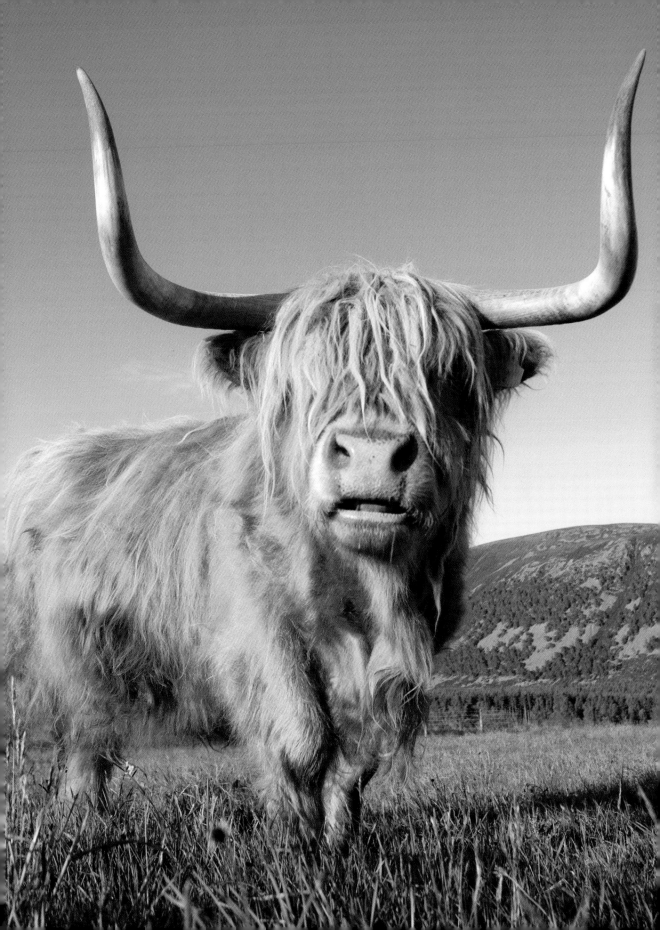

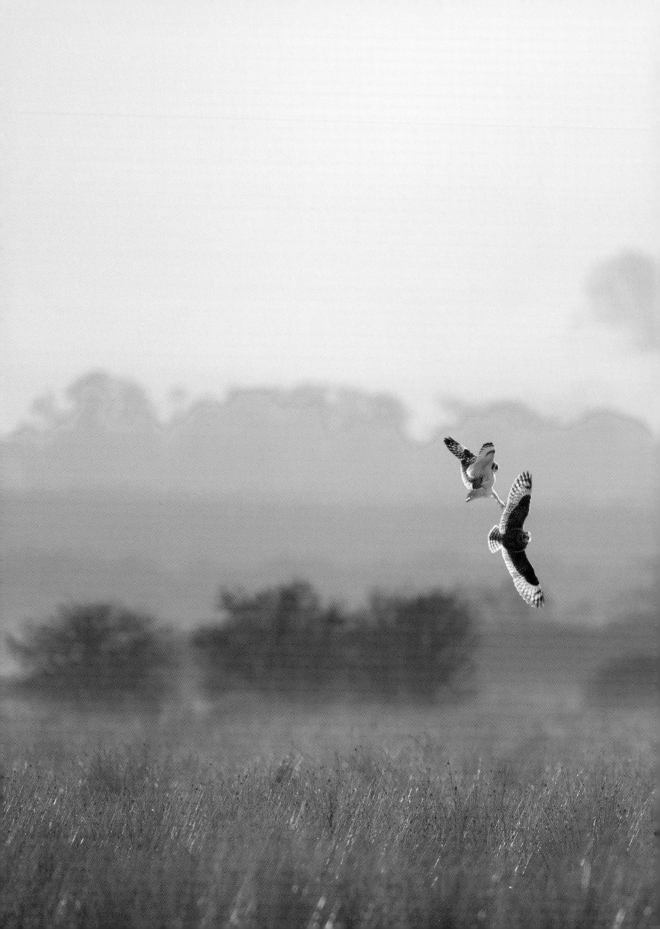

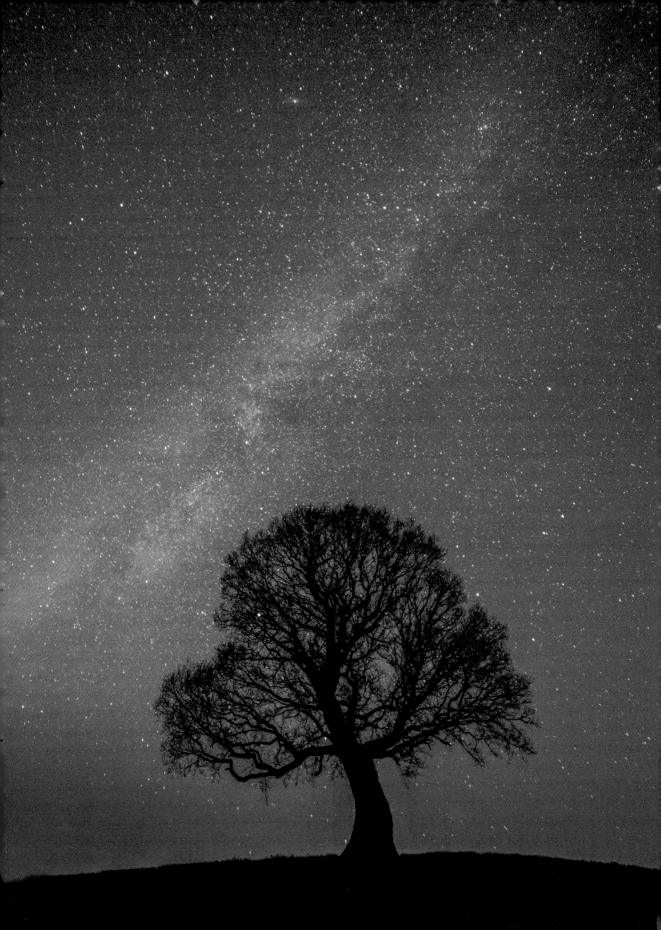

January

To get the very best from nature you need to look at every level: down to see Earth's wonders on the ground, up to take in the glory of its land and sea scapes, and higher to marvel at the vastness of the daytime skies and at night the immenseness of the universe.

The darkness of the countryside, away from the electric glow of towns and cities, is the best place to go stargazing and January's nights hold many delights if you know where to look. But how many of us do? In the following pages you'll find a beginner's guide to the constellations – and you won't need a telescope!

A highlight in my long career reporting on nature was an evening in 2009 spent in a small boat on a Scottish loch waiting for something that hadn't been seen in the UK since the sixteenth century. After a couple of hours I was rewarded when a wild beaver emerged from its lodge and swam towards us in the still waters. A magical moment.

Sixteen of them, imported from Norway, had just been released in Argyll's Knapdale Forest in a pioneering project to bring back this once-commonplace creature that was hunted to extinction for its fur, meat and scent glands. Knapdale really started something; today around a dozen beaver projects are under way across the UK (they are now legally protected in England and Scotland) and here you can read more about the return to our wetlands of nature's top, but controversial, ecosystem engineer.

In January you may or may not see snow but you are likely to see white blankets of snowdrops – millions of them festoon gardens, woods and roadsides. They can flower until March and bring much joy – but why pay £725 for a single bulb? The answer is in the following pages.

An oak tree deep in its winter slumber beneath a glittering canopy of stars.

Snowdrops

James Alexander Sinclair

Everybody can recognise a snowdrop. It is one of those omnipresent flowers with which we measure the passage of the seasons. If the snowdrops are in flower, the end of winter is in sight – albeit quite a long way down the road. Most of us love to see a great glittering duvet of snowdrops naturalised through tall deciduous woodlands or lapping like lava-flows around the edge of shrubberies. It is one of the great pleasures of winter (most of the others involve warm firesides and buttered crumpets).

Snowdrops, though not strictly speaking native to Britain, have spread themselves around with great generosity. They are gloriously adaptable and you can see them in abundance at this time of year.

Snowdrop Crazy

If you want to take this feeling of general appreciation a step further, then welcome to the world of the galanthophile, the name given to snowdrop aficionados (after the Latin name for the plant, Galanthus). To most of us, a snowdrop is a snowdrop, but to the true connoisseur it is so much more than that.

If you look closely into the dangling flower, then you will see little green tracery on the petals, and it is this sublime detailing that excites the galanthophile. However, to see these little modifications you need to get right down in the mud, head down, bottoms up in a flowerbed and with magnifying glass in hand.

Nobody really knows when (or how) the snowdrop arrived in this country from continental Europe; some say the Romans brought it over, but it appears more likely that it came over in the sixteenth century. It took another couple of hundred years or so for the snowdrop to be spread until we thought of it as a wildflower.

World Record Price

Snowdrops became very fashionable in the nineteenth century, when the Victorians took them to heart. It was they who first started creating new cultivars and hybrids. Interestingly, many of these new snowdrop varieties were made by clergymen. In those days the lot of the vicar was not as onerous as it is today; every village had an incumbent, whereas now they are stretched rather thinly throughout the parish. So apart from a couple of sermons and a bit of light ministering to the sick, many nineteenth-century vicars had a bit of free time. And many of them turned their hand to botany. The Revd William Ellacombe, for example, worked hard on snowdrops and exchanged plants with Kew Gardens. In fact, he insisted that his plants travelled with a generous helping of soil from his churchyard in Gloucestershire, as he considered the Kew soil inferior.

The excitement over these small flowers has not waned in the twenty-first century: in 2012 a single bulb of the lovely *Galanthus woronowii* 'Elizabeth Harrison' went for £725, beating the previous record of £350 for a bulb. As a result, some collectors have had to alarm their snowdrop patches to deter horticulturally minded burglars.

Snowdrops appeal to everybody, whether you are just a casual Sunday afternoon dog-walker, an intrepid explorer or a mad-keen galanthophile. Whichever way you choose to look at them, it is an unarguable fact that they are a breath of fresh air to lighten the dog days of the new year. As William Wordsworth says:

> Survive, and Fortune's utmost anger try;
> Like these frail snowdrops that together cling
> And nod their helmets, smitten by the wing,
> Of many a furious whirl-blast sweeping by.

Which sums it up rather neatly – snowdrops: tough as old boots, but as delicate as a butterfly in a tornado.

The first flower of the year, the delicate snowdrop is a stepping stone from winter to spring.

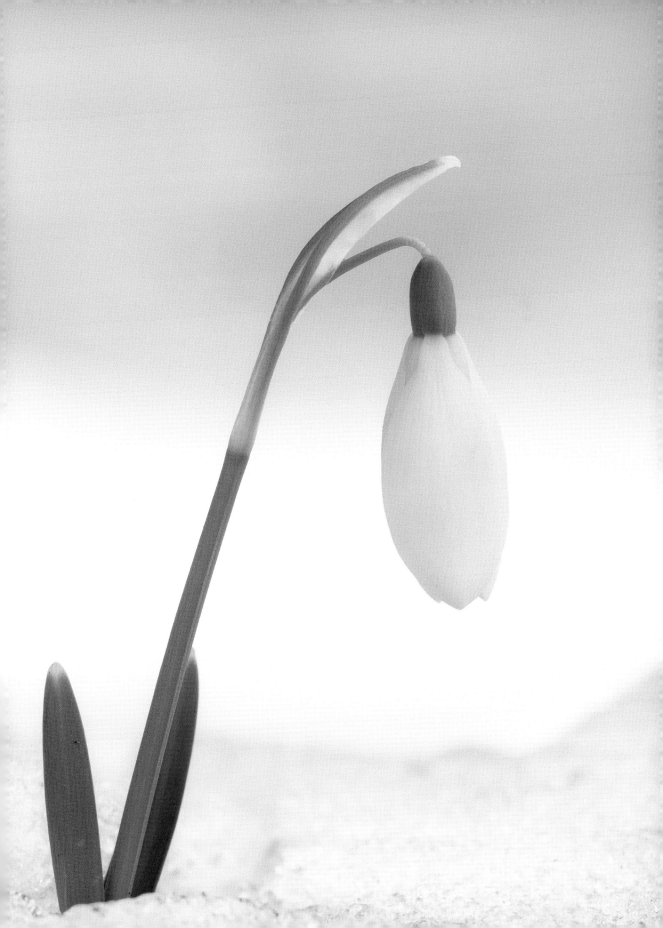

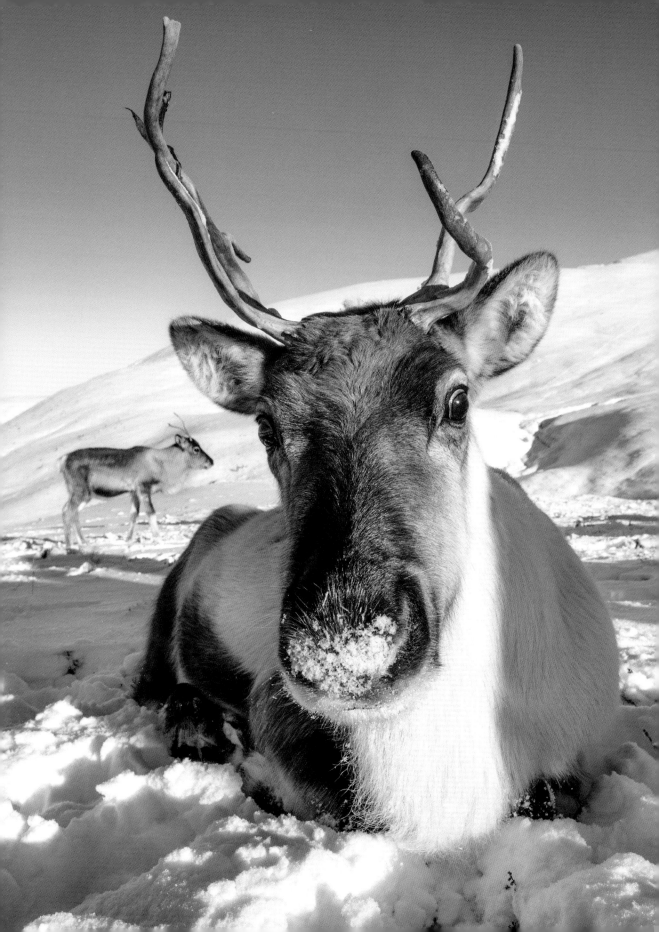

Britain's Arctic

Chris Townsend

Vast snowfields sweep to the horizon, covering the great, rolling, tundra-like plateaux. Icy cliffs, frozen waterfalls and huge, steep-sided, snow-filled corries ring the mountain. Lochs and lochans are frozen hard.

It's winter in the high Cairngorms. Deep glens and passes cleave through the mountains. These can be as wild and wintry as the summits, great clefts through which the winds roar and the snow blasts. Below the high tops lie magnificent Caledonian pine forests, part of the subarctic boreal forest that rings the globe. Here the snow lies quietly, settling on the trees and whitening the forest floor.

The scale of the Cairngorms is massive. The area above 800m (2,600ft) alone covers some 260 square kilometres (100 square miles), the largest area of high ground in Britain by far. Five of the six highest mountains in Britain are found in the Cairngorms.

In winter, this is an Arctic landscape. Snow lies on the tops for more than 100 days a year and the heaviest falls in Scotland occur here. In winter, blizzards are common, often brought in on very high winds that can reach more than 160km/h (100mph). Britain's highest-ever wind speed – an astounding 278km/h (173mph) – was recorded by the weather station on the summit of Cairn Gorm.

The area has record cold temperatures, too. At Braemar, -27°C has been recorded twice. That is exceptionally cold, but temperatures below -10°C are not uncommon and in a strong wind any sub-zero temperature feels bitter and can freeze exposed skin.

But when the snow eases and the sun shines, the beauty of the white, frozen mountainscape is breathtaking. And the mists, which are often damp, condense and freeze on rocks, forming long, delicate frost feathers or overlapping plates of white ice. This is a very special place.

Reindeer were hunted to extinction in the UK in early medieval times but a herd was reintroduced to the Cairngorms in the 1950s.

Winter Wildlife

Life is harsh on the high plateaux for birds and animals. The Arctic-alpine fauna and flora found here is unique in Britain.

GOLDEN EAGLE *Aquila chrysaetos*

The sight of a golden eagle soaring above vast snowfields is one of the most inspiring in the Cairngorms. Far below, mountain hares and ptarmigans cower against the ground, hoping the hunting eagle won't spot them.

SNOW BUNTING *Plectrophenax nivalis*

The pretty little black and white snow bunting is an Arctic species that breeds in Greenland and Iceland. While some remain in the Cairngorms year-round, numbers are swelled in winter by northern migrants that can form large flocks and feed on seeds from plants not covered by the snow.

PTARMIGAN *Lagopus muta*

The commonest bird in the winter hills is a member of the grouse family. In winter its plumage turns white, making it hard to see against the snow when stationary, and even when flying low over the snow. Often only its harsh rattling call gives away its presence.

MOUNTAIN HARE *Lepus timidus*

Britain's only true Arctic mammal. Grey-brown in summer, it turns white in autumn and can be invisible against the snow until it moves. Sometimes seen on the highest hills, mountain hares are more common on the moorlands of the Eastern Cairngorms.

REINDEER *Rangifer tarandus*

The Cairngorm's Arctic feel is enhanced when you see a herd of reindeer ambling across snowfields. Introduced in the 1950s from Sweden, these semi-domesticated animals roam free in the Northern Cairngorms, pawing through snow for the lichen they eat.

How Ice Shaped Our Land

Ian Vince

As the midwinter celebratory twinkle and glitter passes by and the season threatens to throw its worst at us in the shape of a cold snap or two, it's a good time to consider how our landscape has been shaped by ice and snow over our long history. Most of us will be familiar with the U-shaped valleys of the Lake District, Snowdonia and the Scottish Highlands, gouged out by glaciers during the last ice age and hammered into our consciousness by geography lessons since time immemorial, but they are not the only effect of glaciation, which, like love, changes everything.

Every part of Britain has been affected in some way by the various glaciations of the last two million years. When glaciers reach a depth of 800m (2,625ft), as they did in Britain during their most recent appearance between 10,000 and 20,000 years ago, it should come as no surprise that the features they shaped are of a similarly colossal scale, but even the annual act of freezing and thawing shapes the landscape. And the effect upon our countryside is all around us, no matter how far north or south we are.

At 100m (330ft) deep, the Devil's Dyke, just north of Brighton, is the deepest dry valley in the world and its creation was a consequence of what tundra does to porous rock. Situated on chalk, a rock that usually has the porosity of a sponge but which became frozen and impermeable during the last ice age, the area would nevertheless have enjoyed the briefest of Arctic summers. Warm enough, perhaps, to thaw the chalk nearest the surface, which would be sludged away by the meltwater from the snowfields, leaving frozen, impermeable chalk to be eroded by a great meltwater river.

Further north, at the boundary between the ice and tundra, huge mounds called moraines were left at the snouts of glaciers. The most impressive of these forms the Cromer Ridge in North Norfolk, a 15km (9-mile) line of hills more than 90m (300ft) high, made from clay and boulders bulldozed up from the floor of the North Sea.

But what of the land that was ground down to be eventually deposited as irregular blobs on a landscape hundreds, if not thousands, of kilometres away? Aside from U-shaped valleys, the most famous outcomes of glacial progress are the whale-back hills known as drumlins. Rounded hills with 'blunt' ends that face the origin of the glacier and a long tapered tail on the lee side, drumlins often occur in swarms and form what is termed, rather descriptively, a 'basket of eggs topography'. There's an excellent set of them in Ribbleshead in Yorkshire, but since there are 8,350 of them in Britain, it might be worth a trudge out in the snow to find your own.

Useful Words for Hills

FELL From the Old Norse fell or fjell, meaning 'mountain'. Later used for communal grazing areas on high land.

PIKE Also probably from Old Norse, meaning peak: a hill or mountain with a pointed top.

SCARP or ESCARPMENT A steep slope or long cliff that occurs from erosion or faulting.

TOR Rocky moorland hilltops; from the Cornish for hill.

BEN Mountain or peak, from the Gaelic beinn.

PEN In place names of Wales, Cornwall and parts of England, may mean hill, top, head or end.

KNOLL, KNOWLE or **HILLOCK** A small, low, natural hill.

DOWNS Open chalk hills. From Old English dun, or hill.

Magical Loch Maree awaits travellers following the path of ancient glaciers through Glen Docherty.

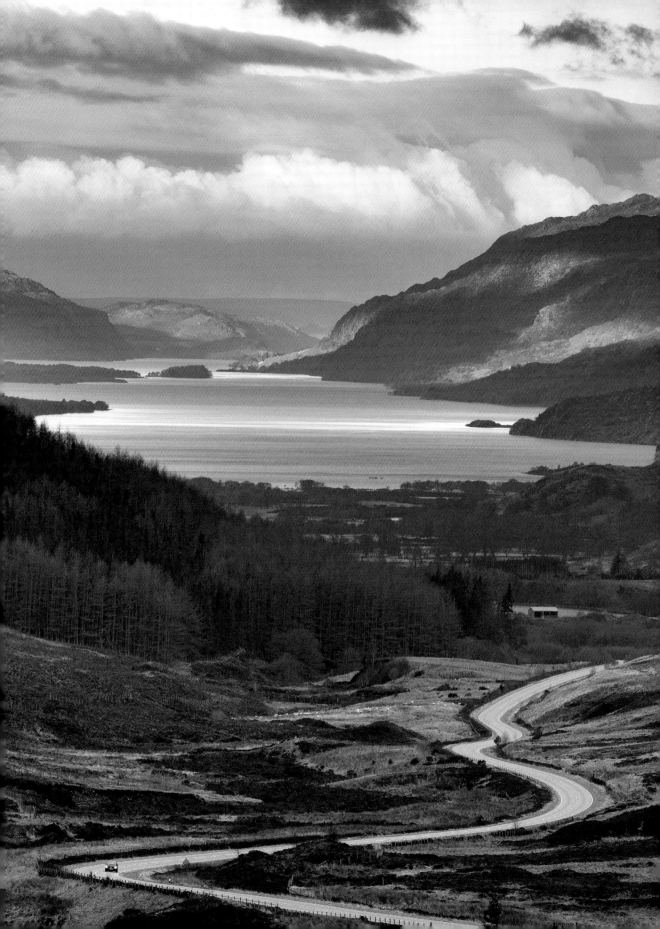

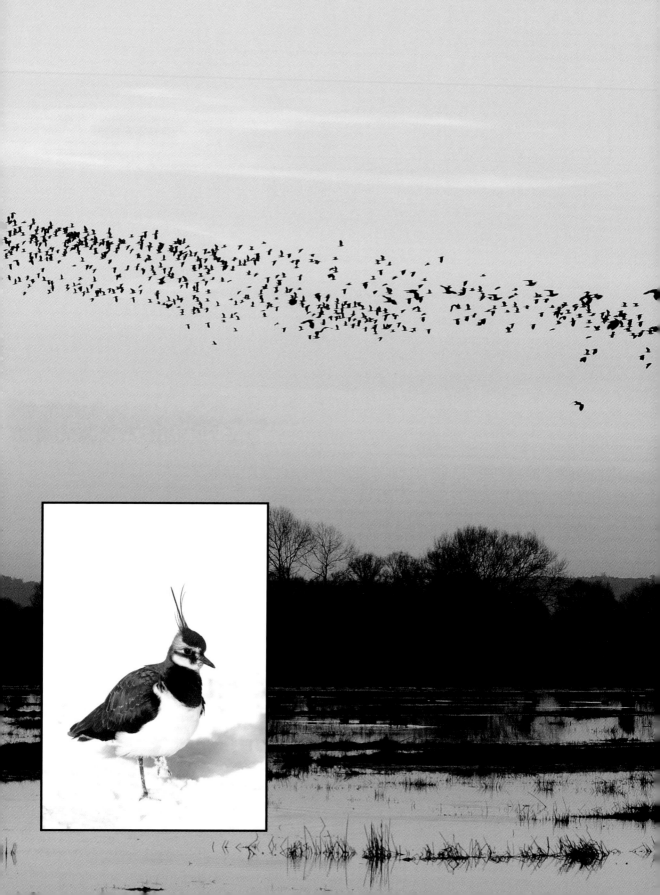

Lapwings *Fergus Collins*

Flocks of lapwings drifting above muddy fields in winter are one of those visions that make winter walking worthwhile. These ever more scarce waders head to farmland when the weather chills to glean any invertebrates stirred into action by late ploughing – or grains left exposed by recent sowing. If spooked, they take off as one, beating stiff wings and creating little m-shapes in the sky – exactly how a small child draws a bird in flight.

When on the ground, the lapwing can be distinguished by its lovely long crest and its oily green back. But sometimes it's easier to pick out the bird's white belly and head against the muted, wintry landscape. Watch as it stands motionless, then darts a short distance before stopping still again. It's a very different way of foraging to the rooks and crows that often share the fields with the lapwing and are constantly bobbing, weaving, cawing and complaining. The lapwing prefers not to draw attention to itself.

If you see a lapwing this winter, you should feel very privileged. This once common bird has declined precipitously since the 1970s, largely due to farming changes. It lays its eggs on the ground in spring and needs spring-sown crops to hide its nests from foxes and other predators. Unfortunately, most crops are now autumn or winter sown and too tall by the time the lapwing is thinking about nesting, so it is forced to breed on marginal land or pasture, where nests are vulnerable to foxes or can be trampled by livestock. Fortunately, there are many sensitive farmers trying to provide more nesting grounds on their land, but it's a tough battle.

If you're lucky, you'll hear the bird utter its call, a slightly chilling swanny-whistle that gives rise to its nickname: 'peewit'. It should be a common sound on a wild winter walk – let's hope it is heard in more of our countryside in the future.

Lapwings drift in to roost on the Somerset Levels.

INSET: *The lapwing has a distinctive crest and emerald sheen to its plumage.*

North Norfolk's Birding Paradise

Adam Stones

Norfolk is like nowhere else in Britain. The contrasting wild landscapes – from reedbeds to sandy plains and watery woodlands – are a marvel in their own right. But it's the way these lands mesh together, diffusing into one another, that attracts the kaleidoscope of wildlife that calls Norfolk home.

The stars of the show are the birds, which arrive in such variety and number that even the most reluctant birdwatcher will be amazed. There is something to see all year round; in spring, some of the waders and wildfowl depart as new species such as grey plover arrive, stopping off on their way back from Africa. During summer, breeding birds on the coast provide the main interest, especially huge colonies of terns. Autumn sees birds stopping on their long return journey south, but it is in the winter when the county provides some of the year's most unmissable spectacles – sights that are unrivalled anywhere else in the UK.

Awash with Birdlife

The Norfolk coast provides important feeding grounds and safe roost sites and in January it teems with wildfowl, waders and gulls, as well as seaducks, divers and grebes.

It is likely there will be as many as 400,000 birds there at any one time. It's home to scores of Bewick's and whooper swans, but by far the most numerous birds are the pink-footed geese, with tens of thousands arriving from Iceland and Greenland every year. Watching them erupt in huge, noisy numbers and pass overhead as they head inland at dawn to feed is one of the sights of winter.

Novice birders needn't even worry about where to head, as Snettisham RSPB reserve runs events, where guides help you enjoy the spectacle. Snettisham is also home to another unmissable spectacle – that of waders, most typically knots, coming off the flats at high tide, rising in colossal balls of tens of thousands, silhouetted beautifully against the sky. But

it is Titchwell Marsh that is the RSPB's most popular Norfolk reserve, visited by around 90,000 people each year. On the foreshore you might see twite, snow bunting and shorelark, while you may also hear the deep boom of the elusive bittern sheltering in the reedbeds.

The bittern has been a cause for concern for the RSPB for years, its red conservation status making it one of the most threatened species in the UK, but numbers are now improving. There are now around 230 booming males in the UK, around 100 of which call Norfolk home.

Conservation Pioneers

In 1926, an area of marsh at Cley was bought to be held in perpetuity as a bird breeding sanctuary. This was the beginning of conservation as we know it today and the first of the country's 47 Wildlife Trusts. Norfolk Wildlife Trust (NWT) has grown considerably since then and now cares for 50 nature reserves and other protected sites, including 10km (6 miles) of coastline, nine Norfolk Broads, nine National Nature Reserves and five ancient woodlands.

Inland, look out for finches, tits and woodpeckers in the winter woods, and make time to explore the man-made 500-acre wetland at Pensthorpe. And in the Broads, the lakes, rivers, reed beds, fens and grazing marshes form our largest protected wetland and teem with cranes, marsh harriers and hen harriers in the winter.

But the fact is that the rich tapestry of landscape and wildlife in Norfolk has changed, adapting beyond comprehension over the centuries, The evolution of the area will continue in the years to come, but whatever the future holds for this birder's mecca, there will always be something truly magical to see. Just don't forget your binoculars.

Norfolk's vast and noisy flocks of pink-footed geese provide one of the UK's most magnificent wild spectacles.

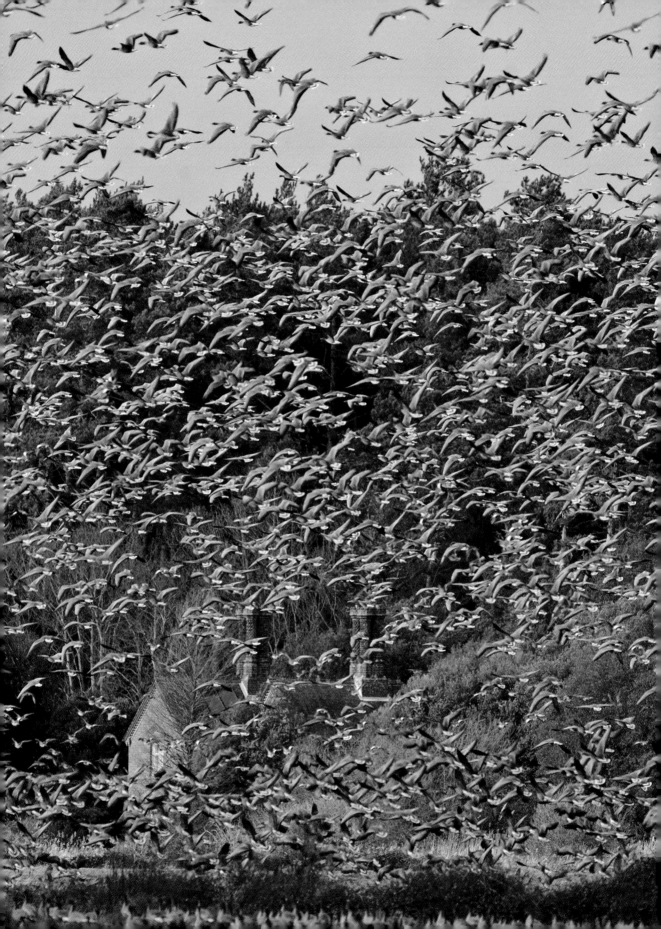

Stargazing for Beginners

Will Gater

Ask someone to describe the British countryside to you and they'll probably mention rolling hills, windswept coastlines and lush woodlands. They may even talk of the rich variety of wildlife it's home to and the bucolic serenity of country living. But few will likely describe another feature of these rural oases – their dark night skies.

Away from the bright lights of our towns and cities, the countryside offers a glimpse up at the glittering splendour of the night sky, unfettered by the creeping orange glow of urban light pollution. With the cold, clear nights of winter upon us, there's no better time to get out and explore this magical celestial landscape.

Our fascination with the night sky is, of course, not a recent development. The grand arch of the Milky Way and a sparkling – light pollution free – night sky must have been a source of incredible awe and intrigue to the ancient peoples of this country. And for centuries the Sun, Moon and stars have guided sailors who have set sail from these wave-battered shores. Today, though, stargazing is not a matter of survival but one of pleasure. You don't need expensive equipment to enjoy it either – a small amount of preparation and a desire to learn is all that's required.

Searching for Patterns

At first, the best way to work out what you're looking at is to identify patterns of bright stars. For example, you may be familiar with the pattern of stars in the northern hemisphere known as the Plough. Astronomers call these patterns of stars, such as the Plough – that aren't official constellations – asterisms. There are many asterisms in the night sky that can be used as staging posts to 'jump' to other stars or celestial objects – a navigational method astronomers fondly call star-hopping. In the case of the Plough, you can follow the curve of its 'handle' backwards to reach a bright star

(Arcturus) in a different constellation (Boötes). As you begin to recognise and identify bright stars, asterisms and even whole constellations, you'll be able to make your own star-hops; before too long you should have a pretty good idea of where many things are in the night sky.

You don't need a telescope to be an astronomer either. There's a huge wealth of things in the night sky that need nothing more than your eyes to see. The stars are the most obvious. At first glance you may think they all look the same. However, if you look carefully, many show subtle colours. At this time of year, there are some great examples of the striking colour differences between stars, which are due to their differing temperatures. Take the bright stars Rigel and Betelgeuse, in the constellation of Orion, for example; Rigel appears a bright blueish-white, whereas Betelgeuse has an orangey-red tint.

The Milky Way is another spectacular sight from a dark sky site. It appears as a misty band of light stretching up over the horizon and right overhead at this time of year. Our galaxy is home to 200–400 billion stars and it's the combined light of many of these stars that we see as the faint band of the Milky Way. If you have very dark skies, you may even spot the huge clouds of dust and gas weaving throughout the galaxy, which create dark silhouetted patches within the bright star fields of the Milky Way.

Meteors, more commonly known as shooting stars, are another astronomical sight that are best seen with the naked eye. A meteor is caused when a tiny, sand-grain-sized piece of space dust enters our atmosphere. Its enormous speed causes the air ahead of it to compress and heat up and, in the process, produce a brief streak of light that we see as a shooting star.

You can see many of the planets with the naked eye, too. They look like bright stars, perhaps with a hint of colour. Mars, for

example, has a clear orangey-red hue to it, while this month Jupiter is visible high in the southern part of the sky at around 8–10pm.

Other astronomical objects to look out for with the naked eye include bright star clusters (groupings of many stars) and bright nebulae (glowing gas clouds in space). In mid-January, the famous Pleiades star cluster – often known as the Seven Sisters – is visible high in the south, at about 8.15pm, while the grand Orion Nebula looks like a fuzzy star in Orion's Sword.

Whatever objects you choose to observe, your first steps in astronomy will no doubt be an enthralling experience. You'll be starting out on an exciting journey that'll mean you never look at the night sky in the same way again. As astronomers like to say, clear skies and good luck!

Six Constellations to Look Out for in January

Once you've found a light-free spot in the countryside, get out there and look to the skies to spot these constellations – all of which you can see clearly with the naked eye.

AURIGA The constellation of Auriga represents a charioteer. The best way to identify it is by first finding the brightest star in the constellation, which is called Capella, which will appear in the west-north-west sky a few hours after sunset.

TAURUS If you're looking at Orion in the evening sky, you'll find Taurus, the Bull, above and to the right of it. The bull's head is marked by a V of stars, known as the Hyades star cluster, and the bright orange-tinted star Aldebaran.

CYGNUS Cygnus, the Swan, is best seen during the summer and autumn months, but it's still visible low in the south in early January. The main stars in the constellation make a distinctive cross shape, with the top point of the cross marked by the bright star Deneb.

CASSIOPEIA The constellation Cassiopeia appears to sit within the sparkling star fields of the Milky Way and is easy to identify thanks to its clear W shape. You'll find the W on its side, high in the north-west part of the sky.

URSA MAJOR The Great Bear, Ursa Major, is probably most famous for the pattern of seven stars within its boundaries known, informally, as the Plough. In fact the constellation of Ursa Major is much more than these few bright stars. You'll find it in the north-east this month.

ORION Orion, the Hunter, is one of the most recognisable constellations in the winter night sky, and it's been known since the time of the ancient Greeks. Many are familiar with his glittering 'belt' made up of the three bright stars Alnitak, Alnilam and Mintaka. You can find Orion towards the south at around 10pm in mid-January.

OVERLEAF: *Dark Skies sites such as Glenmore Forest Park in the Cairngorms offer unrivalled stargazing.*

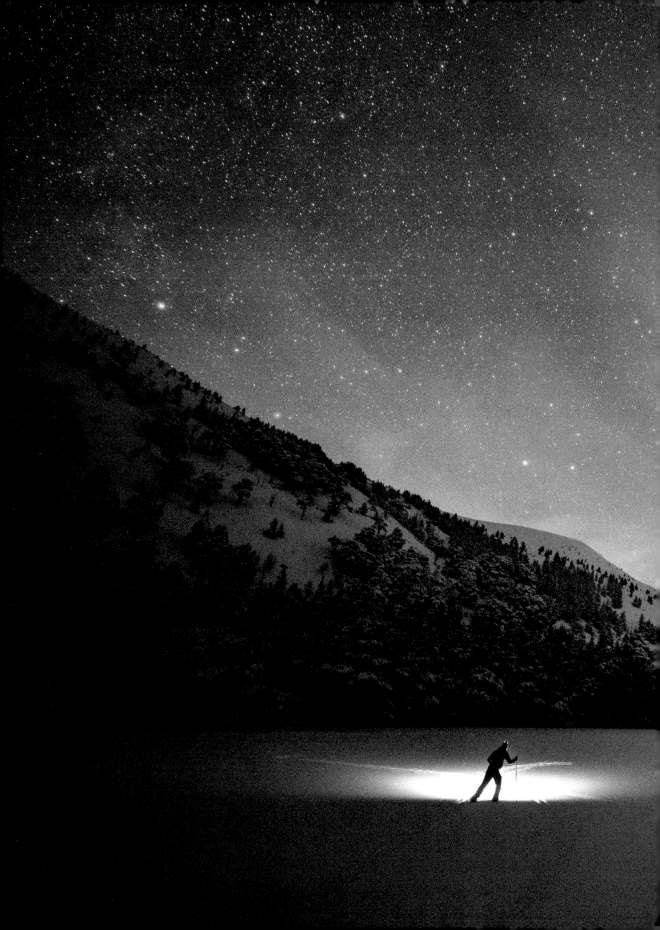

Know Your Cows

Holstein or Holstein-Friesian crosses dominate farms to the extent that if you asked any schoolchild to draw a cow, it's a good bet that they'd sketch a big creature with black and white markings.

Pure Friesians arrived first and eventually replaced traditional shorthorn dairy and Ayrshire breeds. Later, the Friesians were themselves replaced by Holsteins or Holstein-Friesian crosses. Holsteins and Friesians originated in Holland and northern Germany. The Americans produced specialist milking herds of Holsteins and exported them, while in Europe farmers preferred Friesians with a strong Dutch ancestry for both dairy and beef. Cross breeding resulted in the Holstein-Friesian we're so familiar with today.

BBC Countryfile *Magazine*

Spot the Difference

HOLSTEIN (BELOW LEFT) After the Second World War, purebred Holsteins were introduced. Before long, the big milking cows left the British Friesians behind. Holstein specialists stress that in a modern market you need commercial animals that can be housed indoors all year if needed, producing quality milk and lots of it. They say that's especially true when profit margins are tight. Bred purely for milk production, the Holsteins are taller than Friesians but are less muscular and have a more pronounced bone structure.

SHORTHORN DAIRY (BELOW RIGHT) Established in north-east England in the eighteenth century and the dominant dairy cow until the mid-twentieth century. Now considered a rare breed. Mainly red and white in colour.

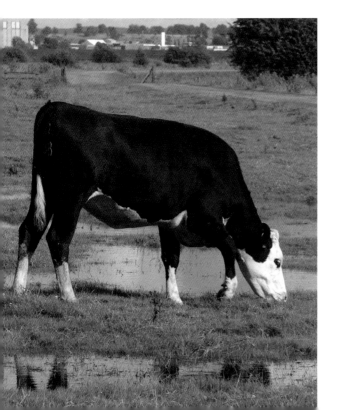
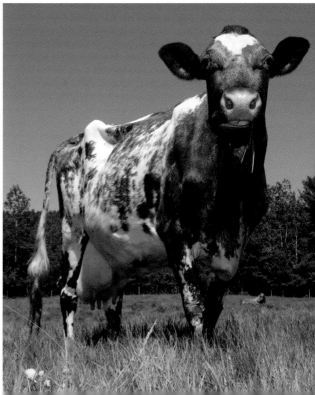

BRITISH FRIESIAN (BELOW LEFT) In the UK, Friesians were a familiar sight in the Victorian era, but in the 1890s foot-and-mouth disease was so widespread on the continent that live animal imports to Britain were banned. The breed society was set up in 1909 and five years later the first official shipment of Friesians arrived on British soil. By the 1950s, the majority of UK cows were British Friesians. Friesians are about 15cm shorter than Holsteins and have a more filled-out appearance that reflects their use as both a dairy and beef breed.

In the last decade or so, there's been a resurgence of interest in the British Friesian. The president of the breeders' club used to have a large herd of milking cows but has switched to rearing bull calves for beef. Now he has more stock than he did when he was dairying and his experience points to the breed's durability.

AYRSHIRE (BELOW RIGHT) The typical brown and white cow, hardy and rugged. Originated in mid- to late nineteenth century in Scotland. Becoming more popular again.

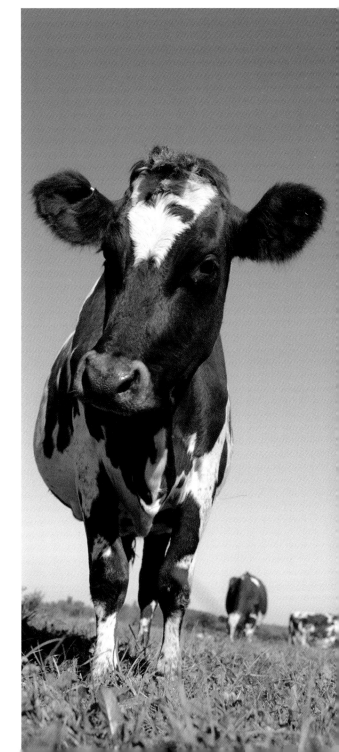

The Swede

Richard Aslan

Some vegetables have all the luck – glamour, fame, flawless complexions and seemingly endless TV appearances with Nigella. Then there is the poor swede. Warty and hairy, it isn't even unconventionally beautiful. It's the dread of schoolchildren the country over, and, adding insult to injury, the poor swede all too often finds itself mistaken for its better-known cousin, the turnip – it took science until 1768 to recognise it as a distinct species.

'Swede' is an abbreviation of 'Swedish turnip'. It is also known as the yellow turnip to distinguish it from the common white turnip (just 'turnip' to its friends). In the USA, swedes are known as rutabagas, which adds a bit of all-American pizzazz. The glamour fades when you find out the name comes from rottabagge, a Swedish dialect word meaning 'bag root'. The old French *chou de Siam* 'Siamese cabbage' raises hopes again, only to have them dashed. The reference to Siam isn't literal, but rather refers to unknown origins.

The Swede was first mentioned in print in 1620 by Swiss botanist Gaspard Bauhin, who discovered it growing wild in Sweden. It was listed in the English royal gardens in 1669, but took another century to become widely established. It had to wait another two decades to cross the Atlantic with Swedish and German emigrants to Illinois.

Before the late Middle Ages, the swede simply didn't exist. Puzzled botanists shuffled swedes from one botanical family to another until 1935, when Korean-Japanese scientist Woo Jang-choon discovered the truth. He published his magnificently named Triangle of U theory, showing that the swede is actually the hybrid offspring of turnips and wild cabbages.

Unusually for a hybrid, it maintained extra pairs of chromosomes, with one set from each

Too often overlooked, the swede has a mellow, earthy flavour.

parent enabling very different kinds of hybrid to arise. So the unexpected siblings of the round-rooted swede are the bright yellow, long-rooted oilseed rape, which was first recorded at the end of the fourteenth century (and can be seen brightening up fields throughout the British countryside in spring and early summer), and the poorly named Indian mustard, which is found in cuisines from Africa to Korea.

To this day, swedes are mostly eaten in north-western Europe. In the UK, they are grown mainly in Somerset, Devon, North Yorkshire, Lancashire, Durham and Northumberland. Next time you see this fascinating – and, many would say, delicious – root in the greengrocers, don't pass it up in favour of something smoother or with a longer pedigree. Peel it, chop it, stick it in a stew or mash it with butter, and remind dinner guests just how special this particular vegetable really is.

Neeps and Tatties

Scottish for swede and potatoes, this hearty side dish is traditionally served with haggis, but makes a fine accompaniment to any winter meal.

- 450g (1lb) swede, peeled and roughly chopped
- 450g (1lb) potatoes, peeled and roughly chopped
- 4 tbsp warmed milk
- 4 tbsp melted butter
- large pinch of nutmeg

Place the swede and potatoes in separate pans and cover with cold water. Put the lids on, and bring to the boil. Cook for about 20 minutes, or until tender, and drain. Add half the milk and butter to each pan and mash, making sure all lumps are mashed into submission. Add nutmeg to the potato and serve side by side.

Beavers in the UK

Fergus Collins

'Size of a Labrador – well, at least a cocker spaniel', says Peter Burgess, conservation manager for Devon Wildlife Trust (DWT), standing beside the River Otter in Devon. He is talking about the Eurasian beavers that have set up home here, and, just like that, we have to revise our idea – upwards – of how big these creatures are.

Beavers were once native to the UK but were hunted to extinction 300 years ago – 'as vermin, for their fur and also for their meat, which was highly prized', says Peter. Now, ten to fifteen human generations later – 'only a blink of an eye in ecological terms' adds Peter – they have returned and there are now probably 50 on the Otter. No one knows how they got here, although escapes from private collections have occured elsewhere in the UK. Others claim the beavers were released deliberately.

Arguments rage as to whether the animals should stay. Conservationists such as DWT say that beaver dams improve a river's water quality and flow, as well as creating mosaics of habitat for a range of wildlife; some anglers fear the dams will impede migrating fish, while some landowners and riverside homeowners are concerned about potential flooding caused by the dams as well as loss of trees and crops.

Defra (the Department for Environment, Food & Rural Affairs) wishes to capture the beavers to test them for a disease that is potentially fatal to humans: *Echinococcus multilocularis*. This is welcomed by the Angling Trust and landowning organisations such as the CLA. The DWT agrees that they need to be tested but is concerned the beavers would not be released back into the wild if proved to be disease-free.

Peter and his colleagues are monitoring the wild population on the River Otter and he walks from a public footpath into a willow and alder thicket beside the river. Here there is a wilderness of waterlogged woods, oxbow lakes and side streams – the result of the river's sporadic, meandering force taking advantage of the area's friable soils. A kingfisher zeeps past, a young heron takes off wearily with an audible 'harrumph' and siskins chatter from the alders.

The water is deep enough here that the beavers haven't built any dams. 'They use dams to create deep pools as refuges, as well as to make it easier to get around. They also use deep water as a refrigerator to store food in over the winter. So they tend to build the dams in the smaller upper tributaries', says Peter.

He has to search quite hard to find signs of the animals' impact – the ends of willow twigs and branches, chiselled to a fine, pencil point, and occasional felled saplings. Eventually he comes across a newly felled willow tree. Its trunk is 30cm (a foot) in diameter, chiselled through in cartoon fashion and surrounded by bright wood chips. It would take a beaver just one evening to do this.

Beavers are mostly active from dusk to dawn, and Peter says that the best way to monitor their impact on the landscape is through a captive breeding project that has been running since 2011. He drives to the little-known heart of Devon some 80km (50 miles) from the River Otter – an area of rare 'culm' grasslands. Here the DWT has built an impregnable fence around a soggy area of scrubby wood and introduced a pair of beavers, which have raised three young. The idea is to see whether these captive beavers will control the scrub through their felling and dam-building and if there is an additional impact on biodiversity.

Throughout this wet woodland with its trickle of water, the beavers have built dams, creating glades and a series of stepped pools, which Peter describes as 'paddyfields'. Between these, the beavers have built a network of canals to help them move around. Peter says that 'they're triggered by the sound of running water, which helps them patch up holes in their dams'.

The dams themselves are impressive – up to a metre (3 feet) high – and, though there are no fish in this boggy wood, such a structure would

surely impede a stream. Peter acknowledges that beavers could be a localised problem for fish in tributaries, but he offers a solution. 'In places where it's unacceptable, dams could be removed or access restricted to vitally important fish-spawning areas. The same could be done if the beavers damaged orchard trees or favoured crops such as sugar beet and carrots. As a last resort, the beavers could be relocated.'

Peter also accepts that beaver activity might prompt more vegetation flowing downstream, which could block culverts and cause localised flooding. Again he says this could be managed.

Beavers are a keystone species whose actions offer multiple benefits. A study by Scottish Natural Heritage shows that beavers' pools (with plenty of woody material in them) act as refuges for vulnerable fish fry and generally improve a river's fish stocks. Beavers' felling activity also opens up banksides, letting light and life into rivers, and that's not just good for fish – butterflies, dragonflies and a host of creatures love riverside coppice woodland and meadow.

The DWT has put in sophisticated equipment to measure water and pollution flows in and out of the 'test area'. It demonstrates how the beavers' actions are keeping water in the woody meadows for far longer than in the surrounding pastoral and arable fields. 'We've shown that this creates a steady year-round flow – with the potential to keep flash flooding to a minimum', says Peter. 'The dams also act as settling tanks and filter systems, removing pollution from the water. Several water companies have shown interest in how this works. It's a far cheaper solution than trying to sort the problem downstream. The landowners are cautious, waiting to see what happens on the Otter – and one or two can see the potential for beaver-watching ecotourism. Other locals are almost wholly in support. Of the 230 responses, 225 are in support. The public consultation is still open.'

In the meantime, the DWT will continue its project in the culm grasslands – and look for a wider water catchment in which to test the efficacy of the beaver.

Beavers are now being introduced elsewhere in England. And on the River Tay in Scotland, increasing numbers of beavers are living wild. Is it possible that the beaver dam has already burst?

Wild Populations of Beavers in Britain

KNAPDALE In 2004, a small group of beavers was introduced to the Knapdale area of Argyll in a controlled experiment – the Scottish Beaver Trial – to assess their impact on the ecology of the area. Since then, the beavers have bred and there is a small population though it is not thought to be self-sustaining and beavers are regularly released into the wild to maintain numbers.

RIVER TAY Some 300 beavers live wild throughout the River Tay catchment area from accidental releases in the past 20 years or so. Scottish Natural Heritage has abandoned plans to trap and remove the population despite strong pressure from landowners who claim the animals are causing substantial damage. Some culling has taken place under licence. A survey by NatureScot, the Scottish government conservation agency, estimated that there are as many as 1,000 beavers in the wild in the Southern Highlands.

RIVER AVON A family of beavers has been found upstream from the city of Bath – origins unknown.

RIVERS TAMAR AND TAW The Devon Wildlife Trust has found evidence of beaver populations in the west of the county on two major rivers and their tributaries.

RIVER STOUR Beavers have been spotted on the River Stour in 2023 and it is likely a small colony has set up home in the wild here.

OVERLEAF: *For many conservationists, beavers are important allies in restoring degraded river systems.*

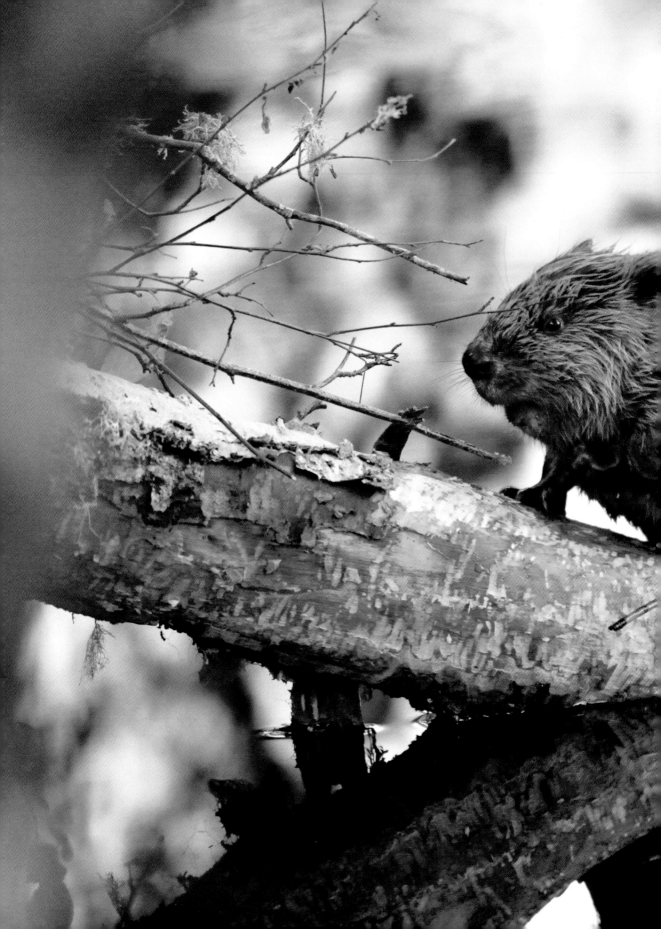

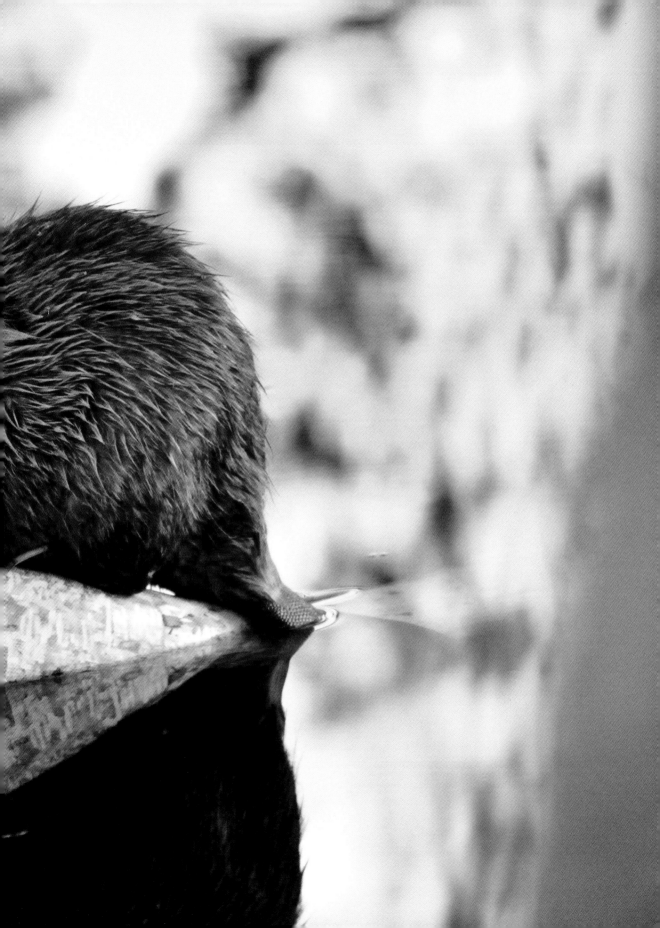

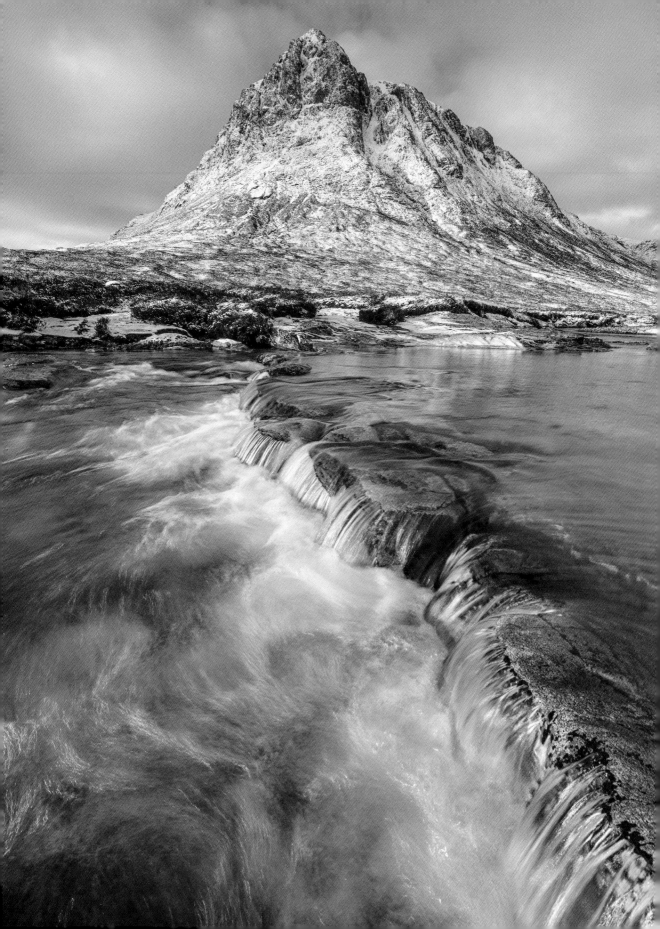

February

'Why, what's the matter. That you have a February face, so full of frost, of storms and cloudiness?' asks Beatrice of Benedick, in just one of the many taunts between the two in Shakespeare's *Much Ado About Nothing*. Over the centuries, nothing much has changed – that is still a pretty good description of the face of February.

Except it does seem to be a little less frosty and rather stormier these days, with the finger pointing towards climate change: in 2023 the whole of the UK saw the fifth-mildest February since records began in 1884 (mean average 5.8 degrees Celsius), and in England it was the driest in 30 years, but there was also Storm Otto, which brought gusts of more than 130km/h (80mph) and cut power to 61,000 homes.

A kinder view of February came from the renowned gardener Gertrude Jekyll who must have been an optimist because early last century she managed to create a delicate garden in the castle grounds on bleak Holy Island off the Northumberland coast. 'There is always in February some day, at least, when one smells the yet distant, but surely coming, summer,' she wrote. Nice thought.

For me February is a good month for wrapping up well, soaking up the moody atmosphere and walking in the footsteps of our ancestors. Strange shapes and patterns we come across under our feet could signify ancient fortifications or long-gone methods of farming; and in Cornwall, our county of the month, derelict tin mines and old chalk quarries remind us of how industrialised now-empty landscapes once were.

Nature itself has created many anomalous features to admire – I remember once putting my hand into a narrow gap between layers of different rock on a Scottish crag and in doing so bridging a gap of many millions of years, created when two tectonic plates clashed.

The shapely peak of Buachaille Etive Mòr dominates
the wilds of Rannoch Moor in the Highlands.

Early Wildflowers

Phil Gates

The first wildflowers of the year lift our spirits with their promise of spring. They also provide vital sources of nectar and pollen for the emerging bees and butterflies, tempted out by late winter sun.

Lesser Celandine *Ficaria verna*

Wordsworth wrote famously of the daffodil, but it was a smaller, more reticent, yellow flower that truly captured his poetic heart. *'There's a flower that shall be mine, / 'T is the little Celandine.'*

We have two flowers with the name celandine, the greater and lesser, though they are neither closely related nor strikingly similar in appearance – save the yellow of their flowers. Wordsworth's inspiration was the earlier-flowering lesser celandine, whose heart-shaped leaves are among the first greens to slip between the tired pastels of late winter. They keep a low profile away from the bite of the wind, and often go unnoticed until the flowers unfurl. And on a cold February morning, the narrow, pointed petals shine like the midsummer sun.

The lesser celandine draws the attention of pollinating insects, though the plant is more likely to reproduce through its root tubers, which develop as the plant photosynthesises. These store energy during winter, enabling the plant to grow so early in the year.

The shape of the tubers has been likened to a bunch of figs, hence the Latin name *ficaria*, whereas in the late Middle Ages another similarity was noted. The doctrine of signatures was widespread, suggesting a plant could be used to treat the body part it resembled. This led to the naming of flowers such as eyebright, lungwort and hedge woundwort. The tubers of lesser celandine were considered to resemble haemorrhoids and the plant was applied accordingly, becoming popularly known as pilewort.

More February Flowers

ALEXANDERS *Smyrnium olusatrum*
Its green umbels have a musty smell that attracts fly pollinators. A former herb, it fell from favour after celery was introduced. It's now naturalised near the coast.

WOOD SORREL *Oxalis acetosella*
Its nodding flowers may be marked with pink veins and yellow spots at their base. Wood sorrel often grows over decaying branches on the woodland floor.

BUTTERBUR *Petasites hybridus*
Underground rhizomes produce conical pink inflorescences that erupt through riverbank soil before the leaves expand. It has separate male and female plants.

BARREN STRAWBERRY *Potentilla sterilis*
Similar to wild strawberry, this blooms earlier and its petals don't touch one another. Fruits are inedible. It is common on woodland edges.

BUTCHER'S BROOM *Ruscus aculeatus*
This evergreen of dry woodlands used to be bound to make brooms. Star-shaped flowers are carried in leaf-like structures that are really flattened stem branches.

SPURGE LAUREL *Daphne laureola*
Clusters of scented green flowers on this evergreen shrub attract the first bees and brimstone butterflies. Find it in calcareous soils, in hedge banks and beech woods.

SWEET VIOLET *Viola odorata*
The only native violet that's fragrant, this is always the first to flower. Creeping stolons root at their tip, so plants form patches in hedges.

Sweet violets bring welcome colour to late-winter hedgebanks and woodland edges.

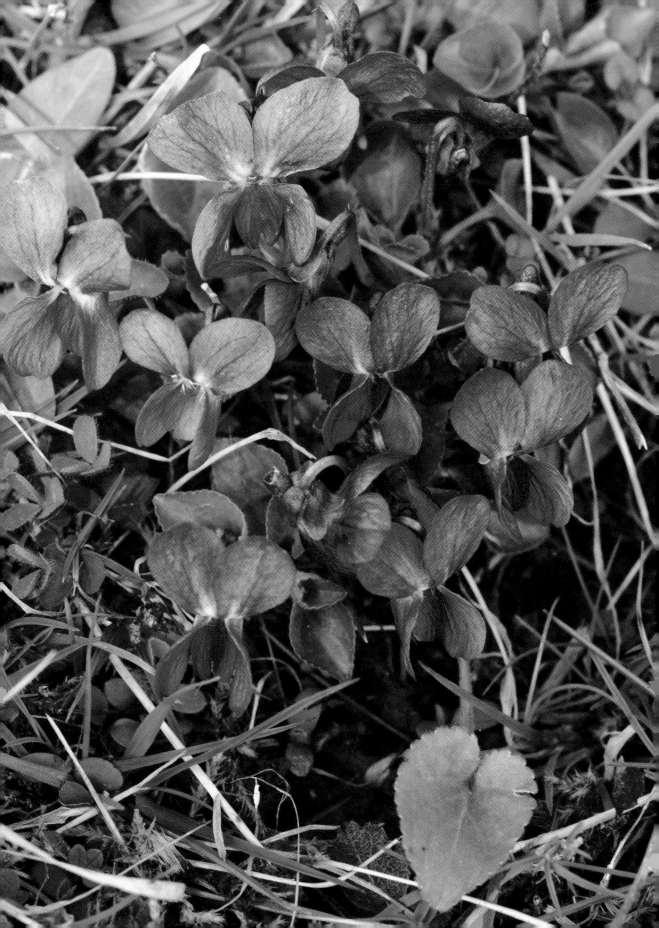

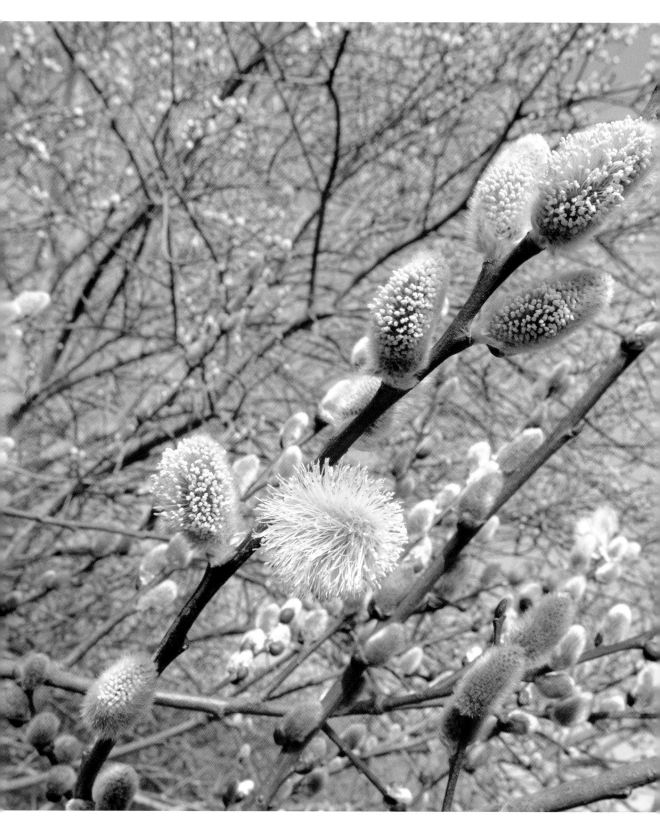

Willow Tree *Dominic Couzens*

There is much that is sumptuous about riverbanks in the early spring: the permanently rich waterside vegetation, the gentle flow and glint of the water in a largely motionless land, the shock of seeing a kingfisher's electric blue. But nothing quite defines a meandering river in winter in the same way as its willows, the undisciplined sentries charting its course.

Their apologies for trunks, as twisted as screwed-up cardboard; their bad haircuts of branches; the soft winter light showing up green or orange on their bark: all of these provide punctuation for a river's story and its flow.

Perhaps the greatest delight of willow at this time of the year, however, is in its outrageously early blossom. It is often January when the male trees start to send out their fluffy, whitish bulb-shaped catkins, which earlier generations called goslings because of their resemblance to the fluff of newly hatched geese.

Later on, their bulbs burst into yellow and swarm with visiting bees and other insects that have little else to feed upon. These are the pussy willows, the flowerheads of our most abundant species, the goat willow (*Salix caprea*). Those of the grey willow (*Salix cinerea*) come out a bit later. With so few blooms out during an early Easter, the flowering stems of willow have often been used as substitute palms on Palm Sunday.

People have much to appreciate from willows, other than reminders of spring. If you've ever had relief from a headache or other pains, it is the willow you have to thank, or at least an ingredient in its bark called salicylic acid. A synthetic form of this compound led to the development of aspirin.

The wondrously pliable shoots and branches have long been used in the weaving of baskets, while the equally straight timber of a hybrid of the white willow (*Salix alba*) is deemed perfect for making cricket bats.

From silken 'cat's paws', male goat willow catkins burst into sprays of yellow pollen, irresistible to early bees.

A Guide to Rocks

Roly Smith

The English Romantic painter John Constable said: 'We see nothing truly until we understand it.' That certainly applies to the British landscape.

We love our wonderfully varied landscape and the animals, birds, trees and flowers that populate it. But all life on Earth depends on the rocks beneath – the skeleton beneath the flesh. And a little knowledge of geology can add immeasurably to our understanding and enjoyment of a country walk. Come with us as we embark on a journey of discovery into the hidden Britain beneath our feet...

The Ancient Ravine – Cheddar Gorge

The river that created the winding, 137m (450ft)-deep Cheddar Gorge on the southern edge of the Mendip Hills is virtually invisible to visitors to the famous show caves today. The gorge was formed by meltwater during interglacial periods over the last 1.2 million years, but during warmer times, such as we are experiencing today, the water flows underground through the permeable carboniferous limestone, creating the caves and leaving the gorge bone dry.

Today the underground Cheddar Yeo River emerges in the lower part of Gough's Cave, where Britain's most ancient complete human skeleton, estimated to be over 9,000 years old, was found in 1903. Interestingly, it has been suggested that the caves might have been used for maturing cheese in prehistoric times – perhaps the earliest examples of the eponymous cheese.

The Chalk Face – Hunstanton Cliffs

The vivid bands of white, orange and brown rocks that make up the spectacular coloured cliffs of Hunstanton, on the edge of The Wash on the north Norfolk coast, are a cross-section of geological time.

Dating from the Early Cretaceous period, about 100 million years ago, they consist of a dazzling-white layer of Ferriby chalk on top; a layer of fossil-rich orangey-red chalk (including fossil ammonites and belemnites), and finally the deep red-brown carstone forming the base of the cliffs. The three main beds are separated by bands of marl.

All these rocks were laid down under the sea in various conditions, ranging from shallow tropical lagoons to – in the case of the white and red chalk – deeper marine deposits.

The Village Without Sun – Peak Cavern, Castleton

The yawning void of Peak Cavern – the largest cave entrance in Britain and originally indelicately known as the Devil's Arse – was once the home of a community of rope-makers, in a village that never saw the sun.

The moist, damp conditions in the vast cave entrance made it ideal for twisting the ropes that were essential in the local lead mining industry. Now occupied only by a noisy flock of jackdaws, Peak Cavern is a prime example of the power of the meltwater at the end of the last Ice Age, about 10,000 years ago. Peakshole Water, which flows out of the cave, created an extensive system of caverns, including the recently discovered Titan, at 142m (464ft) the deepest cave shaft in Britain.

Finn's Footbridge – Giant's Causeway

Locals will tell you that the extraordinary columnar basaltic columns of the Giant's Causeway on the Antrim Coast are the remains of the legendary giant Finn McCool's attempt to cross the Irish Sea to fight a rival giant.

The geological explanation is no less amazing. Around 55 million years ago, intense volcanic activity created fissures in the Earth's crust, through which molten lava poured and cooled to form the 40,000 hexagonal columns we see today. The process is similar to the way mud cracks in a desert or on the bottom of a dried-up pond.

Finn's 'landfall' on the other side of the Irish Sea is found in the identical formation

of the basalt columns of Fingal's Cave, on the Hebridean island of Staffa.

Stand on a Ruined Volcano – Arthur's Seat

In its peaceful green hills and parklands, Scotland's ancient capital of Edinburgh hides a violent volcanic past, born in the fury of earth-shaking eruptions. Arthur's Seat, Calton Hill, Salisbury Crags and the crag on which the castle stands are all the result of volcanic activity during the Carboniferous period, around 350 million years ago.

Robert Louis Stevenson described Arthur's Seat, a 251m (823ft) summit, as 'a hill for magnitude, a mountain in virtue of its bold design'. It is actually the eroded stump – or plug – of a long-extinct volcano. The same applies to Castle Rock, across the city, occupied since the Bronze Age and where the castle is now one of Scotland's top tourist attractions.

Higher than Niagara – Malham Cove

It's hard to imagine, but the sweeping, 91.5m (300ft)-high limestone amphitheatre of Malham Cove in the Yorkshire Dales, bypassed by head-down Pennine Wayfarers, was once the site of a waterfall higher than Niagara.

At the end of the last Ice Age, torrents of freezing meltwater came crashing down the now-dry Watlowes valley above the Cove, tumbling over its lip and creating the verdant dale below. In times of heavy and prolonged rainfall, it still sometimes happens today.

Ice Age meltwater was also the architect of nearby Gordale Scar, thought to be the remains of a vast cavern whose roof has collapsed. The gurgling little Gordale Beck that leaps from the rock at the head of the gorge was the innocent cause of the catastrophe.

RIGHT: *Walk in the footsteps of the mighty Finn McCool at Co Antrim's Giant's Causeway.*

OVERLEAF: *Time is recorded in sharply defined layers of white and red chalk at Hunstanton Cliffs in Norfolk.*

Where Continents Collided – Knockan Crag

At Knockan Crag, north of Ullapool in the far north-west of Scotland, you can unlock the mysteries of one of the oldest landscapes in Europe, and see evidence of where continents collided.

Follow the Thrust Trail from the visitor centre through the 'knock and lochan' landscape to see the internationally famous Moine Thrust, where much older and darker Moine schists were pushed over the younger and lighter Durness limestone – leaving the older rocks on top. Here you can bridge an unimaginable 500 million years of geological history with one hand.

The theory of this dramatic rock reversal was confirmed in 1882 by two brilliant geologists, Benjamin Peach and John Horne from the Scottish Geological Survey.

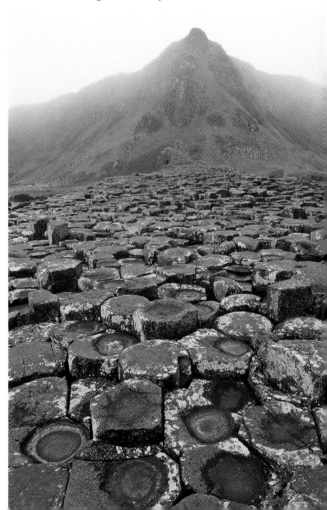

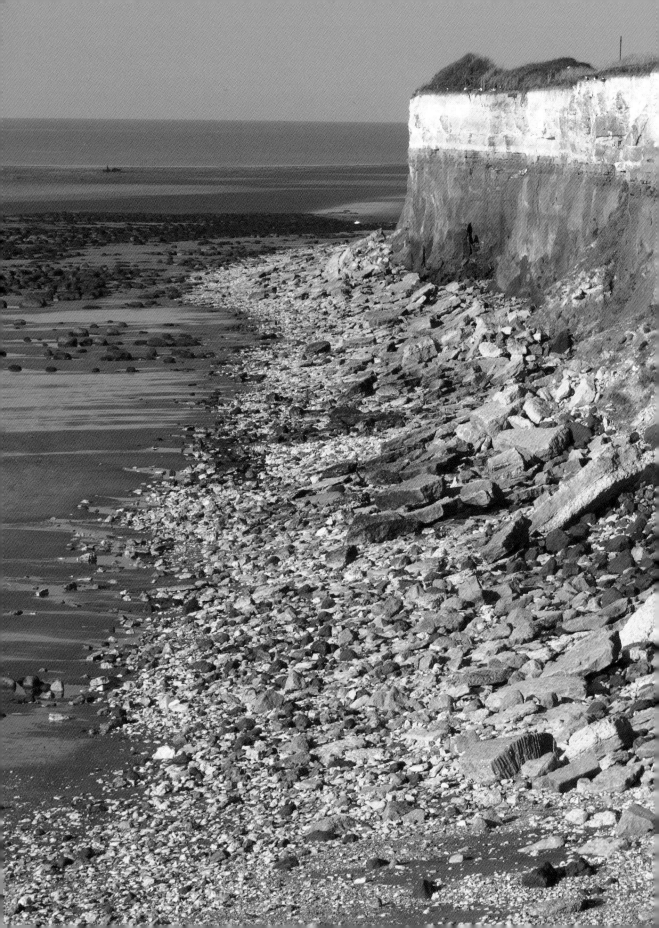

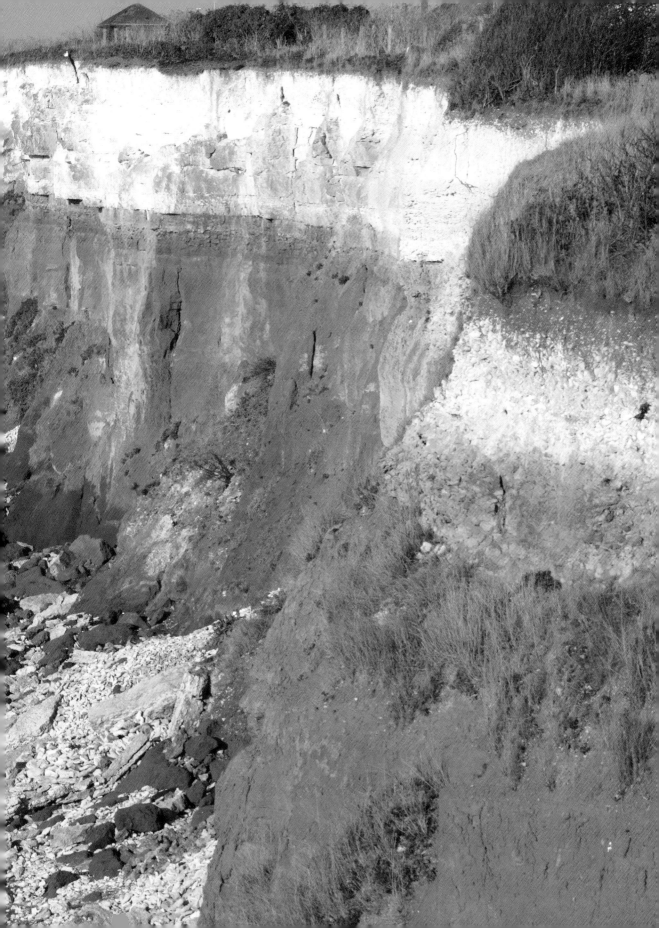

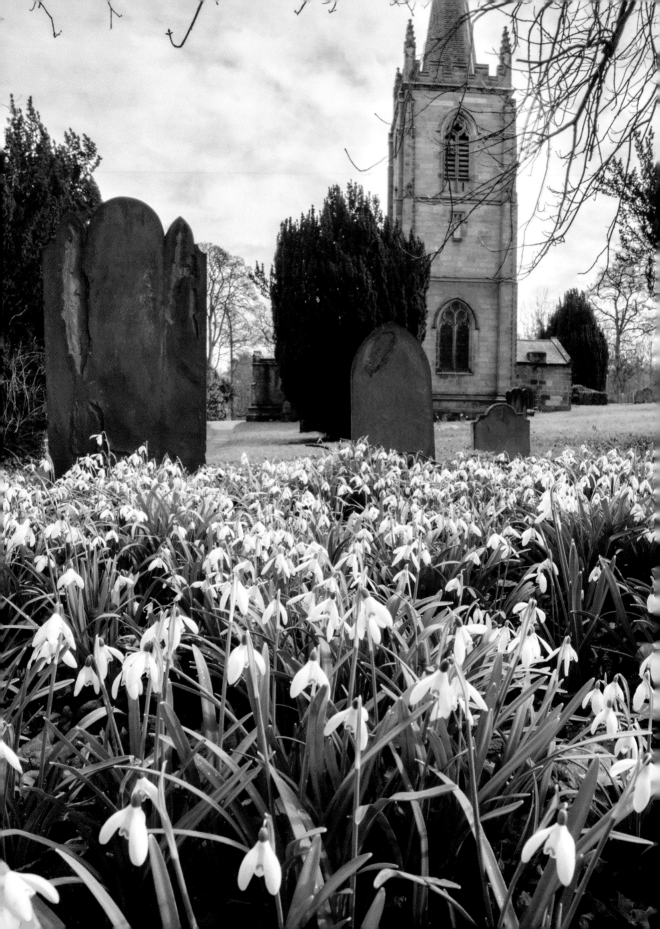

Churchyard Ecosystems

Gemma Hall

When winter holds tight under weakly lit skies, and paths are brown with rotting leaves, a burst of snowdrops is an antidote to post-Christmas gloom and reminds us that spring is nigh.

These February fairmaids awaken something within when we see them dance along riverbanks, under hedges and in woods and churchyards. Indeed, their link with purity, light and new life has encouraged their cultivation in God's acre for centuries, and is why snowdrops feature in the Candlemas festival on 2 February, which celebrates the Virgin Mary's purification.

As spring progresses, primroses, cowslips, winter aconites, lesser celandines and daffodils join in this celebration of life, bringing a warm, yellow glow to thousands of burial grounds. Nowhere else is the sense of spring triumphing over winter, light over dark and life over death more striking than in a graveyard at the beginning of the year – as surprising as that may seem.

The abundant flora in churchyards and cemeteries is, in part, explained by the cultivation of certain species such as snowdrop and primrose (the choice of memorial plant for children's graves in Victorian times) and the naturalisation of plants found in church flower decorations. But, to explain the proliferation of wild plants we must look, says Francesca Greenoak, author of *Wildlife in the Churchyard*, to the origins of these sacred enclosures.

'A number of churchyards, particularly in the Middle Ages, were carved out of woods and forests and enclosed by a wall or hedgerow,' says Greenoak. Many others originate from flower-rich meadows. Over the centuries, the land outside the church boundary was 'improved' by the plough and artificial fertilisers or engulfed by concrete. But inside, the grasslands remained comparatively untouched, locked in an ecological time warp.

Cemeteries and churchyards are often surprisingly rich oases for wildlife, even in heavily built-up areas.

If you walk through a traditionally managed churchyard or cemetery, you gain a sense of the botanical diversity that was once common in lowland Britain before modern farming practices destroyed more than 80 percent of our wildflower grasslands. Meadow saxifrage, pignut, bulbous buttercup, cuckoo flower and orchids flourish between graves. Even where no meadow ever existed or where churchyard grasslands have been transformed into manicured gardens, it is relatively easy to re-establish the assemblage of plants found in semi-natural grasslands. 'Treat it like a meadow and it becomes a meadow,' says Greenoak.

Next time you pass a churchyard, step through the gates and see for yourself.

Five Classic Churchyard Species

SPOTTED FLYCATCHER This migrant eats insects and nests in ivy, both plentiful in churchyards, so you could hardly find a better habitat for this increasingly rare bird.

PRIMROSE This common churchyard flower has been planted on graves for centuries. Some have become naturalised from flower displays, others originate from old woods.

LICHENS The abundance of lichens increases with the age of the graveyard's stones and their geological diversity. Some churchyards have more than 100 varieties.

YEW TREE No other tree is more strongly associated with churchyards than the yew. Many of the oldest specimens predate the church buildings they face.

SLOW WORM This legless lizard hides in long grass and cracked tombs and enjoys meals of slugs and snails harvested from churchyard meadows and dry-stone walls.

Great Crested Grebes *Fergus Collins*

Wildlife TV programmes often wow us with the beautifully choreographed courtship dances of birds of paradise from remote places. But if your local park has a decent-sized lake, you might find yourself with a front-row seat at one of nature's great water ballets. It's at this time of the year that great crested grebes perform their courtship displays.

Grebes have a slight resemblance to ducks but are more graceful on water (they are hopeless on land). They are also superb divers and can outpace their fish prey underwater. The great crested is the most handsome of our native grebe species, with a long sharp bill, fiery orange head plumage and a spiky crest. This headgear is an essential part of the mating dance.

February is never dull if you're a great crested grebe. It is the month when the bird's thoughts turn to courtship and, through an intricate dance on the water's surface, a pair of grebes forge a powerful bond that will enable them to successfully rear a brood of youngsters.

When male and female great crested grebes meet, both birds raise their crests, flare their fiery throat feathers and mantle their wings. Alternately, the birds bob and shake their heads, remaining beak to beak for long periods. One bird may then dash away – the retreat display – only to suddenly turn and face its pursuing partner. The birds then make synchronised dives and emerge holding weed in their bills. They then rear up, chest to chest, feet paddling madly, and offer each other a weedy present. Though the water is frothing below them during this 'weed dance', the two birds remain remarkably poised.

If the dance is successful, they form a lasting bond, mate and begin building a nest.

Great crested grebes are now a relatively common sight in the UK, but they almost went extinct in the nineteenth century, as their orange tufts were much sought-after as decorations for fashionable hats. Fortunately, this pointless slaughter was stopped and the birds recovered.

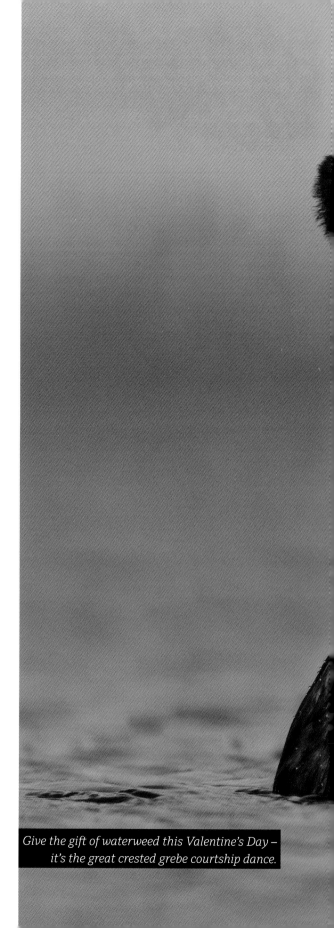

Give the gift of waterweed this Valentine's Day – it's the great crested grebe courtship dance.

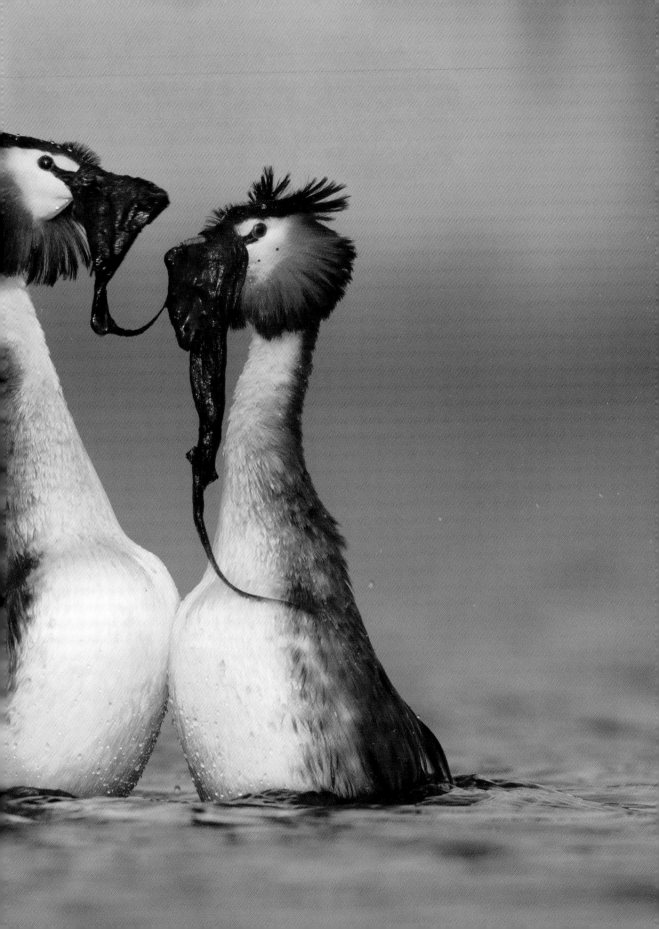

Woodpeckers

Fergus Collins

Late winter is an excellent time to go woodpecker spotting – with fewer leaves on the trees, they are more visible and their drumming reverberates through stark woodlands.

The Woodpeckers of Britain

GREAT SPOTTED WOODPECKER
Dendrocopos major
Largely black and white with flashes of red on its head (male) and rear (male and female), this is the size of a blackbird. Its bursts of drumming in spring are a courtship call. Its emits a high-pitched 'kik' sound and has distinctive undulating flight. Of the four, it's most likely to visit garden birdfeeders.

LESSER SPOTTED WOODPECKER
Dendrocopos minor
This tiny sparrow-sized bird is now extremely scarce in the UK, and hard to see as it lives high among the outer twigs of trees. It lacks the great spotted's white shoulder patches and drums much faster – 15 blows a second compared to the 8–10 of its larger cousin.

GREEN WOODPECKER *Picus viridis*
With its red crown and green-yellow body, this species is often mistaken for an escaped parrot. Though it nests in woods, it tends to forage in parkland and meadows where it probes anthills to eat ants and their larvae. It has a laughing, shrieking call, and is known as the 'yaffle'.

WRYNECK *Jynx torquilla*
This tiny mottled brown woodpecker is extinct as a breeding bird in Britain but still appears on passage in spring and autumn – especially in gardens. It hunts ants and, unlike other woodpeckers, lives mainly on the ground.

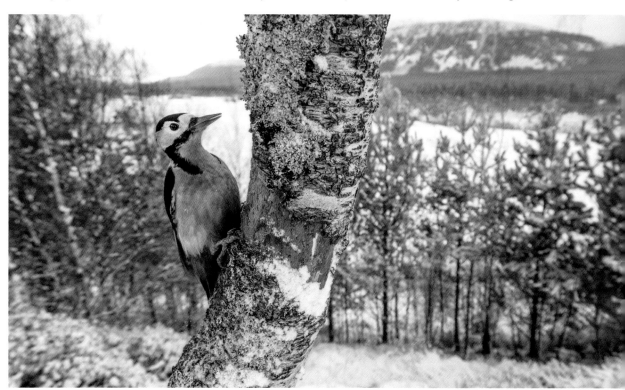

The rapid hammering of great spotted woodpeckers in early spring is a courtship 'song' to attract a mate.

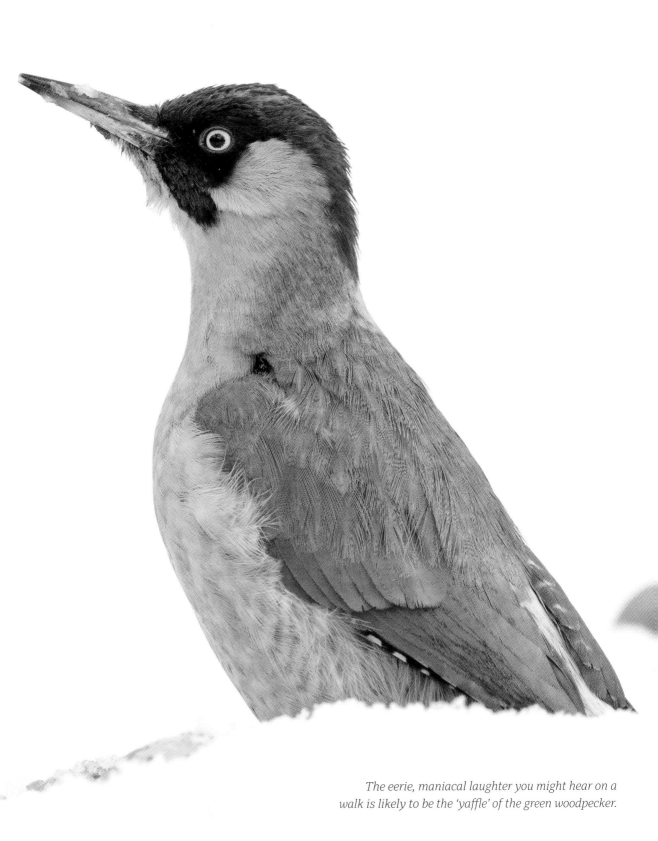

The eerie, maniacal laughter you might hear on a walk is likely to be the 'yaffle' of the green woodpecker.

Mussels

<div style="text-align: right">*Clare Hargreaves*</div>

Not only do mussels look and taste amazing, but eating them is a joyous ritual in itself. First there's the comforting sound of their shiny shells being gently stirred in a large pan with plenty of garlic, wine and parsley. Then there's the whole procedure of lifting these plump orange beauties from their beds and popping them into the mouth: the taste of the sea is so strong that you can almost feel sand between your toes. Finally, there's the delicious task of soaking up the remaining juices with a wedge of crusty bread.

The tasty mollusc's virtues don't end there. Because there are plenty of them, and they can be farmed sustainably, we can eat them with a clear conscience. And they won't make a hole in your pocket either; which is why they've traditionally been known as poor man's shellfish. They are also highly nutritious.

Of course, you can find mussels growing on rocks and stones in the wild, but as they are filter feeders, it is unwise to harvest them from areas where they may come in contact with dirty water. The majority of mussels available to buy will have been farmed in coastal waters, either grown on ropes or on the seabed. The UK consumes around 4,500 tonnes of mussels a year, and exports even more than that to Europe.

Some of the best mussels are found in Shetland (mostly rope-grown), but also in Wales, Northern Ireland, Norfolk and the south-west of England. They're at their succulent best in the colder months, outside the breeding season.

Although they've been used as food for at least 10,000 years (remains have been found in UK middens dating from 6000BCE), mussels are believed to have been cultivated in Europe since 1235. It is said that Patrick Walton, an Irish sailor shipwrecked on the French coast, hung up nets in order to catch fish and discovered that mussels were sticking themselves to the poles supporting the nets; the rope method of mussel cultivation was born. In medieval times, monks dredged mussels with long-handled rakes, a practice that can still be seen today in some parts of France.

Top Tips for Enjoying Mussels

- Buy your mussels from a reputable source, ensuring they've been sustainably caught and are alive and fresh. It's best to eat your mussels on the same day that you buy them.
- Select those with tightly closed shells, avoiding any that are broken. They should smell briny, not fishy, and have sharp-edged, blue-black shells.
- If storing in the fridge, do not soak them in water, as this will kill them. Eat them as soon as you can.
- Carefully place the mussels into a sinkful of cold water and discard any that stay open when tapped. Remove any beards and give the mussels a good scrub under cold running water, scraping off any barnacles.
- Use around 500g (17oz) of mussels per person for a main meal, or about half of that for a starter.
- To cook, place the mussels in the bottom of a large, heavy-based pan with oil/liquid that is already very hot. As soon as the shells start to open, they are ready. Don't overcook them or you'll end up with rubbery flesh. Reject any that fail to open fully.
- Mussels are delicious with a wide range of flavours. Steaming them in vermouth or white wine – along with shallots, garlic and parsley or coriander – is a classic. Or try them with south-east Asian flavourings such as coconut, ginger, lemongrass and chilli.

Commercial mussels are grown sustainably on ropes in many coastal areas of the UK.

Medieval Clues

Ian Vince

The period from January to February, halfway from winter solstice to spring but still the coldest part of the year, often feels like a distinct season of its own. With low grass in the fields, a touch of frost or a light dusting of snow can reveal a swarm of slumbering lumps, bumps and hummocks of every form, suddenly apparent in a landscape sculpted by the long shadows of the low sun.

Despite appearances, many of these undulations, earthen ripples and waves across the landscape are not defensive earthworks, ramparts or relics of long-forgotten battles, but evidence of our ancestors' struggle with the land itself – the remains of various ancient methods of farming. Others are the outcome of nothing more violent than the gradual creep of soil down a hill, occasionally exacerbated by the tracks worn by sheep.

The most marked features are those shown on Ordnance Survey maps as 'strip lynchets', the consequence of ploughing along the contours of slopes to create a flat area for crops, as practised in medieval and, occasionally, even earlier times. Dorset and Wiltshire have the best examples – below the Ridgeway near Bishopstone in north Wiltshire and near the village of Loders near Bridport,

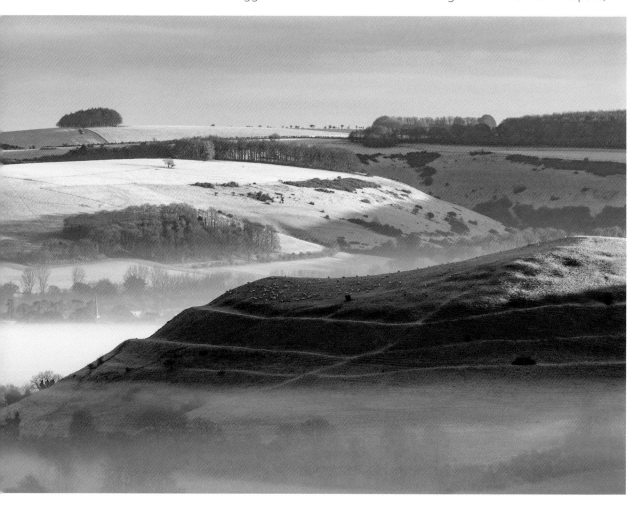

Dawn mist hangs around Hambledon Hill in Dorset, one of the best Neolithic landscapes in Europe.

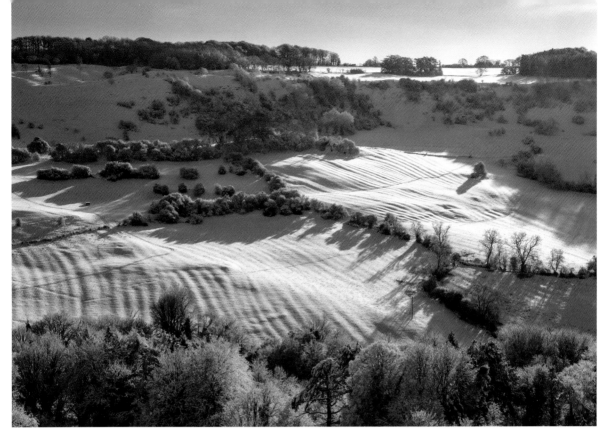

A snow-covered field clearly shows the marks of ridge-and-furrow ploughing, Gloucestershire.

Dorset, where giant stair-flights climb the slope. It's not for nothing that 'risers' and 'treads' have crept into the terminology of strip lynchets to describe the relevant parts. Further north, at Conistone in Upper Wharfedale, North Yorkshire, and Hall Garth, near Great Musgrave in Cumbria, the effect is gentler, but just as striking.

On more level ground, a pattern of regular undulation can reveal another medieval farming practice – ridge and furrow. Vast open fields were cultivated in furlong (literally furrow-long) strips by tenant subsistence farmers. Working clockwise around their strip, their ploughs turned the sod inward, building up a shallow ridge at the centre of their strip and leaving furrows along the long edges. Hauled by a team of eight oxen, the turning circle in the headland was difficult to achieve without curving slightly to the left at the end of each furlong, and a shallow reverse-S or C form to the ridge can often be detected.

Names for Bumps and Hollows in the Landscape

BARROW OR TUMULUS A mound of earth or stones over a grave. Some are as much as 5,000 years old.

SAWPIT Often found in woodlands – a pit over which logs would be cut with a two-handed saw by two men, one above and one below. Most were abandoned by the late nineteenth century.

FOSSE A ditch or moat, especially one dug for defensive purposes. From the Latin *fossa*; the most famous example is the Fosse Way, the Roman road from Exeter to Lincoln, which may have begun life as a huge defensive ditch.

REAVE Low, stony bank that marks Bronze Age field divisions. Can be seen on southern Dartmoor and in scattered locations elsewhere and may once have been more widespread.

Cornwall for the Bards

Mike Segar Fenton

This is a special journey through Cornwall – not to see the regular beauty, but instead to see the places that resonate with atmosphere and history. It's an insider's track through some of Cornwall's roots and branches; a bard's trail.

The first stop is easiest. Cross our border, the Tamar on the A30, and leave the main road for Launceston. This is a fine hilltop town with a generous square, the wonderful exterior carvings of St Mary's church, and countless unexpected views over the countryside beneath. But we've come to look at the castle, a huge round bailey with far-reaching views eastwards towards the heights of Dartmoor; an unsleeping sentinel. But it wasn't, as it appears, designed to protect Cornwall from invaders from the English side. No, Henry III's brother Richard put it there to keep the Cornish in – or out, depending on your viewpoint.

South along a pretty route, skirting the edge of wild and haunting Bodmin Moor, lies Bodmin itself. Bodmin was Cornwall's county town until Truro took over. Somewhere out on the dark Bodmin Moor lurks a beast… But its real beast is closer at hand, a stupendously grim building that strikes the smile from everyone's face.

Bodmin Gaol was built by George III from 20,000 tonnes of Cornish granite, so dense that later attempts to demolish it with explosives failed to dent this monstrosity. Public hangings here in the mid-nineteenth century used to attract enthusiastic crowds, many arriving via the Camel railway from Wadebridge and Padstow. It symbolises Cornwall's violent past. Three rebellions marched on England from here, each to its doom. It's now described as an 'all-weather family attraction'. *Memento mori.*

Time to strike south. Make time to stop at the lovely village of Lerryn or even walk to St Winnow's riverside church, then make your way through the lanes to Polperro. There are two ways to our next destination, either through some scary narrow lanes, or better still by walking the coast path east from Polperro,

stopping for a paddle and a cream tea on Talland Bay beach, and climbing the hill to the church.

Church of Quirks

Selecting just one church from Cornwall's rich store is a hard task. You might be tempted to choose Minster, a forgotten church tucked into a silent wooded coombe near busy Boscastle, founded by a Welsh princess in 500CE on the site of a holy well. On the other hand, you might choose Talland, quirky with its detached tower and perching alone on the side of a hill above a busy holiday beach. It was once home to an early Celtic hermit, but now it is full of finely etched slate memorials and some of the most engaging medieval bench-ends in Britain.

Then it's time to go west, so head up to Lostwithiel, another former capital. You could stop for a look at Restormel Castle or the even older twelfth-century bridge. Settle in for a longish drive via St Austell and Truro to Falmouth's older neighbour, Penryn.

A walk around Penryn is a must, but our next important location is Glasney College on College Hill. The unique feature of Glasney College is that it's no longer there. What is now an empty playing field was the site of a mighty church and college complex, the Bishop of Exeter's western outpost from 1265 to 1549, whose scholars helped to found Oxford's Exeter College.

It also became the living heart of Cornish culture, and the few major surviving works in the Cornish language – in particular the cycle of mystery plays known as the Ordinalia – were written there. But its Cornishness was its downfall. The Tudors, who had tasted Cornish rebellion once too often, used the Reformation to expunge the college despite the pleas of the local population, selling the plate, vestments, lead, windows, arches (some of which survive in local doorways), and the stones themselves. Now in this bare meadow, imagine a magnificent church, bells, canons, students, vicars and scribes, the ghosts of our greatest institution.

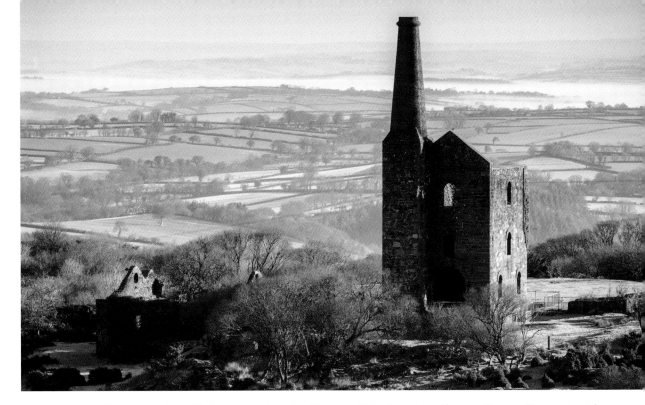

Poignant ruins of industry, such as the Phoenix United tin mine, festoon Cornwall's countryside.

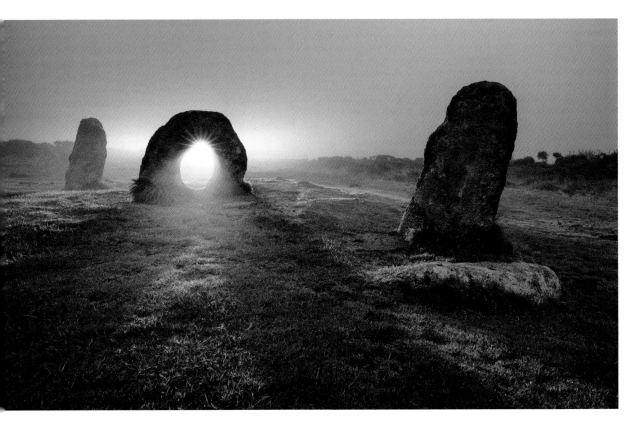

Winter sunrise beams through the 4,000-year-old doughnut-shaped Mên-An-Tol stone.

A Cornish Genius

Next, leave ghostly Penryn for workaday Camborne. Look for the library at the junction of Trevenson Road and Basset Street. Outside it is the Trevithick Statue. Richard 'Cap'n Dick' Trevithick represents the best and worst of the fiery Celtic character. The word 'genius' hardly does credit to his career, though his erratic temper and contempt for money ensured that others claimed the credit. Among his creations were the first self-propelled steam locomotive, the first self-propelled road vehicle (or car), the high-pressure steam engine, which revolutionised mining throughout the world and made most Victorian achievements possible, and even the ship's propeller.

But he's best remembered in his native Camborne for the steam-driven vehicle he drove 'Up Camborne Hill coming down', according to the song when, to the astonishment of the locals, 'The horses stood still; the wheels went around…' Sadly the world's first car journey ended in a ditch. Dick and his friends went to a nearby pub to cheer themselves up with 'roast goose and proper drinks', while the abandoned first vehicle continued to put on steam until it blew up. A proper Cornish story.

Every April, Camborne celebrates Trevithick Day, when scores of mighty steam traction engines gather in the town and process past this statue, each sounding its whistle to salute the Cap'n as they pass.

A Town of Contrasts

Across the bay, St Ives sleeps on its peninsula, another phenomenon our forebears would have found it hard to comprehend. It is a town of contrasts, a fishing port full of seekers after artistic truth, high culture rubbing shoulders with fish 'n' chips around the harbour, all plagued by Cornwall's greediest seagulls.

We'll leave it there in the sunset and stare instead at Godrevy Island, with its white octagonal tower, the title character of Virginia Woolf's *To the Lighthouse*. Or perhaps we'll peep into the inaccessible cove nearby, where you can spot seals flopping around on the shingle far below.

En route to Penzance, stop at St Michael's Mount. Words are wasted on this famous beauty, a tidal island topped by a castle. The first known consignments of Cornish tin were exported from here by Phoenicians as early as 325BCE.

Approaching Penzance, ignore signs to the bypass but enter the town and take the harbour road to Newlyn. This is almost the last place in Cornwall where industry means everything and tourism almost nothing. Newlyn is a busy working port but always near the edge, subject to the vagaries of fish stocks and international regulations. The harbour is a picture, as artists over the years discovered. You can buy the freshest fish, drink in a proper pub, admire the Penlee lifeboat or just stand and enjoy the view. But don't get in the way.

The Boscawen-Un stone circle, an unspoilt round, with its 19 stones and sloping central pillar, is a highly significant site for bards, as the first Gorsedd of the modern era took place here in 1928. Stone circles are subject to many explanations – astrological calendars, Druidic ceremonial sites or other earth mysteries, according to taste. A lot can happen in 4,000 years and perhaps its most impressive feature is its very survival, a tribute to its unspoken power over our imaginations. It's a place to simply stand and be, especially in the spring, when its turf is full of bluebells.

And now for the last lap. Go back to the A30 and in less than a mile you come to the hamlet of Crows an Wra – in English: Witches Cross. Turn right up a steep hill. Chapel Carn Brea is the last hill of the western peninsula and the Cornish land. Its panorama reaches around from the hills above Camborne, St Michael's Mount and its bay, the long finger of the Lizard, Lamorna Cove, the hidden Minack Theatre, the angular tourist complex of Land's End, the offshore rocks guarded by the Longships Lighthouse, the dark smudges of the Isles of

Scilly on the horizon, the still-bare landscape, and gaunt engine houses of the mines around St Just and Pendeen.

Even those who've spent their lives here are not immune to the majesty of this landscape, which arrows like a mighty ship into the Atlantic and the setting sun, beautiful on a summer's night, magnificent in a winter storm. True Cornwall.

Godrevy Lighthouse has been beaming its warning light – and saving lives – since 1859.

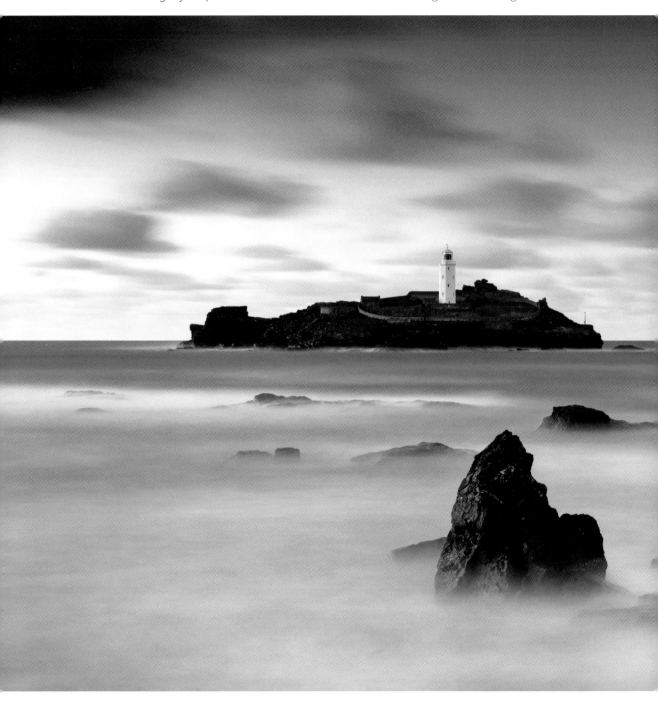

Children and Access to Nature

John Craven

The news that today's youngsters spend seven hours a day in front of a screen and are increasingly disconnected from nature should give us pause for thought.

More than half the parents questioned in a recent poll admitted that their children spend less time outdoors than they did when they were young. But does it really matter in these changing times if a generation seemingly more interested in iPads than insects, in computer games than conkers, fails to hear the call of the outdoors?

It certainly concerns Sir David Attenborough, who, among many things, is Professor Emeritus of the Wildlife Trusts, which commissioned the YouGov poll. 'It is critical to the personal development of our children,' he affirms. 'Contact with nature should not be the preserve of the privileged. It is moving to see the delight on the face of a six-year-old looking at a pond skater or caddis fly larvae.'

The Proof is There

Among the facts emerging from the survey are that only one child in 10 has ever played in wild places, only one in three has seen a hedgehog or climbed a tree, and just 46 per cent have looked for wildflowers with a parent/guardian.

Yet 91 per cent of parents agree with Sir David that having access to nature is important

Getting children interested in the outdoors at an early age is key to a life-long love of nature.

Studies have shown that regular access into green spaces can dramatically improve children's physical and mental health.

for children, so obviously many of them, no doubt for many different reasons (such as vastly increased traffic and fear of strangers), are not putting their belief into practice.

The proof positive is there. Inner-city children have had their lives transformed during a week on a farm. And for those children with special needs, being close to non-threatening animals can give great comfort.

In the poll, more positive results included 95 per cent of children saying they had been to a park with a family member and 82 per cent had held a ladybird. Like many other conservation groups, the Wildlife Trusts runs special projects to attract children, and one of these projects, called Every Child Wild, 'hopes to get people talking and sharing ideas on how we can all help put the wild back into childhood'. It's a huge task, but this new generation has to be made aware, otherwise who will stop the decline of nature?

Billy Stockwell from Nottingham is leading the way. In an Every Child Wild podcast he said: 'The other day I dropped my phone. I was so annoyed, but then spending time in nature, which has been around for millions of years, helped me understand that I worried about the little things far too much.' Surely the message to parents is clear: 'Get your kids out more.'

For more ideas about how to connect children and nature, see: www.thewildnetwork.com

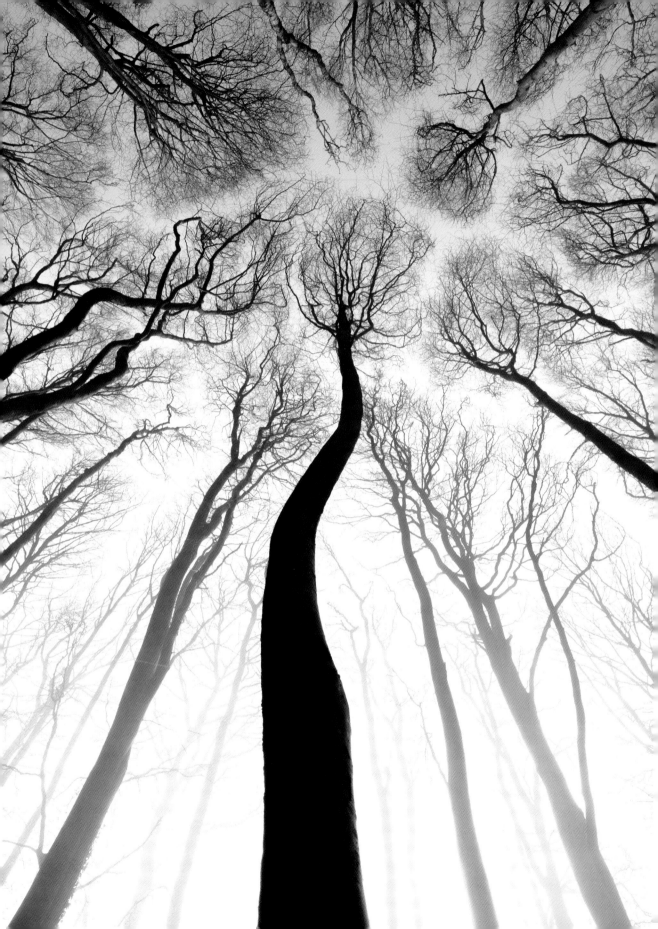

March

Though sometimes it doesn't feel like it, March marks the start of spring – either on the first day of the month according to meteorologists, or, if you are a traditionalist, at the time of the vernal equinox when the sun is directly above the equator, making night and day of equal length. That usually falls around the 20th.

The American writer Garrison Keillor, famous for his stories based on Lake Wobegon, isn't convinced there is anything positive about March. He wrote: 'March is the month God created to show people who don't drink what a hangover is like.'

But, like a hangover, things usually get better and not for nothing is the old saying that March comes in like a lion and goes out like a lamb. In our review of this month we feature among other things an assortment of four-legged creatures (neither lions nor lambs) ranging from one of the least seen and least known mammals, the mole, to that loyal assistant to all mankind, the working dog.

Now is the time when moles, like most living creatures, get the urge to breed. But, unlike all others, that quest finds Mr Mole trespassing underground in tunnels belonging to females, hoping to bump into a receptive one and not a rival male. To keep up the energy he'll have to eat his bodyweight in earthworms every day.

To anyone who earns their living from the land working dogs are a godsend, but of course many breeds have become household pets as well. I've always admired border collies for their intelligence and faithfulness, but as I don't have a flock of sheep to round up or go for a long walk every day to keep them fit, I won't be owning one.

Finally, grumpy Garrison Keillor, have you forgotten about wild daffodils? Images of their pretty heads gently dancing in the wind would be too calming to feature in any hangover and they do seem to be flowering earlier every year. So March as a whole is not quite as drab as it used to be.

Slender, sinuous trunks of beech trees reach for the sky – twig tips full of leaf buds ready to burst open.

Wild Daffodils

Phil Gates

Winter might still have a sting in its tail but here is an irrepressible wildflower, buffeted but unbowed by cold March winds, whose trumpets herald better days to come.

It has been a welcome sight throughout history – the flower's old alternative name, Lent lily, marks the association of its flowering with the church calendar, breaking up a particularly bleak period with its brightness. By the time John Gerard described it in his Herball, Generall Historie of Plants, in 1597, it was already popular as a cut flower. Contemporary accounts record that it grew in profusion around London, where it was sold in bunches and used to decorate taverns in spring.

Despite their place in national affections, native daffodils have decreased since the nineteenth century, leaving large populations in the Lake District, North Yorkshire, Wales and the Welsh Border counties, but only scattered colonies elsewhere.

Intensification of agriculture, woodland clearance and uprooting of the bulbs for use in gardens have been implicated in the disappearance of the once ubiquitous bloom. Picking prevents seed production but diverts the plant's energy to further bulb production, although trampling of foliage can prevent this and lead to rapid loss of plant vigour. The blooms produce seeds that take between five and seven years to produce a flowering plant.

Daffodils are remarkably versatile in their habitat preferences, which range from grassland and open woodland to pockets of stony soil in hedge banks. Some of the finest displays can be seen on coppiced woodland in dappled spring sunshine, although the decline in this traditional form of woodland management has made this a rare spectacle.

Poisonous but Productive

Daffodils contain natural chemical defences that protect them against pests and also make them poisonous to humans. On rare occasions, people from cultures where daffodils are unknown have become ill after eating them by mistake, as was the case in 2012 when a family of Chinese origin bought and cooked daffodils from a Bristol supermarket where they had been displayed alongside vegetables.

Nevertheless, at least one daffodil toxin has become a valuable drug. By happy coincidence, the leaves of the plant that inspired Wordsworth's poem that so many have committed to memory are a source of galantamine, a drug used to treat memory loss and the early stages of Alzheimer's Disease.

Controversially, it was a daffodil gene that was used in the first experiments to produce Golden Rice, a product of GM technology. Although it has since been replaced by a gene from maize, the daffodil gene demonstrated that rice could be genetically manipulated to produce the yellow pigment carotene, a key precursor of vitamin A, yielding grains that might help combat vitamin A deficiency in rice-based diets. Its use has been vigorously opposed by the anti-GM lobby.

Early Risers

Like all our spring flora, the wild daffodil faces an uncertain future in a changing climate. A recent study by Professor Tim Sparks at Coventry University found that the date of the annual Thriplow Daffodil Weekend in Cambridgeshire, a celebration of the flower, has been gradually shifted forward by 26 days since its inception in 1969, thanks to milder springs that are causing earlier flowering.

What is certain, though, is that Wordsworth's evocation of spring will always come to mind when the first daffodil flowers unfurl on a blustery spring day to gladden our hearts.

Wild daffodils are smaller and more delicate than their cultivated cousins.

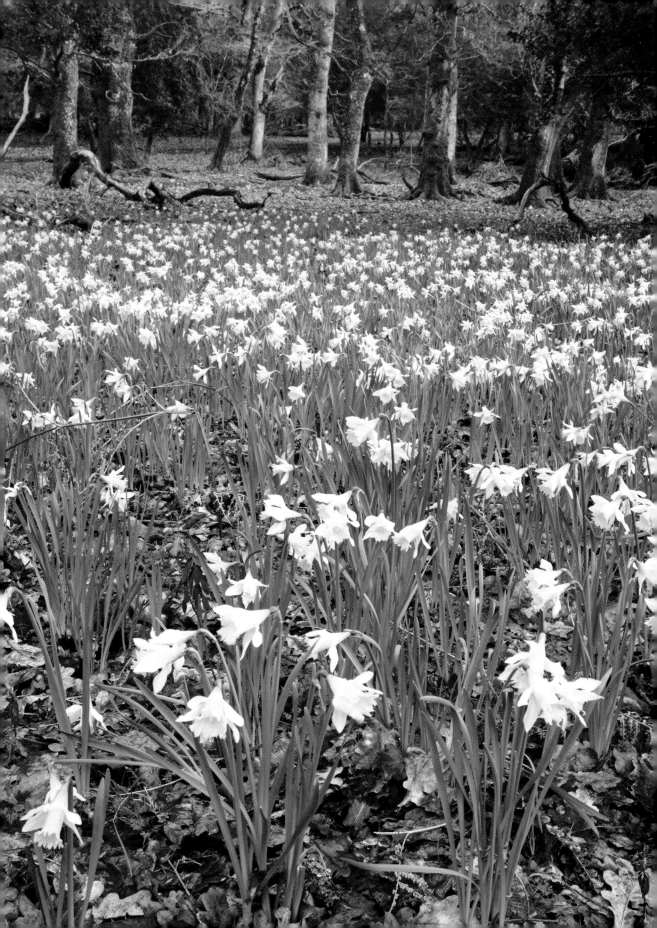

Catkins

Phil Gates

Trees festooned with catkins are a sure sign that spring has finally arrived. For a few weeks they release pollen into blustery March breezes, then fall as the leaf canopy unfolds. Enjoy them while you can.

The greens and yellows of early spring are bringing life back to our river valleys. For much of the winter, the flooded fields have reflected little other than the grey of the leaden sky. Some colour has come from the burgundy-branched alders, whose hues still mark the true river path when the banks themselves have breached.

The alder is not a large tree, nor does it live for particularly long, but it has a fondness for water that few other trees can match. In low-quality soil, the alder is a pioneer. Within its root nodules live bacteria, *Frankia alni*, that feed on sugars produced by the tree. The Frankia begin processes that allow the alder to pass amino acids and nitrogen into the soil, improving fertility for future growth. On a steep riverbank, the alder sends out roots from its lower trunk that reach sideways to find footing, preventing the tree from being unseated from below. Those roots that finger out over the water will tuck back beneath themselves, forming a tangle that provides sanctuary for fish and invertebrates. Should a limb fall into the water, then it will not necessarily rot. If alder remains submerged, then it will solidify like granite. Man has long utilised this property, building crannogs upon alder in the lochs and loughs of Scotland and Ireland, and using it as a foundation in Amsterdam and Venice.

In March, the catkins of the alder are maturing from claret to yellow and, once pollinated, the smaller female flowers harden like miniature pine cones. They remain on the tree until long after the rounded leaves have fallen, and snare the lines of anglers who cast for the fish that lurk in the root mass beneath.

Types of Catkins

ALDER *Alnus glutinosa*
Perhaps the most iconic of the lot, these are the first catkins to shed pollen in spring. They're carried on the tips of twigs, often alongside clusters of tiny red-tipped female flowers.

HAZEL *Corylus avellana*
Golden catkins on bare twigs release clouds of yellow pollen that seem to dissolve in the air, destined for tiny female flowers that are just clusters of carmine stigmas protruding from a bud.

GOAT WILLOW *Salix caprea*
This has separate male and female trees. Male catkins are clad in golden stamens; female catkins are spiky and green. Both secrete nectar – key energy for bees and butterflies in early spring.

SILVER BIRCH *Betula pendula*
Male catkins elongate and shed pollen at the same time as leaf buds open. Female catkins are short and point upwards, hanging downwards after pollination, when the seeds develop.

WHITE POPLAR *Populus alba*
These long, fat, red-tinged catkins are often carried at the top of the tree, so you may need binoculars to appreciate them. Easily dislodged by wind, they litter the ground after a gale.

WALNUT *Juglans regia*
The short, fat, green catkins shed pollen at the same time as the leaf buds release their grip on the purple-hued foliage. Female flowers are shaped like little pots, tipped with a pair of curved stigmas.

Finches such as siskins find tasty morsels among the first hazel catkins.

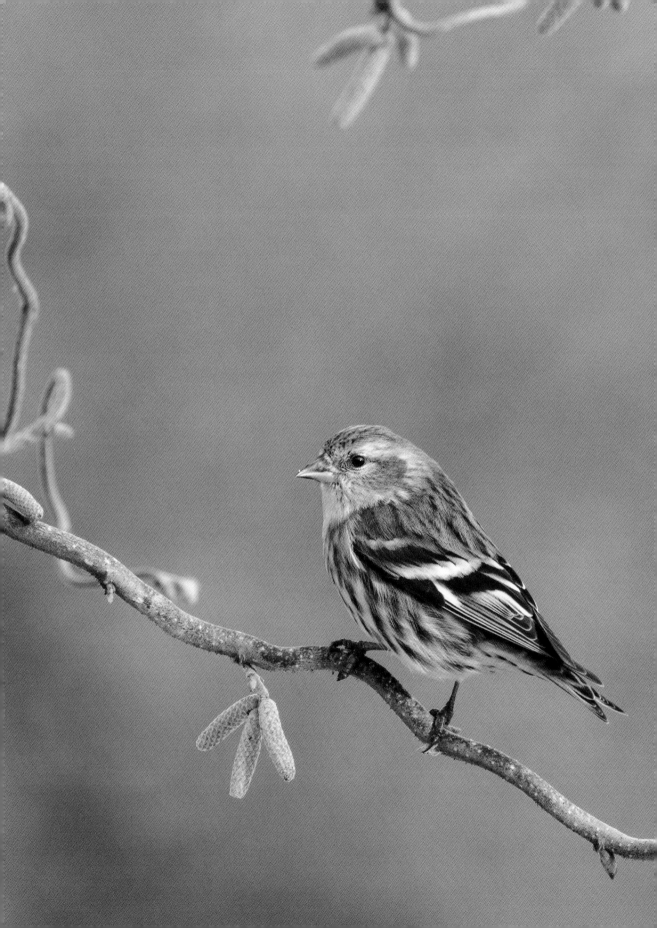

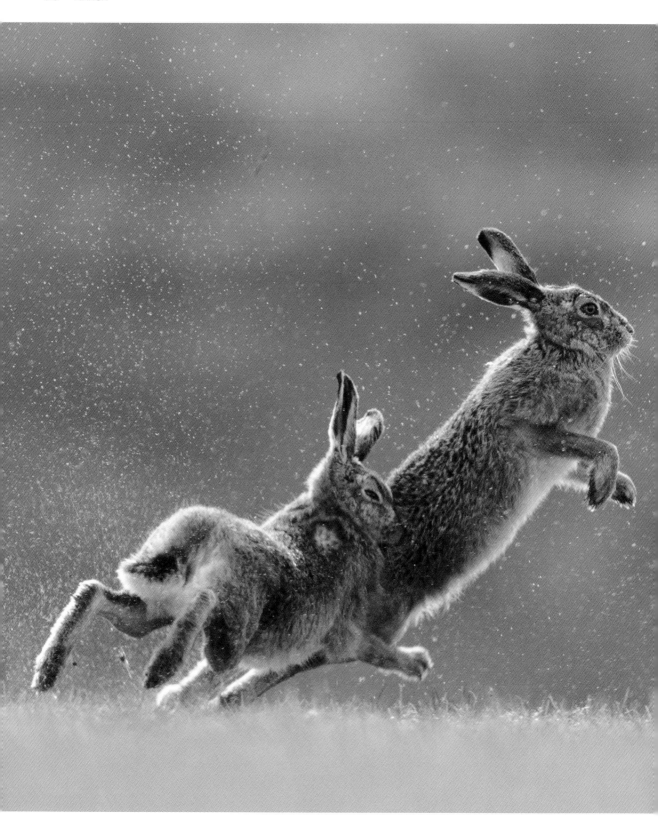

March Hares

Amy-Jane Beer

It's March, so tradition dictates that we spend some time chuckling at the slapstick springtime antics of brown hares. They perform dutifully – the chances are that, in a field near you this month, there they will be, bursting with vigour, leaping and capering among the new shoots, and pausing at regular intervals to bash one another enthusiastically about the head with their great clown feet.

Even if we realise this reckless circus has nothing to do with welcoming the spring, it so neatly reflects our own feelings as the season unfurls that it's hard not to regard the whole performance as an expression of joy. Of course, like other joys of spring, the truth is more sordid. Birdsong is a declaration of aggressive territoriality, flowers are plant genitals, and the 'March madness' of our gangly friends is most definitely about sex. Males pumped with a seasonal surge of testosterone pursue every opportunity with relentless enthusiasm.

Females, on the other hand, are only receptive for a few hours during their six-week ovulation cycle, and the rest of the time they regard amorous bucks as pests. Boxing pairs were once imagined to be sparring males, but in fact they are the retort of an exasperated doe to a buck that has pushed his luck too far. When the female is good and ready to mate, her response is different. Then, she'll lead her suitors on a headlong chase, testing their fitness to the limit before permitting a mate that stays the pace an opportunity to father her next litter.

Witnessing one of these chases, even from a distance, is a treat. You might expect a hare to be mistaken for a rabbit, but in practice you're more likely to wonder if you just glimpsed a gazelle escaped from a zoo. Hares are tall, decidedly orange in decent light and breathtakingly swift.

A female hare, known as a 'jill', spars with a male 'jack' to test his strength and suitability as a mate.

March Madness All Year Round

Contrary to popular representation, mad March hares also have a sex life in other months of the year. Indeed, according to a study in the 1970s by reproductive biologist Gerald Lincoln, female hares fall pregnant in every month from January to August, with most babies conceived not in March, but in May, June or July. More recently, there have been examples of hare pregnancies in all the remaining months, too, perhaps as a response to climate change.

The best explanation for March madness is not that the behaviour happens only in March, but that March is when we're most likely to see it. Earlier in the year, the shenanigans take place in long, dark evenings, while later in the spring there is cover among longer vegetation.

The essence of this otherwise rather unobtrusive small herbivore, expressed mainly in mating chases but also in the more controversial context of hare coursing, is speed. A sprinting hare is a magnificent work of nature. The species makes number six in a list of the world's fastest land animals, most of which you'll have to make a longhaul flight to watch in the wild. And yet these super–heroes can be seen streaking across the landscape within a few kilometres of nearly every home in Britain. Why aren't we all avid hare fans?

Hare to Stay

The brown hare isn't native to Britain, but has been here long enough to become a naturalised part of our fauna. It is so embedded in our ecology that removing it, were such a thing even possible, would have such extensive and unpredictable repercussions that no one is likely to consider it seriously. However, the muddled history of the brown hare has given it a strangely conflicted status in the UK. It is introduced,

but accepted as a valuable component of our fauna, and is the subject of both legal hunting and concerted conservation.

Best estimates put the date of first introduction of brown hares to Britain in the late Iron Age – certainly they were here before the Romans. The introductions probably continued in later centuries. The Normans, for example, were avid hunters, and as larger areas of agricultural land became available for brown hares they would likely have been stocked or encouraged as game animals.

Dogs such as harrier hounds were bred as hare hunting specialists; part foxhound, greyhound, bloodhound and basset, they had the superlative tracking skills, speed and stamina required for this challenging quarry. Hunting was for food as well as sport, but hare meat is lean, so was considered to be poor man's food. Typically hare would be roasted, stewed or 'jugged', the latter being a slow cooking technique for meat that is tough or less than fresh.

Hunting hares with dogs was outlawed by the Hunting Act (2004), as was coursing, in which hares are flushed from cover or released into an arena and raced against greyhounds or lurchers. Coursing remains legal in the Republic of Ireland, where the dogs are muzzled. Greyhounds are among the few animals able to outsprint a hare, but they are less agile, and the hare gets a head start. Coursing is a test of speed and agility rather than a hunt, and on balance the hare usually 'wins'.

Mountain Hares

In Britain we have two species of hare. The brown, *Lepus europaeus*, is the one making an exhibition of itself in lowland farmland, while in Ireland and upland areas of Scotland and northern England is a less brazen creature, the native mountain hare, *Lepus timidus*. The mountain hare favours upland habitats, especially in areas such as the Peak District, where its range overlaps with that of the brown hare.

Mountain hares appear superficially more rabbit-like, with shorter ears and legs. Although large ears are obviously useful for picking up sound, and in warm climates they also help dissipate excess body heat. In cool conditions, this function is a disadvantage and animals adapted to life at higher latitudes and altitudes have shorter extremities. Our two hares sit neatly on the ear-length gradient between the extravagantly equipped antelope jackrabbit (actually a hare) of the southern USA, with ears up to 20cm (8in) long, and the snowshoe hare of Arctic regions, its ears a modest 9cm (3½in) long.

In another adaptation to cooler conditions, mountain hares are one of just two British mammals able to moult to a white winter coat (the other is the stoat).

Spotting Hares All Around

MYTHIC HARES In classical and Pagan history, hares crop up as companions of Aphrodite, of satyrs and cupids and of Eostre, the Anglo-Saxon goddess of spring described in the first written account of British history by the eighth-century historian Bede. Eostre is said to have given her name to the festival of Easter, subsequently adopted by Christianity. Pagan and Christian versions of Easter share the theme of life renewed, but the Easter bunny (actually a hare) and Jesus Christ make an incongruous pairing.

THREE HARES The three hares is a threefold symmetrical motif, or triskelion, used in religious and symbolic art and in architectural design. The hares run in a never-ending circle. Each hare has two ears, yet only three ears are depicted in total, forming a triangle at the centre. Rich in meaning, the image has its origins in sixth-century Chinese Buddhism and arrived in Europe and England via the Silk Road trade route.

HARES AND ALES The distinctive hare logo of the Bath Ales brewery nicely sums up some of the hare's mythical, historical and cultural

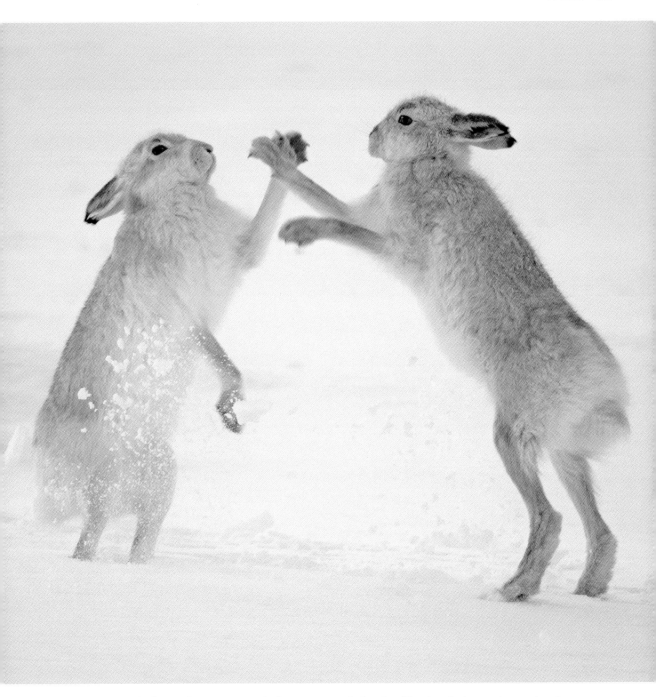

Like brown hares, mountain hares engage in bouts of boxing during spring and early summer.

significances. The logo was inspired by a vase, decorated with a depiction of a hare hunt, that had been found on the site of a Roman villa not far from the brewery. The company felt that the hare's significance as a symbol of fertility fitted nicely with the earthiness and bountifulness of the brewing tradition – and also with the role of beer as a social and ceremonial lubricant!

The Mole *Dominic Couzens*

Surely no British animal offers such a discrepancy between its apparent abundance and the evidence of one's own eyes. Many a seasoned mammal-watcher has never seen a live mole at all, or has perhaps seen just one in their lifetime. Yet those people have spent that same lifetime seeing molehills only too readily, perhaps cursing them, and even tripping over them. Few animals are so familiar in one respect, yet so mysterious in another.

March signals the beginning of the mole's breeding season over most of the country – not that we would realise it. As with many a mammal, males go in search of receptive females. But of course, they travel underground, digging their way into the home range of a neighbouring female and hoping to meet up by trespassing in one of the female's tunnels. They might do this several times in a few weeks, since moles are generally promiscuous. What they don't want to do is to meet another male in the same tunnel, because this is where moles can be extremely aggressive towards each other, and brief fights take place quite often.

In our minds we probably never credit moles with the ability to fight, nor anything else much. This is a poorly known and often misunderstood animal. For example, most of us probably think that moles are only found in gardens and fields, whereas they were originally woodland animals and are still abundant there. We just don't associate them with woodlands because molehills aren't so obvious under the trees. The mole is a major consumer of earthworms and needs to eat the equivalent of its entire body weight every day. Catching food is easy because worms burrow through the soil into the mole's tunnels and are caught during the mammal's daily rounds. Moles also cache worms, biting off their heads and thus leaving them immobile but still alive to be eaten later.

A mole's powerful forelimbs are perfect tunnelling equipment.

Hedgehogs

Hugh Warwick

The first hints of spring are just tickling the senses and there is a real desire to wake up properly from a winter buried deep in a well-insulated sleep. The winter is not a great time for a hedgehog to be out and about. Long ago they sacrificed the insulating fur that protects other small mammals and invested in remodelling the hair as spines: an evolutionary gamble that requires energy to be preserved through inaction.

Other animals continue to hunt and forage as the ice spreads; or they store reserves of food in caches. Old natural history guides will tell you that the hedgehog does the latter, collecting fruit on its spines and storing it up to consume through the long dark nights of winter. But despite bestiaries containing artful images of apple-carrying hedgehogs, this is untrue. Hedgehogs are carnivores. And while they do store up food, they do it in a much tidier fashion: in reserves of fat.

There are two types of fat: white fat, which is for keeping the animal ticking over, and brown fat, the starter motor. One of the many risks facing a hibernating hedgehog is running out of this source of energy. Every time the environment changes to stimulate a hedgehog to emerge from its slumber, a little more of that 'starter motor' gets used up. If it is disturbed too often, the hedgehog will run out of that fuel and will not be able to crawl back to consciousness when spring truly arrives.

Sleeping Beauties

The time when hedgehogs are at their most vulnerable is while in this state of deep torpor. But those that do survive will, on the whole, start emerging in March.

Hibernation has always been something of a mystery; the ancient Egyptians fashioned

As soon as spring warms the land, hungry hedgehogs emerge from hibernation.

amulets in the shape of the animal – perhaps due to the mistaken belief that hibernation was actually a form of death and, in the spring, rebirth. So for cultures deeply wedded to reincarnation, the hedgehog must have seemed a powerful animal.

Closer to home, but still 3,000 years ago, a child was buried at Stonehenge in Wiltshire with a small chalk hedgehog. Why? Could it be to do with a belief in sympathetic magic? An animal that apparently comes back from the dead, imparting some of that capacity to the lamented child? Or was it a favourite toy?

Today, hedgehogs have inveigled their way into the heart and consciousness of the country. Which is a little surprising when you consider how many people still think of them as riddled with fleas. In reality, they have no more fleas than other animals their size; it is just that the hedgehog you are most likely to see is going to be a sickly one – these are nocturnal creatures and, on the whole, if they are out in the day, something is wrong. They are probably ill or injured and therefore more likely to be infested with parasites such as fleas.

But why has the hedgehog charmed us so much? Perhaps it is because it is the most approachable of wildlife. It retains a sense of wildness, yet it lets us get close. Nearly everything else in Britain has, as its first line of defence, flight. But the hedgehog hunkers down, frowns (the muscle that we use to frown, on a hedgehog, reaches down to the tail and helps pull the spines up to a jagged defence) and, if really bothered, rolls into a ball.

As the landscape has become increasingly hostile, hedgehogs have moved into our gardens, where we can have an enormous effect on the quality of their lives. So try to look at your garden from the point of view of a small spiny mammal, considering in particular accessibility and shelter.

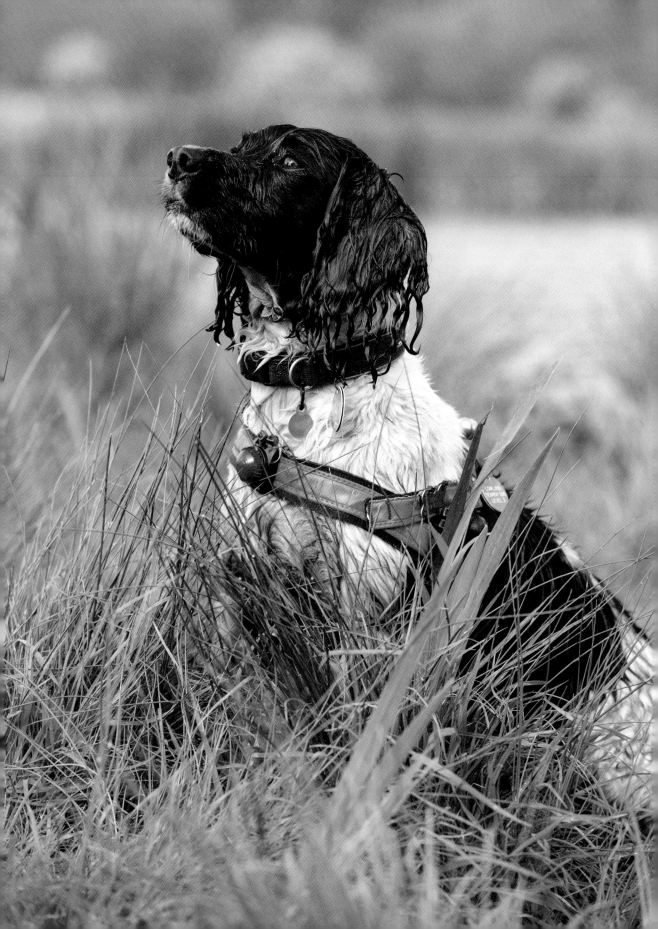

The Perfect Country Dog

Gwen Bailey

If you are planning to escape to the country this year, this could be the perfect opportunity to own a dog for the first time. Or maybe you have always wanted a dog for weekend walks in the countryside, but are nervous about how to proceed. Either way, if you wish to buy a dog this year, your choice of breed could be crucial. Some breeds will suit your lifestyle perfectly, but the wrong dog will lead to stress and unhappiness – for both of you.

Owning a dog can change your life for the better. Dogs give you a reason to go outside every day for fresh air and exercise; they bring a whole new dimension to exploring the countryside as they enjoy the space and freedom; and they will regularly bring you into contact with others of a like mind. And there is nothing quite like the companionship that a faithful dog can bring.

All this only becomes possible if you have chosen and trained your dog wisely. To avoid problems, such as your dog running away, chasing, or pulling incessantly on the lead, you need to make a wise choice that suits your household, and also give good education and training.

Be Realistic

To make a good choice, get the family together to make a list of all the characteristics you want from a new dog. Think about things such as exercise, personality, size, and attitude to visitors and other dogs. Include what you can offer the dog. Be realistic: how much free time does each member of the family really have? Who will do the feeding, walking, playing, taking to the vet and the extra cleaning? Armed with your list, find a dog with the genes to suit you all.

If any breeds look appealing, research their temperament traits. A big clue to

Springer spaniels were bred to be retrievers, and the characteristics of this make them excellent search-and-rescue dogs, like this good boy in Hampshire.

personality is the history of the breed and the job its ancestors did. So once you know the temperament predispositions you're dealing with, consider what a dog with those traits will be like living in your home.

Once you've settled on the type of dog you want, do you buy a puppy or find an adult from a rescue centre? A puppy is a clean slate and you will enjoy the delights of watching them grow, but you will need lots of time for education during the first year to develop a well-behaved dog. Alternatively, an adult will be past the house training and chewing phases, and what you see is what you get.

If you decide on a puppy, be sure to choose your breeder wisely as this will make a tremendous difference to the health and temperament of the dog you end up with. Not only will the breeder be responsible for the genetic make-up, but they will also be caring for the puppy for the majority of the socialisation period, a time when the puppy needs to learn all about the world in which it will live if it is to be well adjusted and unafraid later. Finding good breeders is not easy, but it is best not to visit litters unless you have done your research. It is almost impossible not to fall in love at once when you see those little balls of fluff, so it is better to only visit puppies that you know have been raised by a conscientious and dedicated breeder.

Finding a Healthy Dog

In addition, make sure the breeder you choose has had all the tests done for the inherited diseases for that particular breed. Sadly, in producing pedigree dogs, gene pools have become small and inherited diseases abound. This has become such an issue that many owners are turning to crossbreeds, such as Labradoodles or Cockapoos. So find out about the diseases affecting your chosen breed and make sure you are buying a dog that has every chance to live a long and healthy life.

Whether you get an adult or a puppy, one of the most important things to do is to train and educate. This will allow you to have a dog that can be controlled outside on walks and is nice to live with at home. Modern methods of positive training allow this to be a fun activity for both you and the dog, and all the family can enjoy teaching the new dog or puppy how to behave.

And finally, if going out in all weathers really fills you with dread, or work and a social life keep you away from home, it may not be a good time to get a dog. It's better to wait until your circumstances change so that both you and the dog will have a good chance of enjoying life together.

A Tour of Some Great Country Breeds

BORDER COLLIE

Bred for: Herding sheep
Size: Large; height 46–54cm, weight 14–22kg
Personality: An energetic, close-bonding, willing-to-please workaholic
Attitude to Others: Reactive and needs good socialisation when young to be friendly to all
Exercise Requirements: Loves to chase and needs plenty of games and training to fulfil its very high need for mental and physical exercise
Special Characteristics: Loyal, affectionate and eager to work, quick to learn and intelligent
Perfect Owner: Energetic, sensitive owners who have time and room to exercise, play and train

BOXER

Bred for: Seizing and hanging on to large game until hunters arrived
Size: Large; height 53–63cm, weight 25–32kg
Personality: Energetic, enthusiastic and extrovert
Attitude to Others: Friendly
Exercise Requirements: Lively and agile, and needs plenty of exercise every day
Special Characteristics: Boxers are good-natured, tolerant and playful, making them good companions for children
Perfect Owner: Boisterous families who want an energetic and exuberant companion

BORDER TERRIER

Bred for: Catching vermin and digging out foxes
Size: Small; height 25–28cm, weight 5–7kg
Personality: Affectionate, easygoing and enthusiastic
Attitude to Others: Good with others, except small pets
Exercise Requirements: Lively and keen to go on long walks, but also content with quieter days with less exercise
Special Characteristics: Good watchdog without excessive barking
Perfect Owner: Families who want a small dog that is bright and keen to be involved with daily life

YORKSHIRE TERRIER

Bred for: Catching rats, by Yorkshire miners
Size: Small; height 22.5–23.5cm, weight 2.5–3.5kg
Personality: Affectionate, playful and feisty
Attitude to Others: Needs to be well socialised; care needed with small pets
Exercise Requirements: Daily exercise and activity needed to be calm
Special Characteristics: Has a big character, despite its small size, and needs plenty of socialisation and training early in life to develop a good temperament
Perfect Owner: Ideal for careful owners who want a small dog with a big personality

DALMATIAN

Bred for: Running alongside carriages, guarding their masters and the horses
Size: Large; height 56–61cm, weight 23–25kg
Personality: Active, gentle and affectionate
Attitude to Others: Friendly if well socialised in early life

Exercise Requirements: Loves to run and has plenty of stamina, and so needs open areas where it can exercise safely, away from traffic
Special Characteristics: Quiet and sensible at home, providing it gets the exercise it needs
Perfect Owner: Active families who enjoy regular long walks in the countryside

BEAGLE
Bred for: Hunting hares and rabbits in packs
Size: Medium; height 33–40cm, weight 8–14kg
Personality: Happy, enthusiastic and tolerant
Attitude to Others: Friendly to all
Exercise Requirements: Boundless energy but usually content to be quiet at home if given sufficient free-running exercise outside
Special Characteristics: A strong desire to chase wildlife can lead to control issues outside unless careful training is started early and continued throughout life
Perfect Owner: Active families who appreciate the need to keep this energetic dog under control

WHIPPET
Bred for: Chasing and catching rabbits
Size: Small; height 44–51cm, weight 12.5–13.5kg
Personality: Gentle and affectionate
Attitude to Others: Reserved but friendly
Exercise Requirements: Can make do with limited exercise but needs daily bursts of free running off lead, especially when young
Special Characteristics: Thin coat makes it vulnerable to the cold. It needs good socialisation when young, as well as early training, to ensure control over hunting instincts on walks
Perfect Owner: Gentle, sensitive owners who want an independent, elegant dog

LABRADOR RETRIEVER
Bred for: Originally, to assist anglers in the cold waters of Labrador, Canada. Later used for flushing and retrieving game

Size: Large; height 55–57cm, weight 25–34kg
Personality: Amiable, fun-loving and playful
Attitude to Others: Easygoing and friendly
Exercise Requirements: Plenty of daily exercise and toy play needed to keep it content
Special Characteristics: A powerful swimmer, and loves to play games. It will need lots of chews when young to save family possessions from being shredded
Perfect Owner: A good choice for families

ENGLISH COCKER SPANIEL
Bred for: Flushing and retrieving game
Size: Medium; height 38–41cm, weight 13–14.5kg
Personality: Lively, enthusiastic, strong willed, but eager to please
Attitude to Others: Friendly and outgoing
Exercise Requirements: Needs energetic walks and plenty of play daily
Special Characteristics: Can be strong-willed, so you need to put in the time to socialise and train it well when young
Perfect Owner: Active owners who are determined but kind, and have plenty of time to exercise and train this intelligent dog

ENGLISH SPRINGER SPANIEL
Bred for: Flushing and retrieving game
Size: Medium; height 46–48cm, weight 16–20kg
Personality: Happy, enthusiastic and willing to please
Attitude to Others: Friendly to all
Exercise Requirements: Will work tirelessly all day and still be ready for more, so will require long walks and lots of play to feel content
Special Characteristics: Makes a gentle but enthusiastic playmate for children
Perfect Owner: Active owners with plenty of time and energy. Ideal for families or sport enthusiasts

Wild Garlic *Fergus Collins*

Dense clusters of green spears thrust from the woodland floor in March: these are ramsons, better known as wild garlic, and they are a sign that the woodland you are walking in is very old. Closely related to onions and garlic, ramsons similarly grow from bulbs and give off a strong and attractive garlic smell. In continental Europe, the bulbs are thought to be a favourite food of brown bears, hence the plant's scientific name *Allium ursinum* (bear leek). Like the domesticated alliums, ramsons are edible and the leaves are an excellent addition to a cheese or pâté sandwich. Whizzed up with walnuts and olive oil – and with a few tablespoons of parmesan added afterwards – the leaves also make a delicious pesto.

Better still, you can create a lovely spring soup from the leaves. Fry an onion in butter until soft and add a finely cubed potato and a bay leaf. After another five minutes frying, add 500ml of vegetable stock and simmer until the potato is soft – about 10 minutes. Add the bunch of ramsons leaves and cook briefly – no more than a couple of minutes. Remove the bay leaf, blend the soup, add seasoning and you will have a bowl of spring green goodness.

Ramsons throws up pretty white flowerheads as spring progresses.

Nettles

Richard Aslan

In this day and age, we're not used to our food fighting back. Painful encounters with nettles are as much a part of life in the UK as rainy bank holidays, but how exactly do they deliver their sting? Needle-like hairs grow on the leaves and snap off at the slightest touch, injecting a payload of itchy, burning chemicals under the skin. Surprisingly, science hasn't yet fully decoded this chemical cocktail; formic acid (similar to that produced by stinging ants), histamine, acetylcholine and serotonin are all present, but a final mystery ingredient still eludes identification.

When boldness is required, we are urged to 'grasp the nettle' – while the plant's defences are triggered by a delicate touch, a firm grasp flattens the hairs and leaves them undetonated. This characteristic was noted by John Lyly in the sixteenth century. '…he which toucheth the nettle tenderly is soonest stoung'. Like humans, rats and the common cold, nettles can be found across most of the planet, and some claim Roman soldiers are responsible for their spread across Britain. The story goes that they rubbed nettles on their legs and the burn fought off the cold. But could anyone ever be that chilly?

There is an upside to all this chemical warfare; nettle patches are important habitats and scientists have counted more than 40 resident species, including tortoiseshell and peacock caterpillars. The nettle's sting developed specifically to ward off grazing animals, so insects can navigate the leaves unharmed. To avoid ending up in someone else's stomach, a nettle leaf is a happy home.

Birds eat the numerous seeds, and we too can benefit – the nettle is famed for its nutritional value. Nettles are rich in vitamins and minerals, including iron, silica and potassium, and a few minutes in boiling water renders the leaves harmless. You can use them in much the same way as spinach – steamed or sautéed, in soups, pesto, tarts or omelettes. The recent trend for foraging also sees them included on the menus of swanky restaurants.

Nettles find their way into infusions, tinctures, compresses and ointments as herbal cures for everything from asthma to gout, and the roots are used to ward off dandruff.

So next time you encounter a footpath crowded with nettles, don't scowl and press past. Instead, gather up some of Mother Nature's bounty. But when you do, either show your mettle and grab them firmly, or put your gloves on first.

Nettle Soup

Tasty and nutritious, nettle soup's main ingredient is totally free. Choose the young, tender leaves from the tops of the plants. Though the stinging leaves are less potent once they are picked, they can still leave you tingling, so wear gloves to wash and chop them. Once they are boiled, the leaves are harmless.

- 2 tbsp butter
- 1 onion, chopped
- 450g (1lb) potatoes, peeled and chopped
- 1,400ml (6 cups) vegetable stock
- 225g (½lb) nettles, washed and chopped
- Pinch of black pepper, nutmeg, salt to taste

Melt half the butter in a large saucepan and cook the onion until soft. Add the stock and potatoes and bring to the boil. Reduce the heat and simmer for 15 minutes. Add the remaining butter, spices and nettles and cook until tender – for about 10 minutes. For a smooth soup, allow to cool and then blend in batches.

Feared by many for its painful sting, the nettle has a myriad of uses – from food to medicine.

Ancient Boundaries

Ian Vince

March may be the official start of spring, a little warmer and with promises to keep, but it also hides a dark secret, for the month has martial connections. Named after Mars, the Roman god of war, it was not only the start of the Roman year, but also the month for mounting military campaigns.

Those campaigns, and many more before and since, have left marks on the countryside – battlefields, mottes and baileys and castle keeps whose names we all recognise, from Hadrian's Wall to the magnificent Maiden Castle in Dorset, with medieval and Tudor strongholds the length of the country between. The ubiquity of battle and war in Britain is evidence of the part conflict has played in our history. But for every famous hillfort, castle and Roman wall, there are dozens of military connections hiding in our countryside.

Among them are miles of Iron-Age 'Grim's ditches' or dykes. These are common in Wessex,

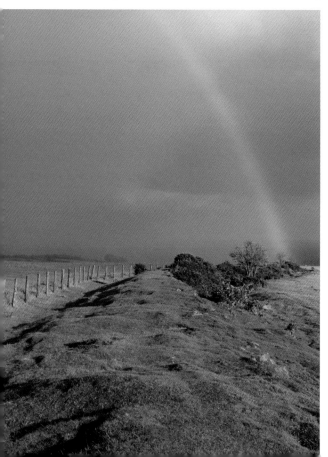

and are believed to be territorial markers. The Wessex ditches are not usually large enough for defensive use – the remains tend to be the size of a modest railway embankment. Nevertheless, the ditches have an etymological cousin in Graham's Dyke, a local name for the Romans' short-lived Antonine Wall across the central lowlands of Scotland. 'Grim' was the Old English name for the Anglo-Saxon god of war, Woden, and other Grim's ditches, particularly the one at Colton, east of Leeds, may have been substantial enough to have a defensive use.

Compared to Offa's Dyke – up to 20m (65ft) at its widest and some 132km (82 miles) long – Grim's dykes may seem modest. The eponymous creation of the eighth-century king of Mercia, Offa's Dyke marks the English–Welsh border (running along Marches of a different kind) and is a potent symbol of tension throughout history. The dyke was built to have commanding views of Powys to the west, with the bank on the Mercian side and the ditch in front to deter any hapless invaders from Wales.

Seven hundred years before Offa, at Wales' north-western horn, advancing Roman legions were confounded by both the treacherous Menai Strait and the Celtic tribes of Ynys Môn (Anglesey) on the other side. Roman governor Agricola inflicted a punishing and conclusive triumph over them in 78CE, and Ynys Môn was taken for good. But the memory of his brutal campaign is allegedly preserved in the names of fields; close to Brynsiencyn on the island, one howls its name as Cae-oer-waedd or the 'Field of Bitter Lamentation', while another is simply 'The Field of the Long Battle'.

Twelve hundred years after they were raised, Offa's Dyke's ramparts remain impressive.

OPPOSITE: *Devil's Dyke, near Brighton, has been the subject of myth and legend for thousands of years.*

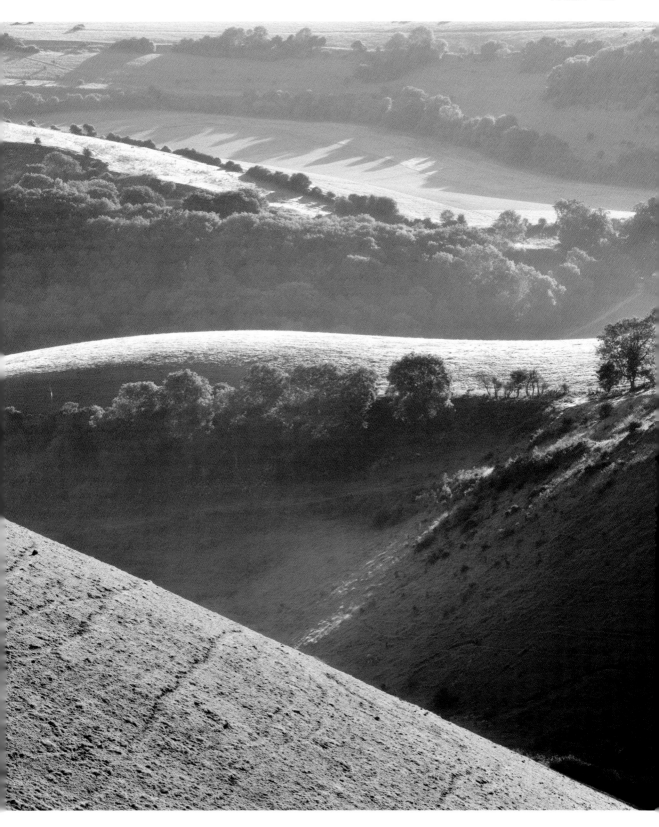

Smugglers' Dorset

Fergus Collins

Imagine you're on a beach. It's night and the moon is passing in and out of cloud. You hear a louder splash above the soft, rolling surf, followed by a muffled curse. Out of the murky sea a dark shape emerges; a boat is being pulled up on to the shingle by shadowy figures. Swiftly they unload kegs and drag them up the beach. You can smell spilt rum.

Should you run to the village and alert the coastguards? Or would it be better to sit tight? These smugglers are desperate men and will stop at nothing to avoid the noose. Lights appear on the cliffs above and the men curse and work harder. A horse and cart are hidden in the gloom at the head of the beach, ready to take the contraband deep into Dorset down sunken lanes and remote droveways, where few dare to tread at night. It looks like they might just get away with it.

A Bloody History

If you'd lived on the Dorset coast in the eighteenth century, there's a good chance you'd have had a few scary nocturnal encounters with smugglers and wreckers. The beaches, bays, cliffs and coves are the backdrop to a gutsy and sometimes bloody history. And now you can follow in the footsteps of these ne'er-do-wells and discover an intriguing new side to this astonishing coast.

The journey begins among the thatched cob and sandstone cottages of Chideock, home of the Chideock Gang. This now peaceful village saw more smugglers through the courts than any other parish in Dorset. It was off here that the last recorded smuggling of kegs occurred in the mid-nineteenth century. A certain Bartlett was forced to drop his cargo in the sea and recover them by trawler six months later. Of 120 kegs, he lost just one.

The smugglers' favourite hiding place was St Gabriel's Chapel, away west over the hill in remote Stanton St Gabriel. Now a ruin, the chapel lies at the heart of a magical, time-warp landscape of flower- and butterfly-rich pastures and hedgerows beneath Golden Cap. At 191m (618ft) above sea level, this peak, named for its top-most band of sandstone, is the highest cliff on the south coast, with a panoramic 90km (55-mile) view from Start Point to Portland Bill.

It's a long climb to the top, but the most demanding aspect of walking the Dorset coast is that you then drop down to sea level and have to repeat the process all over again. To the east the twin peak, Thorncombe Beacon, holds a replica of the fire-beacons lit to warn of the approaching Spanish Armada. Just beyond is a welcome descent.

The Smugglers' Path

The path is the only intimate way to explore the coves and cliffs of the coast and is perhaps smuggling's greatest legacy. It was created for the nightly coastguard patrols.

Bridport is a welcoming place, where antique shops vie with traditional greengrocers, fishmongers and butchers. But smugglers were less welcome – this was a respectable place where hemp was turned into canvas, nets and ropes for fishermen and the navy. 'Stabbed with a Bridport dagger' was to be hanged – the fate of many a smuggler.

But illicit goings-on were never far away. William Crowe's poem 'Lewesdon Hill' of 1788 alludes to Burton Cliff, overlooking Lyme Bay, near the delightful village of Burton Bradstock: 'Burton, and thy lofty cliff, where oft the nightly blaze is kindled'. This was a smugglers' beacon, lit to signal that the coast was clear.

In tandem with smuggling, the windfalls of 'God-given shipwrecks' were augmented by deliberate wrecking of vessels, which were then plundered. *De Hoop* (*The Hope*), a treasure ship returning to Amsterdam from the Spanish colonies, was stranded on Chesil Beach on the night of 16 January 1748. Thousands flocked to the beach from nearby villages and the towns of Weymouth and Portland.

The crew, who narrowly escaped with their lives, put the loss at £25,000, a vast fortune then. The Revd Thomas Franklyn preached a sermon at Fleet to remind parishioners of the Acts of Parliament relating to ships stranded on the coast and the penalties for plundering: 'This has long been looked upon as a thing right and lawful to be done.' An anonymous pamphleteer put the situation succinctly in 1752: 'All the people of Abbotsbury, including even the vicar, are thieves, smugglers and plunderers of shipwrecks.'

Wild and Wonderful

Further east along the coast is wild and wonderful Kimmeridge Bay. Here, as recently as 1929, a half-anker keg with a six-pronged hook and 3m (10ft)-long grappling pole were found in the boathouse – left by smugglers a century before. The items now sit in the Dorset County Museum in Dorchester. The present beachside building houses an underwater Dorset Wildlife Trust marine webcam link to the adjacent nature reserve.

Nestled in the suburbs of Bournemouth, the parapet of the Kinson church tower is gouged with grooves from ropes that were used to lift the kegs that were regularly stored there. Casks were also hidden in an ancient table-tomb. A nearby gravestone records the death of Robert Trotman, who was shot dead on the shore at Lilliput on 24 March 1765, 'barbarously murder'd' during a pitched battle between smugglers and a naval detachment, in whice nine horses were also killed.

Smuggling gave Bournemouth much of its early history – before it developed into a Victorian seaside town – such as the seizure at 'Bourne Mouth' of 411 casks of 'spirituous liquors' (and a bag of tea) being carried off by 13 horses and three carts on 3 October 1785.

Take Shelter

The Dorset coast is not always benign – swirling hill fog may cloak the wonderful views or be blown away by breath-stealing force 10 gales, which make boating, birdwatching or following smugglers' footsteps difficult. If in doubt, adjourn to one of the smugglers' hostelry haunts in the area, such as the Square and Compass in Worth Matravers. It's dependable for drink, pasties and pumpkins in season. Locally caught dinosaurs are also on the menu – in the museum out the back. It's a great place to swap tales, as it has been for centuries.

Smuggling's legacy to Dorset is a sense of hidden history and strange tales around every corner. Hopefully now, when you explore those thrilling, always surprising beaches, cliffs and coves, you will imagine some of the characters who once lived here.

Treasure Hunting

You cannot indulge in Thames-style mud-larking here. Dorset's English Channel coast is elemental and rocky. It helps if seriously wild weather has shifted things around. To be in with a chance of finding Spanish gold, wait until the next real hurricane abates – particularly if it has washed pebbles off Chesil Beach to reveal its underlying core of blue clay. Stretching west from Portland, the shore is known for its long history of shipwrecks in Deadman's Bay.

Coins are liable to come from everywhere, including those of the East India Company, powerhouse of the British Empire. More likely, however, metallic bits will prove to belong to aircraft lost in the Battle of Britain or the immense tonnage of wartime shipping claimed by U-boats and mines.

Cannonballs and shell-cases are common, as are musket flints, with bigger finds having included the rear wheel of a Hurricane fighter from Kimmeridge Bay. A display piece from beside Chesil Beach, now outside the Anchor Inn at Seatown, is the 4m (14ft) anchor of the wrecked *De Hoop*, recovered by fisherman Jack Woolmington in September 1986.

OVERLEAF: *A magnet for tourists today, Durdle Door would have been a critical landmark for smugglers of yesteryear.*

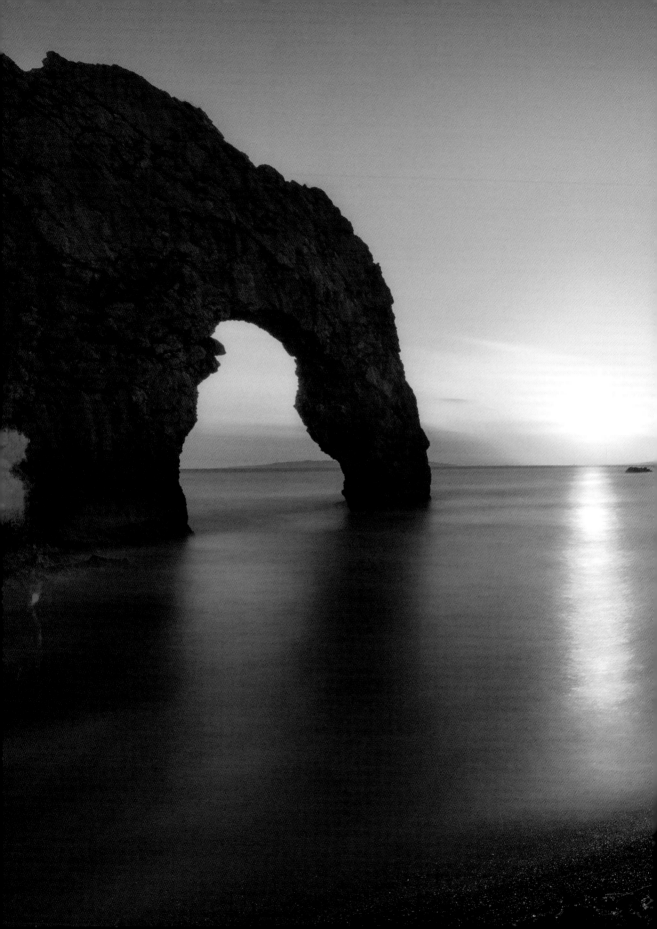

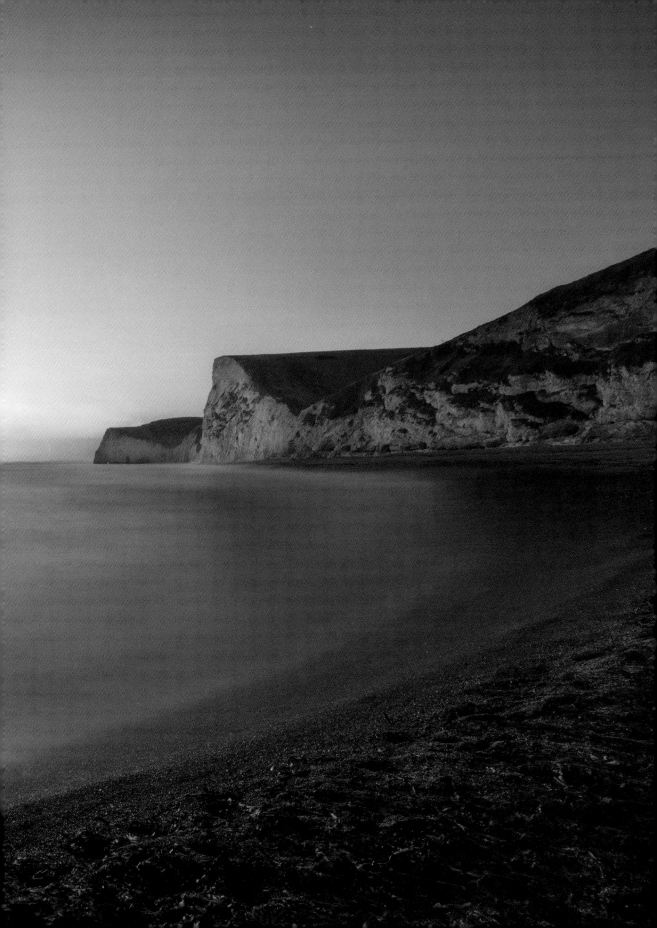

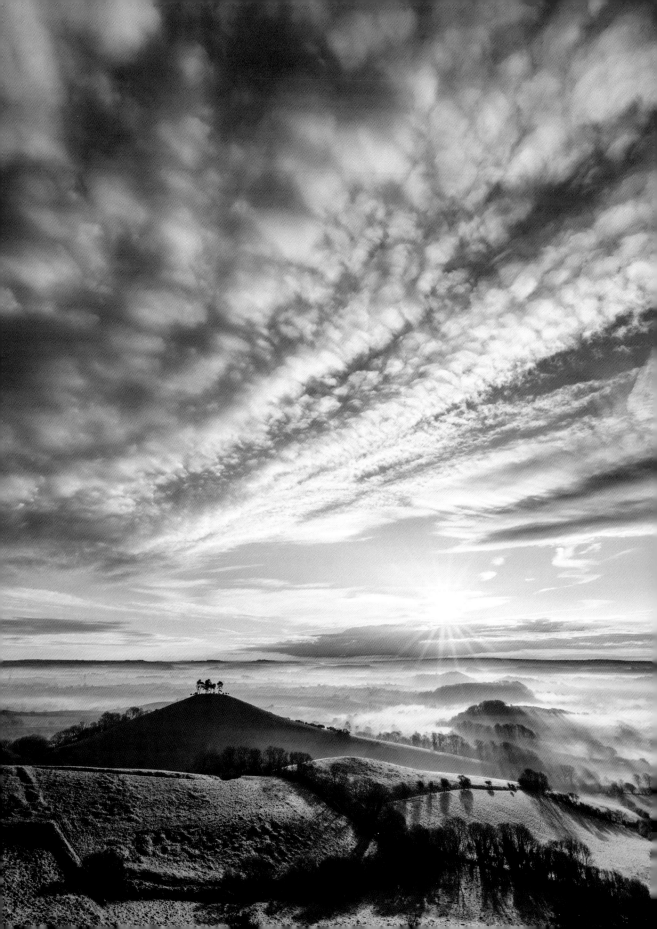

April

Two of our nation's endangered natural treasures are featured this month – chalk streams and wildflower meadows, plus a tiny fish that brings back boyhood memories: the stickleback.

There are just over 200 chalk streams in the world and 85 per cent of them are in England. They are fed by crystal-clear spring water from chalk aquifers, not the rain, and Sir David Attenborough called them 'one of the rarest habitats on Earth'.

These streams, the home of salmon, kingfishers, otters and a wide range of aquatic flora, are found from Yorkshire to Dorset, but many of them are not in good health because too much of their pure water is being abstracted and ends up in our taps. But restoration projects are under way – just as they are with wildflower meadows.

Since the end of the Second World War 97 per cent of these hay meadows have disappeared, largely due to the way land is now farmed. That's 1.2 million hectares (3 million acres) of beautiful wildflowers with names like bird's foot trefoil (also known as lady's slipper or even granny's toenails) obliterated from the landscape.

King Charles is a great supporter of attempts to save what remains of these meadows, and to celebrate his coronation English Heritage has set about creating or restoring a hundred of them at its castles and abbeys, stone circles and palaces.

I've been intrigued by nature ever since, as a small boy, I went with a couple of pals and our home-made fishing nets to a local beck where, in our short trousers, we waded in search of sticklebacks. These tough, darting little fish were quite a challenge – once I fell in and returned home bedraggled to a scolding with only a couple of sticklebacks in a jam jar to show for my efforts. But it didn't put me off.

These days one of my quiet pleasures is to sit in the garden on a late April evening, maybe with a glass of something in my hand, and search the sky for the return from Africa of swallows, swifts and house martins. Their amazing aerobatics as they hunt for insects is one of the natural world's greatest free shows.

A spring sunrise bursts over Colmer's Hill and the surrounding coombes of south Dorset.

Wildflower Meadows

Phil Gates

Now rare and precious, traditional meadows are both beautiful and fizzing with wildlife. Conserving the floral diversity in these old meadows, which can be home to more than 150 plant species, depends on a traditional cycle of management, maintaining a delicate competitive balance between wildflowers and grasses. By delaying the hay-cut until the flowers shed seed, and then following up with a short period of grazing, the soil fertility is restricted so that wildflowers can thrive alongside grasses that would otherwise respond to high soil nitrogen levels by dominating the whole plant community.

Bees, Butterflies and Moths

The importance of ancient meadows extends far beyond their floral diversity. Hay meadow food webs can be bewilderingly complex. Flowers provide pollen and nectar for bees, butterflies and moths, while the foliage of flowers and grasses supplies food for caterpillars, which in turn are prey for birds, bats, mice and voles. Leaving hay-cuts until late in the season maintains cover for hares and gives ground-nesting birds a chance to complete their breeding cycle. In high summer, they conceal partridges leading fledglings through the undergrowth, skylark nestlings, curlews calling to their young and wagtails snapping flies. Overhead, swallows swoop low over the grasses, trawling for insects. Nothing encapsulates the essence of summer better than a hay meadow in full bloom.

There is only one way to fully appreciate all this biodiversity. Resist the temptation to wander through the flowers; trampling disfigures a meadow, flattens rare plants and can destroy hidden nests. Instead, arm yourself with a good field guide, stick close to footpaths and boundaries, and hone your wildflower identification skills. Then sit down and immerse yourself in the flowers and swaying grasses, so that you have a hare's-eye view. Take a camera – preferably one with a macro lens with a shallow depth of focus, so you can isolate individual flowers and insects against a diffuse background – and record the activity that unfolds around you. The hours will fly by.

Types of Flower-rich Meadows

The range of flower species found in meadows varies according to subtle differences in soil type, climate, geography and local management regime. The oldest, most florally diverse meadows were once forest clearings that, because they have never been levelled by repeated ploughing, retain hillocks and hollows where species that favour wet or dry soils can thrive in their favoured niche.

Upland hay meadows may be home to wood cranesbill, ragged robin, globe flower, adder's tongue fern and the magical lady's mantle. At sunrise after humid nights, the serrated rims of lady's mantle leaves are fringed with sparkling water droplets, once believed by alchemists to be essential for converting base metals into silver (the Latin name of this plant, Alchemilla, means 'little alchemist').

Lowland meadows are on neutral or alkaline soils, where you can find lady's bedstraw, clustered bellflower, hoary plantain and salad burnet. Rarer species include dyer's greenweed, green-winged and greater butterfly orchid.

Seasonally flooded meadows are recorded as agriculturally valuable in the Domesday Book. Unlike water meadows, which are deliberately flooded in winter to maintain fertility, these hay meadows on river flood plains depend on natural winter inundation, which favours the growth of moisture-loving wildflowers such as marsh marigold, lady's smock and meadowsweet in spring and early summer, followed by devil's bit scabious and greater burnet later in the year.

Clover, buttercups and yellow rattle throng a traditional Peak District hay meadow.

The Chalk Streams of Hampshire

Charles Rangley Wilson

April sun shines through a lime-green canopy and dapples the curving road in a pattern like the spots on trout. The lane snakes downhill under cliff-faces of fractured chalk, ferns and a cascade of beech leaves, then levels out as it hump-backs a wrought-iron bridge, under which flows – darkly, quietly – a small spring-fed stream. It is one of many that thread and braid their way through the damp thickets of wild wood and water-meadow all about. This is the upper valley of the River Itchen.

Hear the sounds of a Hampshire summer's day: voices in a garden, a tinkle of crockery, the soft 'take-two-coos-taffy' call of wood pigeons. All around the electric fidget of chirruping birds: reed warblers, willow warblers, sparrows. And a lilting ripple. Water is everywhere. The river slides languorously while other streams and tributaries join from north and south, burbling here and there, so that it feels as if the land were floating on water, and partly mobile, the roads and paths only stepping stones. Stamp and the ground wobbles.

The Heart of Chalk Country

The Itchen is a chalk stream that, like the Test, its sister in the next valley, flows through the heart of chalk country, the rolling landscape of southeast England that might call to mind wheat fields under billowing clouds in summer, warm beer or novels by Thomas Hardy.

Chalk builds a landscape that is friendly and malleable. So much of it is built over or riven through with fast roads that it is all too easy to take chalk for granted, and not to see that beyond the suburban margins and industrial-scale wheat fields that cover much of it lies an older, slower England, and nature at her most fecund and beautiful.

At the end of the lane beside a pub called the Bush Inn, the path to Itchen Stoke is effectively a causeway across streams. The narrow, reed-fringed trail seems perched on water that is invisible but for the shimmering reflections and

the domed tresses of swaying weed beneath. The surface is dotted with constellations of white flowers – stream-water crowfoot – and the banks are a bunting-lined street of yellow flag iris. Pilasters of sedge and dog rose rise out of the marshy peat like the stumpy remains of an ancient temple.

For a long time no one quite knew the true origin of chalk. It took a microscope to see that this white rock, which more or less defines us in the defiant and luminous cliffs of Dover, is made up of the tiniest of tiny shellfish. And it took the surveyors of the Atlantic floor – working on inter-continental electric telegrams – to discover that the very same stuff is at the bottom of the sea in a wide, even and unbroken

When in good health, like this stretch of the River Itchen, chalk-stream water is crystal clear.

plain. Our chalk hills were once the bed of the sea too – a prehistoric sea. They were built from tiny shellfish that died and sank and took millions of years to accumulate; millions more to become the surface of a European landmass; and millions again to erode away into the solitary wave that is left, a line of whiteness that stretches from Dorset to Yorkshire, taking in most of the home counties and East Anglia between. But Hampshire is at its centre, where the chalk hills extend to the horizon in all directions and the rivers are the most perfect expression of an already perfect entity.

Across this expanse of chalk, rain falls and sinks underground so that an ocean of it is trapped within the rock until gravity, the lie of the land and the impermeable seams of clay and flint that intersect the chalk deep underground, all combine to force that water to the surface. It may surface beneath a yew tree, or in a church yard, or deep within the copse on the side of a hill, or perhaps in some unprepossessing sheep field. And when this happens a chalk stream is born.

Charged by the alchemy of the rock, chalk streams are cold, clear and fertile. Nurtured by their ceaseless and equable flows, chalk stream ecosystems are as vibrant and varied as any on Earth. And in England there is deep history, too. People have lived beside, with and because of chalk rivers for thousands of years.

Centre of the Community

Close to the source of the river in Alresford, a thatched fulling mill bestrides the waters. A notice high on the wall cautions passers-by that fishing is prohibited. The sign is dated 1275. Chalk rivers have worked mills for thousands of years: grinding corn, washing wool, mashing rags to make paper.

Nearby stands the old tanning yard, a polite neighbourhood nowadays. A little further on huddles an eel house, only 200 years young. And at the end of this path, an arched brick culvert spans a small stream and is flanked by two ash trees that have been there so long their roots have woven together to form the structure of the bridge, its parapets and pavement.

Back to the river, and fish shimmy away and shimmy back again. Occasionally a brown trout rises to take an insect and leaves a splashy whorl on the surface. Once in a while you might see someone fishing for them here, their fly line flicking back and forth in the air, landing like thistledown. It is a bewitching spectacle and baroque too, given the same fish can be caught just as easily, in fact far more easily, with a worm. But the cult of the dry fly – fishing with a hook dressed with special feathers to represent not just an insect, but a particular type, sex or stage in any given insect's lifecycle – was born on the Test and Itchen, in part because these chalk rivers are so fertile.

Around 150 years ago, the leisured gentlemen of Victorian London began to travel here by train and experiment with elaborate imitations of the zooniverse of insects that thrive in these chalk waters. They mounted their creations on silk lines and threw them at pernickety trout. And followers of the religion – though some say it is more serious than that – have been doing the same ever since. The trout play along in as much as that, for a reason no one quite understands, they will focus on one insect and eat only it to the exclusion of all others. This is the fishing version of *The Times* crossword and utterly addictive. You might ask that angler how he's getting on and if he answers at all he'll shrug his shoulders, while the fish rise all about him. Don't worry. That's the whole point.

It is mesmerically still and peaceful here. The river glides serenely under banks of willow and sedge. Catkins and mayflies drift by on the surface. A pair of bright blue dragonflies spar and dogfight among the reeds. All you can hear is the breeze skittering leaves into a dry, lazy, springtime rattle, the 'chu chee, chu chee, chu chee' rise and fall of reed warblers, the buzz of flies, the flow of the water. It's the best place on Earth.

Sticklebacks in Love

Dominic Couzens

While it's easy to tell that spring is here in the countryside at large, let's not forget that it is in full flow underwater as well – in streams, in ponds and lakes, and in marshes. And while many of us may be familiar with the delights of great crested grebe courtship or the shameless spectacle of copulating frogs, beneath the surface, hidden away in the watery hinterland, is a spring ritual the equal of anything you might see above the surface.

By this time of year, one of our most familiar mini-fishes, the most frequent catch in a child's net, is embarking on something astonishing. The male three-spined stickleback is about to stage its very own choreographed show, a sort of *Stickly Come Dancing*.

In early spring, it first togs up in suitably gaudy attire, a bright red belly, blue eyes and a crisp green upperside instead of its usual dull green. Then it becomes fiendishly territorial, ejecting any rival males that dare to come close to its patch of stream or pond bed. It builds a tubular nest out of small pieces of plant debris and the scene is set for some feverish courting.

The appearance of a plump, egg-laden female engenders a dance in which the male zigzags, alternately coming towards and swimming away from the female, with heavy emphasis on the approach, a sign that its hormones are buzzing. If the female judges this performance satisfactory, she will then respond to the male's invitation to follow him to view the nest and, having seen it, she will swim inside. The male then rubs her back to stimulate her to lay eggs and, having got what he wants, he will less than chivalrously chase her away. This ritual may be repeated several times with different females. Having acquired the spoils, the male fertilises the eggs and protects them until hatching, and beyond, herding the fry from danger.

The small bright red male stickleback ushers a female into his nest.

Arrival of the Swallows

Stephen Moss

The appearance of a special creature is one of the highlights of the year. On a fine, sunny day, around the last week of March or the first week of April, you may catch sight of a small, slender bird flying low and purposefully towards the north. This is the first swallow of the spring, newly returned from its winter quarters thousands of kilometres away in southern Africa.

All over the country, people are waiting and watching. As each day goes past, the tension becomes close to unbearable – when will these birds return? Then, a flash of blue; a snatch of twittering song; and they're back – as if they've never been away.

Fair-weather Friends

Shakespeare celebrated the swallow's return, with one character noting its connection with the seasons: 'The swallow follows not summer more willing than we your lordship.' Aristotle did, too, though he also warned: 'One swallow does not a summer make, nor one fine day.' But even as we welcome its return, how many of us stop to wonder where this bird has been in the half a year since it left our shores? Or to ask why it comes here at all?

Like all summer visitors to Europe, swallows fly north to take advantage of the longer hours of daylight, abundant sources of food (in their case, flying insects) and, especially, the lack of competition in these temperate latitudes. In its African winter-quarters, our swallow must share its airspace with more than a dozen other related species, whereas in Britain there are only two others: the house and sand martins.

So although it is a very long way to fly – especially for a bird that weighs about 20g (less than an ounce) – this epic journey almost halfway across the globe is definitely worth it. All the more so for us, for whose heart doesn't leap when they see these beautiful and elegant birds hawking for insects in the clear blue sky?

No Rest, Must Nest

After arriving in Europe, the birds may wait on the other side of the Channel until weather conditions are suitable for crossing. The first birds we see in spring are the males, which arrive back to find a suitable territory a few days before their mates. Once the female does return, however, swallows cannot afford a moment's rest. As soon as they can, they begin courtship and breeding.

Swallows have long lived alongside human beings, nesting in man-made buildings such as barns (hence the official name 'barn swallow'). They build a loosely made nest from grass lined with mud, often on a high beam. Here, the female lays her clutch of smooth and glossy eggs – between three to eight of them – which are coloured white with reddish speckling.

For the next two weeks or more, the female incubates the eggs while the male collects tiny insects to feed her all day long. The chicks are born after 14–19 days and are naked (apart from a thin coat of down) and blind. They are also hungry. From now on, both the parents spend every daylight hour going back and forth to the nest to feed their ever-growing brood.

Packed to the Rafters

After 10 days or so, the nest is beginning to get a bit cramped; by day 20 it is positively overcrowded. Finally, encouraged by calling from both parents, the young birds leap into the unknown – literally, as this is their first flight. Having experienced this unfamiliar mode of transport, they land awkwardly on a barn beam, roof or telegraph wire, where they pose unsteadily before mum or dad arrives with some welcome food. But they must quickly learn to fend for themselves, for swallows usually have two or three broods, so the parents will soon have a new family to feed.

A swallow briefly alights at the margin of a pond to collect mud and other materials for nest-building.

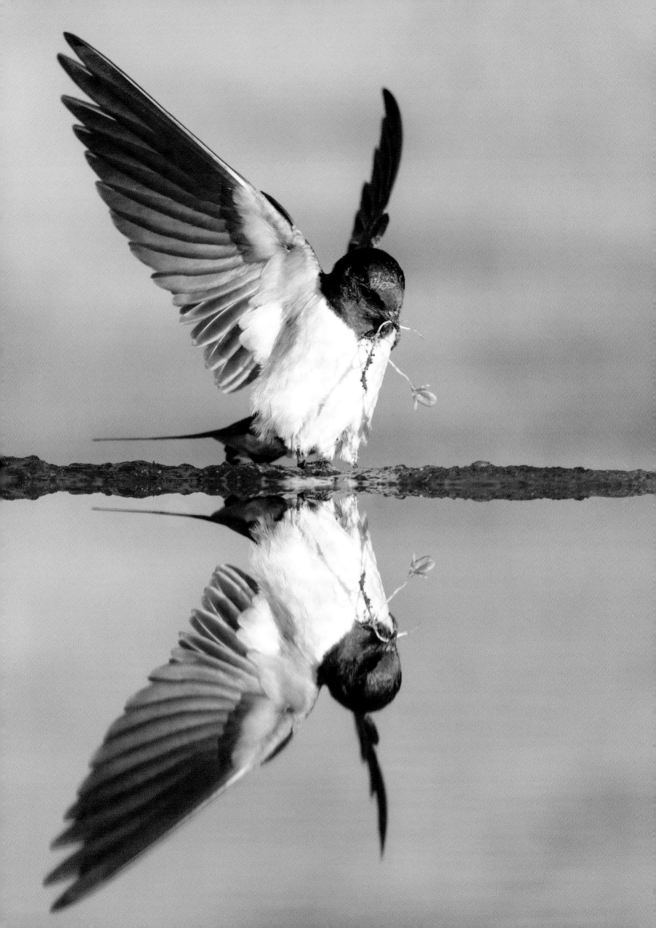

Young swallows are most vulnerable in these first few days away from the nest. Hobbies – acrobatic falcons that look like a giant swift – patrol the airspace above, diving down to pursue a potential victim. They may in turn be chased off by the adults, whose gentle twittering turns into a frantic alarm call when any predator is around.

But if the youngsters do manage to survive, then sometime towards the end of August or the beginning of September they gather with the adults in groups on wires, like musical notes on a stave. For the next few weeks there may be several false starts: they will fly high into the air, then return to their perch a few minutes later.

But one day from the middle of September onwards, they will head off for good. Their epic journey takes them south over the English Channel, across Europe, the Mediterranean Sea, the Sahara Desert and the jungles of equatorial Africa, until Table Mountain comes into view, signalling that they have at last reached their destination. Meanwhile we are left alone and bereft, waiting for that magical moment, sometime next spring, when the birds that hatched out here earlier in the year make their dramatic – and very welcome – return.

Migration

Long-distance migrants, swallows breed on one continent and winter on another. Our swallows, along with the 20 million that visit Europe and western Asia, travel to Africa; others, which breed in Asia, winter in southeast Asia and north Australia. Across the Atlantic, North American swallows head all the way down to South America.

Unlike most songbird migrants, swallows and martins fly by day, feeding on small flying insects as they go. They navigate using the Earth's magnetic field, polarised light and visual

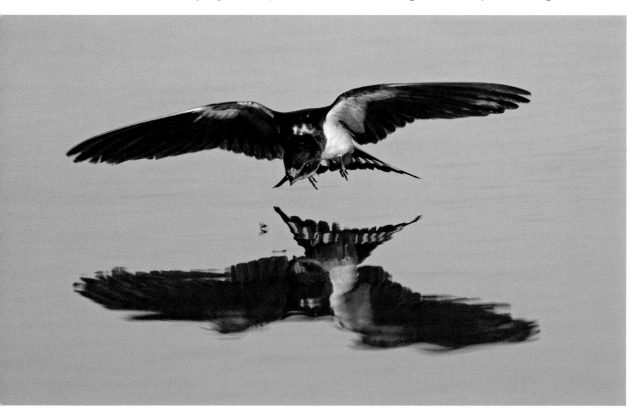

Swallows both eat and drink on the wing.

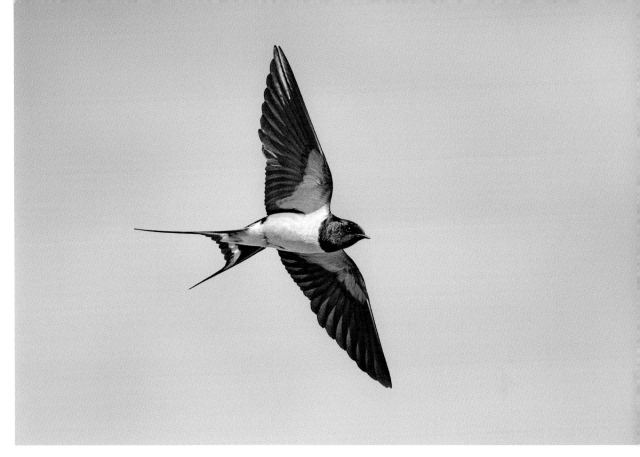

The deep V of the swallow's tail is the best way to identify it in flight.

landmarks, which incredibly allow swallows to return to the place they were born.

British swallows winter across sub-Saharan Africa, as far as the Cape – a journey of more than 10,000km (6,000 miles). They usually leave there in February or March, heading north to reach Europe a few weeks later, and arrive in the UK in late March or early April.

Swallows, Martins and Swifts

The swallow is larger than its relatives, the house and sand martins. It has a bluish head and back, russet face and throat, creamy underparts and a long, forked tail. Swallows generally fly fairly low to the ground, especially when feeding, and nest in barns or other farm buildings.

THE HOUSE MARTIN Nests under the eaves of houses and is smaller and more compact than the swallow, with dark blue upperparts, white underparts and a prominent white rump. The wings are triangular, rather than long and swept back, and the tail is short with a notch at the end.

THE SAND MARTIN The smallest of the three hirundines (martins and swallows), with brown upperparts and creamy-white underparts, and a brown band across its chest. Like the house martin, it has triangular wings and a short tail. It is usually found near water and perches on overhead wires and branches.

THE SWIFT Not related to swallows and martins, the swift is entirely sooty black, with long, narrow wings and a short tail giving a 'bow-shaped' silhouette. It breeds in the eaves and attics of old buildings, but otherwise spends its entire life airborne – feeding, sleeping and even mating on the wing.

Spring Nesting

Dominic Couzens

It's spring, and everywhere birds are building, refurbishing or planning nests quietly and furtively. There are, of course, exceptions – colonies of rooks in the treetops make an almost continual din – but on the whole birds don't want to draw attention to their nests. Nest-building is a trade-off between the necessity of making a nursery for the eggs and the need to hide from the threat of predators. So non-colonial birds bring in materials cautiously, keeping well hidden and being particularly careful if they think they are being watched (some, such as waders, may even pretend to build another nest nearby).

Thrown Together

Not surprisingly, the majority of bird species make only as much effort as is strictly necessary when building nests. You only have to look at a wood pigeon's effort to see the embodiment of this reality; pigeons and doves are the original cowboy builders, creating the flimsiest stick bases through which it is often possible to see the eggs from below.

On the other hand, too bulky a pigeon nest would be dangerously obvious. Birds are expedient. A robin can build its nest in just a couple of days. Long-tailed tits are unusual in taking up to three weeks to build theirs, using thousands of pieces of moss, lichen, cobwebs and feathers, but they begin very early in spring, well before the eggs are laid.

In most birds, the female is at least in charge of the nest and most often the sole builder. This isn't because of the male's laziness or need to take a coffee break; it is because the male is forever engaged in the vital task of protecting the territory in which the nest is placed, usually by singing. Without border protection, a breeding attempt will fail.

Nest sites require two main attributes – safety and shelter – and some are much better for this than others. A significant number of birds nest in holes in trees or rocks (among them tits, starlings, owls and flycatchers) and demand invariably outstrips supply. Great tits have been known to fight to the death over a choice tree hole.

Quest for a Nest

You might think that, as far as safety is concerned, a bird would nest as high up as possible, either on a rock face, a building or a tree. However, treetops are not very good as nest sites: they are exposed to the elements (including swaying branches) and are accessible to aerial predators (and some climbing animals).

In fact, most small birds build very low down, almost on the ground (robins, for example, often nest on a bank), where the vegetation is thickest and there are more hiding places. Water birds may simply put their nests on an island, accessible only by swimming, or on a cliff, accessible only to an agile flyer. Goldfinches are interesting for building cup nests quite high up, usually right at the end of a branch that is hard to reach for a ground predator; they also often nest on branches overhanging water.

Every bird lays eggs and a gathering of eggs incubated at much the same time is known as a clutch. Most eggs complement the general invisibility of the nest, so in open nests or on the ground they are dull coloured and often intricately patterned with speckles and spots, a pattern individual to the female concerned.

However, birds that usually lay eggs in holes and other dark places tend to have white or pale blue eggs, to help the parent or parents see them and incubate them correctly. Starlings even capitalise on their dark nest cavities to steal into a neighbour's nest and lay one or more of their own eggs, taking advantage of a foster-parent's hard work, cuckoo-style. There are, of course, exceptions to the egg colour theories. Tits, which ought to have white eggs, lay reddish ones with blotches, while dunnocks lay blue eggs despite building 'normal' cup nests.

Raising the Brood

The amount of time a parent spends incubating its clutch is surprisingly consistent among different groups of birds, with approximately two weeks being the norm for birds from tits to crows – although there are plenty of exceptions, including waterbirds and raptors. The fact is, though, that nests are definitely not homes offering long-term safety and comfort. Instead, incubating and fledging are rushed through, so as to minimise their risks. The less time spent in the nest, the better.

Although many birds incubate for about the same length of time, the precise starting point, when they actually apply body heat to their eggs, is highly significant. Most species only begin when the clutch is complete, or just before. So, if a tit lays 10 eggs, it doesn't start until the last or penultimate egg is laid. This means that all the eggs will enjoy the same period of incubation and have a roughly equal start in life. In truth it's a rough-and-tumble start, because sibling nestlings have no regard at all for each other, and a visit from a parent is a free-for-all among competing mouths (think giving out sweets at a children's party), where the weakest will struggle to get their share.

Parents spend all day flying back and forth to try to provide for their legions of offspring. A pair of blue tits may make 800 visits to their young in a day because they bulk-produce offspring, all at once. Since tits time their breeding to coincide with a glut in woodland caterpillar production, they only bring up one brood (or one clutch) a year, whereas most other small insectivorous birds (blackbirds, robins etc.) have two or more broods through the season.

Sharp in Claw

Certain other birds follow a very different strategy that, in a way, institutionalises sibling unfairness. Some birds of prey, owls, swifts and jackdaws, begin incubation with the first egg and, since each egg will have a similar development time, subsequent eggs hatch later than others. Those nestlings will need to compete with older siblings for food, often to fatal disadvantage. If food is plentiful, they will get their share, but if it isn't, this strategy at least ensures that the first-born chicks have a chance of survival. It is a sobering example of bird pragmatism.

Another similar example concerns the fledglings themselves. When you spot a young bird it often looks somewhat dishevelled, like a small child with ill-fitting clothing. In fact it is literally wearing cut-price plumage – all the energy goes into growing and the first set of feathers is poor, and quickly replaced.

In the bird world, the survival of breeding adults is paramount, while nests, eggs and young are, to be blunt, mass-produced. It is expediency, once again.

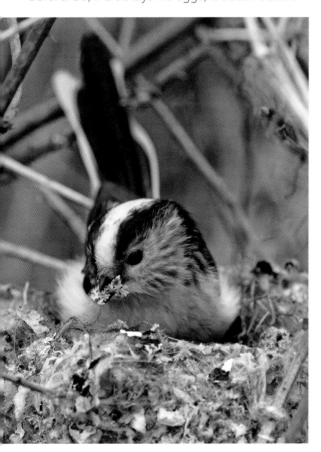

Long-tailed tits build intricate domed nests of moss, feathers, lichen and spiders' webs.

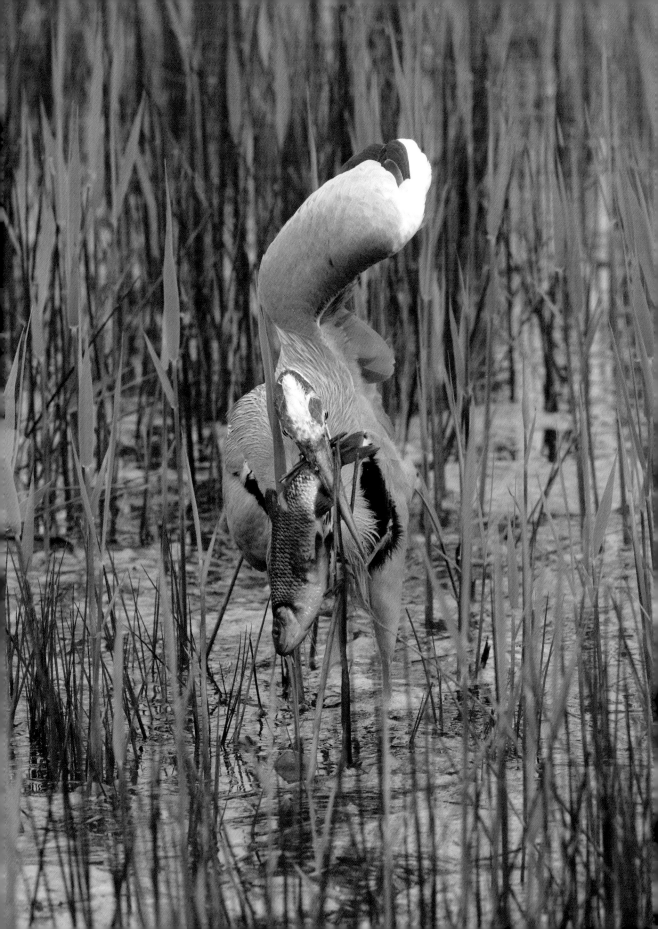

Heron

Mark Hillsdon

All tall, long-legged elegance, with a perky black and white quiff on top, the grey heron is one of our most majestic and instantly recognisable birds. Often seen lurking in the reeds beside canals, standing stock still in the shallows of our rivers, or making daring raids on our suburban ponds, there's a strange mixture of the exotic and the primeval about the heron.

At 1 metre (3 feet) tall, and with the wingspan of a golden eagle, the heron is unmistakable and perhaps that's one of the reasons why it is so popular. After the mute swan, it is our largest common bird, and you are unlikely to confuse it with anything else in flight either, with its long neck bent and feet trailing behind it. More than 14,000 nests are regularly recorded in the UK, and with 60,000 individuals living here during the winter, the heron has become a common sight along our waterways.

Heron Facts

- You may see a heron standing in a field, but they aren't hunting. They are probably digesting, because they eat very large prey items such as eels, which may be almost as long as them. If a heron has swallowed something big, it often flies off to somewhere where it can just stand and digest for a few hours. Often there will be a few herons standing around, digesting together.
- The heron has also developed an unusual way of keeping clean, with special feathers on its breast called powder down, which it crushes with its feet into granules and spreads over itself. The powder soaks up the muck and grime from its feathers, which it then scrapes off with a serrated claw. It also helps waterproof the bird, too.
- Despite being solitary hunters, herons like to breed in colonies and heronries have become a noisy attraction in the countryside, a cacophony of squawking and squabbling. Nesting begins in early February, with birds stumbling around in the treetops, either building a new nest or repairing an old one. The heron is a creature of habit, frequently mating for life and preferring to return to the same lofty heights each year.
- Sometimes herons put on a dramatic courtship display. With the plumes on their necks and crest erect, they'll twist and turn their long, slender necks, while snapping shut their bills and letting rip with their raucous calls. During the spring the female's bill also turns a rosy red.
- Although some herons may nest on the ground, the majority aim for the trees, simply to be able to rear their young away from predators. But while buzzards and ravens may predate some chicks, a heron's biggest enemy is a harsh winter. Following 1963's big freeze, heron numbers dropped by perhaps as much as a half as rivers and ponds froze over, locking herons out of their larders. Fortunately, numbers have increased annually ever since, with the odd shallow dip coinciding with a tough winter.
- The heron has a long breeding season and can still be laying eggs in May, with three to four per clutch the norm. The best time to visit heronries is in April, when there's less danger of disturbing the parents. If you go when the young are larger and you can hear them begging for food by making a loud, distinctive rattling noise using their bill and vocals, it's a special experience.

Standing perfectly still, a heron waits with endless patience before snatching an unwary fish.

The Dance of the Buzzard

Dominic Couzens

Look to the skies in April to witness the dramatic courtship displays of one of our largest birds of prey. It's not quite as symbolic as the cuckoo's song, but the mewing call of the buzzard is undoubtedly a sign of spring. On sunny days when the fair weather allows neighbours to soar in circles on the borders of their territories, male buzzards mew to each other in their distinctive, mildly hoarse, complaining accent.

Later on, the mewing is chiefly heard from courting couples in display, in sky-dancing that no lover of the countryside should miss. Look out for a bird soaring high into the air. Suddenly it will stall, close its wings and plummet towards the ground or the canopy of a wood, only to open its wings at the last moment and swoop upwards again, often to repeat the process as if it were riding a rollercoaster in the sky.

It's usually the males that do this, recklessly trying to impress their mates; the males are lighter than their partners and the aerial manoeuvres are easier for them to perform. However, from time to time the females cannot stop themselves from joining in, and then you may see an exuberant mock cat-fight in the sky.

The buzzard is our most numerous large bird of prey. This is the one you often see perched along roadsides, and sometimes it might be walking in ungainly fashion over ploughed fields in search of worms. When it takes flight it has impressively broad wings, a short tail and a blunt head – and generally looks big, maybe a bit too mighty for the gentle British countryside.

Buzzards are doing well these days, now that they are rarely persecuted, and they have begun to creep back into parts of England where they were absent for many years. This is great news for bird lovers, but not quite so welcome for animals on the buzzard's varied menu, everything from rabbits and voles to moles and frogs.

Riding the thermals on broad wings, a buzzard looks for rabbits and other prey far below.

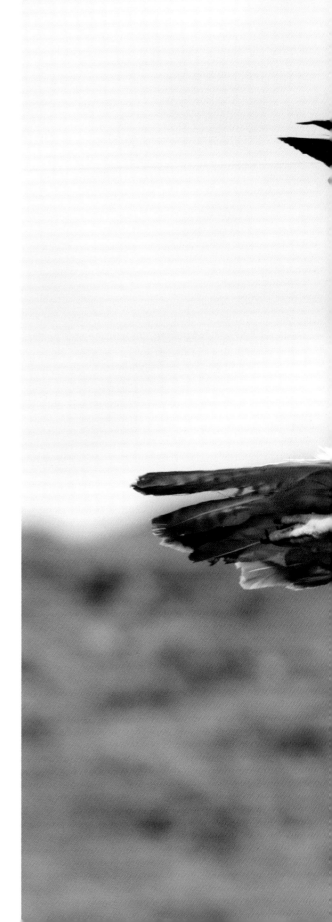

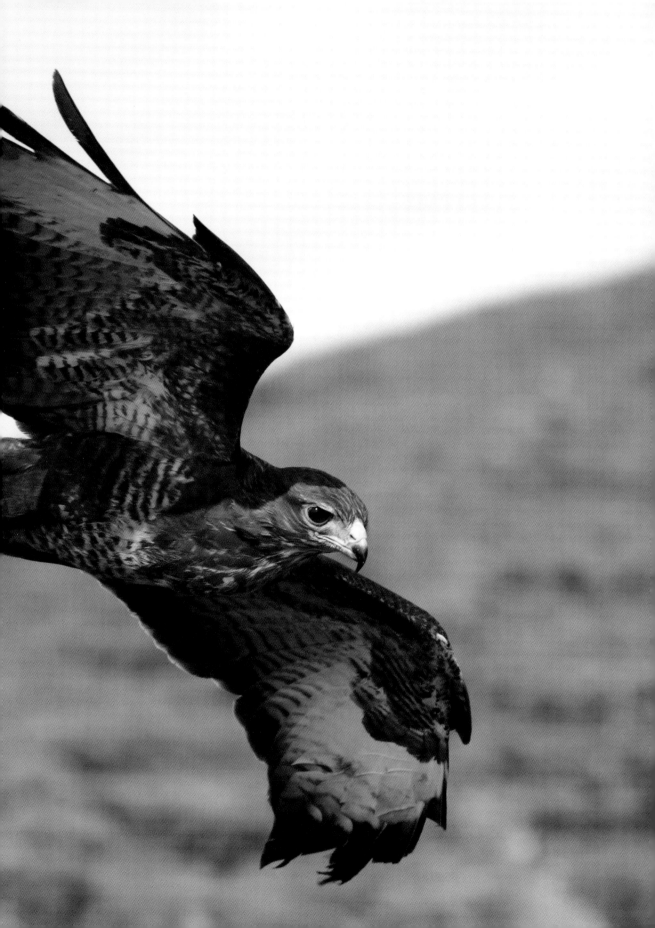

Peas

Richard Aslan

'Pea' is one of the smallest words in the English language, which isn't surprising seeing as all it's ever done is shed letters. Greek 'pison' evolved into Middle English 'pease' with a plural in 'pesen' – this form survives in 'pease pudding'. In the seventeenth century, the singular pease got confused with one of the fashionable, new-fangled plurals ending in s and voila! The humble pea was born.

But peas don't only attract grammatical confusion. Along with tomatoes, squashes and cucumbers, they're considered vegetables by chefs but fruit by botanists and have been responsible for more than a few pub quiz bust-ups. A good way to defuse any rancour is to class them as legumes, along with lentils, and then hear no more about it.

Brits love the protein-, vitamin- and mineral-rich pea. While they don't find their way into our role-call of most-grown crops (that honour goes to wheat, barley, oats and potatoes), they thrive all over the country and are an important crop in Lincolnshire and East Anglia. Around 35,000 hectares (86,000 acres) of peas are grown in the UK each year, producing about 160,000 tonnes of peas, which is roughly 2 billion portions. Peas are also an excellent way to replenish soil that has been exhausted from arable crops. Along with other legumes, peas 'fix' nitrogen in their roots and seeds. Once the crop is harvested, the roots rot and the nitrogen is released to re-fertilise the soil.

Peas have been grown in the British Isles for at least 3,000 years, but our forebears preferred their peas fully ripened and yellow. They dried them as a staple to thicken soups and stews. The fashion for less ripe, green garden peas originated in seventeenth-century France.

Garden peas must be eaten absolutely fresh – it was this that made them an indicator of luxury in the French court. Paradoxically, the drive for freshness means that we are now less likely to eat fresh peas and the frozen pea has become an institution. Fresh versus frozen is usually a clean-cut debate, but many chefs cite the pea as a rare exception. Indeed, we are Europe's largest producer of peas for freezing. The sale of frozen peas overtook fresh in 1959 – a remarkable date given that so few households had freezers at the time.

But what you don't get with frozen peas is the satisfaction of plucking them fresh from your garden or allotment, and you also miss out on a good hour in the kitchen shelling them, nattering to someone you love. So perhaps freshness isn't the be all and end all, after all.

Green Pea Dip

This light and tasty dip is a great alternative to hummus for a spring picnic. Adjust the seasoning according to taste – you can substitute the paprika for chilli powder if you want to give the dip a kick. Serve with vegetable batons or toasted flatbread. Serves four.

- 350g (12oz) fresh or frozen peas
- 2 cloves of garlic
- 2 tbsp tahini (sesame seed paste)
- Juice of a medium lemon
- Cumin, paprika, salt, black pepper
- 1 tbsp extra virgin olive oil
- Finely chopped coriander leaves

Simmer or steam the peas for 2–3 minutes, or until tender. Allow to cool, then drain and put in a food processor with the garlic, tahini, spices and lemon juice. Blend to a smooth paste. Season to taste, then drizzle with olive oil and sprinkle with finely chopped coriander leaves.

Sweet and delicious when first picked, peas are easy to grow, even on the smallest plots.

The Hidden Depths of Village Ponds

Ian Vince

Despite its obvious charms as a wildlife haven and somewhere to relax, the village pond can seem like a quaint anachronism – a little out of step with modern life. For all its current serenity, however, the village pond was once a place that would be far from quiet. In fact the pond, and its green, would be at the very centre of village life. And although the pond might look pretty today, such was the effort required in constructing it that aesthetics were probably the last thing on the minds of its medieval builders.

Like the village green, the pond is often common land – a communal facility for the use of the whole village. Historically, the village pond is likely to have provided fish, for pisciculture (the rearing of fish) was common in the Middle Ages. It would also have been used for soaking cartwheels (to prevent them from shrinking), for washing clothes and as a watering hole for cattle – either for animals grazing on the green or for itinerant drovers on the move to market or up the valley to summer pasture.

Once those cattle were safely moved up to the downs, another kind of artificial pool, the dew pond, would come into its own. Chalk, limestone and sandstone are porous and, as a result, surface water is absent from higher land, so dew ponds were needed to provide water for livestock. Sometimes known as mist or cloud ponds, these circular pools are up to 2.5m (8ft) deep at the centre and often built in a slight hollow on a hilltop. They were made between September and April by touring workers – it would take four men four weeks to make a large dew pond.

Traditionally made dew ponds are lined with puddled clay, although chalk can also

Once an important resource for local communities, the village pond is a crucial haven for wildlife today.

RIGHT: *This village pond in Herefordshire is a great crested newt breeding site.*

be puddled. If you mix chalk powder with water until it's the consistency of clotted cream, smooth it out and let it dry, it becomes completely impermeable and better suited to the task than the Portland cement used today. Once built, the pond is filled with rainwater rather than dew or mist, while its position in a slight hollow helps keep the water cool and reduces evaporation.

It's claimed that the two dew ponds of Chanctonbury Ring in Sussex date to the Neolithic period, but the oldest recorded dew pond is Oxenmere on Milk Hill in Wiltshire, which is named in a Saxon charter of 825 CE.

The Essex Coast

Jules Pretty

Beach, salting, sea wall and marshland. Fishing, farming and sailing. Birds watched and birds shot. Created communities, deserted resorts, eroded cliffs, villages under water, caravan parks and new, entirely invented places: scenes all played out on a linear stretch of land and sea, from the Thames Estuary east of London to the Wash at King's Lynn.

Essex hides some of the most evocative and wild landscapes in Britain. It's a predominantly rural, estuarine county strongly affected by proximity to London. Yet Essex is also a county with a rich rural, coastal, urban and industrial heritage.

A Dramatic Backdrop

In every part of Essex, local people say their region is distinctive because of the huge skies. When dark clouds hang over the waterscape, it turns slate grey and menacing. But when the sun comes out, the waters become like shimmering mercury. As the tide recedes across the wide mudflats, distant container ships elevate as mirages, or sink into perfect reflections. It is a special part of the country, bringing space and freedom, and creating a sense of land that is both near and far.

These liminal landscapes where land and water daily intersect are full of bird life. Here curlews burble, redshanks pipe, geese clamour and wigeon whistle. All these birds were once commonly shot and eaten, but today only wigeon and some geese remain quarry for the few wildfowlers. The creeks are the reserve of oysters – once food for the masses but now unequivocally exclusive – and the sadly rare migratory eels, swimming free since tastes have changed and they no longer command a culinary audience. On the mudflats and sea walls, sea beet and purslane grow, as does glasswort (marsh samphire) – now resurgent in fish restaurants. On reclaimed grasslands, wiry marsh sheep roam, and behind the dykes lie modern wheat and lucerne fields.

Here on the Essex coast, you can feel wild and remote just around the corner from civilisation. This is what characterises Essex – the wild is close by, near to the developed

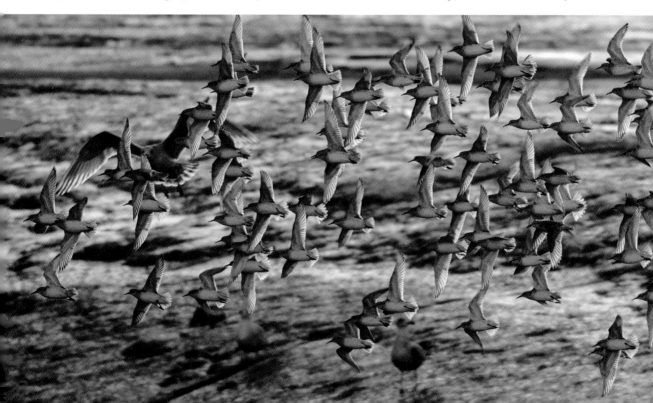

and industrialised, but far enough to allow a complete escape. You can hear the plaintive calls of hidden waders and wildfowl and all the while the water laps and gurgles as the fleets, creeks and rills fill with the returning tide. A marsh harrier quarters the saltings, the predator's dark and deadly shadow bringing temporary silence.

This is where Cnut defeated Edmund Ironside in 1016, to be declared king of all England. And where did he, known today as Canute, stand and try to hold back the sea to show he was not immortal, and that even a king could not hold back the rising tide? Perhaps at Bridgemarsh? The light falls, turning the saltings from pink to yellow, then to green. The half moon brightens and vapour trails streak across the amethyst sky. The other world goes onward the same, as Thomas Hardy wrote, and, as night falls, the cold rolls over the marshes and across the carpets of sea-blite, glasswort and sea lavender, the huge skies stretching from one era to another.

The Ague

Essex's creeks and marshes hold a deadly history: the ague was a mostly non-fatal form of malaria, and it stalked the Essex marshes from the sixteenth to the nineteenth century. A common greeting in April was to ask 'have you had your ague this spring?' But there was no need to ask again come the autumn, when malaria peaked again, because almost everyone suffered attacks. Also called marsh fever, sufferers had sallow, sickly faces and children in particular had swollen stomachs. It was the source of one great myth of Essex. Daniel Defoe, not altogether given to double-checking everything he heard, wrote that the Essex men of the marshes would commonly take anything from five to fifteen wives. They fetched them from the inland uplands, and when each died of the ague, would return for another.

The ague has been gone for more than a century, but it's not clear why. Marshmen believed that gold earrings warded off the ague, and also gave them long sight, but it's more likely to be a mix of drainage, the increased use of quinine, and the discovery of the role of the Anopheles mosquito, which all came towards the end of the 1800s.

Flocks of knot perform intricate aerial ballet over the creeks and marshes of Essex's estuaries.

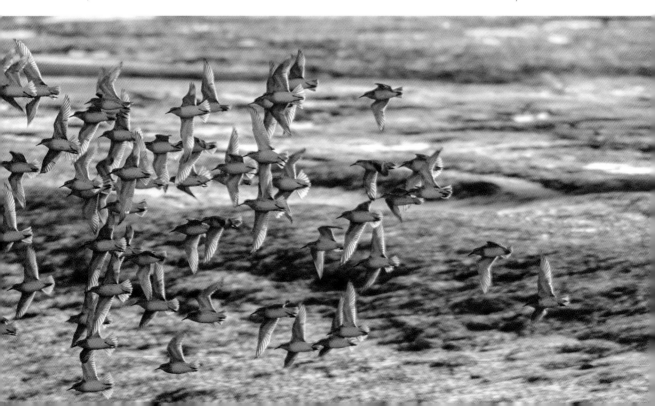

May

I love fossil hunting, and while walking on the beach at Happisburgh in Norfolk not long ago I came across a rather well-preserved ammonite perhaps a hundred million years old. But that was nothing compared to a find (not mine!) on that same beach in 2013 – of the earliest human footprints ever discovered outside of Africa.

Around fifty of them were made by two adults and perhaps three children, who were skipping alongside – just the kind of prints a modern family might leave at the seaside, except these dated back 900,000 years. The tides had revealed them and researchers carefully took 3-D images before the sea reclaimed this unique record of a family outing, by a species known as *Homo antecessor*.

This month we feature the UK's best-known hunting ground for fossils, the Jurassic Coast of east Devon and Dorset. Back in the nineteenth century Mary Anning started it all with her amazing discoveries including the first skeleton of an ichthyosaur, a large marine reptile, when she was 12 years old. Today new finds just keep on coming.

Who knows what sounds dinosaurs might have made, but if we take a country stroll in Maytime we can hear the spring chorus all around – the buzz of the bumblebee, the call of the cuckoo, the glorious song of the nightingale and (if we are lucky, because they are so rare) the distinctive boom of the bittern. It's a magical time so let's find out more about these creatures with major roles in nature's choir.

The New Forest would be a good place to listen – indeed, in some places the sound can be quite deafening. For more than a thousand years the forest's ponies have wandered the woods and open spaces, disdainful of developments in human life such as cars and tourists. It's as if William the Conqueror set up this protected forest just for them. Now all wildlife there benefits because since 2005 the New Forest has been a national park.

Lambs enjoying a spring walk in the Yorkshire Dales National Park.

Woodlands

Dominic Couzens

It's not often that fairies are featured in *Countryfile*. It's probably because they are so difficult to see – some people even deny their existence. But never mind, they are useful in introducing the subject of reading the wooded landscape.

You must have seen pictures of these ephemeral creatures dancing around toadstools that have a red cap and white markings. Those toadstools are known as fly agarics and they are found only in specific woods. Birch is their prime habitat. And so it is fair to conclude that, should you ever wish to catch a glimpse of a fairy, a birch wood is the place to start.

Joking apart, many British animals do have a strong association with particular types of tree – and even woods with a certain tree structure – and a little knowledge can be an invaluable tool for finding them whenever you are walking in the countryside. Have you ever seen a purple hairstreak butterfly, for example? If not, go to an oak wood in July and watch the treetops. Have you ever seen the hawfinch, a shy bird with a bill that could crack human bone? Then you must seek out a stand of hornbeam during winter. In these cases, reading the woods will help you home in on some exciting wildlife.

Conifers Versus Broad-leaved Trees

Conifer needles are a prickly problem for many birds. They grow in dense clusters, meaning that it is hard to reach in between them, at least for insects. The two most characteristic birds of conifers are the coal tit and the goldcrest, which rarely breed elsewhere. Both are tiny and have narrow bills, which help them to squeeze between needles. Both are light-bodied and acrobatic, and can even hover if necessary to reach the thin end of twigs.

In their favour, conifers produce very large numbers of small seeds, and some birds specialise on these. Look out particularly for

the crossbill and siskin. Conifers are also the area of refuge for red squirrels in Britain. The effort of working on many small seeds is too much for the grey, which is at heart a deciduous forest animal, and whose favourite food is acorns.

Another advantage of conifer woods is that they have dense, protective foliage, which is especially useful in winter. The much-maligned cypress is a favourite roosting site for small birds, for example.

Most wildlife watchers know that a day in a deciduous wood is almost always more productive than an evergreen counterpart. Normally, deciduous woods are multi-layered, with vegetation from the canopy down to near the ground, providing a range of habitats. In deciduous woodland, there is usually an understorey of shrubs, and often a layer of flowers or grass on the ground (the field layer), rich in wildlife. In a deciduous wood, most bird nests are on or close to the ground, while in conifers they are near the canopy. Birds almost confined to broad-leaved woods include the lesser spotted woodpecker, nuthatch and marsh tit.

Close Relationships

Although the distinctions between conifers and broad-leaved trees are useful, you can predict with much more accuracy what a single wood might offer. For example, the marsh tit (unfortunate name: it doesn't live in marshes) is commonest in broad-leaved woods that have a holly understorey. And if a wood is to host hazel dormice, it will need an understorey of hazel, as you may expect, but the rodents will also need honeysuckle in order to line their nests.

Certain species of trees attract their own wildlife. Some of these associations are hard and fast, especially among insects: the

A red squirrel finds a comfy perch on a bracket fungus commonly called 'chicken-of-the-woods'.

white-letter hairstreak butterfly relies on elm and the black hairstreak on blackthorn.

Others are less biologically imperative, but still useful in the field. If you've never seen a redpoll, for example, find a birch wood, and sooner or later you will see one of these rouged-up finches. Bramblings, winter-visiting relatives of chaffinches, are usually found in beech woods. In winter, stands of alder trees will often be alive with small yellow finches called siskins, as well as goldfinches and blue tits. In the breeding season, blue tits switch their allegiance to oak, where they mix with other oak lovers, such as jays, grey squirrels and badgers.

In the oak woods of Wales and northern England, pied flycatchers, wood warblers and redstarts live in profusion. Bullfinches have a predilection for ash, while the rare firecrest usually nests among spruces (but also sometimes holly). In Scotland, native Scots pine forests hold crested tits and capercaillies, and the latter are among the few birds that eat conifer needles, which are unpalatable to most animals.

The Structure of the Wood

It isn't just the types of trees that attract certain wildlife, but it is also the physical structure of the wood. For example, one of the reasons why conifer stands harbour less variety than deciduous woods is that they have all their vegetation in the canopy, with the thick needles shading the ground and preventing plant growth, so there is little understorey. Another

Known in Gaelic as the 'horse of the woods', the capercaillie is a turkey-sized grouse.

reason is that conifer woods tend to contain just a handful of tree species, whereas a good deciduous wood offers different species with different physical characteristics. Thus, in the same wood you may get oaks, with their fissured bark, next to beeches with their smooth trunks.

Sometimes the physical characteristics have obvious advantages or disadvantages for particular species. For example, a spotted flycatcher needs an open canopy so that it can fly around catching insects on the wing; the same applies to a brown long-eared bat at night. The wood warbler also needs an open canopy to allow it to perform a song flight above ground, but below the treetops.

By contrast, nightingales aren't fussy about the canopy, but care deeply about a thick, dark understorey. These songsters prefer to forage on almost bare ground in deep shade under bushes. So for them, the heights of the trees are important.

Roe deer have similar preferences for thick, ground-level vegetation, mainly because of their need for concealment. They like low cover, so they are often found in young plantations (including conifers).

It is easy to tell when deer (or other grazers, such as domestic livestock) are present, simply by a feature known as the 'browse line'. This is the height to which grazing animals can reach fresh leaves on trees, and it is usually at about a person's head height. Above the browse line leaves are untouched; when grazing pressure is intense, almost all the vegetation has been nibbled away.

By contrast, other creatures have a genuine need for tall trees. For example, in the summer, male purple emperor butterflies gather at the tallest tree in a wood to display to females. Lesser spotted woodpeckers and blue tits also prefer to feed in the high canopy, on the thinnest outer branches.

The amount of dead wood among the live trees is another important feature. Stag beetles have to have dead wood below ground in order for their larvae to survive. Woodpeckers also

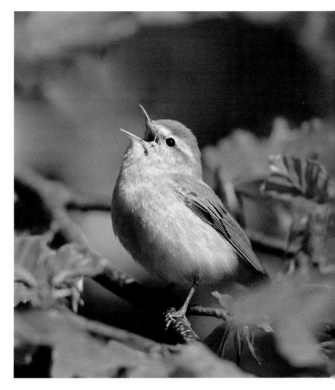

The wood warbler pours all of its energy into a pulsating cascade of notes that seem to drip from the trees.

prefer to make their nest holes in dead trees, and in the winter the two smaller species – great and lesser spotted woodpeckers – spend a lot of time hunting on dead branches. A common woodland warbler, the chiffchaff, also likes to perch on dead (or leafless) branches in order to sing.

Finally, a note about one basic rule of woodland wildlife watching. If you want to see a good variety of wildlife on your walk, make sure you stick to the edges of a woodland, or walk along rides. You might think that the forest interior will hold more promise and excitement, but the truth is that the juxtaposition of two habitats will always be better. It's called the 'edge effect'.

So, stay around the edges and you'll always see more. Though, of course, you might miss the fairies.

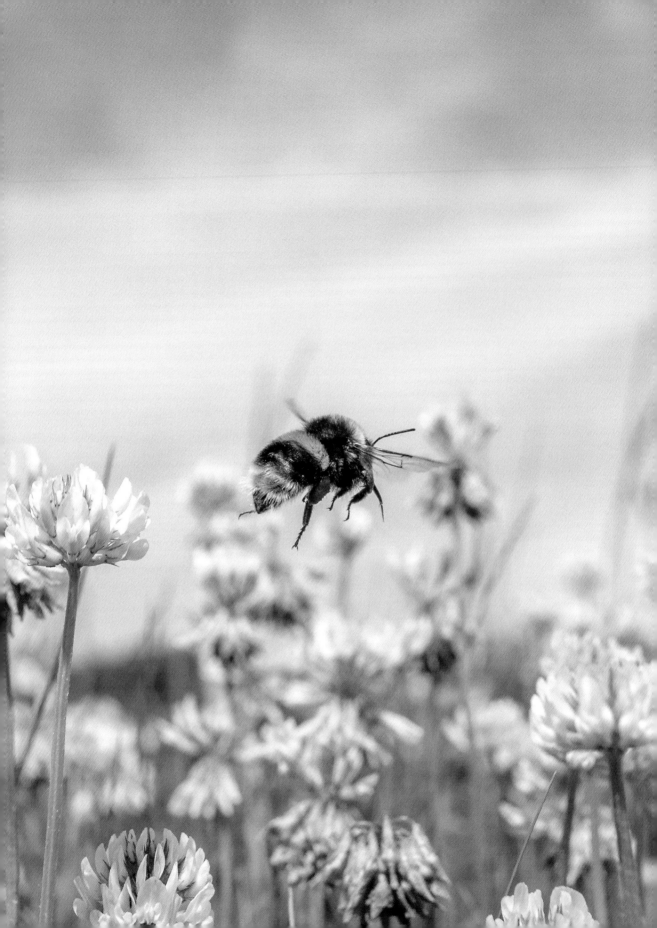

Bumblebees

Richard Jones

A bumblebee buzzing madly in the grass is not ill or dying – it is shivering. By chemically uncoupling its wings from its strong thoracic flight muscles, it can rapidly vibrate them, generating body heat. It needs to reach a critical temperature before it can fly properly. This ability, combined with a furry coat, enables bumblebees to forage earlier in the year and earlier in the day (also further north and higher up mountains, incidentally) than many other insects.

Only mated queens (fertile females) survive the winter, hibernating under a log, beneath loose bark or in dry leaf litter under a hedge, and each must make a new nest on its own during spring. Some use old mouse nests, ready supplied with a thatch of twisted grass stems and a lining of fluff; others find a suitable nook under a large grass tussock, or an overhung cranny in a steep, sunny bank.

Feeding a paste or 'cake' of pollen and nectar to the first batch of grubs should, by May, have started to produce the first generation of adult workers (infertile females) to help the queen extend and expand the nest. Only during late summer will the queen switch from laying worker eggs to laying those that give rise to the short-lived males and new queens that will, hopefully, survive into the next year.

British Bumblebee Species

BUFF-TAILED BUMBLEBEE *Bombus terrestris*
One of our largest species, up to 40mm (1½in) long and appearing huge, like a flying mouse, on the wing. The yellow collar and waist bands tend to mustard rather than primrose. The smaller workers, appearing cleaner tailed, are active now, too.

RED-TAILED BUMBLEBEE *Bombus lapidarius*
The red-tailed bumblebee is as huge as the buff-tailed and perhaps even more striking because of its stark velvet fur and bright tail. Workers are half the size of the queen. The intermediate male has a broad yellow collar band across the front of its thorax.

RED-TAILED CUCKOO BUMBLEBEE
Bombus rupestris
This bee has distinctive dark wings. It makes no nest of its own, but invades that of the red-tailed, and lays its eggs there for the resident workers to rear unknowingly. It often kills the host queen and has no worker caste of its own.

COMMON CARDER BUMBLEBEE
Bombus pascuorum
A medium-sized, variably orange-brown bee, the thorax of the common carder sometimes appears foxy red or yellowish buff. The shining black abdomen can be seen through the often scruffy bands of orange hairs.

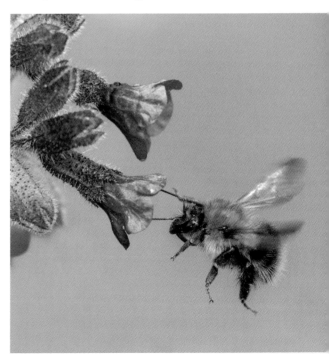

Bees such as this common carder bumblebee depend on early-flowering plants such as lungwort.

Buff-tailed bumblebees and other insects thrive where clover and other wildflowers bloom.

The Cuckoo

Nick Davies

'Summer is a-coming in, loudly sing cuckoo!' proclaims the oldest English song. For thousands of years, the loud, ringing 'cuck-oo' call of the male common cuckoo has heralded the arrival of our spring.

This 'wandering voice' is the source of many myths. To hear your first cuckoo before breakfast was just unlucky, but if you were still in bed it was a sure sign of impending illness (incentive to rise early). However, good fortune would come if you heard one while out walking, and a child born on the day of the first cuckoo in spring would be lucky for all its life.

The Interloper

The cuckoo's breeding behaviour is one of the wonders of the natural world. The cuckoo never raises its own offspring. Instead, it lays its eggs in the nests of other birds; just one egg in each host nest. Soon after the cuckoo chick hatches, it balances each of the host's eggs on its back, one by one, and heaves them out of the nest. Any host chicks will get thrown out too. Once the cuckoo chick has claimed the nest to itself, the host parents are then tricked into raising a young cuckoo instead of a brood of their own.

The sight of a little warbler or pipit feeding an enormous cuckoo fledgling, six times the size of the foster parent, has astonished human observers for centuries. How does the cuckoo get away with such outrageous behaviour? In fact, cuckoos need extraordinary trickery to get past host defences, for the hosts are on the lookout for cuckoo eggs, and if they detect one, they puncture it and eject it from the nest.

Two favourite hosts in Britain are reed warblers in marshland and meadow pipits in moorland. Individual female cuckoos specialise on one host species and there are genetically distinct cuckoo races. Reed-warbler-specialist cuckoos lay a greenish spotted egg, just like those of reed warblers, while meadow-pipit-specialist cuckoos lay a brownish spotted egg, just like those of meadow pipits. Both these

hosts reject eggs unlike their own, so the specialised cuckoo-egg mimicry is essential to fool them.

The female cuckoo also needs secrecy to succeed, because if the hosts see her at their nest they are alerted to inspect their clutch more closely. She glides down to the host nest from a hidden lookout perch, removes a host egg, lays her own in its place, and is off – all within a 10-second visit. As she departs, she often gives a chuckle call, as if in triumph. This is perhaps the most remarkable trick of all. The chuckle is similar to the rapid call notes of a sparrowhawk, and it diverts the hosts' attention away from noticing changes in their clutch and towards their own safety instead. So the female cuckoo has the last laugh as she flies away.

When the seasons change, the cuckoos set off on an epic journey to the rainforests of the Congo, where they will spend the winter. The young cuckoos will follow the parents they never met a few weeks later and all alone, guided on their incredible journey by the night skies and the Earth's magnetic field. Let's hope some will make it safely back to our shores one day, as heralds of a new spring.

Where to See Cuckoos in Britain

With long, pointed wings, a long tail and barring underneath, the common cuckoo looks rather like a bird of prey. Only male cuckoos call 'cuck-oo'. The bill is opened for the 'cuck' and closed to form a sound chamber for the 'oo'.

Good places to look out for them are: the wonderful RSPB reserve Lakenheath Fen in Suffolk, the New Forest, Dartmoor, Cannock Chase in Staffordshire, the North York Moors, Brecon Beacons (Bannau Brycheiniog), central Wales around Tregaron, and throughout the western Highlands of Scotland, the Isle of Skye and the Hebrides.

The male cuckoo calls his distinctive two-note song from a prominent perch to attract a female.

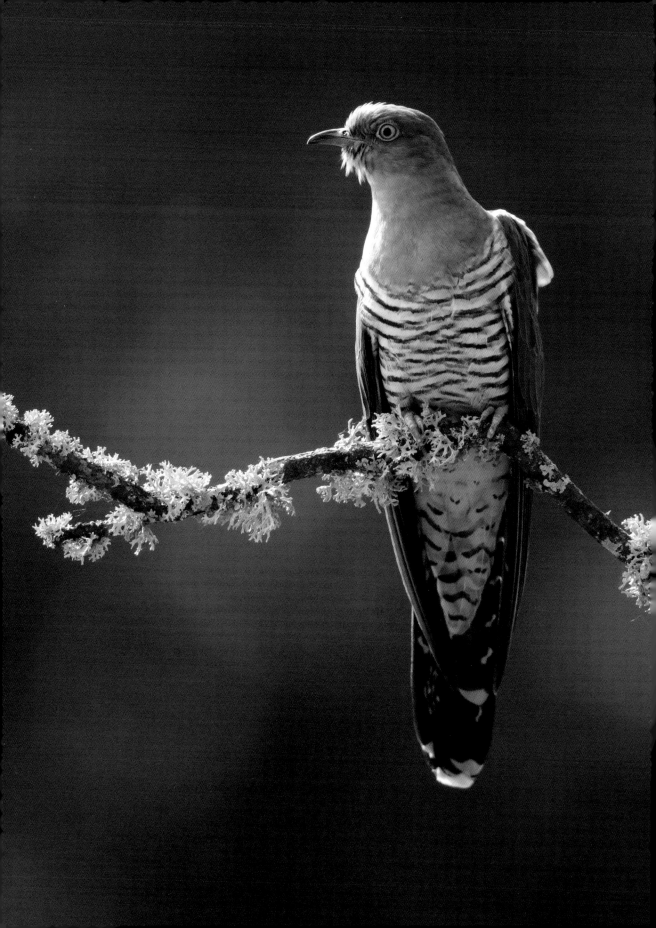

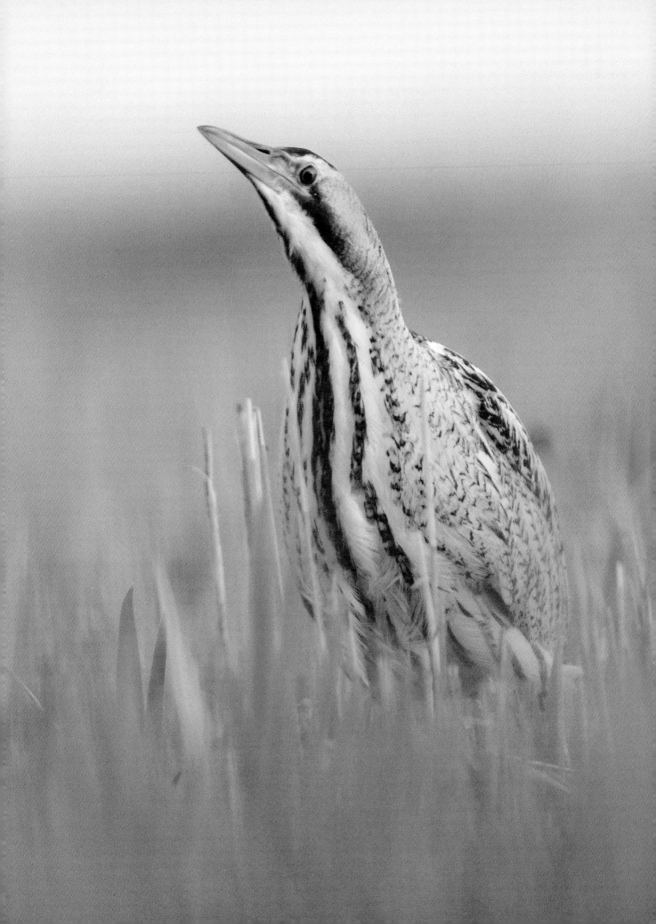

Bitterns

Mark Hillsdon

Elusive and secretive, the bittern is a stocky bird, with a cryptic plumage of mottled browns, greys and black. It is a master of disguise, blending in perfectly with the sedges and rushes, even swaying in time with reeds to avoid detection.

It's a bird bound up in folklore, its sonorous boom once seen as a harbinger of doom. It comes with a wonderful array of colloquial names, including bumbagus and butterbump, and makes a cameo appearance in Raymond Briggs' *Fungus the Bogeyman*, where the bogey bittern is described as a solitary and skulking bird, at home in the damp and wet.

Bitterns were once widespread across lowland Britain, from the marshes of Kent to the bogs of the Scottish Borders. They were eaten, too, with more than 200 served up at a medieval banquet held by the Archbishop of York in 1465. By the 1880s, this persecution, along with the steady decline in their habitat – as reedbeds were drained and turned over to farming – saw them declared extinct. In 1911, a lone bittern was spotted at Hickling Broad in the Fens, and by the 1950s around 80 boomers were recorded in Britain, a revival often put down to the flooding of low-lying coastal areas during the war as a deterrent to German invasion. But slowly numbers dwindled again, as Britain's reedbeds dried out.

By 1997, organisations such as the RSPB realised they needed to act, restoring old reedbeds but also creating new ones, often by reclaiming abandoned industrial sites such as St Aidan's, and the peat workings of the Somerset Levels. Making these new reedbeds attractive to bitterns called for careful design and management, and importantly, they also needed to be part of a wider wetland system that provided alternative places for the bitterns to forage for food.

The otherworldly booming call of the bittern echoes over marshes and reedbeds this month.

Given the right conditions, bitterns have shown remarkable powers of recovery. They can breed in their first year, the males are polygynous and take more than one mate each spring, while the females can produce two broods. The results have been amazing, with the latest figures showing at least 228 males are now active at 82 different sites across the British Isles, although seeing these elusive birds remains a true ornithological test. Perhaps the best chance of seeing a bittern is in flight, around May and June when the female leaves the nest to feed, skimming low over the reeds.

The famous call of the bittern, which the males use to establish territories and attract females, is created by an extraordinary build-up of muscle in the oesophagus, which can account for as much as a fifth of their bodyweight. It creates an echo chamber that can propel the sound up to 5km (3 miles).

While most British breeding birds are resident, wintering birds from Scandinavia and the Baltic countries migrate here, too. Watching these birds prepare to fly back is a treat, as the the group begins circling the reeds at dusk, making gull-like round-up calls. Then, if the conditions are suitable, they'll just spiral up and head off north.

Sounds of the Dawn

On the Avalon Marshes in Somerset, the RSPB's landscape management has proved successful for bitterns and their relatives. The Somerset Levels are now home to more boomers than anywhere else in Britain, while the night heron, great white egret and cattle egret have all nested here for the first time.

This special landscape is made even more magical by the return of the bittern, and its powerful echoing call.

Nightingales

Dominic Couzens

It is now spring, the buds have burst and, in a few blessed places in England, nightingales are singing. But if you want to hear them, you have to be quick. They arrive around the second week of April and by the end of May will have largely fallen silent, not to be heard again until next year. Most will be gone by the end of August, migrating back to Africa. Yet, while the bird hastens south, it leaves behind a lasting impression.

But what is it about the nightingale's song that's so captivating? Firstly, it's not just the song; it's the experience. The nightingale's song is at its best when the world around it is at its best: the flowers, the brilliant leaves, the frolicking animals. The beginning of May is the only time in the year when the bird sings all day long. The dawn chorus can be deafening at its peak, but the soundtrack never stops.

Contrary to popular belief, males do sing during the day. It's said to be the time when males communicate only to males; a time when individuals declare and defend their territories, using song to keep rivals at bay. But the nightingales have to fight to be heard, because all the other species of bird are doing the same.

Something marvellous happens in the evening, though. After an exhausting day of vocalising, one by one the other birds stop. Warblers finish singing while it's still light; blackbirds, song thrushes and robins continue until it's almost dark. Eventually, though, the coppiced woodlands and tall scrubs where nightingales live fall silent. As with any theatrical performance, a hush descends as the lights go down. The stage is set…

The Evening Performance

Nightingale songs start as they mean to go on: strong and confident. Their voices are loud – firm, shrill and, due to the darkness, disembodied, adding drama to the experience. The song is a series of long trills and glorious melodies punctuated with pregnant pauses.

A male may have 600 elements in his vocal repertoire, which he rearranges to give each song a unique flavour. One of the loveliest parts is when the bird preludes a phrase with a series of clear, upslurred whistles, progressing towards a crescendo with something that sounds almost like sobbing. When you hear this, you almost have to laugh at the wonder of it all.

The nightingale's song is unlike any other bird's in the way that it's breathlessly soft in some parts, and loud and strident in others. It's clear and sweet one moment, then a mechanical rattle the next. The monologue is original and unexpected.

It's said that female nightingales – which, like many small birds, migrate after the males and fly by night – are drawn down from their nocturnal journeys by the males' song. Early ornithologists mistakenly assumed it was the other way around and that it was the females calling up to attract the attentions of the males flying by. Thus, the bird's name, which comes from the Anglo-Saxon for 'night songstress', refers to the females.

No birdsong, however glorious to our ears, ever escapes the blood-and-guts reality of male competition. Only the males sing; they sing to compete – for territory and for sex. The finest singers with the biggest repertoires do best and they're usually the oldest birds – the veterans. The best singers get to pair up with a mate quickly and occasionally acquire more than one. And then, so quickly, their song finishes. The notes fade once they're no longer needed, and nightingales settle down to concentrate on a normal family life, with eggs and chicks and mess and hard work. If the males were to go on singing, they'd make terrible fathers.

Perhaps that's it – the song is like the sweet early stages of romance, sweeter for being so brief but all the more unforgettable for it.

The increasingly rare nightingale sings for just a few short weeks in late April and early May. But what a song!

Broad Beans

Clare Hargreaves

The broad bean, with its luxurious fur-lined pod, has the delicious distinction of being the only bean that's native to Europe. Inhabitants of our island have probably been chomping it ever since the Bronze Age.

At this time of year, the succulent young beans are excellent cooked in their casings. As the season progresses, beans are lovely in a salad with a crumbly white cheese, or married with chunks of bacon and some chopped dill. Another great way to enjoy broad beans is as a sort of houmous – the colour is eye-catching and the taste is nice. Just fry up some onion and garlic, throw in some cooked broad beans, some olive oil and a dash of lemon juice and then purée. Towards the end of the season, when the beans are getting on, you can remove the shell, which prevents them from tasting tough and bitter.

Oddly, our ancestors viewed these glorious green jewels with suspicion, if not with outright hostility. The ancient Egyptians regarded broad beans as unclean, while followers of Greek philosopher Pythagoras were forbidden to eat broad beans or even walk through a bean field. Pythagoras believed the souls of the dead had migrated into beans, possibly because of their windy effects on the body – the ancient Greek word *pneuma* means both spirit and wind or breath. Perhaps for this reason, the Romans ate beans at funerals. The bean's image took a turn for the better in medieval times when it became one of the most important crops, partly because it could be dried so successfully. Bean stealing was punishable by death.

To enjoy broad beans at their succulent best, grow them yourself. Easy to germinate, broad beans normally come in two types: the Windsor, with three or four seeds inside a short pod; and the Longpod, containing eight or more seeds. Another bonus of growing your own beans is that you can enjoy the leafy tops that you pinch out in late spring to prevent blackfly. They're great in salads.

What's Good with Broad Beans

PORK Any will do, especially in the form of bacon, pancetta or Parma ham. Black pudding can work, too.

MINT Try making a sauté of beans, spring onions, mint and olive oil.

DILL Mix with beans and olive oil in a salad, or add to a houmous-style purée.

SALTY OR CREAMY CHEESES Use ricotta, goats' or sheep's cheese.

GLOBE ARTICHOKES Such as in the Greek stew *anginares me koukia*. Broad beans and their pods are simmered with chopped artichokes, olive oil, lemon juice and dill.

SUMMER SAVORY Known as the 'bean herb', peppery savory is delicious with broad beans. Growers often plant the herb alongside the bean to attract blackfly, thus keeping it away from their crop. Mix fresh broad beans with melted butter, add finely chopped savory leaves, then an egg yolk and a spoonful of crème fraiche.

RICE You will find this coupling all around the Mediterranean. In Italy, for instance, broad bean risotto or pilaff is a springtime delicacy.

Open up the leathery pod of broad beans and you'll find the beans nestling on a downy bed of soft silk-like fibres.

Curious Villages

Roly Smith

Rose-framed cottages and the ancient church tower cluster protectively around the oak-shaded green. Here, in summer, the crack of willow on leather indicates that cricketers are conducting their weekly ritual, to the utter bemusement of foreign visitors. There's nothing more English than the village.

But how, and why, did villages first appear in our landscape, and what made people want to congregate in these small, tightly knit communities, which in many instances have stood for over 1,000 years?

According to pioneering landscape historian, Professor WG Hoskins, England became a land of villages during the 20 generations that made up the Anglo-Saxon period, between about 450CE and 1066. Most of our villages date back to that time, and their names reflect this.

Wherever you see the suffix 'ham', for example, it was originally a Saxon homestead, and if that's prefixed by an 'ing', such as Franglingham, that means it was the 'ham' of a family or group of people, or the dwellers at a specific place, whose names are usually preserved in the first element of the placename, ie 'fram'. A 'tun' or ton meant a farmstead, and the many 'worths' indicated an enclosure; a 'burh' or borough, a stronghold, and a 'cot' or cote, a cottage. Incidentally, Piddletrenthide means village on the river Piddle that is worth 30 hides (medieval land units).

Scandinavian Influence

The Danish, or Viking, influence, found mainly in the north and east of England, is often indicated in village names by the Old Scandinavian suffix 'by', which also means a farmstead; 'thorp', which means one outside the main settlement, or 'thwaite', which means a clearing.

Europe's oldest village, Skara Brae in Orkney was only uncovered after the great storm of 1850 blew away the sand covering it.

Before the Saxon period, prehistoric and Celtic villages were smaller and much more isolated, such as those still found in the hill country of the north and west. We'd probably call them hamlets today. Apart from the obvious fact of their size, the main difference between a village and a hamlet is usually the presence of a church.

The typical Saxon village came about as a grouping of families in the centre of the parish, or around a key natural feature, such as a village pond. Villagers later had shares in the great open fields that had been won from the surrounding wildwood by their ancestors. Strips of land were allocated to each 'villein' (free villager) on a three-field rotation system where, every year, one field is sown with winter wheat; the second, a spring-sown crop, such as barley, and the third is left fallow to recover its nutrients. This ancient system is still employed at places such as Laxton in Nottinghamshire and Braunton in North Devon.

But that chocolate-box picture of a typical village we started with is far from reality in many British villages, which often tell entirely different stories. In some cases, they speak of our ancient past, in others, they reflect more recent aspects of the social and economic history of our ever-fascinating countryside.

The Green Man

Jo Tinsley

The Green Man is one of Britain's biggest secrets. His familiar, eerie face, shrouded in leaves, is cut into gargoyles, depicted in stained glass and carved into church pews across the country. He is honoured in pub names, music festivals and real ale, while his more mischievous counterpart, Jack in the Green, still parades through villages on May Day. Yet strangely for such a prolific image, his origins remain a mystery.

The figure takes three main forms: the foliate head, a benign male face that peers from behind a mask of green leaves; the disgorging head, which spews vegetation from its mouth; and the grotesque bloodsucker head, which sprouts greenery from every facial orifice.

You couldn't get a more Pagan idea – fertile and ever-growing, he's a symbol of man's union with nature and of the cycle of death and rebirth. So why does this pre-Christian image appear in churches across the country?

The answer perhaps lies in the way early Christian missionaries would adapt Pagan gods and practices, rather than try to eradicate them. Some of the church carvings date as far back as the eleventh century, but it's likely the roots of the Green Man stretch back even further. It's possible his origin was shrouded in mystery even at the time when he was assimilated into Christian imagery.

Once absorbed in our culture, the myth evolved and, just like the vines that spew from his mouth, reincarnations of the Green Man began to spread throughout Britain's history. Folklorist Lady Raglan was the first to name the Green Man in 1939, but his literary appearances can be traced back centuries. Some argue that he has his roots in Woodwose, the wild man of the forest in medieval tales, and that the myth ties in with Puck from Shakespeare's *A Midsummer Night's Dream* and the mysterious warrior in the fourteenth-century poem 'Sir Gawain and the Green Knight'.

A Man of the People

In the poem, a mysterious warrior attired completely in green challenges a knight to a duel. The Green Knight offers anyone the chance to strike him with his axe if, in one year and a day, he can return the blow. Sir Gawain accepts and lops off his head, only to look on in horror when the Green Knight retrieves his head and sets a date for their next meeting.

Then there's Puck, or Robin Goodfellow, a half-tamed woodland sprite, who appears in *A Midsummer Night's Dream.* He has a habit of leading folk astray in the woods using echoes and lights, as well as swapping babies for elflings. More tenuously, some say Peter Pan – the boy from Neverland – is a modern-day embodiment. Even jolly Saint Nick was once depicted in a green fur-lined coat, wreathed in holly or ivy – could Father Christmas really be the Green Man?

Many believe Robin Hood is born of the same myth. Long before he became a charitable outlaw who scuffled with the Sheriff of Nottingham, Robin Hood was the Lord of Misrule. Along with his Maid Marian, he formed part of the May Games in late-medieval May Day celebrations, which included wrestling, maypole dancing and sleeping in the greenwood.

The figure still springs up on May Day. Sometimes he appears as the Green Man himself – in the Shropshire town of Clun, May Day culminates in a skirmish on the town's ancient bridge between the Green Man, the bringer of spring, and the Frost Queen.

Other times he appears as Jack in the Green, a vaguely sinister figure that looks a little like a walking tree. Mischievous and rowdy, he cavorts drunkenly through the crowd, alongside the Lord and Lady of May. This boozy manifestation might explain why the Green Man is one of the most common pub names in the country.

The Green Man festival is a highlight at Clun in Shropshire on May Day.

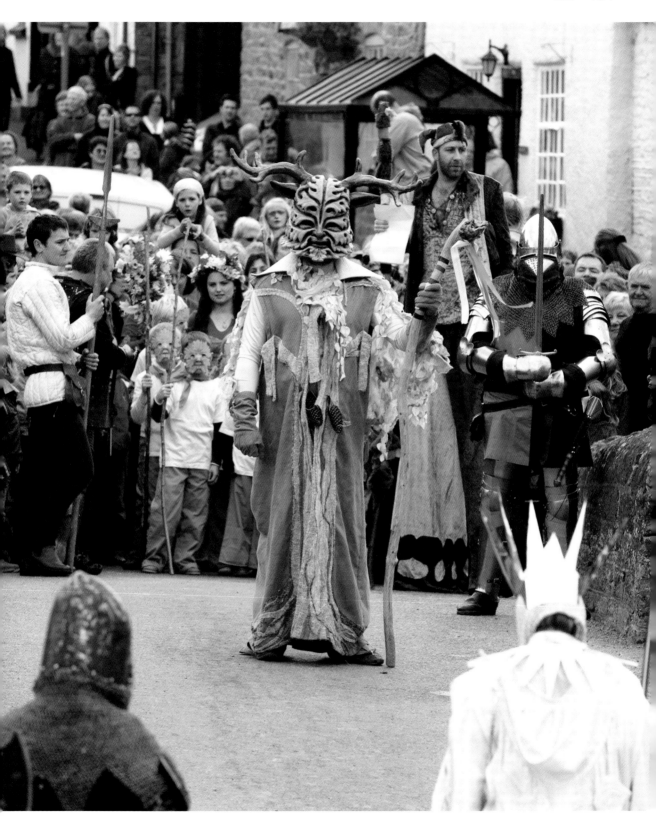

Jurassic Coast

Hermione Cockburn

The coastline of east Devon and Dorset offers something unique: in just 154km (96 miles) of colourful and varied rocky cliffs, you can time-travel through hundreds of millions of years of Earth's history. The rocks give us an unrivalled insight to an exciting time in the life of our planet and you don't have to be a trained scientist to appreciate it. With a little help, anyone can decipher the evidence and look back to lost worlds filled with exotic creatures.

It is a fossil-hunter's paradise, a delight for wildlife enthusiasts, and a geomorphologist's wonderland of outstanding scenery where you can see coastal features evolving. Add to this pretty villages, industrial heritage, charming hotels and award-winning pubs and you could say the Jurassic Coast has it all.

Age of Reptiles

So exceptional is the geology of the area that the Jurassic Coast was designated a natural World Heritage Site in 2001. In fact, the rocks don't just date from the Jurassic period but span the older Triassic and younger Cretaceous geological periods, too: so really it should be called the Mesozoic coast, after the era that comprises all three.

A trip from Orcombe Point in the west to Old Harry Rocks in the east is a continuous geological journey into the Mesozoic era, from 250 to 65 million years ago. Also known as the 'Age of Reptiles', it was during this time that dinosaurs evolved to rule the world, only to face extinction by the end. Fossil dinosaur bones are rare, but you can still see their unmistakable footprints preserved in rocks at many places including Durlston Bay and Worbarrow Bay.

A great place to start exploring is Budleigh Salterton, a small town close to the western end of the World Heritage Site. The beach is backed by dramatic cliffs of 250-million-year-old Triassic rocks, the oldest anywhere along the Jurassic Coast. Their deep red colour comes from iron oxide minerals that are only preserved in dry conditions. This clue tells us that back in the Triassic period, Devon was part of a hot desert, a bit akin to the Namib in southern Africa today.

As you travel east, the rocks become progressively younger. Originally laid down as sediments on top of each other, massive earth movements have tilted the ancient layers eastwards. Weathering and coastal erosion have created the landscape we see today, with the oldest Triassic exposures lying in the west, Jurassic-aged rocks generally forming a middle section and Cretaceous rocks to be seen in the east – hence the feeling of travelling through time.

Ichthyosaur Park

One of the joys of the Jurassic Coast is an afternoon spent fossil-hunting at Charmouth or Lyme Regis. It was here, in the early nineteenth century, that fossil hunter and palaeontologist Mary Anning made her exceptional discoveries, including the first ichthyosaur known to science. Anning's specimen of this marine reptile was 5.2m (17ft) long.

The rocks are formed from mud and clay deposited in warm Jurassic seas, and within them are the fossilised remains of ancient sea creatures. The rocks are soft and the unstable cliffs ensure a constant supply of new material onto the beach – so despite hundreds of visitors, the supply of fossils is never exhausted. With a little patience, it won't take you long to spot the beautiful swirl of an ammonite shell in among the pebbles and experience the thrill of connecting with a creature that lived 195 million years ago.

Fossil hunters flock to Lyme Regis on the Dorset coast in the hope of finding the enigmatic remains of ancient creatures such as this ammonite.

New Forest

Dominic Couzens

If you want a snapshot of the history of the New Forest, it's easy to get one: just look into the eyes of a deer. Try to approach one of these timid animals and it will run from you in the same way that deer have been running away in these parts for 900 years. The fear on its face is the same as it has been from the time when deer were pursued by kings, right up to today, when they try to avoid curious tourists.

Everywhere you go you will be borrowing a trail with a human history, possibly bloody and almost always intriguing, while nowhere can you escape the all-pervading wildlife. The ponies wander the area's villages as if they are idly window-shopping. This is a place of intermingling: local with visitor, wild with domestic, past with present.

William the Conqueror really didn't know what he was starting when he first designated his Nova Foresta on the south coast of England as a place to hunt as long ago as 1079. The New Forest would become a land of preservation, where places would be protected and looked after through the generations. Thus, the erstwhile tract set out as a royal hunting ground would transmogrify, some 900 years later in 2005, into a national park for the benefit of all.

Wild Attractions

There is nowhere better to sample the plump indulgence of early summer than in the quiet corners of heath, bog and woodland that abound within the national park's spaces.

In the old woodlands around Acres Down, for example, the birdsong can be so loud that you just have to let go and allow it to wash over you. Some birds hereabouts will be singing from perches that could have been used for the same purpose for as much as 200 years. Imagine that: before the age of cars or telephones, people could have been standing in your spot, listening to the same songs on the same trees. And happily, the New Forest has been

so well preserved that some species, including redstarts and wood warblers, are breeding here, while they have almost disappeared elsewhere in southern England.

Inside the wood you can smell the tannin – and the slightly aerosol-like scent of bracken – while outside you can catch a pleasing whiff of dead leaves under the sun. Everywhere it feels as though the whole ecosystem is switched on and running at full capacity.

The long periods of preservation in the forest are perfectly embodied in the Knightwood Oak, the largest oak tree in the area. It is a giant with a girth of 7.4m (24ft), and is at least 400 years old. That doesn't make it the oldest in the forest – a yew tree in Brockenhurst Cemetery is thought to be 1,000 years old, pre-dating the formation of the Nova Foresta – and it doesn't make it the tallest, which is a 55m (180ft) giant sequoia. But the fact that it can grow large and a little skew-whiff and bulging and ugly for so long is a healthy sign of continuity in this ancient land.

Galloping Through History

One inhabitant of the forest that almost everybody has heard of is the celebrated New Forest Pony, found here since at least 1016. Over the years the royals have made a number of attempts to improve the breed, not least Henry III, who introduced ponies from Wales in around 1208, for hardiness. However, Henry VIII took exception to the diminutive size of the breed, and decreed that every horse below 14½ hands in height should be slaughtered, leaving only the biggest animals to continue the line. So, as you catch sight of the ponies, be assured that they have wandered over this ground since medieval times, shaped by kings. They are, if you like, four-footed embodiments of the New Forest's rich history – like the fleet-footed deer.

New Forest ponies are not completely wild – but are managed and cared for by commoners.

June

J une literally bursts into magnificent life in ways that have inspired literary figures as diverse as the English romantic poet John Keats and, two centuries later, the American author John Steinbeck, best known for his novel *The Grapes of Wrath* about a family of poor farmers during the Great Depression.

But the Nobel Prize winner found nothing depressing about the sixth month of the year. 'In early June the world of leaf and blade and flowers explodes and every sunset is different', wrote Steinbeck, while Keats pondered: 'And what is so rare as a day in June? Then, if ever, come perfect days.'

For me, it was a perfect June day when for the first time I saw a red kite soaring effortlessly above my Oxfordshire garden. Could it, I wondered, be a descendant of the one I brought from Spain years before?

During the Middle Ages red kites were a welcome sight because, as scavengers, they cleared rubbish from urban streets. Yet by the beginning of the twentieth century they had been persecuted to extinction in the UK, apart from a very small number in Wales.

In the early 1990s a red kite reintroduction campaign was launched – which is why, on a *Countryfile* assignment, I was on an airliner returning from Madrid with a large box on the next seat. To the bewilderment of fellow passengers it contained a kite emitting a strange mewing noise – not the kind of call you might expect from a large and impressive raptor.

'My' kite joined a few dozen other 'Spanish imports' that were released in the Chiltern Hills. Since then, the project has been amazingly successful with more than 10,000 red kites now enhancing the skies across Britain with their distinctive forked tails and 140–165cm (4ft 7in–5ft 5in) wingspan. So successful, in fact, that chicks are now being sent from here to Spain to help bolster now-declining numbers on the Iberian Peninsula.

So the story of the red kite in Britain has come full circle and you can find out more about this stunning bird in the following pages where it joins, among other seasonal treasures, butterflies and Kent cherries.

June is perhaps the best month for spotting flying jewels such as these common blues.

Poppies

Lara Hurley

The ancient Egyptians associated poppies with blood and rebirth because of the flower's seemingly endless ability to regrow from nothing after the harvest. The Romans considered the flowers sacred as a symbol of fertility – they made garlands from poppies and barley to decorate statues of Ceres, the goddess of agriculture and fertility. The poppy is thought to have come to Britain in the Neolithic era, mixed in with corn seeds and spread throughout the country with the ancient settlers. Medieval peasants named them 'thundercups' and 'lightnings' because they believed that picking them would induce crop-flattening summer storms. Leaving them be would protect the harvest.

The Meadow Muse

Poppies en masse inspire great joy but vast swathes of red are no longer a common sight. Occasionally a poppy flush appears when soil is disturbed, such as when a bypass is dug or a field ploughed for the first time in years. The fighting in Flanders during the First World War caused such a show, by churning the fields and creating conditions perfect for the blood-red flowers to thrive.

Poppies can remain dormant for years. Each plant produces an average of 17,000 seeds and can be viable for at least 50 years. If you turn a patch of soil in your garden in autumn, you could enjoy a miniature poppy field the following June. Poppies prefer open, free-draining soils and are most abundant on the chalky soils found in the southeast.

Although they flower from June to August, their transient nature means that a poppy field that appears one year may not be there the next. The best places to see poppies are traditionally managed farms, roadside verges and conservation areas.

Annuals, they germinate best with a cold snap, so sowing in autumn should guarantee a blaze of scarlet. They thrive on disturbance, so if you want subsequent flowerings, cultivate the surface of the soil lightly each autumn and the poppies will return. Many a wildflower meadow looks fabulous in the first year due to the burst of poppies, but these colourful plants only return if the soil is tilled – a source of consternation for many a landscape manager or ranger for whom ploughing isn't the most practical way to manage the community landscape. Poppies thrive if the land is managed as a cornfield, planted with a crop like barley. They won't germinate in a normal, perennial wildflower meadow because there isn't enough open ground.

Poppy Power

Poppies are valuable for wildlife. Our threatened pollinators – bees, butterflies, wasps and hoverflies – all use poppies as a source of nectar. If enough people sow them, it will make a real difference to our declining bee and butterfly population. Poppies help to fill the June gap after the spring flowers have died back, and before the heady blooms of summer come in. Pollinators can find this time hard and just a small patch of poppies can keep them topped up with nectar.

Remembrance Day has made poppies ubiquitous, a symbol of love and loss. It will be a great shame if they become paper symbols only, no more to be seen on our land. This year, why not commemorate the First World War by buying some poppy seed along with your lapel badge? Remember the past but think of the future too, lest we forget.

A field of poppies is a spectacular sight, South Downs, West Sussex.

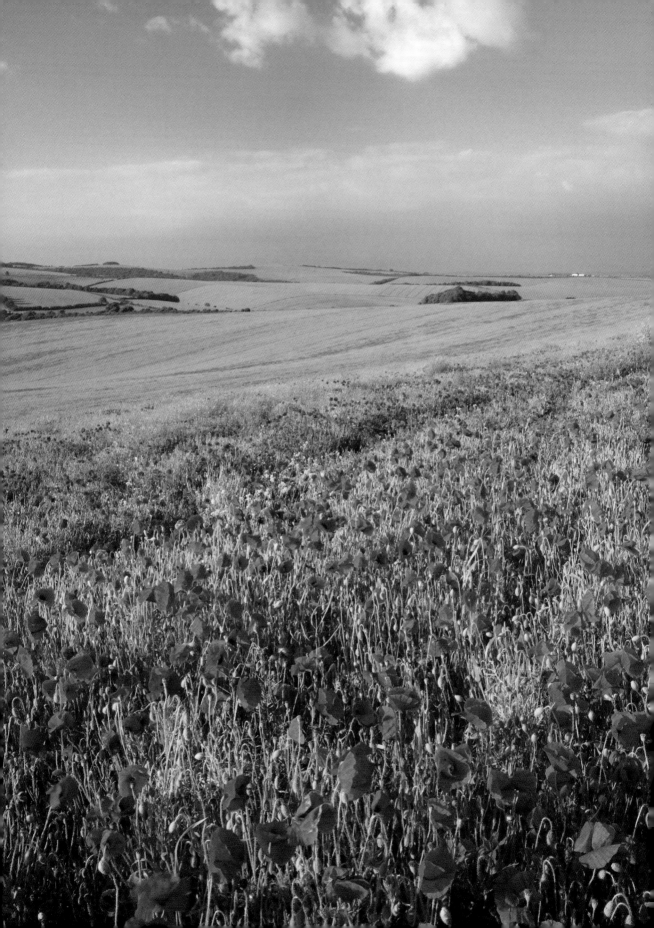

Hay Meadows

Phil Gates

The hay bale has a warm, sweet fragrance, far removed from the acrid smell of new-mown grass. To understand the source of its subtle aroma you would need to travel back in time to a day in June and to the meadow that it came from. Such fields can be home to as many as a hundred plant species, cohabiting in a delicate balance that depends on an ancient form of husbandry.

Hay cutting, followed by grazing and limited manuring, maintains a low level of soil fertility that prevents any species from becoming dominant, supporting a level of floral biodiversity that is breathtakingly beautiful. There, among the grasses, you would find the sources of that comforting fragrance: the leaves of meadowsweet, with their vaguely medicinal smell; lady's bedstraw, with a soporific scent that led to its use in stuffing mattresses; and coumarin-scented sweet vernal grass. Add to that a bouquet of other botanical ingredients – lady's mantle, cranesbills, buttercups, hay rattle, scabious and clover, to name but a few – and then leave it to dry in the sun. This alchemy creates the sweetest, most fragrant bale of hay, the essence of summer.

There cannot be another agricultural crop that contributes so much to wildlife and to the rural landscape. It teems with life. At peak flowering time, these old meadows hum with bees, nectaring on clover and hay rattle flowers. Swarms of hoverflies collect pollen and moths lay their eggs among the leaves; a myriad of other insects live and breed here. They in turn provide food for swallows that skim across the fields and redstarts and wagtails that make feeding forays from the enclosing walls. Stand and watch for long enough and you'll likely see curlews and skylarks, watch a kestrel stoop on mice and voles that scurry in the undergrowth, or catch sight of the long ears of a hare among the flowers.

A Brief History of Hay Meadows

Only about 1,000 hectares (2,470 acres) of traditional upland hay meadow remain, mostly in North Yorkshire and the North Pennines. A further 1,500 hectares (3,700 acres) of lowland meadow are scattered across the British Isles, together with a smaller area of seasonally flooded grasslands and managed water meadows that have a diverse flora. Traditional meadows that survive depend largely on financial incentives for farmers or are in the care of conservation charities.

The presence of woodland flowers such as wood cranesbill in some old grassland suggests that the origins of these flower-rich habitats can be traced back to original forest clearings, and that centuries of hay harvesting, followed by grazing with minimal nutrient input, maintained a highly diverse flora.

The ploughing of hay meadows for conversion to arable production began in earnest during the First World War, gathering pace during the Second World War. In the latter half of the twentieth century, the application of artificial fertilisers in many meadows favoured vigorously growing grasses at the expense of less competitive wildflowers. More recently, reseeding with high-yielding forage grasses, which are harvested without drying to make the fermented silage fed to cattle, became an economically more attractive alternative to traditional hay-making. The latter requires at least four consecutive days of fine weather in our capricious climate.

What's in a Hay Meadow?
- Hay rattle is a parasite on grass roots that steals their nutrients and reduces their vigour, helping surrounding wildflowers

Old hay meadows are a riot of colour compared to the green pastureland that dominates so much of lowland Britain.

to compete successfully. Traditionally, hay making begins when its dry seed pods rattle.

- One of the first species to flower, meadow saxifrage produces porcelain-white flowers on long stems. It dies down quickly after flowering, leaving tiny buds called bulbils that will begin growth again in early March.
- Wood cranesbill is perhaps an echo of meadows' origins as woodland clearings. It's the first large-flowered cranesbill to bloom, followed by paler blue meadow cranesbill. Both have beaked fruits that catapult seeds into surrounding vegetation.
- Old meadows are home to the greater butterfly orchid, whose pale flowers are pollinated by night-flying moths that are attracted by its scent. Nectar is hidden in a long, slender spur, only accessible with a long proboscis.
- Hungry swallows swoop low over the flowers and grasses on summer days, feeding on the abundance of insects that feed and breed on the wealth of plant species in a meadow.
- The day-flying chimney sweeper moth is a common sight in north Pennine meadows, where its caterpillars feed on pignut.
- The wing markings of the Shipton moth resemble a witch's face.
- Hay meadow grasses are important food for several butterfly caterpillars. Larvae of the

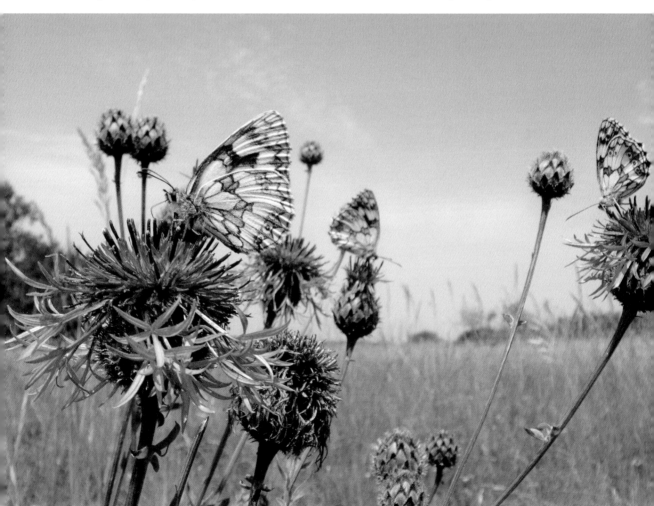

Gorgeously patterned marbled whites feed on nectar from greater knapweed flowers.

meadow brown butterfly feed on fine leaves of fescues and bents.

- Large skipper butterflies produce larvae that eat the coarser foliage of cock's-foot grass.
- Meadows are a particularly good source of nectar and pollen for hard-pressed bumblebee species such as the white-tailed bumblebee. Burrows of small mammals around field edges provide nest sites.
- Meadow and common green grasshoppers hatch in April and go through four nymphal stages before becoming winged adults in early July, just in time to escape the mower. Their chirruping is the music of a drowsy summer afternoon.

A Field Guide to Common Grasses

CRESTED DOG'S TAIL *Cynosaurus cristatus*
This hardy grass has a flattened, spiked inflorescence, the florets of which dangle their stamens towards one side. Its flower stems, which were formally used to make straw hats, become tough and unpalatable so persist late into the year on grazing land.

COCK'S-FOOT *Dactylis glomerata*
A robust, tussocky grass with flattened vegetative shoots. Its one-sided, dense spikelets are clustered on three or four branches, likening its outline to a chicken's foot. An important contributor to the hay crop, cock's foot also occurs in many other grassy habitats.

COMMON BENT *Agrostis tenuis*
Beginning to flower in late June, this fine-leaved grass competes best in drier parts of meadows, on poorer acid soil. It is also known as brown top, because its airy, open flower panicles resemble a brownish-purple haze. It's widely cultivated for high-quality lawns.

MEADOW FOXTAIL *Alopecurus pratensis*
This begins growth early in spring and its distinctive cylindrical inflorescences bloom in mid-May. It is at its most impressive in moist, fertile soils of water meadows, where its flowering stems may reach 1m (3ft) tall.

QUAKING GRASS *Briza media*
Heart-shaped spikelets dangle from slender stems and tremble in the slightest breeze, a characteristic that is reflected in quaking grass's local names like cow quakes, doddering dillies, shivering and totter grass. It favours dry, calcareous grassland and is soon lost when this is 'improved' with added fertiliser.

SWEET VERNAL GRASS
Anthoxanthum odoratum
One of the earliest grasses to flower, often in April, sweet vernal grass thrives in acid soils in upland meadows. It contains high levels of coumarin, which is responsible for the intense hay fragrance of a freshly mown meadow. Its inflorescences ripen to a golden yellow in summer.

YORKSHIRE FOG *Holcus lanatus*
This major component of hay meadows has a prolific seed output that rapidly colonises bare soil patches. The soft, hairy inflorescences have a delicate red tinge, so dense populations of this grass look like a pink mist on a summer evening.

SOFT-BROME *Bromus hordaceus*
An annual species, flowering mid-May onwards, with soft hairy stems and leaves. Also known as lop grass. The flowering panicle is erect at first but the spikelets soon nod once seeds begin to form. Common in a wide range of grassy situations.

FALSE OAT GRASS *Arrhenatherum elatius*
A species of coarse flowery grassland, often alongside meadow sweet and hogweed in rough pastures. Its broad leaves and tall flowering culms are conspicuous from a distance. The bristle-like awn, protruding from the flower spikelet, has a distinctive knee-bend.

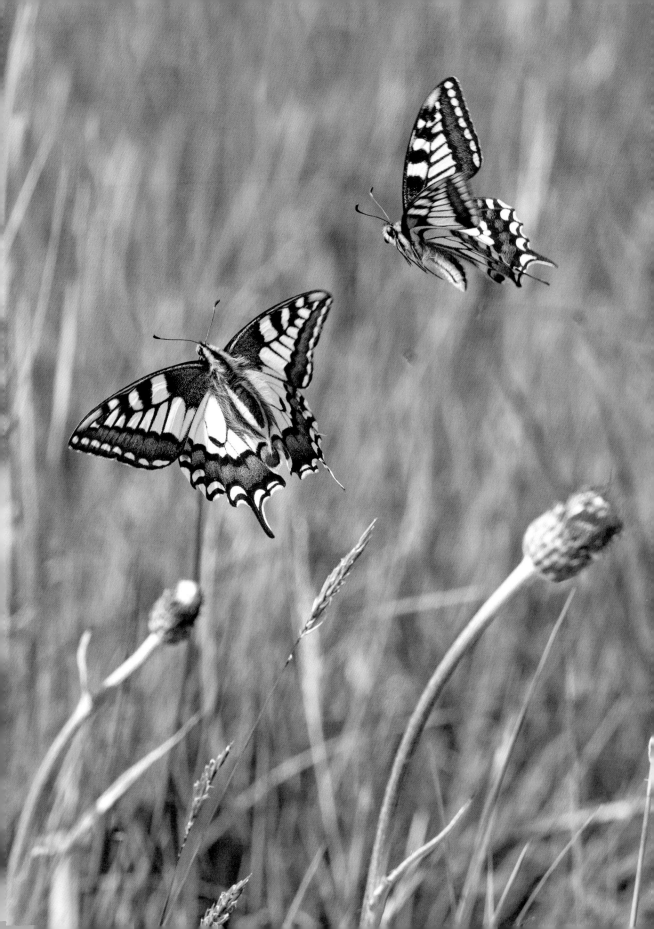

Butterflies

Matthew Oates

For wonderful surprises, watching butterflies – butterflying – can scarcely be bettered. Butterflies take you into the heartland of fantastic landscapes when those places are at their most beautiful – and the weather has to be good or the insects won't be on the wing. So you're almost guaranteed golden, summery memories.

Add their intense beauty and mysterious nature and you will begin to understand why butterflies have long been one of the most valued elements of our wildlife. Their lifecycle – where they transform from earthbound caterpillar to ethereal flying adult – still seems miraculous.

Favoured Habitats

Woodland is one of the richest habitats for butterflies, and in particular broad-leaved woodland with a varied age structure. Some species of butterfly favour new clearings and young plantations, while others colonise later, in succession, as the trees grow. Many exploit the sheltered conditions provided by woodland rides and glades, and are essentially opportunistic creatures of flowery sheltered grassland.

Those species that favour new clearings and young plantations, such as the pearl-bordered and high brown fritillaries, are now among our most rapidly declining butterfly species. Limestone grassland, such as chalk downs, supports the most species of butterfly. A good down will hold more than 30 species. The third favoured habitat is a coastal hotchpotch of hard and soft rock cliff systems, sea combes and sand dunes. Unlike woods and downs, no butterfly species are actually restricted to coastal habitats. There are also a few specialists of upland and northern Britain, including the brown argus, and a couple of wetland species, such as the magnificent swallowtail.

Britain's largest butterfly, the magnificent swallowtail is restricted to a few wetland sites in Norfolk.

The Must-see Butterflies of June and July

BLACK HAIRSTREAK *Satyrium pruni*
Found around blackthorn jungles in clay woods in the Midlands in late June.

CHALKHILL BLUE *Polyommatus coridon*
Myriad sky-blue wings, on southern downs. Look for them throughout August.

DARK-GREEN FRITILLARY *Argynnis aglaja*
Battles in the wind on downs and sea cliffs during July.

LARGE HEATH *Coenonympha tullia*
Found in raised bogs and some basin mires and blanket bogs in north Wales, northern England and Scotland in late June to mid-July. Also occurs in Ireland.

MARBLED WHITE *Melanargia galathea*
Lives in downs and other rough grassy places in southern England.

PURPLE EMPEROR *Apatura iris*
Found in woods in central southern England from late June to mid-July. Elusive and haughty, but seriously spectacular.

WHITE ADMIRAL *Limenitis camilla*
Lives in woods with dense honeysuckle tangles in southern Britain from late June to late July.

MOUNTAIN RINGLET *Erebia epiphron*
Look on mountain tops in the Lake District and the Grampians in late June to mid-July.

SWALLOWTAIL *Papilio machaon*
This butterfly, found in the Norfolk Broads in June, is Britain's largest native species.

SILVER-WASHED FRITILLARY *Argynnis paphia*
Big and bouncy, the happiness butterfly of southern woodland during July.

Dung Beetles

Richard Jones

No idyllic British landscape is complete without a scatter of grazing cows or sheep dotted across the emerald green meadows or flowery hillsides. More than wheat fields, vegetable plots, hop gardens or orchards, free-ranging stock animals are the essence of our island farming.

Today, there are something in the order of 10 million cows, 22 million sheep, four million pigs and one million horses grazing in the UK, busily transforming grass into meat and maintaining the diversity of water meadows, chalk downs, limestone hillsides or upland moors. But, of course, what goes in one end has a direct consequence on what comes out of the other, and between them an estimated 500,000–600,000 tonnes of dung is dropped each day – over 200 million tonnes each year.

This manure is still rich in nutrients (typically herbivores only extract 10–30 per cent from the tough cellulose fibres and complex plant chemicals), but they are not immediately available for plants to use. More breakdown and digestion needs to take place first.

Simply dumped onto the countryside, this quantity of dung would soon swamp the land. We know this because of a near ecological disaster that happened on the other side of the globe. When European colonists took cattle, horses and sheep to Australia from the eighteenth century onwards, their animals' dung was not recycled or absorbed into the landscape – it just sat there, smothering the grass. An oft-quoted statistic is that the dung of five cows can cover an acre of meadowland in a year. The runny dung was highly attractive to bush-flies (the Australian equivalent of the housefly), and travellers told of stifling swarms, thick as smoke, making it impossible to breathe without the insects flying into their mouths or up their noses.

The missing ingredient was dung beetles. In Britain and indeed the rest of the world, a rich and diverse fauna of beetles feed in the dung, breaking the pats into smaller nuggets, moving it, redistributing it, burying it, laying eggs on it so that their larvae can feed on it. The native Australian dung beetles were well adapted to small hard dry marsupial droppings, but shunned the copious, much wetter manure from sheep, horse and cow. It took an international scientific effort, and the release of millions of live African, American and Asian dung beetles into Australia from the 1960s onwards, to start the clear-up process.

In our verdant countryside, this clear-up continues unnoticed, involving an estimated 500 different species of insect alone. It starts with the dung-feeders, mostly beetles and flies, which lay their eggs in the fresh droppings. Yellow dung flies arrive within seconds of the pat hitting the ground. These are usually males staking out territories, waiting for the females to arrive to mate and lay eggs. Dung beetles fly in very soon, buzzing downwind as their sensitive antennae follow a cocktail of pungent chemicals including methane, hydrogen sulphide and indoles, potent-smelling bacterial products giving faeces their (to us) disagreeable scent.

As usual with insects, the adults do very little feeding – the larvae do most of the eating. In the dry subtropics, some dung beetles excavate balls from the main mass and roll them away before they dry too hard in the blazing sun, burying them as brood supplies, each with an egg laid on it. This behaviour duly impressed the ancient Egyptians enough to deify their sacred scarabs.

In Britain our native dung beetles don't need to be quite so hasty; some smaller species simply live inside the dung, others dig a tunnel down into the soil underneath, then drag morsels of excrement down to stock a cell in which an egg is laid. Each grub feeds alone in its tunnel, before pushing up through the soil weeks or months later.

There are also predators, mostly other beetle and fly larvae, feeding on the insect grubs inside or under the dung, but sometimes the adults snatch at each other on top of the pats. Rooks, jackdaws and magpies sometimes peck at cow pats – they are not eating the dung, but the fat maggots within. Then there are the parasitoids, laying eggs inside various insect larvae, the offspring eating their hosts alive from the inside. A veritable ecological web begins to be woven.

As the dung remnants age, they dry and harden and become less attractive to dung-feeders. Fungi now become a major digestive force; many of these are small insignificant growths, but the shaggy ink cap is a handsome edible species regularly growing from the barely visible remains of an old pat (don't drink alcohol with your meal, though; it combines to make a mild poison in the stomach, causing nausea and hot flushes). With the fungi comes a new slew of fungus-feeding insects.

After a few months, a cow pat becomes hard and stiff and it's difficult to tell if its inhabitants are feeding on it, or just sheltering under it – earwigs, ants, woodlice, millipedes, centipedes, spiders. Eventually, the distinction between dung pat and soil becomes so blurred that earthworms move in for the final breakdown and burial. The pat is gone, the nutrients dispersed and recycled. All that remains is a green field and quietly munching farm animals, as picturesque as ever.

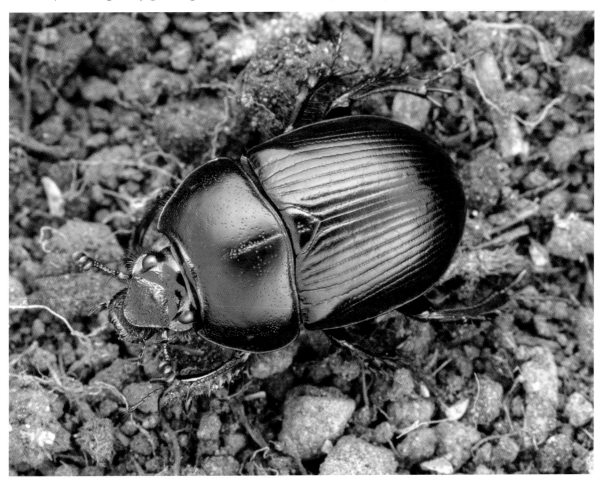

Dung beetles such as the impressive dor beetle burrow in or under animal droppings and use it to feed their larvae.

Glow-worms

Pete Dommett

The church clock of St Lawrence's chimes 10 times and, right on cue, there it is: low down in a scrubby verge, a glow-worm. It is incredibly bright. A brilliant, lime-green light shines with the same unwavering intensity of any LED indicator found on a hundred electrical appliances around the home.

A grub-like, woodlousy creature – 25mm (nearly an inch) long – the glow-worm is revealed, clinging tightly to a long blade of grass, the tip of its tail twisted upwards and ablaze with two narrow stripes and two tiny spots of neon. It's obvious how the glow-worm got its name, but the truth is it isn't really a worm at all. Glow-worms are simply female fireflies without wings – the common glow-worm *Lampyris noctiluca* belongs to the same family as fireflies Lampyridae (which are really bioluminescent beetles) and it is the flightless female that does the glowing.

Glow-worms are a rare example of bioluminescence in terrestrial animals. Although unusual, this natural phenomenon is visible in a diverse array of wildlife, including insects, fungi and bacteria, and is more often seen in marine life, such as jellyfish, sponges, corals and squid. The purpose of light for many of these life forms is to lure prey or repel possible predators, but for the glow-worm it's all about sex.

After spending two years as voracious, snail-devouring larvae, followed by two weeks pupating under logs, the first adult glow-worms usually emerge soon after sunset on June evenings. The females find a good vantage point, from where they will be visible to the smaller, winged males flying overhead, and turn on their lights. This display may last for two hours or more, but few carry on glowing much beyond midnight. For many, if they are

fortunate enough to attract a male, it's a night-only performance. If unsuccessful, she will return to precisely the same place at the same time, for up to 10 nights, and try again.

Once mated, she will switch off her signal, lay between 50 and 150 eggs in a moist spot, then crawl away and die – her life's work done.

Dark Days

The increasing illumination of our countryside – by streetlighting, home security lights, garden lights and cars – coupled with the all-too-common cocktail of habitat destruction, fragmentation and the use of pesticides, has created many 'no glow' areas and is thought to be one of the reasons for the species' long-term decline. By attracting male glow-worms, artificial lighting could be reducing the female's ability to do the same, with potentially disastrous consequences for an isolated population made even more vulnerable by the wingless female's inability to colonise new areas. Despite the difficulties they face, glow-worms are not protected in any way.

How Do Glow-Worms Glow?

The glow-worm's famous light show is produced by the chemical luciferin (from the Latin *lucifer*, meaning 'light-bearer') as it reacts with oxygen in the air. It's an incredibly efficient process: virtually all the energy is transferred into light, compared to an old-fashioned phosphorescent bulb, which wastes most energy as heat.

It is the adult female's bright beacon that has earned the glow-worm its name, but males can glow faintly, too. The insect lights up at all stages of its lifecycle, in fact – probably as a warning to would-be predators. Even glow-worm eggs give off a faint glimmer.

Choose a warm summer's evening and look for the tiny lights of glow-worms in the grasses and flowers that line old country lanes.

Red Kites

Tim Dee

Britain's red kite population sank to its lowest in the 1930s, when there were just two female breeding birds in Wales. There are now around 5,000 breeding pairs across the British Isles. 'What is remarkable about these numbers', says Duncan Orr-Ewing of the RSPB, who has worked on the kites' return to Scotland, 'is that human activity was and has been responsible for both.' We pushed the bird to the edge and thank goodness, we have brought it back.

In 1800, red kites bred in all but five counties in England, Wales and Scotland. By 1870, they were extinct in England. By the 1880s, they were gone from Scotland. The guns of Victorian Britain (and later egg collectors) did for them all. We liked our raptors dead in those days.

Most of us prefer them alive today. A reintroduction scheme began in 1989. By then, the red kite was one of three globally threatened birds in the UK and was a priority for rescue. Kites were clinging on in their Welsh refuge, but were considered unlikely to survive without assistance.

Readjusting to Raptors

Overall, the reintroduction has been very successful. The discrete populations have met and merged. The genes are flowing and the reintroduction scheme has finished. Britain now has 15 per cent of the global red kite population (the species is otherwise found across Europe from Spain to western Russia).

However, there are still problems: 'While the bulk of the English (4,000 pairs) and Welsh (1,000 pairs) populations are at, or near to, carrying capacity', Duncan Orr-Ewing says, 'numbers in Scotland and in Yorkshire and Durham are lower than they should be because of illegal persecution.' All raptors, including kites, that are associated with moorland ecosystems managed for grouse shooting are doing badly. Duncan says birds have been illegally shot and illegally poisoned. Other threats affect the whole population: lead from ammunition in discarded pheasants, which kites scavenge, poisons the birds, as do highly toxic new-generation rodenticides. Duncan has found kite chicks dead in the nest after eating the carcasses of poisoned rats that had been left available to scavenging birds.

What these misfortunes underline is something that can be more intuitively understood by watching the birds feeding on scraps in back gardens, and scavenging the road-kill smorgasbord along many motorways. Red kites are not really birds of wild places – they are our familiars and they have evolved with us. Early modern Britain knew the kite to be a scavenger: the bird was protected in order that it could work on our behalf. Shakespeare and his contemporaries would have known that kites had a reputation for stealing linen for their shambolic nests – underwear was said to be favoured. Duncan knows them to eat 'the absolute dregs', and he has also found kite nests 'woven with old socks, lost gloves, and a mess of plastic'.

But any adjustments needed to live alongside these birds again are surely worth it: to see a red kite turn a brilliant corner in the ordinary skies above our workaday lives is to be thrilled every time. These are magnificent birds piloting their own magnificent flying machines.

Kite Spotter's Guide

Kites look light and buoyant in flight. Their long wings and deep forked tail make them readily separable from buzzards, the most similar bird of prey. Kites soar – they always seem to be looking down at what is beneath them – but they are also extraordinarily manoeuvrable. Watch them rudder their tail and tilt their wings. The metallic hue to their plumage means they catch the sunlight. They are truly dazzling birds.

Just 30 years ago, red kites were seldom seen – now they are a common sight across much of Wales and southern and central England.

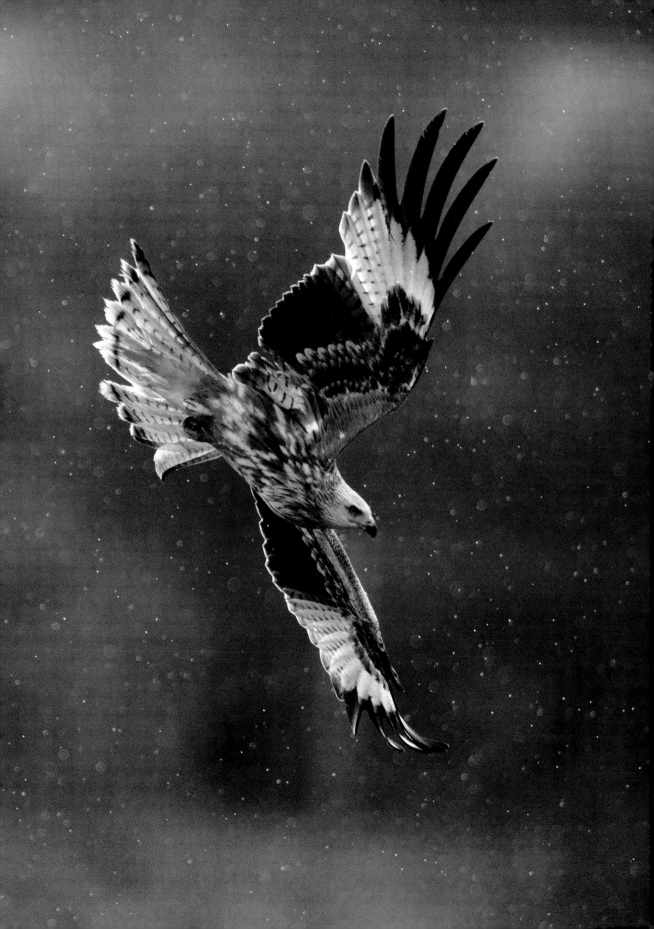

Cottage Gardens

Stephanie Donaldson

It's amazing how consistent people's idea of a 'cottage garden' is. The mind's eye conjures up an attractively rustic cottage with roses and honeysuckle round the porch, hollyhocks under the window and a brick path lined with old-fashioned favourites such as pinks, pansies, sweet william, cornflowers and lavender, leading to the front door. It's always summer and the sky is blue. There's something irresistibly romantic about the idea of a cottage garden, and gardeners have been busy romanticising the reality for well over 200 years.

Before that, most of these gardens were far from picturesque. Poverty made it hard to give time or energy to prettifying a hovel. It was only when conditions for workers began to improve slightly that the garden became more than a patch of land where, if you were lucky, you could fatten a pig, keep a few hens, grow some vegetables and plant a selection of herbs for cooking, country cures or strewing. The strewing herbs, including aromatic lavender, southernwood and hyssop, were crushed underfoot to disguise the many unpleasant smells and also to repel fleas, lice and other vermin. Scratching a living and scratching yourself was the reality in early cottage gardens.

Encouraged to Grow Flowers

The picture-perfect cottage garden that we know today had its beginnings in the eighteenth century, when landowners developed a penchant for 'emparking' their land. The idea was to impress their visitors with the beauty of the surroundings, so if this involved demolishing tumbledown cottages that spoilt the view, that's what happened.

The more fortunate tenants were moved elsewhere, to live in terraced cottages in model villages. These were built with small front gardens where the residents were encouraged to grow flowers so that passing visitors could admire them as they made their way to the 'big house'. The more prosaic pigs, chickens and vegetables were to be kept out the back.

Garden Flowers from the Wild

Of course, this was all long before seed merchants or plant nurseries were available to most gardeners, so many of the flowers they grew were gathered from the wild (not recommended these days). These included foxgloves, primroses, lily of the valley, wild roses and bluebells, while others were potherbs – marigolds, thyme and mint.

Most of the herbs originally came from monastery gardens or had been brought to Britain even earlier by the Romans. Gradually though, a wider variety of flowers became available, probably passed on by gardeners who worked for the upper classes and managed to save seed or take cuttings for their own use. Roses were no longer just the single wild variety, but included doubles and climbers. Night-scented stocks and mignonette began to appear, as did columbines, wallflowers, honesty, Madonna lilies and sweet rocket. The cottage garden began to be decorative as well as productive.

Alongside these 'locally sourced' plants were the 'florists' flowers' that arrived in Britain from Europe, supposedly with the Huguenot weavers. It was said that after a day spent at the looms, the weavers would relax by devising elaborate crossbreeds of their favourite flower.

Among the most popular were tulips, auriculas and carnations. 'Florists' Feasts' were organised, where they would show off their newest plants while enjoying a meal together. The commoner and hardier varieties of these flowers made their way into many cottage gardens and have remained popular ever since.

A well-planted cottage garden is both beautiful and offers plenty of food for insects, including honey bees.

Kent Cherries

Clare Hargreaves

Few fruits are as beautiful as they are delicious, but the cherry pips pretty much every other fruit to the post on this score. And that's not even mentioning its stunning springtime blossom, which the poet AE Houseman believed made it the 'loveliest of trees'.

Few fruits are also so closely associated with an area of the country as cherries are with Kent. It was largely its cherries that earned the county the title of the Garden of England. Wild cherries probably flourished in Kent for millennia, but it was the Romans who introduced the cultivated cherry, both sweet and sour. It is said that you can trace old Roman roads by the wild cherry trees that grew up from the stones spat out by legions as they marched across the country.

By the Middle Ages, cherries were extensively grown in monastic and private gardens, and were a summer treat relished by rich and poor alike during their all-too-brief season. A lovely fourteenth-century poem by John Ludgate describes the cry 'Cherries in the rise' of the cherry sellers on the streets of London. A 'rise' in Kent is a twig; sellers tied cherries to a twig to advertise their wares, allowing their customers to pluck a sample and taste.

It is Henry VIII whom we have to thank for turning Kent into the UK's premier cherry growing area, and improving its varieties. Soon after ascending to the throne, Henry launched a campaign to make Britain self-sufficient in fruit and ordered his head fruiterer Richard Harris to propagate sweet cherry varieties from Europe. Kent was the ideal place. Not only did it have the well-drained, sandy soils that cherries love, but it was near the markets of London. The ruby fruits were transported along the river Medway to the city.

Soon cherries were planted all over Kent, from Canterbury to Rainham. From the late

Merton Favourite cherries ripening in an English cherry orchard.

nineteenth century, Morello (or sour) cherries growing around Lenham were used by the Grant family to make their famous cherry brandy. Sadly, by the 1960s the difficulty and cost of picking from trees that were often more than 15m (50ft) tall made Kentish cherries uneconomic. They were unable to compete with cheaper foreign imports from countries such as Turkey and the US. From around 5,190 hectares (12,832 acres) of cherry trees in 1951, there were just a paltry 381 hectares (943 acres) by 2003. But the last 20 years have seen a tremendous revival of the UK cherry crop. Across Kent, commercial orchards started planting modern dwarf rootstocks that make the fruit far easier to pick, and production is now strong enough that the UK no longer imports cherries during the British season.

While many traditional varieties of cherries that our grandparents would have enjoyed have disappeared, Kent cherries are once again thriving, and reminding people of the amazing flavour of our native cherries.

English-grown Cherries to Enjoy

- Early Rivers, the earliest black variety to ripen, often around the middle of June. It is one of the first to appear on roadside fruit stalls in north Kent.
- Roundel is a large heart-shaped sweet red to dark-red cherry that ripens mid-season. It is one of the varieties that was bred in Kent.
- Bradbourne Black is a black cherry with dark flesh, ready for picking at the end of July.
- Napoleon Bigarreau is a fine white cherry. It is renowned for its firm, very sweet flesh and ripens in early August.
- Gaucher Bigarreau is a variety bred in Kent since 1907. It has large, round, black juicy fruits with a sweet flavour and dark-red flesh. It is a good cropper with vigorous, upright growth and is ready for picking from mid- to late July.
- Kentish Red is a sour bright red cherry with small, transparent fruit. This is Kent's answer to Morello, our favourite sour cherry.

Barrows and Tumuli

Ian Vince

With up to 20,000 burial mounds in Britain and 'tumulus' a common word on Ordnance Survey maps, it's not surprising that a barrow, howe, hump or tump is never far away. Of all the ripples and bumps on the land, these resting places for forgotten chieftains and mighty warriors are the most abundant.

They might be ubiquitous, but they're far from uniform, occurring in a wide variety of shapes and influenced by geology, the materials that were available, and the shifting cultural trends of 4,500 years. In some places, these different species of barrows occur as swarms around other features – especially henges (there are around 300 barrows in the immediate vicinity of Stonehenge alone) – while others appear to have a relationship to parish borders: vestiges of Saxon estate boundaries that may, in turn, follow older territorial lines.

On Your Next Country Walk, Look Out For…

The most basic – and common – form of tumulus is the upturned dish shape of the bowl barrow. This burial mound has adopted a consistent form throughout prehistory from the Neolithic period on, even reappearing in sixth-century Saxon England as chieftains' tombs. Simple barrows with pleasingly rotund, roughly circular mounds, usually surrounded by a ditch and an external bank, bowl barrows were built all over Britain.

The mounds of bell barrows from the early Bronze Age on are separated from the ditch and bank that surrounds them by a narrow, level platform, or berm. They are most frequently associated with male burials and often contain daggers and other weapons among the grave goods. The ditch and platform can encompass up to four separate mounds, as can the ditch and bank of its refinement – the disc barrow – which features a much smaller mound and wider platform.

While bell and disc forms are usually the graves of Bronze Age men, saucer barrows are predominantly the tombs of women and can be recognised by a low, wide mound that extends without a berm to the ditch. Of the 60 in Britain, most are in Wessex. Of the handful in Sussex, the best is at Chanctonbury Ring.

Of all the burial mounds, long barrows are the oldest. There are around 300 of them in England and Scotland and a handful in Wales, all dating to the early Neolithic. As the name suggests, they are long – up to 125m (410ft) – and they are usually the site of multiple interments. Their physical dominance of the landscape and elaborate construction – some even have false entrances – inspired legends about their origin; Wayland's Smithy on the Berkshire Downs, pictured below, is a good example.

RIGHT: *Belas Knap, a Neolithic chambered long barrow at Winchcombe, Gloucestershire.*

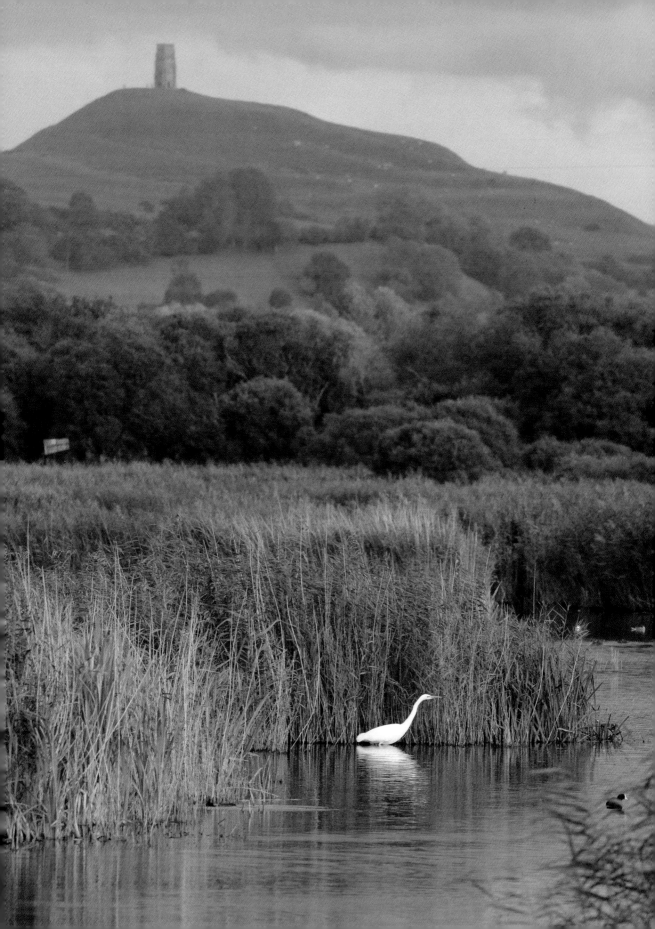

Somerset Levels

Stephen Moss

A great white egret – surely the most elegant of all Europe's waterbirds – stands stock-still, waiting to pounce on an unsuspecting fish. Overhead, a hobby – that streamlined and aerobatic falcon – grabs a dragonfly out of the clear air. An otter dives beneath the glassy surface of the water; and deep in the reedbeds, an unseen bittern booms its bass courtship song in answer to a rival male.

As the sun beats down and the heat-haze shimmers, we could be in the Camargue of southern France. But that distant tower-topped hill looks eerily familiar, and the voices around us are English. Despite the exotic species, this is not some far-flung wildlife haven: the hill is Glastonbury Tor, and this is the Somerset Levels.

Legend has it that this is the magical land of Avalon, where King Arthur is said to have been buried after receiving mortal wounds at the battle of Camlann. Avalon is thought to mean 'isle of the apples', a fruit that still grows in abundance in the region and so gives the myth some sort of root. Glastonbury is the heart of Arthurian Somerset – it's an acquired taste, but many people have grown to enjoy the mysticism, the curious nooks and crannies, and the ancient taverns.

Mythology aside, this is where a later and very real king, Alfred the Great, took refuge from the Danes after he had narrowly escaped their clutches during the sack of his royal residence at Chippenham, further east. It was here, so another legend tells, while in hiding in a poor cottage, that he burned the cakes he was supposed to be looking after – he was too preoccupied with how to win his kingdom back. Even today, if you walk or drive down the lanes of the Levels, with rivers, streams, lagoons and marshes all around you, you can imagine it would have been very difficult to winkle the king from his miry hideout.

Great white egrets are a recent arrival in Britain, a symbol of the great conservation success story of the Somerset Levels.

Even further back, 4,000 years before the birth of Christ, this is where an unknown labourer began to build the Sweet Track, the oldest-known pathway in Europe, to enable people to travel across the marshes. You can walk it today within Shapwick Heath National Nature Reserve and imagine the lives the willow weavers and fisher folk must have led.

Water has always been the defining characteristic of the Somerset Levels. The name 'Somerset' means 'land of the summer people', a reference to the age-old custom of moving down from the hills each spring and summer to graze livestock on the lowlands, where pastures had been reinvigorated by winter flooding.

Even today, the main human settlements are on higher ground, such as the low spine of the Polden Hills, while landmarks such as Glastonbury Tor, Brent Knoll and Burrow Mump peer out over this flat landscape.

As well as farming (mainly sheep and dairy cattle), local people still make a living from two classic crops: the withies produced by the numerous willow trees, and of course the dark peat that makes up much of the low-lying ground.

For Peat's Sake

Until recently the Somerset Levels was one of the best-kept secrets in Britain – lying forgotten between Wells and Yeovil in the east and the coastal resort of Burnham-on-Sea to the west. The area was known, if anything, as a place where dark, thick lumps of peat were dug from the ground, willow was grown for weaving baskets, and strong, cloudy cider was produced and imbibed.

It is the peat that has been the key to the region's turnaround. For when peat is dug, you are left with huge holes that rapidly fill with water. The land cannot be farmed or built on; but with careful management it can be restored for nature.

Within a decade or two – with a considerable amount of effort from conservation bodies,

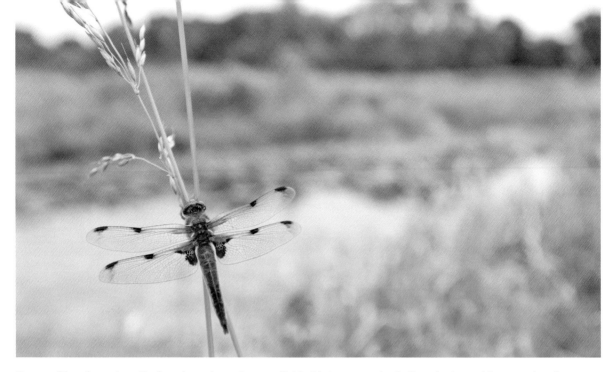

Dragonflies abound on the Levels and species are divided into groups including darters, skimmers, hawkers and chasers: this is a four-spotted chaser.

their staff and willing volunteers – those scars on the landscape have been transformed into open pools surrounded by vast reedbeds, the perfect habitat for a range of wetland wildlife.

No sooner had the reeds started to take hold than dragonflies and damselflies began to colonise this new habitat. They were swiftly followed by a range of wetland birds, including garganey, little egret and marsh harrier. The otter – once driven virtually to extinction in England – is also thriving, and Noah's Lake within Shapwick Heath National Nature Reserve is one of the best places in England to catch sight of this elusive mammal.

On a good day, you can hear up to eight different warblers: Cetti's warbler and whitethroat in the scrub, sedge and reed warblers in the reeds, and willow warbler, chiffchaff, garden warbler and blackcap in the surrounding wet woodland. There's also a wealth of waders – black-tailed godwits are regular – and ducks, including the shy and beautiful garganey. Low-flying marsh harriers float over the reedbeds, while passing ospreys regularly turn up, stopping to fish on nearby Noah's Lake.

But without doubt, the stars of the show are the herons. It is incredible to think that in 2006 only two species – grey heron and little egret – were breeding in the county. Less than a decade later, six species have bred, including the bittern, little bittern, cattle and great white egrets. When you add the occasional glossy ibis and white stork, the odd purple heron and the resident cranes, that makes a round 10 species of long-legged waterbird.

Birds are the most obvious attraction, but other groups of wildlife are doing well, too. The hairy dragonfly – a scarce and localised species – is usually the first to emerge in late April, soon followed by other dragons and damsels, including a recent colonist, the scarce chaser.

Butterflies are thriving too. Species include the beautiful white admiral, purple hairstreak and silver-washed fritillary, all of which can be found in the wet woodlands around the newly restored Sweet Track.

Later in the season the Polden Hills – more of a small ridge, really – are home to one of our rarest butterflies, the large blue. This delicate and beautiful insect became extinct

in the late 1970s, but thanks to a successful reintroduction project, it can now easily be seen on sunny days in late June and early July, at the National Trust reserve at Collard Hill, just south of Street.

Rare Fish House

Humans have long made a living here, too, though even today settlements feel few and far between. In the central Levels area in particular, you'll find ruins and other evidence of monastic houses that exploited the Levels' natural resources. The fourteenth-century Abbot's Fish House at Meare is England's only surviving building relating to a freshwater fishery. Eels, pike and bream would have been dried and salted here to be served to the abbot and his friends at Glastonbury.

Well worth a detour further south is Muchelney Abbey. This Benedictine stronghold is almost totally ruined aside from the impressive Abbot's House, but its riverside setting and attached legends make it enchanting. From here you can walk along the River Parrett (look out for pike!) to the vibrant town of Langport, which, as its name suggests, used to be an important trading centre when the Parrett was navigable. It still has a vibrant, upbeat feel and a couple of excellent pubs.

For more of the human story of the region, you must not miss the city of Wells – actually no bigger than a small market town. Wells is dominated by its cathedral, famous school and the Bishop's Palace. It's not uncommon to see lines of smartly uniformed pupils snaking their ways through the cathedral close – giving it a slightly Hogwartian feel: homely, yet from another time. Wells is also packed to the gunnels with interesting shops, quirky corners as well as excellent restaurants and pubs. Or, if you fancy something similar but on a smaller scale, try charming, upmarket Wedmore to the west, typically perched on a rare ridge of high ground.

What is most impressive about this region is that, for the first time in recent years, we have managed to recreate a vast wetland habitat, where birds and other wildlife don't just survive, but thrive.

The Somerset Levels are threaded with ditches and drainage channels known as rhynes (pronounced 'reens').

July

J uly is the month when the nation starts to pack its bags and go on holiday: school is out, it's usually the hottest month (though June is the sunniest), harvest is beginning, endless purple fields of lavender are in bloom and only bad weather can sour the upbeat mood.

The last thing we want is rain on St Swithin's Day, 15 July, because according to folklore it will last for 40 days. On the bright side, if the sun is out on that day it will shine for just as long. However, there's no meteorological evidence to support this myth either way.

Though many people head for foreign shores for their holidays, recent years have seen a boom in staycations – especially since the Covid-19 pandemic – with families rediscovering the attractions of the British seaside. So, our reports on July include two prominent features of our coastline: sand dunes and cliffs. Dunes are nature's sandcastles, built by the winds and held together by grasses such as sea couch and marram.

Some UK sand dunes are spectacular: a favourite of mine is the Big Dipper near Bridgend in South Wales, which is the second tallest in Europe at around 61m (200ft). They all teem with wildlife and are great for clambering through with eyes wide open.

Don't clamber up or down cliff faces, though, unless you're an expert climber. One of the hairiest moments in my career came early on, while making a television documentary about the search-and-rescue services. An RAF helicopter dropped me onto a narrow ledge about 20m (60ft) above the waves on a chalk cliff on the south coast.

As I hung on for dear life the sea was surging below and the downdraught from the chopper thrust shards of chalk like knives into my body. After a few minutes, which felt like a lifetime, the winchman who had put me there was lowered back down to rescue me.

It made a great sequence but, much as I appreciated the skill of the crew and got a taste of the fear that those in accidental peril must feel, I vowed never to do anything like that again. Our cliffs can be dangerous enough without taking unnecessary chances.

Warm sun teases heady scent from these Somerset lavender
fields, which will be buzzing with bees until harvest time.

Sand Dunes

Phil Gates

There can be few places that are as exhilarating to walk through as our coastal sand dunes, accompanied by the sounds of the tide lapping on the shore and the song of skylarks. Open horizons draw us to these inspirational places shaped by waves and wind on the edge of our islands, but look down at your feet and you'll find they are also home to a beguiling variety of wildflowers, insects and birds.

Towering dunes, sometimes more than 20m (60ft) tall, begin life as grains of wave-worn sand and seashell fragments, blown along the beach until they become trapped among plants that grow above the strandline, such as the beautiful lilac-flowered sea rocket. These embryonic dunes would be short-lived without the aid of sand couch and marram grass – dune builders whose webs of deep, fibrous roots bind the sand together while still more grains become trapped among their tough leaves that grow fast and resist burial.

The lofty yellow dunes that form shifting ridges are among the harshest habitats for plant life, but coastal specialists thrive here, including sea holly – with its silvery blue, spiny leaves – and the trailing stems of sea bindweed, whose pink-and-white-striped trumpets are reminiscent of seaside ice-cream-parlour awnings.

Walk a little further inland and, as the soft sand becomes firmer, the tang of salty air and seaweed gives way to the aroma of wild thyme underfoot: these are the fixed dunes, often encrusted with grey lichen and drought-tolerant mosses. Stabilised by a tapestry of ground-hugging wildflowers, including kidney vetch, biting stonecrop and restharrow, and often studded with pyramidal orchids, they shimmer with heat haze on a scorching summer afternoon.

It's hard to imagine a more perfect place to picnic than in these sun-drenched, sheltered hollows, so settle down amongst grayling and common blue butterflies, serenaded by the sounds of grasshoppers and stonechats, and watch lizards hunting insects. This part of the dune system is home to a fascinating array of unusual species, including burrowing sand wasps that hunt caterpillars and day-flying crimson-and-black burnet and cinnabar moths.

Further inland lie the damper dune slacks, where rainwater sometimes accumulates to provide shallow breeding pools for rare natterjack toads. There are moisture-loving floral gems here, too, including the exquisite grass of Parnassus, with blooms that look as though they have been sculpted from the finest porcelain, and exotic marsh helleborine orchids. Beyond lies dune scrub, often an impenetrable tangle of orange-berried sea buckthorn and fragrant wild roses that provide a haven for migrant birds in spring and autumn.

Perhaps the most evocative times to visit are at opposite ends of the day. Arrive at dusk to listen for the strange rasping croak of natterjack toads, and perhaps catch sight of a short-eared owl hunting for voles. Come back soon after dawn and you'll find the dew-covered sand criss-crossed with tracks of resident animals that spend the heat of the day hidden from view. Look for footprints of rabbits and foxes, the telltale sinuous trail of a lizard dragging its tail in the sand and the tiny tracks left by beetles struggling to maintain a foothold on unstable slopes. The imagination can reconstruct little dramas that must have occurred here by night.

Preserving Vulnerable Habitats

There are dune systems within easy reach along much of our coastline. They are among the few remaining genuinely natural habitats in Britain, but are vulnerable to a variety of threats. The most insidious is climate change, because rising sea levels combined with storm surges can

Sand dunes stabilse coastlines and provide unique wildlife habitats, such as here on Tresco, Isles of Scilly.

undermine the seaward side of dunes overnight, sweeping away hundreds of tonnes of sand.

Yellow dune 'blowouts', usually caused by loss of marram grass – either through natural causes or the pressure of hundreds of people who flock here on summer days – are the result of wind scouring away sand that's no longer stabilised by plant roots. It's so tempting to 'dune surf' down the loose sand on the steep seaward-side slopes of high dunes, but this can be all that is needed to open it up to scouring winds that can whisk away what nature has taken many decades to build, burying the rich fixed-dune biodiversity. Carefully managed replanting of marram can restore the damage, but it is a very slow process.

There is pressure on dunes from the landward side, too. This can come from agricultural run-off and pesticide contamination, while invasive dune scrub sometimes needs to be kept in check by carefully managed grazing. In some places, conifer forestry has encroached on to the fringe of dune systems. But perhaps the biggest threat from this direction comes from developers in the leisure industry, who see coastal dune systems as prime locations for caravan sites and new golf courses.

The golden rule for visiting sand dunes is to stick to obvious footpaths or boardwalks that have been built across popular locations to minimise the erosive impact of passing feet. Pay heed, too, to signs warning visitors away from particularly sensitive areas, where marram grass replanting has taken place or where seabirds are nesting. Some of our rarest breeding birds, such as the little tern

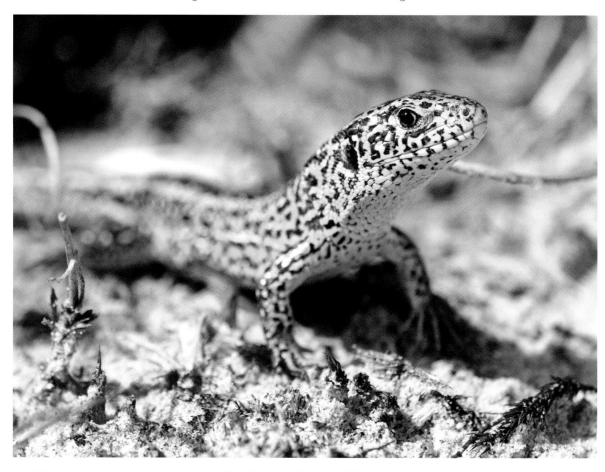

Scuttling among the dunes, a male sand lizard reveals his magnificent breeding colours.

and ringed plover, nest along dune edges just inland from the strandline; this is their home, and an inconsiderate walker or a dog that isn't under control can ruin their chances of nesting successfully.

Sand Dune Field Guide

SAND LIZARD *Lacerta agilis*
One of our rarest and most beautiful reptiles, the sand lizard digs narrow tunnels in dunes for winter hibernation. The flanks of courting males turn bright green in spring. It buries its eggs in sand, in sheltered dune hollows, where the eggs depend on the sun's warmth for their incubation.

AUTUMN LADY'S-TRESSES *Spiranthes spiralis*
The last native orchid to flower, and unmistakable with its 15cm (6in)-tall spikes of white florets twisted in a spiral, like braided hair. It cannot survive competition from tall grasses, so look for it in the short, flowery turf in fixed dunes.

STONECHAT *Saxicola rubicola*
This robin-sized bird likes to perch on the highest bushes in the dunes, flicking its wings then darting down to the ground to catch insects. It sometimes nests in the protection of prickly gorse bushes in the dune scrub. Its call sounds like two stones being tapped together.

MARRAM GRASS *Ammophila arenaria*
Its mass of fibrous roots can grow over a metre deep, stabilising the sand in yellow dunes. The tough, spikey foliage traps windblown sand, building dunes. During the driest periods, the leaves roll up, preventing water loss from pores on their upper surface.

SEA ROCKET *Cakile maritima*
Produces seeds in buoyant pods that act as lifeboats and are carried by sea currents, then wash up to germinate on the strandline. Fleshy leaves and masses of lilac flowers attract bees and butterflies, while the plant traps windblown sand and begins building dunes.

BITING STONECROP *Sedum acre*
Carpets patches of fixed dunes, where its small, succulent leaves allow it to store water and survive drought. Broken, leafy fragments can quickly regenerate into new plants. The plant sometimes blooms in such profusion that it disappears under a layer of star-shaped yellow flowers.

HOUND'S-TONGUE *Cynoglossum officinale*
A tall, hoary-leaved biennial, often growing in the fixed dunes. Flowers the colour of dried blood are often described as smelling of mice, although their aroma has been likened to roasted peanuts. Its hooked seeds are dispersed in rabbit fur.

PYRAMIDAL ORCHID *Anacamptis pyramidalis*
With its densely packed pyramids of pink flowers, young inflorescences resemble small strawberry ice-cream cones. Most commonly found between marram and lyme grass, where yellow and fixed dunes merge. Flowers have long, slender nectar spurs and a slightly foxy scent at dusk, attracting long-tongued moth pollinators.

GRAYLING BUTTERFLY *Hipparchia semele*
Our largest brown butterfly, but surprisingly difficult to spot when it settles and quickly closes its wings, thanks to the cryptic colouring of its undersides. The caterpillars feed on various grasses, including marram.

SAND WASP *Ammophila sabulosa*
Hunts caterpillars, which it paralyses then carries back to its nest hole excavated in the sand to feed its developing larva when it hatches. The wasp temporarily closes the nest tunnel until fully provisioned.

A Guide to Cliffs

Ian Vince

As July advances, more and more of us make a bee-line for the beach to enjoy a day beside the seaside. But there's more to the coast than just sandcastles and ice-cream cones (important as they are). The sea is endlessly fascinating, especially now it has calmed down enough to stop taking huge chunks out of the shoreline, as is sometimes the case in winter. But there are interesting details to note when you turn around and appreciate the hinterland, because for most of our islands' 10,000km (6,000 miles) of coastline, you'll be looking at a cliff.

The cliffs around our shores tell us a lot about the processes that have shaped our islands, and even a cursory study of the various forms they take can be fascinating. Cliffs are usually the products of gradual erosion but sometimes can also be the scene of extraordinary rock falls and landslides, and nowhere are there better examples of this mix than the south coast of England.

Slip of the Land

The highest cliffs on the English Channel are those of Hardown Hill near Charmouth, or, to use its more celebrated name, Golden Cap, which stands at 191m (637ft) above the beach. At the midpoint of the Jurassic Coast, the area's geology makes landslips and rock falls common, especially after wet weather.

Landslips occur when a porous layer of rock – sandstone, chalk or limestone – overlies an impermeable layer, usually of clay. The water percolates through the porous rock and then lubricates the top of the clay until the rock on top slides away. There's a spectacular example of a landslip between Lyme Regis and Seaton, halfway up the cliff. A 9km (5-mile)-long coast path that hugged the 'undercliff' here formerly ran all the way through this National Nature Reserve, an amazing landscape known locally as the Elephants' Graveyard, but it's now closed for much of its length because of further slips. See southwestcoastpath.com for the latest news.

Rock falls are the product of more gradual processes than landslips and part of the evolution of the coastline that forms caves, arches, stacks and stumps in the piecemeal retreat of the cliff-line. Caves form when wave action erodes a weakness in a cliff and when caves are on a headland – like those along the coast around Lulworth Cove.

The erosion can work all the way through to make an arch, such as the famous formation at Durdle Door or the Green Bridge of Wales on the Pembrokeshire coast. When the arch roof collapses, a stack remains, and when the stack is undercut it leaves a stump, which is usually covered at high tide.

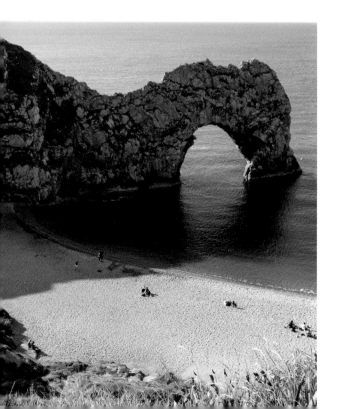

The famous arch of Durdle Door in Dorset is a rare example of a cave eroded and hollowed by waves.

OPPOSITE: *The lonely Black Church Rock in North Devon is a fragment of cliff – known as a stack – isolated by the action of the sea.*

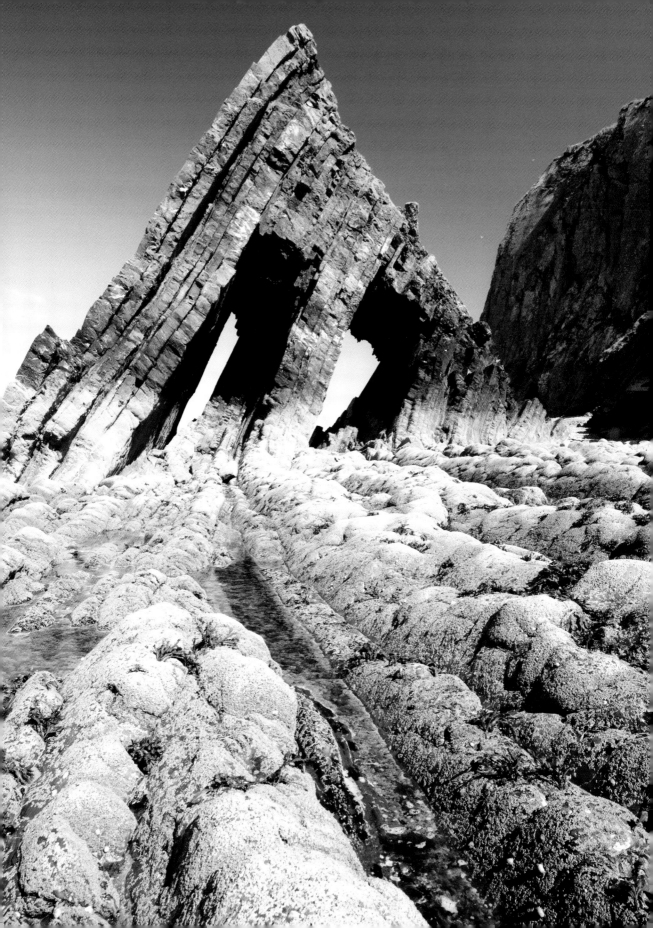

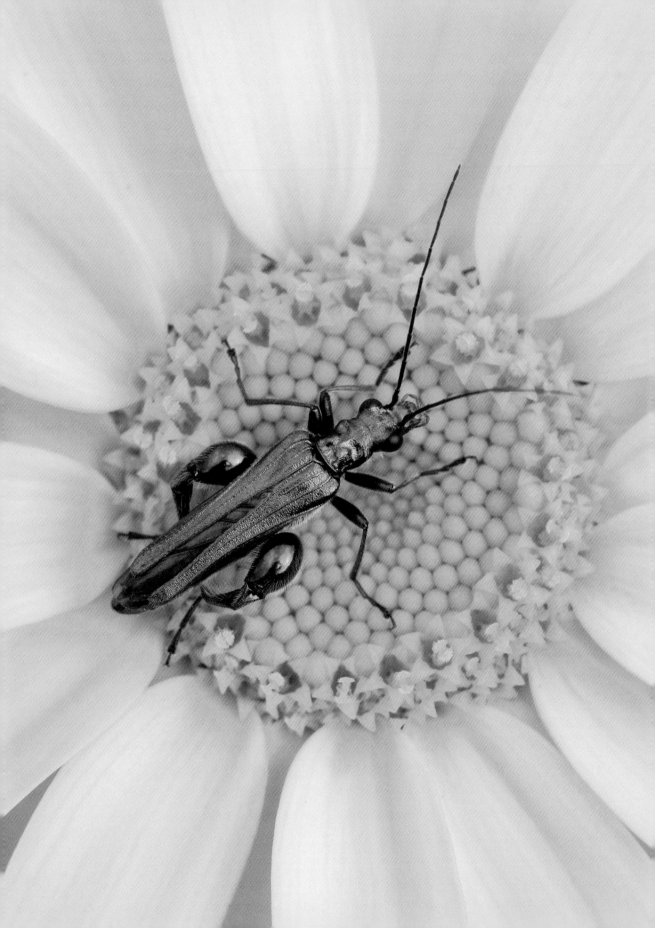

Insect Pollinators

Richard Jones

Most of our native flowers rely on nectar-hungry insects in exchange for pollen redistribution. Honeybees and bumblebees often get the credit, but there are many more creatures doing this necessary work.

Common Pollinators

SILVER Y MOTH *Autographa gamma*
This regular migrant from Europe is unmistakable, with a tufted thorax ridge and vibrant white 'Y' mark on its forewings. Easily disturbed into rapid low wing-blur flutter, it will knock pollen everywhere.

HOVERFLY *Chrysotoxum cautum*
One of many striking yellow-and-black wasp-mimicking hoverflies, this has large ruby eyes, porrect (forward-facing) antennae and a broad abdomen. Fond of basking on sunlit leaves.

MARMALADE HOVERFLY *Episyrphus balteatus*
Slim with an orange abdomen, this has a distinct black moustache marking on each segment. It's a superb hoverer, but lands on flowers to feed, collecting pollen with short blobby mouthparts. Ubiquitous, and one of our commonest insects.

FLY *Phasia hemiptera*
This denizen of damp meadows and hedgerows has a distinctive fat abdomen and short brown/black wings. Females lay eggs in bodies of shieldbugs, inside which the developing parasitic grubs feed.

TREE WASP *Dolichovespula sylvestris*
Very similar to the common wasp, but its face is longer and narrower. An important pollinator of figworts and helleborines, it attacks flies, caterpillars and aphids, feeding chewed bug parts to its young.

The aptly named thick-legged flower beetle forages for pollen in a dandelion head.

ASHY MINING BEE *Andrena cineraria*
One of many species of solitary bee. Females make small burrow nests in the soil and stock a few cells with a pollen-nectar mix for their grubs. It has a short flight period from April to June.

SOLITARY BEE *Colletes succinctus*
This makes individual nests in sandy ground and visits a variety of plant species for pollen and nectar. The pale abdomen bands are thick bars of broad feathery frond-like hairs.

FALSE OIL BEETLE *Oedemera nobilis*
Handsome, shining metallic green. The male has stoutly thickened hind legs, perhaps used for mate-grasping or fighting off rivals. Adults fly between flowers, collecting pollen.

RED SOLDIER BEETLE *Rhagonycha fulva*
The male has smaller, more bulging eyes than the female. Pairs stay coupled for hours. The soft grey velvety larvae are secretive predators of small invertebrates in root thatch and loose soil.

Unlike most of its moth cousins, the silver-y moth will frequently fly during daytime.

Dragonflies, Demoiselles and Damselflies *Richard Jones*

No lakeside stroll is complete without the rattle of dragonfly wings across the reeds and rushes. These large colourful insects are both brazen and yet also flighty. They have superb all-round vision for hunting their flying insect prey, but are easily spooked – stand stock-still and you will often see them return to the same stem perch or resume their regular patrol up and down the hedgerow or streambank.

Common Species

EMPEROR DRAGONFLY *Anax imperator*
Britain's largest species, up to 78mm (3in) long, is a brightly coloured dragon with an apple-green thorax and a continuous blue stripe along its tail if male or a green stripe if female. Very active, it flies with its tail slightly held down and rarely settles except in cool weather. Found across England and Wales, scattered in Scotland.

SOUTHERN HAWKER *Aeshna cyanea*
Large (length to 70mm/2¾in) and brightly coloured, this hawker has broad green bars on its sides and thorax, and a distinctive pale golf-tee mark on its first tail segment. The male is dark with apple-green or blue dots down its body; the female is browner with green marks. Common throughout lowland Britain.

BROWN HAWKER *Aeshna grandis*
This huge hawker (length to 73mm/3in) has dark, smokey-brown wings, visible even from afar across open water. It usually breeds in large lakes, but will fly many kilometres from water to hawk up and down woodland edges, rides and hedges. Common in England, it is scattered in Scotland, Wales and Ireland.

BROAD-BODIED CHASER *Libellula depressa*
Medium-sized (length to 48mm/nearly 2in) but highly distinctive, this has dark wing bases and a broad, flattened body – powdery blue in male, brown in female – edged with yellow spots. Common in gardens, it breeds in streams, ponds, ditches and lakes. Found across England and Wales, with inroads into southern Scotland.

COMMON DARTER *Sympetrum striolatum*
Medium size (to 43mm/1½in), the darter has a narrow body – red in male, brightening for days after emerging; brown or straw-yellow in female. It sometimes perches with its tail up in the air. Often the last species to be seen, well into November, it is found in all water bodies across Britain except the highest Highlands.

BANDED DEMOISELLE *Calopteryx splendens*
Medium (length to 45mm/1¾in), this demoiselle has a fragile, narrow body, emphasised by its gentle fluttering flight. Metallic bluish body in male, green in female, it often settles on waterside vegetation along slow, muddy-bottomed streams. It is found in England and Wales, scattered in Scotland and Ireland.

BLUE-TAILED DAMSELFLY *Ischnura elegans*
Small (length to 31mm/1¼in), narrow, fragile and delicate, this flies secretively through waterside vegetation. It is black with a pale blue thorax and bar across its tail tip, while its pterostigma (lone wing-tip spot) is two-coloured on front wings. Found in any water body throughout Britain, scattered in Ireland.

LARGE RED DAMSELFLY *Pyrrhosoma nymphula*
This small damselfly (length to 36mm/1½in) is bright red with black wing-spots. The male's abdomen is all red; the female's is barred lighter or heavier with black. It is often found in large numbers around water bodies, including ponds, meadowland dykes and peat bogs. It is perhaps the most widespread species in Britain.

Azure damselflies show off the delicate abdomen and folded wings that differentiate damselflies from dragonflies.

Wildcats

Amy-Jane Beer

In a tumbledown shed in the Clashindarroch Forest in Aberdeenshire, a wad of hay has been stuffed into an old feed trough. A well-packed circular impression suggests a regular occupant, and this cosy bed may belong to a free-living Scottish wildcat.

The Scottish wildcat is the UK's rarest and most threatened native mammal, a distinct type of the European wildcat and a close cousin of the smaller Middle Eastern wildcat, from which domestic cats are descended. It was persecuted to the brink of extinction in the nineteenth and twentieth centuries, but made a slight recovery when game-keeping declined after the two World Wars.

Contrary to popular imagination, wildcats are not naturally creatures of high mountains or deep dark woods. In truth, they are edge-lovers – favouring forest fringes, rocky rough ground, and low-intensity farmland.

Wildcat ranges are dictated by the seasonally changing needs of females. A mother may den in a rocky cairn or outcrop, safe from foxes, dogs or badgers, then move her family to a secluded area of forest when they're old enough to begin exploring. Within the area she needs access to food – mainly rabbits, voles and ground-nesting birds – and a network of linear features such as hedges, walls, ditches and dykes, whose cover allows her to traverse the land unnoticed. Male cats live where females do, their larger ranges usually overlapping those of several potential mates.

Persecution may have waned, but the species' decline continues as a result of a more insidious threat. Wildcats are not the only cats in the Highlands. The region is home to many thousands of feral domestic cats, strays and free-ranging pets, all of which are able to interbreed with Scottish wildcats and produce viable offspring. Often these no-name hybrids

Once common across the whole of Britain, the wildcat is reduced to fewer than 300 individuals in the wild.

have a look of wildcat to the untrained eye, but they are genetically diluted. The percolation of domestic genes deep into the wildcat population is extinction by stealth.

In 2019, a landmark report by the International Union for Conservation of Nature said the Scottish wildcat population was close to being functionally extinct because of the loss of genetic integrity and population decline. Its wild population, estimated then to be about 30 animals, was found to be 'no longer viable'. Eleventh-hour conservation was needed.

In 2023, the Royal Zoological Society released 19 young wildcats into a secret location in the Cairngorms, protected by CCTV cameras. Each has been fitted with a GPS tag so their movements and behaviour can be tracked. The project also provides extra food, to supplement their normal diet of rabbits, voles and mice.

One of the wildcats has since died, but the rest appear to be thriving and are venturing away from the release site, though it will be several years before the project's success can be evaluated.

When is a Wild Cat a Wildcat?

The most reliable means of identifying a cat's ancestry is DNA analysis, but this takes weeks – little use in the field. So the team relied on physical characteristics. Typically, wildcats are bigger than domestic cats, more muscular and much more densely furred, especially in winter. The gait is prowling – more like that of a tiger than a pet cat – and the attitude is feisty. The tail is thick with a blunt tip. A study of skulls suggests wildcats have a larger cranial capacity and a larger brain than their domestic cousins, but their guts are shorter, perhaps because their diet is more meaty.

But the method used in the field is 'pelage scoring', which uses coat markings to score an individual out of 21. Any cat scoring 17 or higher is regarded as a true wildcat, and such cats have been shown to have mostly wildcat ancestry.

Summer Currants

Clare Hargreaves

Amid all the excitement over strawberries, raspberries and blueberries, it's easy to overlook some of our most traditional and nutritious summer fruits – currants. Blackcurrants, redcurrants and whitecurrants are vibrant jewels that no summer pudding would be the same without.

Perhaps part of the reason they're overlooked is that these quintessential summer fruits need a modicum of preparation and are often a bit too tart to eat raw, so benefit from a few minutes of cooking with some sugar to draw out their deep flavours.

But those are small niggles when you consider their nutritional virtues. In particular, blackcurrants are a rich source of vitamin C and a powerful antioxidant.

Interestingly, the blackcurrant took much longer than the redcurrant to win its way onto the British table. Red- and whitecurrants have been grown in British gardens since the 1500s, and for a few centuries reigned supreme. The blackcurrant, considered inferior in flavour, didn't make a significant appearance until the eighteenth century. Only when sugar became a cheap commodity, and the blackcurrant was turned into jam, did its fortunes turn. Consumption of all currants diminished in the nineteenth century, however, with the arrival of large varieties of raspberries and strawberries. Currants thrive in the UK because they like cool weather and tolerate shade, conditions that promote acidity and ensure the fruit ripens slowly. It's no coincidence that many currant varieties were developed in Scotland. A cold period of dormancy during winter is vital, which is why growers are increasingly concerned about climate change. They fear that bushes may awaken too early, only to be killed off by late frost. So growers are now

A redcurrant bush dripping with ruby-like berries. But harvest them quickly or the birds will get there first.

using varieties that can cope with warmer conditions.

Because they are expensive to harvest commercially, currants can be difficult to find in supermarkets. But they are abundant at farmers' markets. They are also easy to grow – stick in a bush in November, and you'll be plucking fruits by the punnet-load the following summer.

Redcurrant

- Use the juice to make redcurrant jelly, superb with lamb or game. You can also use the jelly to enhance the flavour of gravies, casseroles and piquant sauces.
- Use in a summer pudding.
- Add the juice to rum and brandy and create a fruity cordial called a shrub. Just keep back some of the juice after straining redcurrants when making jelly and use to make this easy tipple.

Blackcurrant

- The blackcurrant's intense flavour makes a wonderful jam. It's an ideal fruit for beginner jam makers as its high level of pectin means that it sets easily.
- Essential in a summer pudding.
- Makes a refreshing ice cream or sorbet.
- Bottle blackcurrants by topping and tailing, washing and draining before packing into jars in a syrup, water or brine solution.

Whitecurrant

- The whitecurrant is an albino cultivar of the redcurrant, and as such makes a delicious pale pink jelly. It also performs the same role as the redcurrant in a summer pudding.
- Use the juice as a substitute for lemon juice.
- Use as an eye-catching decoration on the top of a chocolate cake or pudding.

Beetroot
Clare Hargreaves

If you were put off beetroot by vinegar-soaked slabs with crinkly edges served at school, please give it another chance. Prepared properly, it's not only delicious, but amazingly versatile, too. By early summer, you have crunchy purple globes that you can juice, munch raw or lightly boil and throw into a salad with olive oil.

Then, later in the year, up until November, you have tennis-ball-sized beets that are lovely boiled or roasted, or turned into a warming winter borscht-style soup.

And what colour! The root's ruby-red hue gives rise to evocative variety names such as the curly-leaved and flavoursome 'Bull's Blood' and an ancient French variety called 'Rouge Crapaudine'. There are also golden and white varieties, and others, such as 'Cheltenham' beet, with the shape of a carrot. There's even a candy-striped variety called 'Barabietola di Chioggia', which has wonderful pink and white circles within it. When cooked it's wonderfully sweet.

In Britain, we tend to bin the leaves, which is strange, especially when you consider that man has been eating the leaves (known as leaf beet) for thousands of years and we've only been eating their swollen roots since the sixteenth century. This 'modern' practice probably began in Italy, which is why, until Tudor times, people referred to them as Roman beets.

John Gerard, in his famous *The Herball or Generall Historie of Plantes*, first published in London in 1597, talks excitedly of 'white' (that is, leaf) beet, and 'another sort… that was brought unto me from beyond the seas', whose 'red and beautiful root (which is to be preferred before the leaves, as well in beautie as in goodnesse) I refer unto the curious and cunning cooke, who no doubt when hee had the view thereof, and is assured that it is both good and wholesome, will make thereof many and divers dishes, both faire and good.'

Turn Over a New Leaf

In early spring, enjoy beetroot's tender, sweet, vitamin-rich leaves in salads, and when they're a little older, lightly steamed and served with meat or fish. They taste very like spinach, in fact, except that the stems are party pink. Talking of stems, some chefs use them as an eye-catching 'pink spaghetti' garnish.

Most of the beetroot that we eat in this country is homegrown – around 55,000 tonnes is produced in the UK each year, most of it the high-yielding 'Pablo' variety. It might sound a lot, but it's not when compared to France, which grows 95,000 tonnes, and Poland, which grows a phenomenal 356,000 tonnes. We Brits, it seems, still prefer our carrots, onions and spuds.

Health wise, we could be losing out, as beetroot has recently been found to have high levels of antioxidants, especially if raw. Finely grated beetroot makes a great salad to accompany a quiche.

To cook beetroot, roast or boil the beets with skins on, to prevent the sweet purply juices from leaching out. If you don't have time or patience for cooking, you can buy cooked beetroot in packs.

A great way of eating cold beetroot is with goat's or feta cheese, or with horseradish and/or smoked mackerel. Roasted beetroot is great with white meat, with salmon or trout, or in a tart.

Beetroot also gives colour, texture (and virtue) to brownies – simply grate a cooked beet into your mixture. Indeed, it's a deliciously versatile vegetable. Just keep it well away from the vinegar bottle.

Easy to grow and incredibly versatile, the beetroot deserves its place on the veg plot.

Chalk Figures

Dave Perrett

There are more than 50 chalk figures in the UK, with many more reclaimed by nature over the years. They are largely located in lonely wildflower-dusted downland landscapes that are also home to prehistoric barrows, henges and hillforts. So it's not surprising that most chalk figures are commonly thought to be equally ancient. Many theories have been bandied about over the years – perhaps they were crafted to celebrate a victory in battle or to signify a local landowner's or tribe's power. For example, the 33m (108ft)-tall Westbury white horse may have been the site of the Battle of Ethandun, an 878CE victory for local hero Alfred the Great over the Danes that saved the Saxon kingdom of Wessex.

Disappointingly, as with many chalk figures, the Westbury white horse may not be as ancient as it seems. The earliest reference to it dates from 1742, though when and why it was actually cut are a mystery. What is for sure is that the current plump, stationary beast was etched in 1778 from an original carving that faced in the opposite direction and looked more like the famous Uffington white horse in Oxfordshire.

While some chalk figures' ancient roots are sketchy, Uffington is a truly ancient, nationally significant monument. At 40m (130ft) high and 110m (360ft) long, it's also the largest white horse in Britain. Its curved, flowing form is much more graceful than the other horses. It's thought that white horses signified heroic warriors or fertility, and this horse could have been a sign to the gods or a territorial marker.

However, it may not always have been a horse – indeed, retired vet Olaf Swarbrick believes it was once a dog. He wrote to the Veterinary Record in 2010 appealing to his fellow professionals to validate his claim that the horse had the form of a hunting dog.

The Osmington White Horse depicts George III (1760–1820) and was sculpted in the Dorset limestone in 1808.

But it has been a horse since at least the late eleventh century, when it was first recorded. There is no doubt though that the carving has been around for much longer than 1,000 years. Originally, archaeologists thought the horse was Iron Age or Anglo-Saxon, but modern soil testing has since dated it to the late Bronze Age, around 3,000 years ago, making it the only definitively ancient British chalk figure.

The Long Man

Of course, not all chalk figures are horses. With his dual staffs and minimalist features, the Long Man of Wilmington, East Sussex, is the largest depiction of the human form in Britain at 69m (226ft) tall. It is not known whether his plain looks are a result of design, wear and tear or re-cutting over the years, though there are several old sketches and written accounts that the man once had facial features and different feet positions.

The earliest-known drawing, from 1710, has the man holding the staffs we see today and his feet pointing in opposite directions from each other, while a later drawing from 1776 sees him with facial features and a rake and a scythe instead of staffs. His origins are equally cloudy – even after he had been recorded, his presence was disregarded in many written records of the area until the end of the nineteenth century.

Many have believed him to be ancient, but he was probably cut in the sixteenth century. A 2002 archaeological study of chalk fragments on the slope, by Professor Martin Bell of Reading University, revealed a sudden change about 500 years ago, which could have seen the birth of the Long Man.

We may not know all the answers about many of our chalk figures, and the answers that we do have may not be as shrouded in ancient mystery as we'd like to believe, but that's exactly why we should look at them – serenaded by skylarks and yellowhammers – with an enduring curiosity. They are relicts of a bygone age.

Roman Roads

Ian Vince

Known as Quintilis before Julius Caesar modestly renamed it in his own honour, the month of July is a fitting time to consider one of the most striking features of the British historic landscape, the Roman road. Although there are about 3,200km (2,000 miles) of them shown on Ordnance Survey maps, estimates of the total length of the network – including presumed minor thoroughfares undiscovered across Britain – could expand it to around 10,000km (6,000 miles).

Roman roads were built as logistical tools of empire, to move legions and supplies at speed and, in some cases, to scare the willies out of the locals. Ackling Dyke on the chalk upland between Martin Down, Hampshire, and Blandford Forum, Dorset, strides out across the landscape on an overstated, 1.8m (6ft)-high embankment that shows utter contempt for the barrows and dykes it ploughs through.

The bank – or agger – of the road, though exaggerated, is of a typical layered construction; indeed, the Latin word for layers, *strata*, gave us the word street, an Anglo-Saxon place name often found along the course of Roman roads. This can be found in names of settlements such as Stretford, Stratford, Church Stretton, Stony Stratford and… er, Street.

In Europe, the maxim holds that 'all roads lead to Rome' while in Britain, they tend to radiate from London. The Fosse Way – between Exeter and Lincoln – goes against the grain, however, and may have even started as a defensive structure during the early years of the Roman invasion, then adapted later as a road. Much of it survives today as a taut thread of primary and secondary routes through a tangle of English country lanes.

Despite their reputation for straightness (between Ilchester and Lincoln, a distance of 290km (180 miles), the Fosse Way never deviates more than 10km (6 miles) from the crow's flight), pragmatism forced Roman architects to make more concessions to the landscape over time and the Roman road eventually learned how to bend.

Stanegate, which crosses the Pennines south of Hadrian's Wall, is one such winding road. It connects at Corbridge with Dere Street, the most easily traceable Roman route into Scotland. Given that there's evidence of Roman activity as far north as Stonehaven and claims of a fort at Inverness, there are likely to be many more long-forgotten roads hidden in the remote straths and glens of Caledonia.

The Fosse Way linked the legion headquarters of Lincoln and Exeter in Roman times and survives as a series of straight roads today.

OPPOSITE: *Resembling a farm track today, this is Beggarmans Road, a Roman road in the Yorkshire Dales.*

Orkney

Jo Tinsley

Lying 16km (10 miles) off the most northerly tip of Scotland, the 70 islands that make up Orkney have fascinated visitors for centuries, from the Viking invaders who settled here 1,200 years ago to the 200,000 or so visitors who flock to the archipelago each year for the archaeology, wildlife and burgeoning art scene.

Until recently the journey was epic and expensive, but flight connections now mean that Orkney is more accessible, and affordable, than ever. Overland the journey is more adventurous and ferries are affordable. But don't let this newfound accessibility fool you; travelling to the extreme edge of Britain still feels like you're stepping off the map. At 59° north, Orkney lies on the same latitude as Oslo and St Petersburg. In June the sun dips below the horizon for just five hours a day, while on winter days Orkney descends into darkness for 18 hours as the heavens strobe with northern lights.

Culturally, Orkney feels a million miles away. The dialect owes more to Old Norse than it does to Gaelic – not surprising when you think the Scottish only gained power here in 1468. It's this geographical and cultural isolation that makes the archipelago so distinctive. It seems familiar yet foreign, and in many ways it feels more Scandinavian than Scottish. Luckily, the Gulf Stream keeps the climate mild, and average temperatures differ by just 10°C between seasons. It's perhaps because of these mild conditions that people have prospered here for thousands of years. The Neolithic village of Skara Brae predates Stonehenge, and Stone Age people thrived here long before the Vikings arrived in the ninth century. This history is (literally) never far from the surface and the countryside is riddled with archaeology. Every few years a storm exposes a Neolithic village or a farmer's tractor wheel falls into the remains of a chambered cairn, while ancient monoliths stand nonchalantly in back gardens.

Rare Magic

The Orcadian landscape has a quiet drama. The mainland is gently undulating and green, scattered with low-lying farms and crisscrossed with dry-stone walls. It doesn't have the desolate grandeur of Shetland or the superlatives of the Highlands, but there's something magical about it nonetheless.

The ancient occupants have certainly left their mark. The Ring o' Brodgar is the third-largest stone circle in Britain (after Avebury, Wiltshire, and Stanton Drew, Somerset). Folklore says these are the remains of a gang of giants who danced the night away, only to lose track of time and turn to stone with the first rays of the sun. Only 27 stones remain, but it is thought that there were once 60. Nearby is 5,000-year-old Maeshowe, the finest chambered cairn in western Europe. The mound itself is 37m (121ft) in diameter and more than 7m (23ft) high, and on the winter solstice the sun sets between the two hills of Hoy and aligns exactly with the 9m (30ft)-long entrance passage to flood the chamber with light. Inside, the walls are scrawled with Viking graffiti, left by Norse crusaders seeking shelter from a snowstorm in the twelfth century.

A Windswept Welcome

It would be fair to say Orkney doesn't always make things easy for you. The weather can be temperamental, to say the least. The first thing you will notice is the wind – a steady buffeting that makes even the sunniest day seem chilly. What you do get, however, is light (19 hours of it in summer), four seasons in one day and a community of people who are complacent about rainbows. It's when these elements kick up a fuss that Orkney's raw beauty comes through, as great waves roll in from the Atlantic and fulmars waltz in the air.

Climbers flock to Yesnaby Stack, a dramatic tower of sandstone off the coast of Orkney.

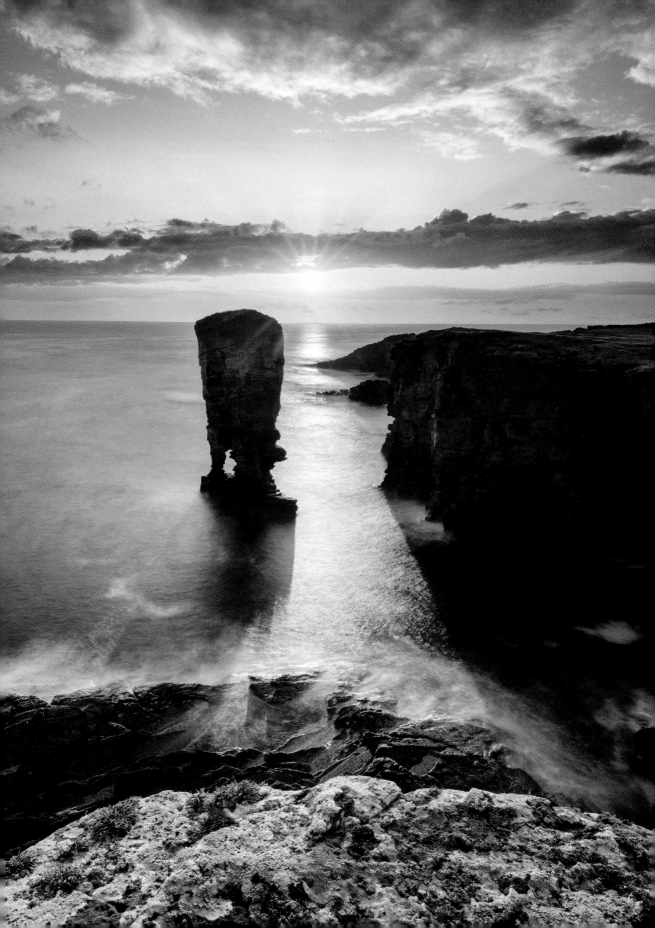

The River Thames

Ben Lerwill

In summer, it starts as a shallow furrow in the grass. Not yet a stream, much less a river, its course doodles a soft line across the land, little more than a dry groove lined with nettles. For miles, this thin green strip curves past low copses and tucked-away villages, still waterless, biding its time. Then, without warning, the presence of some unseen spring brings to life a slight but palpable waterway. The current is slow, clear and ankle-deep. And away it flows.

The Thames is one of Europe's great rivers. Churchill called it 'the golden thread of our nation's history'. For many, it's synonymous with London, where its wide brown waters provide a focal point amid the rush and pomp of the city. It backdrops the Houses of Parliament, surges past the Square Mile and gives Tower Bridge its reason for being. It is a river of heritage, trade and power. But that's hard to remember when you're standing some 280km (175 miles) upstream in a windblown field in Gloucestershire

The Gloucestershire town of Lechlade is where the wild infant Thames becomes a broad navigable river.

and can't even discern the presence of H_2O, let alone the distant dome of St Paul's.

It's a real treat to walk the earliest sections of the Thames Path, the national trail that leads from the Cotswolds to the capital. The path follows the fledgling Thames from its source as far as Oxford, shadowing the river as it loops through rural parts of Gloucestershire, Wiltshire and Oxfordshire. It's an on-foot journey of around 88km (55 miles). The majority of the trail runs parallel to the river, along the edges of quiet water meadows. Congestion out here translates as a view with more than one cow in it.

The Source of the Magic

But back, for now, to that Gloucestershire field, home to the river's source and the official start of the walk. This is Trewsbury Mead, otherwise known as Thames Head, where the grass is long, the hawthorn bushes are unruly and there's not so much as a trickle of groundwater to be seen. It's only a couple of kilometres or so from Kemble railway station.

Near the trailhead look out for roe deer – they're common in this part of the country – which are likely to eye you cautiously then skitter into the trees, caramel coats gleaming. And under a large ash tree at the field's northern edge, you will find what you're looking for – a pale, timeworn marker inscribed as follows: 'This stone was placed here to mark the source of the River Thames.'

The claim, however, is contentious. Some hold the true source to be 17km (11 miles) or so further north at Seven Springs, a spot both higher in elevation and further from the estuary. In 1937, the matter was raised in parliament, to little effect. The counter-argument is that the stream emanating from Seven Springs has always been named the River Churn, and should therefore be seen as a tributary of the Thames, rather than its source.

Interestingly, were the Thames to be measured from Seven Springs, those extra kilometres would make it the longest river in the UK, an honour currently held by the Severn.

It seems unlikely that Old Father Thames, whose statue reclines at St John's Lock midway along the walk, would concern himself with such trivialities. What's beyond any doubt is that the Thames Path itself begins at Thames Head. It's a bright August day and 88km (55 miles) stretch ahead. There's a river to follow.

Beautiful Path

There are few things more pleasant than walking a national trail. They tend to be reassuringly well signed (how many thousand acorn-adorned fingerposts must dot the British landscape?) and carry too a kind of tacit guarantee of quality. As a walker, you know to expect good things. Whether you're walking the full trail or only a part, with friends or on your own, you'll feel confident that you're being ushered into familiar arms.

By its nature, the Thames Path is an almost consistently flat walk. The drop in altitude between the source stone and Oxford is just 40m (130ft) or so. The views throughout are deep, rural and largely untroubled by hills. But forget notions of monotony. In its evolution from soggy ditch to handsome river, the Thames reveals radically different sides to its character. On the first afternoon you'll be walking next to a shady, overgrown watercourse, its slim channel twice lit up – thrillingly – by the blue blaze of a kingfisher. By the fourth, you'll be watching fairground-lettered narrowboats ease past 40-strong flocks of greylag geese.

The route is a sedative one, a world of wheat fields, willows and church spires. On the second half of the walk in particular, once the river is broad enough to welcome boats and has a defined towpath, there's hour after hour of gentle meandering through open water meadows. The banks are often heavy with sloe-covered blackthorns and pink, sharp-scented profusions of Himalayan balsam. For almost a full day, you'll pass only bankside fishermen. 'Perch – loads of them,' one of them may smile, if you ask what he's catching. 'I'm staying a while,' he adds, readjusting his chair.

There are times when the intrusions of modern life are inevitable – electricity pylons, or the high-pitched rumble of bypass traffic – but the joy of a walk like this is that it transports you from the digital age. The trail leads past the mouths of tributaries with deep-rooted names – Windrush, Leach, Evenlode – where vivid-blue damselflies busy the reeds and thistledown plays on the wind. On the Thames Path, wildflowers trump Wi-Fi.

Pass through little villages such as Ashton Keynes and Castle Eaton, snapshots of stone cottages and hand-made 'hedgehog crossing' signs, and spend hours following the route as it wends among the ivy-wrapped trunks and reclaimed gravel pits of the Cotswold Water Park, its large lakes alive with mallards and grebes.

The birdlife is prolific throughout the walk. There are swallows and house martins, wrens and sedge warblers, kestrels and buzzards. And a huge number of herons, inadvertently startled from the riverside. On each occasion they flap silently, regally, away from the water and back out across the land, their great grey wings beating in slow time.

The journey even takes in two different national natural reserves, namely Cricklade North Meadow, one of Europe's finest remaining ancient lowland hay meadows (and excellent for snake's head fritillaries in the spring), and Chimney Meadows, which is peppered with butterflies: red admirals, brimstones and common blues.

A Trail of Two Halves

The walk to Oxford falls broadly into two halves. Before Lechlade, the Thames is wild, narrow and quiet, a squiggling detail on the map. From Lechlade it becomes navigable, which means locks, weirs and gaily coloured pleasure-craft. It now has presence, breadth and authority – it defines the landscape.

The locks themselves are unfailingly charming (typical scene: neatly painted steps, lock-keeper tending to camellias, Radio 2 burbling from the lock-side hut) and have had eventful pasts. Huge quantities of salt, cheese, wool and Taynton stone – a high-quality Cotswold limestone – would all have been transported along this stretch of the Thames on heavily laden barges, destined for sale in Oxford or London.

Aside from the aforementioned villages, the route passes through only a handful of other settlements. Ideally split the walk with overnight stops in the towns of Cricklade and Lechlade, as well as tiny Newbridge, covering 18 to 27km (11 to 17 miles) a day. It becomes a deeply agreeable, unhurried routine: long days on the trail, then evenings to mull them over in the pub.

Places of historical interest stud the route. Catherine of Aragon once held the manor of Lechlade, and renamed its fine church St Lawrence after a Spanish saint. The site also inspired Percy Bysshe Shelley's 1815 poem 'A Summer Evening Churchyard'. Elsewhere, William Morris's serene Kelmscott Manor sits just off the path.

Further downstream you'll pass what are reputedly the two oldest Thames bridges of all. Radcot Bridge is a three-arched span of Taynton stone dating back to the 1200s, and the similarly attractive New Bridge is only a few decades older. Both have been the site of conflict, during the Wars of the Roses and the English Civil War respectively.

At times, landowners' rights mean the path steers away from the river itself, sometimes for hours at a stretch, but these sections are generally pleasant in their own right. Thankfully, a previously unpleasant 1.6km (1 mile)-long slog along the A361 just before Lechlade has now been altered to create an attractive off-road route following the river.

All told, it is a soul-lifting walk, heading downstream among the rushes, stepping minute by minute closer to the spires of Oxford.

Once considered biologically dead, the Thames is now one of the cleanest urban rivers in the world, with 125 species of fish regularly recorded.

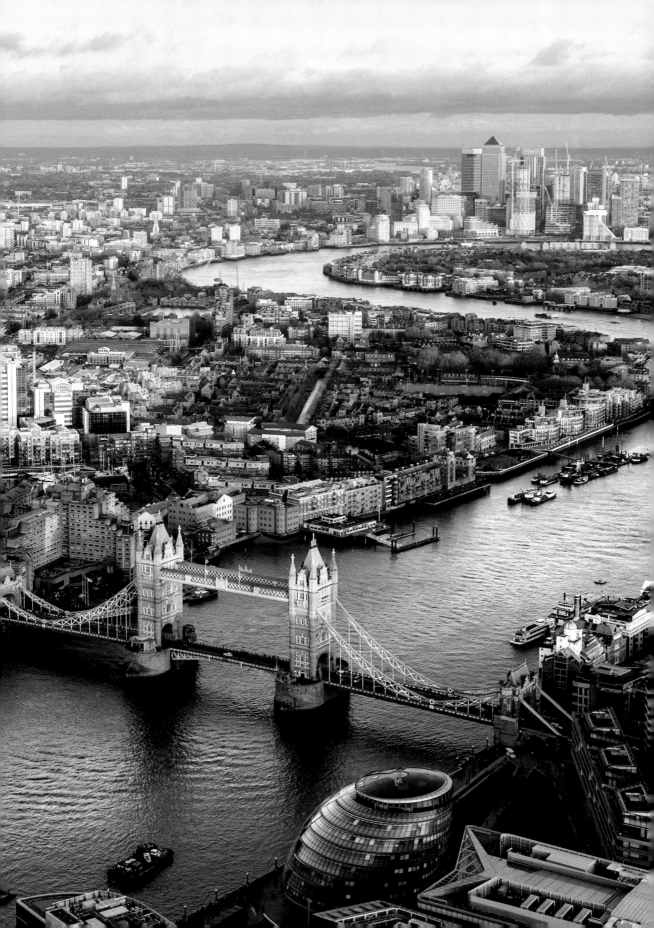

August

For everyone on Earth there is a month that has very personal significance – their birth month. Mine is August and I share my birthday with my sister who had the affrontery (though I soon forgave her) to be born on the same day but seven years later. We have the good fortune to blow out our candles with the feel of summer still in the air.

A real birthday treat in August is to take a boat out into Cardigan Bay in West Wales (the UK's biggest bay at 100km (60 miles) long and featured in the following pages) in search of bottlenose dolphins. Hopefully you will not be disappointed – I've filmed them several times lunging and leaping alongside our craft, making the most of the bow waves. After a few minutes they seem to get bored and disappear, but what an exhilarating encounter!

The bay is home to around 200 dolphins and the southern half is an important feeding and breeding area for them in summertime. And you don't have to go out to sea to spot them: I awoke in my hotel in the seaside town of New Quay, opened the curtains and to my surprise and delight saw a small group of them splashing around in the nearby harbour.

When attempting to film elusive wildlife for *Countryfile* it is very much 'fingers crossed' because usually we only have one day to get the shots we need – unlike some prestigious natural history programmes that can wait for weeks for just the right moment.

But luck is often with us and, as well as dolphins, I've been privileged to see the likes of nightingales, beavers, eagles, hazel dormice and, at the other extreme, blue whales (though perhaps that doesn't count, because I was on holiday in Mexico at the time). But basking sharks, mentioned in the upcoming section on different species of shark in Britain, have so far eluded me.

You may be surprised to read that half the wheat grown in the UK ends up not as bread but as animal feed. Where would we be, though, without sandwiches? They are named after the Earl of Sandwich who, on an August day in 1762, found himself hungry in the middle of a gambling session. As he didn't want to interrupt the game he asked to be brought some meat between two slices of bread – and look what he started.

Poppies fleck fields of flowering linseed (left) and the vibrant yellow of oilseed rape (right) – both crops are usually harvested this month.

Arable Crops *Vernon Harwood*

Fields of golden wheat rippling in a summer breeze, the sight of hectare after hectare of ripening barley or the rumbling sound of combine harvesters, carried on the still night air as farmers work late to gather in their crops…

The image of British arable farming can be a romantic one but growing crops for food is big business and its importance to the UK economy can often be overlooked. The word 'arable' can be traced way back to the Latin word *arare* which means simply 'to plough'; and centuries later we still depend on soil that can be tilled and cultivated productively to provide us with our crops.

Today, cereals alone account for about 15 per cent of all agricultural land in the UK. Cereals differ in many ways but they all have one thing in common – they need plenty of moisture and sunshine.

Common Cereal Crops

OILSEED RAPE
The bright yellow flowers of oilseed rape became a familiar springtime sight in this country from the early 1970s onwards. Forty years later, it's hard to imagine the British countryside without them. But it's after the flowers have gone that the crop earns its keep. When the pods dry out and turn brown, it's time to harvest the tiny black seeds inside.

WHEAT
Wheat is easily the number one arable crop in the UK. It's widely grown, covering about 2 million hectares (4.9 million acres) and producing a national yield of about 15 million tonnes every year. It's best known for use in milling to produce flour for bread, cakes and biscuits. But about half the annual yield is used as an ingredient in animal feed and some is exported.

BARLEY
Barley ripens more quickly than many other cereals and is much hardier in heatwaves or cold weather than wheat. The ears are surrounded by long bristles (or awns) that can look like whiskers. When the ears ripen they hang downwards on soft stems. Malting barley is crucial in beer-making and whisky production.

OATS
Most oats are sown in the autumn months, and although the grain is nutritious, when it's milled into flour it lacks gluten, so a lot ends up as animal feed, although some of the annual harvest is used in popular foods such as breakfast cereals, biscuits and even haggis. In the field, oats are easy to spot by their loosely branched open heads.

RYE
This is the new kid on the block compared with long-established crops such as wheat and barley. It's thought rye was probably a weed originally, but as agriculture spread to cooler regions with poorer soil, the plant was cultivated and developed to add to the harvest. It's particularly well suited to northern England and East Anglia.

While the oats are harvested, wildflowers such as this rosebay willowherb flourish in the field margins.

Solitary Bees

Sophie Pavelle

Few sounds are as soothing as the drowsy buzz of bees bobbing through a flower border on a warm August afternoon. Indeed, it's a sound that brings to mind those long, lazy days of summer.

Yet as familiar as bees are, it seems most of us know less about them than we might think. For example, did you know that the UK has around 270 species of bee? And, amazingly, more than 225 of these are neither honeybees, nor bumblebees.

Solitary bees, as they are known, must be one of the most overlooked groups of invertebrates, and yet they're remarkably important to us, pollinating at least 30 per cent of our food (of which more later).

What Makes Them Solitary?

The lifestyle of solitary bees differs in some obvious ways from their cousins. The highly social honeybees, for example, operate as one seamless superorganism. Many teeming individuals share one home – the hive – within which there is a clear division of labour, with industrious worker bees, male drones and a queen to lay all the eggs.

In contrast, solitary bees fend for themselves and lone females produce eggs in individual nests. With no social structure, solitary bees have no need for hives, and typically inhabit individual nests. These are almost as diverse as the species themselves, and may be made from leaves, mud or other natural materials. Some 70 per cent of solitary species are miners, boring underground burrows in patches of bare earth and lawn. From sophisticated earthen turrets to empty snail shells and bramble stems, the type of nest and seal is a giveaway to the bee species within.

Yellow-legged mining bees have two generations every year, the first between March and May, the second between June and August.

Super Pollinators

While their home life contrasts dramatically with that of their social cousins, the behaviour of foraging solitary bees buzzing around flowers might seem similar. But when you look up close, there's an important difference in their method of collecting pollen, and this makes them far more effective pollinators.

Whereas honeys and bumbles use 'baskets' on their legs to gather pollen, solitary bees have specialised leg hairs that trap pollen. It's effective – but it means that the pollen is often dropped and isn't as neatly packaged. But the resulting spillages on their travels between flowers make solitary bees more effective at spreading pollen around, fertilising the blooms that will later swell into fruit. This method is so successful that an individual red mason bee – a common solitary species – may pollinate as many flowers as 120 worker honeybees. This pollination style has a happy side effect: it is particularly good for the long-term health of the plants the bees visit. That's because solitary bees tend to spread pollen over a larger area, widening the floral gene pool, which bolsters an ecosystem's resilience to change.

Meet the Loners

So how do you recognise the species themselves? They come in many guises, with some being large like bumblebees, and others so small and black they are often mistaken for flies.

The aforementioned red mason bee is a common solitary visitor with distinctive red/ginger markings. To spot a nest, look for mud 'caps' in crumbly mortar and brickwork or hollow plant stems. It is a magnificent pollinator and a familiar sight.

One of the most common (even in cities) and easy to recognise is the tawny mining bee. Many people have these bright, furry ginger bees nesting in their lawns without even realising it. Look for little volcano-like mounds across the lawn in early spring.

The hairy-footed flower bee is one of the first to emerge in spring and is often confused with a bumblebee. The females are darker than males, and they often nest in spectacular (and noisy) hordes on cliff faces, cob walls and exposed earth. See them darting around primroses, dead-nettles and comfrey.

Sign of the Times

Conservationists regard solitary bees such as these as 'indicator species', which reveal the health of the environment. Unsurprisingly, they are not immune to the challenges facing insect life in the UK. Evidence shows that most insect pollinators – including many solitary bees – are experiencing sharp population declines. Recent studies show a 30 per cent overall decline in British pollinators, with most losses occurring among the rare specialised species: the solitary bees. The tawny mining bee has adapted to warmer winters by shifting north, but not all species will be as adaptable.

Habitat loss plays its part. Since the Second World War, Britain has lost 97 per cent of its wildflower meadows, leaving pollinators with fewer places to forage. With increasingly intensive farming and spreading towns and cities, there is more and more pressure on wild habitats.

How You Can Help

Fortunately, there are some simple ways in which you can help boost the numbers of solitary bees by attracting them to your garden or windowsill. And remember – there's no risk to you, as most solitary bees don't sting. With no honey to cultivate and defend, solitary bees are not aggressive.

So how do you attract them? 'More flowers means more bees – it's as simple as that,' says The Garden House head gardener Nick Haworth. He also suggests 'a slightly more relaxed hand' when it comes to the upkeep of your garden. 'Weeds are only weeds if you view them as such.' Self-seeding 'weeds' can be fantastic for pollinators, and if they're managed to ensure there is always something flowering in the garden, the wildlife-boosting results can be extraordinary. If your outdoor space is limited, you can still get creative. There are simple things you can do to encourage them, from offering nesting material to planting wildflowers

Solitary or social, all bees deserve our attention. It's easy to feel disheartened by the environmental situation, but nature is resilient and has bounced back from the brink before. Simple, individual actions can amount to significant change, and your garden is a perfect place to start.

Plants for Bees

With their pollination superpowers, solitary bees need a mosaic habitat. Some, however, such as the harebell carpenter, have co-evolved so intimately with flowers that they cannot survive without them. Variety is the key: plant small, open flowers and a mix of native species and ornamental varieties if possible.

Leaving corners of lawn to grow wild and allowing 'weeds' such as daisy and clover to flower is great for solitary bees. Also avoid using insecticides and pesticides, and use peat-free compost. August is the perfect time to sow, to allow plants time to germinate before winter; they will then flower the following spring.

DANDELIONS are one of the very best plants for solitary bees. Shallow landing pads and high nectar content make the flowers an ideal fuel station for short-tongued visitors.

ALLIUMS not only look sensational but are absolutely dripping with nectar in the summer. A must-have plant for any border or pot.

DAHLIAS are a fantastic autumn nectar source. Being mindful of seasonal flora is really important to nurture pollinators into winter.

CHIVES are fantastic if you let them flower, and a tasty treat for the gardener. Now there's a win-win.

Plasterer bees are so-called because they plaster the cells of their nests with a waterproof and fungus-resistant resin they produce.

Easy Ways to Help

BEE BRICKS
A stylish addition to your garden and great if space is limited. Place in plenty of sunlight on its own, or incorporate into a wall. Aerial nesters are most likely inhabitants of artificial nests, so look out for cavities sealed with mud or chewed leaves.

NATURAL NESTING MATERIAL
Offering natural nesting material takes minimal effort but reaps enormous biodiversity rewards. Think empty snail shells, patches of bare earth, winter seed heads, leafy shrubs and brambles.

HOMELY HOLES
Creating an array of cavities for solitary bees to discover and settle in can make a huge difference, as they can remain faithful to certain nest sites for many years. Drill holes into old fenceposts and log piles, or poke a few into a patch of bare earth. Different species can congregate if the site is favourable, so try to vary the length and diameter of holes.

SOMEWHERE TO DRINK
Bees need to drink too. You don't need anything fancy: a bird bath or pond is perfect, or simply a shallow dish of water.

Sharks in British Waters

James Fair

Around this time of year, Britain's red top newspapers cease consuming their normal diet of celebrity gossip and 'want-away' footballers and target an entirely different prey base. Often for just a day or two, they feed voraciously on highly nutritious stories originating from areas of Britain, such as Devon and Cornwall, popular with holidaymakers, sinking their tabloid teeth into stories that involve sharks.

And not just any sharks – the papers' sub-editors invariably attribute grainy photographs of 1.5m (5ft) dorsal fins cutting through the sea as proof that the great white shark swims in British waters.

Of course, the fins really belong to basking sharks, harmless filter-feeders that eat nothing bigger than peas and yet grow to more than 10m (32ft) in length. Only an idiot – or a tabloid journalist – would suggest that 7m (23ft) killing machines with teeth as long as your index finger and as sharp as razor blades can be found off Padstow.

Fearsome Fossil

Except, they can – or could. British shark expert Richard Peirce obtained evidence of this in 2012, after a Scottish lobster fisherman found a large, serrated tooth embedded in his creel pot. Peirce identified it as belonging to a great white – but, crucially, it was also a fossil about 10,000 years old.

This doesn't mean that this apex predator has disappeared entirely from our shores. Richard has logged about 100 sightings of great whites, of which he assesses about 10 to be credible. In July 2005, for example, a teacher called Philip Harding from the Outer Hebrides saw a 5m (16ft) shark that he identified as a great white off North Uist. 'There's no reason why we shouldn't get great whites in our waters,' Peirce says. 'They are a mirror image of the seas around South Africa, and great whites are thriving there. There are plenty of seals. They should be here.'

Other shark experts agree. Ken Collins, a senior research fellow at the National Oceanography Centre, says the problem – if you see this as a problem – is that great white numbers are heavily depleted all round the world, and Britain is already at the edge of their range. So, the odd vagrant turns up, but nothing more.

But basking sharks are definitely here. They are seen regularly off the southwest and Wales and around the Isle of Man, but the two biggest hotspots are between the Hebridean islands of Coll and Tiree and around the rocky islet of Hyskeir off the west coast of Rum.

Colin Speedie, who ran basking shark surveys for many years in the 1990s and 2000s, was the first person to prove that these two areas are, sometimes quite literally, awash with these ocean giants. 'I once saw 93 sharks in one day,' he says. 'I can't think of anywhere in the world where you can see basking sharks as consistently as you can in UK waters.'

Basking Shark or Sea Monster?

Perhaps not surprisingly, there is a rich seam of basking shark stories in British history. On 1 September 1937, three men drowned off the Kintyre Peninsula when their boat was capsized by a huge basker, while in 1808, a man fishing off Stronsay in the Orkney Islands found the carcass of what looked like a sea monster resembling the extinct plesiosaur. It had a small head, a long neck and three pairs of legs or flippers.

In fact, it was the remains of a basking shark, though at 16.7m (54ft) long, it was one and a half times bigger than any that have been seen since. The explanation of its strange appearance is that when basking sharks die, their massive jaws and gill rakers detach from

*Agile hunters, blue sharks take small fish and squid –
and sometimes unsuspecting seabirds.*

the body, leaving the long plesiosaur-like neck, while the extra pair of flippers are the 'claspers' that sharks possess for mating.

The British naturalist Gavin Maxwell – author of *Ring of Bright Water* – briefly tried to make his fortune out of basking sharks. 'Maxwell was a fabulous writer but a terrible businessman and he bankrupted himself with a crackbrained idea for hunting sharks,' says Colin Speedie. 'He had all sorts of ideas – for extracting their oil, to get insulin from the livers, to pickle their flesh, but the whole thing was a disaster.' He did manage to write his first book, *Harpoon at a Venture*, as a result of the escapade, so perhaps it wasn't a total waste of time and money.

Today, the only hunting of basking sharks that takes place off Britain is scientists armed with darting poles and satellite tagging devices. They spend a few weeks every summer tracking down sharks in the hotspots identified by Colin Speedie.

Tracking Leviathans

The data they obtain from these tags is illuminating: one swam down to the Canary Islands for the winter, another just to the Bristol Channel. But according to Dr Matthew Witt of the University of Exeter, who runs the project on behalf of Scottish Natural Heritage, the tags have also demonstrated that many basking

The world's second-largest fish, the basking shark, is only a danger if you are plankton-sized.

sharks are summer residents in Scotland. They are probably feeding and mating, he says, but nobody knows for sure.

'It makes sense,' he adds. 'An animal that lives in the vast expanse of the ocean needs optimal density [of numbers] for mating to occur, and that's likely to happen when they are aggregating to feed.'

Basking sharks are Britain's most visible members of the elasmobranch class, which also includes skates and rays, and great whites are the most controversial, but there are plenty of others. Every weekend, sea anglers all around the country try to hook, tag and release sharks ranging from blue sharks off Wales to tope, smooth hounds and common skates in Scotland. The porbeagle is said to be not unlike a great white, but smaller, while the spurdog and lesser spotted dogfish are still caught to be eaten.

The most common shark in UK waters, the small-spotted catshark, used to be known as the lesser-spotted dogfish.

Common British Shark Species

BLUE SHARK *Prionace glauca*
Max length: 3.83m (12½ft); average about 2.5m (8ft)
Max weight: 200kg (440lb)
Diet: Schooling fish such as herring, mackerel and squid.

TOPE *Galeorhinus galeus*
Max length: 1.95m (6ft 4in)
Max weight: 30kg (66lb)
Diet: Schooling fish such as cod, and crustaceans and molluscs.

PORBEAGLE *Lamna nasus*
Max length: 3m (9ft 8in)
Max weight: 250kg (551lb)
Diet: Schooling fish such as herring and mackerel, as well as squid and cuttlefish.

BASKING SHARK *Cetorhinus maximus*
Max length: 11m (36ft)
Max weight: 7 tonnes (15,432lb)
Diet: Plankton, from single-cell protozoa to copepods.

SHORTFIN MAKO *Isurus oxyrinchus*
Max length: 4m (13ft)
Max weight: 570kg (1,256lb)
Diet: A variety of fish, from swordfish and tuna to cod.

SMALL-SPOTTED CATSHARK
Scyliorhinus canicula
Max length: 1m (3ft)
Max weight: 2kg (4lb 4oz)
Diet: Mostly crustaceans and polychaete worms.

SMOOTH HOUND *Mustelus mustelus*
Max length: 1.6m (5ft)
Weight: Max 11kg (24lb)
Diet: Crustaceans, such as crabs, and small fish.

Water Vole

James Fair

It's not fashionable to admit it, but some animals are impossible not to anthropomorphise or – at the very least – imagine chatting amiably in a soft, Johnny Morris burr. That's not necessarily to say that Kenneth Grahame was thinking the same thing when he cast a water vole as Ratty in *The Wind in the Willows*, but he seems to have recognised star quality when he saw it.

Having said that, it is ironic that water voles are so loved, because the creature they most closely resemble is the brown rat, a polar opposite on the charm scale. Confusing the two is not unheard of. So watching some of the nation's favourite rodents being released one gloriously sunny afternoon in mid-September on the Holnicote Estate in the Lorna Doone country of Exmoor makes one think. What was it that made Ratty – as opposed to plain old Rat – so appealing?

The 115 captive-bred water voles had been placed in twos and threes in small pens that were scattered around an area of marshy ground. After leaving them for a few days to get a feel for their new environment, special baffles with Ratty-sized holes were put in place to allow the inhabitants to come and go as they pleased. In the business, it's known as soft-release. Jenny Tratt, who works for Derek Gow – an ecologist and environmental consultant who has reared some 22,000 water voles for reintroduction since the mid-1990s – says the chosen area is perfect. 'There's a lot of watercress, which they love, and plenty of brambles providing cover and a source of food around now,' she adds.

For five minutes or so, nothing happens. Then, a face – small, brown, toothy, twitchy – appears in one of the escape holes, peers out briefly and retreats. Was that it? Hopefully the

You can often hear a water vole chomping on waterside vegetation – such as these yellow flag iris seed pods before you see it.

photographer got some shots. After another minute or two, the face reappears, and this time it is sufficiently brave to poke its head right out into the fresh Somerset air, perhaps getting a sense of the intoxicating but scary freedom that beckons, but once again, its nerve fails. Most other animals, given the chance, would have been halfway to Minehead by now.

One theory is that water voles aren't just rats with flatter faces, almost invisible ears and furrier tales (though these are all good ways to identify them), or that they are associated with flower-fringed babbling brooks and not dirty sewers, but rather that they are in fact simply more cautious and polite in a British sort of way. Their motto would be 'After you', or 'Have a nice day', not 'Get outta my way', and they'd never barge past you in the dinner queue. 'Some people say it's as if a water vole has run into a wall,' Jenny says when asked how to identify them.

The water vole's fortunes started to fall after the end of the Second World War. Agricultural intensification damaged and destroyed their riverside habitats, though the biggest declines occurred during the mid- to late twentieth century when the population fell by a staggering 90 per cent.

The cause? The escape and deliberate release of non-native American mink. Because they can swim and are small enough to access bankside burrows, mink are supremely well adapted for feeding on water voles. But the two species evolved in isolation, so the latter have zero mechanisms for defending themselves against their ferocious nemesis.

Creating a Better Habitat

In any water vole reintroduction, then, there are two main things to take into account: is the habitat suitable, and are there any mink? The latter are monitored using special rafts, but Holnicote Estate's Nigel Hester, who worked for the estate in Somerset for 32 years until his retirement at the end of 2018, says on that

score, the area's probably had a clean bill of health for 25 years.

Work to improve the habitat has been necessary, though the primary motive has been to reduce flooding in the village of Allerford and to help a broader suite of fauna and flora. A few kilometres upstream from the release site, a dam made using a tree trunk and other woody debris blocks the flow of water, which then spills out into fields that have been dug out so that ephemeral ponds form after periods of heavy rain. This allows wildflowers, such as the delicate violet-pink blooms of lady's smock, to flourish and provides food for wetland birds, such as snipe. A pair of whooper swans – winter migrants from Iceland – spent a few weeks on the estate the first year after the dam was built. 'They used to fly down to the saltmarsh to feed every day, and then back here at night,' Nigel recalls. 'It was a wonderful sight.'

What's led to the lush, overhanging vegetation that will look like manna from heaven to water voles once they make it this far, however, is erecting a fence to exclude livestock from a roughly 5m (17ft)-wide strip along the river – cattle and sheep would not only reduce this larder to nothing but stalks, they'd also collapse burrows and the riverbank.

Naturally, there's a major feel-good factor around the project, with local people working as, ahem, 'vole-unteers' to assess how the releases are faring. Ruth Hyett lives so close to the site, she could probably spy on the animals from her garden. The volunteers' task is to monitor the area around the release site for feeding signs and droppings.

Derek Gow, who has carried out the reintroductions from the River Meon in Hampshire to Malham Tarn in the Yorkshire Dales and around Loch Ard in the Trossachs in Scotland, isn't getting carried away. While the habitat at Holnicote – albeit a large estate covering 5,000 hectares (12,350 acres) and taking in 14 farms – is vole-friendly, most of the surrounding countryside is not, and it will take more than a few reintroductions to change that.

'It's great to see this type of project,' Derek says, 'but the reality is we are just buying time. Over the rest of Exmoor, the farmland is mostly unsuitable for them. We need a shift in thinking to persuade farmers to plant the odd tree or two and to start changing the environment, but there's no national strategy.'

Water voles, in other words, don't exist in an ecological vacuum, and if we want to see them back where they belong in our rivers and canals, society as a whole needs to rethink how farmers produce our food, and even what we pay for it.

In the meantime, in good news, some of the water voles granted the freedom of Holnicote that September day did eventually take their chance. With luck, they're chewing on a sweet-

Though the water vole digs its own riverbank burrows, it will shelter in any convenient human-made holes.

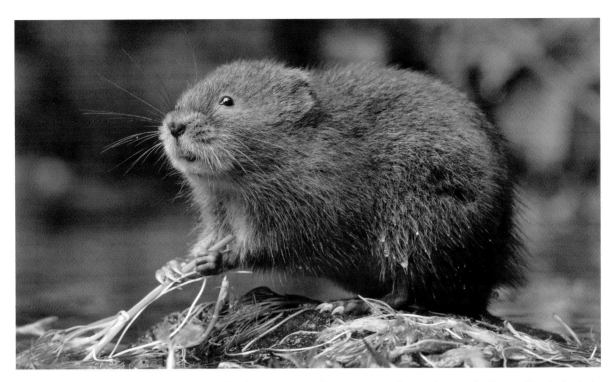

Water voles are mostly active during the day, eating reeds, grasses, rushes, sedges and other wetland plants in the spring and summer, and roots, rhizomes, bulbs and bark in the autumn and winter.

tasting watercress leaf right now while casting constant nervous glances left and right. The traditional British countryside may look benign and pretty, but for Ratty and his friends, it's a jungle out there.

The Life of a Water Vole

Water voles like to live alongside slow-moving rivers and streams, but can also do very well by the side of canals. They need grassy banks into which they can dig their burrows, where they take refuge and breed. Though excellent swimmers, water voles have not evolved truly aquatic adaptations, such as webbed feet. A short, dense undercoat with long outer fur does, however, keep them dry and warm.

They are almost entirely herbivorous, eating grasses, reeds and rushes, and have been recorded feeding on 227 different plant species in total. In the autumn they'll also eat fruits, and in the winter, tree bark.

Non-native mink aside, natural predators range from mammals such as foxes and otters, to birds including marsh harriers, herons and owls, and even pike. In the Scottish Highlands, golden eagles are a threat.

Water voles breed from March to October, normally producing four litters of five to eight babies each time. Young are weaned within 14 days, and those born at the start of the year may produce a litter themselves in late summer. Though they can live for 18 months in the wild, most live no more than five.

Water voles can survive in some remarkably odd locations; in Glasgow, they thrive on the Easterhouse housing estate, more than 3km (1.8 miles) from the nearest river.

On the west coast of Scotland, they live on tiny, rocky islands between Jura and the mainland. In central Europe, they live far from water in a manner more reminiscent of moles.

Lightning

Simon Heptinstall

With thunderstorms reaching their peak in August, what's the best way of staying safe if you are caught out in the open?

It's a lovely summer's day. You decide to take a walk, maybe on an open hillside, maybe through fields dotted with trees. Don't worry about the gathering clouds on the horizon – it's August. What could possibly go wrong?

Well, sadly, quite a lot. Thunderstorms can roll in quickly, especially over fields and most commonly in the south-east of England, and they can pose a mortal risk. If lightning is in the air, open hills and trees are the worst places to be. And Britain's storm season hits its peak this month.

The danger of lightning strike may be greater than many people realise. On average, two to three people are killed in the UK by lightning a year and between 30 and 60 are injured. These figures don't include an unknown number of indirect casualties, caused, for example, by falling chimneys or trees, or fires started by lightning.

Nor do they include widespread casualties among farm animals and wildlife. Whole herds of cattle and sheep have been wiped out by lightning. In 2006, for example, a flock of 91 sheep was killed by a single bolt as they sheltered under a tree on Dartmoor.

Thunderstorms can hit our islands at any time of year but are more frequent in summer when warm, moist air and upward air currents help create ideal conditions. Negative charges tend to build at the lower part of a stormcloud, while positive charges gather in high points such as trees or hills, sometimes prompting a strike between the two. July has more lightning strikes, but August has the most casualties.

Professor Derek Elsom has spent his career studying thunderstorms, recording the details of everyone struck by lightning in the UK over the past 25 years in order to assess the risks. He found that in that period, 720 people have reported being struck by lightning, while 47 have died. Storm casualties range from a Warwickshire schoolboy receiving a slight shock from a kitchen work surface to a man killed sheltering under a tree in Buckinghamshire while walking his dog.

Derek Elsom's results also show that more than 80 per cent of those killed by lightning in Britain are men, who are more likely to work or play outdoors. Another surprise finding is that as many casualties are hit indoors as outdoors. However, there hasn't been a fatal UK lightning strike indoors for 40 years.

Climatic factors mean that the likelihood of lightning is greatest in London and the southeast (where it happens on average on up to 20 days a year) and least in the north-west of Scotland and Northern Ireland (on average less than four days a year).

First-hand accounts vary in severity. One Staffordshire woman was helping her six-year-old into her car and touching the metal when she 'felt a pain like a sting'. Her arm became numb to her elbow and she developed small red marks on her hand but recovered within a few days. A pub landlord on the Isle of Wight received a severe shock when he touched his telephone. 'A flame shot out of my phone and I was flung from the bed as though I had been zapped by a defibrillator,' he later reported.

Derek Elsom is now campaigning for the risks of lightning to be publicised. 'Lightning is very dangerous,' he says. 'Everyone should take care when thunderstorms are forecast. The key is to avoid being in the wrong place at the wrong time. You have to be prepared to delay any outdoor activity if lightning threatens. It could save your life.'

So if you are planning a summer walk or outdoor activity, take notice of the forecast. And be aware that under trees and on open hillsides are the most dangerous places to be when lightning is around.

Lightning forks over the Somerset Levels. Two to three people are killed by lightning strikes in the UK every year.

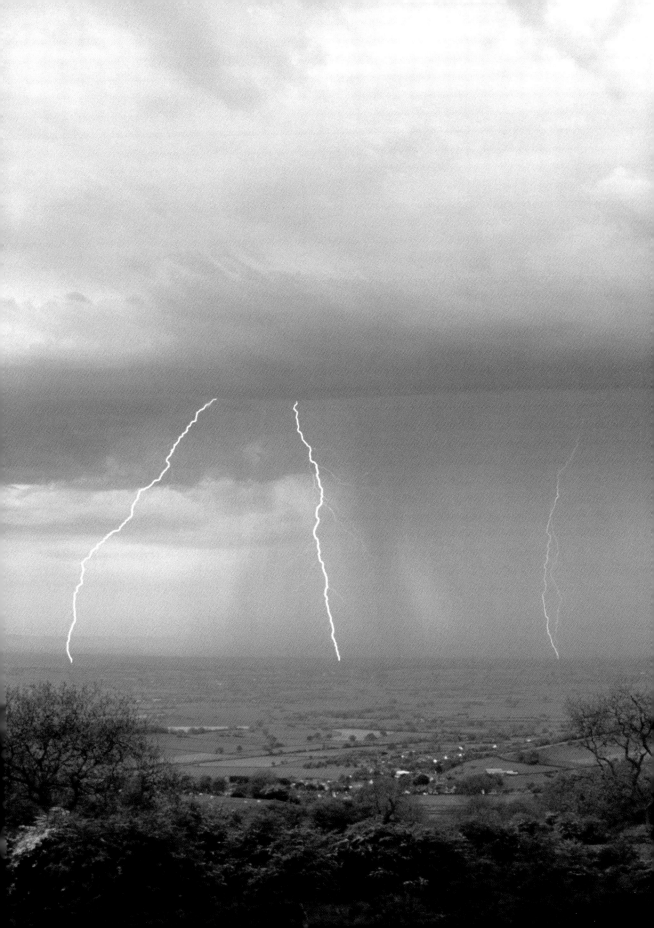

Mackerel

Richard Aslan

With its sharp silver silhouette, midnight-blue-and-turquoise tiger stripes and forked emerald tail, the mackerel is a photogenic denizen of the open water. Huge shoals funnel and billow in the shallows, their kaleidoscopic movement having evolved in part to evade predators. Mackerel find themselves on the menu for sea birds, larger fish, marine mammals and that hungriest of all creatures, humans. For similar evolutionary reasons, it is capable of bursts of extreme speed.

Rather than referring to one discrete species, 'mackerel' is a loose term used for a variety of fish of a similar appearance. It was long assumed that they were all interrelated to an extent, but recent genetic evidence shows that global stocks are made up of at least three separate species. The largest includes the true mackerel, with the archetypal Atlantic mackerel among its number. 'Mackerel' comes from Old French via a Germanic source meaning 'pimp' or 'procurer'. Beyond its energetic spawning habits and the rather lurid imaginations of medieval times, it is unclear how it earned such a name.

The private life of the mackerel is typical for an ocean-going fish. After spawning, its larvae float with the current for a few months and, if not eaten, it grows fast, reaching up to 25cm (9in) in a year. Larger fish can eventually reach 60cm (2ft). It can live for up to 25 years, every moment of which is spent in endless motion. It relies on a constant stream of water over its gills to breathe and so is never at rest. In summer it feeds on sand-eels and shrimps in shallow coastal waters; in winter the fish heads out to the open ocean, where it fasts in the depths until spring returns.

We scoop mackerel from the seas in their millions. As with fish stocks globally, it is a simple case of too many boats chasing too few fish. North-east Atlantic mackerel has long been considered an environmentally friendly choice for consumers, but the species has become increasingly scarce and now experts are calling for more regulation over how it is caught. Net-caught fish are the worst option, so look for mackerel caught by hand line in south-west England. This is a low-impact way of fishing, and catches are strictly controlled. There are also protections in place for juvenile mackerel to make sure they can reproduce before they are caught.

Kedgeree Recipe

Often eaten for breakfast, it's also great for picnics. Omit the fish for vegetarians.

- 4 shelled hard-boiled eggs
- 75g (2.5oz) white long-grain rice
- 50g (2oz) butter
- 2 onions, chopped
- 400g (14oz) smoked mackerel
- 200ml (6 fl oz) milk
- 4 tsp curry powder
- 1 bay leaf, 3 cardamom pods, 2 cloves
- salt, pepper and parsley

Bring the rice to the boil in 300ml (9 fl oz) of cold water. Cover, simmer for five minutes and set aside. Cover the fish with milk in a large pan. Bring to the boil and simmer for six minutes until fish is opaque. Remove fish from the milk and discard the skin and bones. Fry onions in butter and stir in the spices and rice. Flake the fish, quarter the eggs and add to the rice. Stir, garnish with parsley and serve immediately.

The beautiful patterning of mackerel gleams in a fresh catch off the Shetland Islands.

Roadside Crosses

Ian Vince

If you're off on your summer holidays soon, it's likely that you are not only getting ready for a long journey to the beach, airport or woodland cottage of your dreams, but also preparing for the familiar chorus of 'are we there yet?' from the back seat.

Long trips feel shorter for everyone when the sights and sounds distract from the monoculture of asphalt and white lines. Instead of just commuting to your holiday this year, why not investigate the road itself and the romantic tales of travel it offers. Indeed, a variety of monuments erected as waymarks, memorials or commemorations of epic voyages of the past can be found in Britain's verges.

Most of them take the form of the roadside cross which, in Britain, is distributed north and west of the Jurassic line that runs from Dorset to the Tees and marks where upland and lowland meet. A few crosses crop up to the east of this line on the chalk. One such is Fat Betty – often called White Cross – on the North York Moors, just south of the Castleton to Rosedale road.

Betty has a square, squat base that carries a tiny round head on which the cross itself is inscribed. She also serves as a boundary marker and, like much ancient roadside furniture, has numerous myths and legends attached to her origins.

Elsewhere, crosses such as Boswarthen near Madron in Cornwall are sometimes used to mark a route of pilgrimage. Boswarthen stands close to the path that leads to Madron Well, where 'clooties' of cloth hang from the trees. Legend has it that if people suffering ailments enter the well's water and then tie a strip of cloth to the trees, their ills will disappear as the cloth rots.

White Cross or Fat Betty on the North York Moors serves as a boundary marker.

RIGHT: *Twelve late thirteenth-century 'Eleanor' crosses mark the passage of the funeral cortège of Edward I's beloved wife.*

A set of elaborately decorated crosses adorn the route of a medieval funeral cortège between Lincoln and London. These are the Eleanor crosses: 12 were originally erected in wood between 1291 and 1294, but were later replaced in stone. They mark the 12-day journey of the body of Eleanor of Castile, the wife of King Edward I – each cross was erected at a place where the queen's body rested for the night. Of the 12, only three remain – at Geddington and Hardingstone in Northamptonshire and Waltham Cross in Hertfordshire.

A Victorian replica of the original Charing Cross – destroyed by Parliamentarian forces in 1647 – now stands in the forecourt of the railway station named in its honour. As Robert Louis Stevenson would say himself: 'Travel for travel's sake. The great affair is to move.'

Cardigan Bay

Julie Brominicks

The sun is setting, bathing the fireweed in rosy light at Cwm Buwch waterfall, just south of Aberaeron, where the water spills off the cliffs into the sea. Gulls are perched on the rocks either side of the falls and the sky is whirling with clouds. Mist appears on the horizon, so instead of burning into the sea, the sun suddenly dissolves. It is a transcendent moment and a typical one on the coast of Cardigan Bay.

Cardigan Bay is the large, wildlife-rich inlet of Wales between Strumble Head in the south and Bardsey Island in the north. To walk its length is to see dolphins, porpoises, seals, red kites and choughs, and to find landmarks and relics that bear witness to Neolithic hunters, Bronze Age settlers, Irish saints, Viking raiders, medieval merchants, Victorian industrialists and World War Two weapons-testers, to name but a few.

Encircling the Bay, the rocky Snowdonian peaks in the north and the golden rolling Cambrians and Preselis in the centre and south are still remote enough to accommodate the Welsh-speaking heartlands. In earlier times, these hills were almost impregnable to the sea-borne traders and invaders who left their marks on the settlements closer to the water's edge.

Yet despite centuries of human activity borne of the area's strong maritime tradition, the coast of Cardigan Bay remains a haven for flora and fauna thanks to a diverse landscape of swift rivers, sandy shores, sheer cliffs and pebble coves that combine to create a contrasting blend of peaceful open spaces. You can walk for hours along its paths with only mewling gulls for company. Sometimes you'll be ambushed by drizzle or a salty Celtic mist that drenches your hair but draws your attention to the flowers at your feet before suddenly dissipating to reveal a peregrine soaring above the glittering sea.

Chaotic Contortions

The Wales Coast Path loops round the bay from Pembrokeshire in the south, through Ceredigion and into Snowdonia. There are some taxing climbs and one or two remote stretches such as between Llanrhystud and Aberystwyth, but these are interspersed with gentle flatlands and, for the most part, conveniently spaced amenities, allowing you to discover the landscape at a leisurely pace – whether you're walking it in a single trip or splitting it into sections.

The rocks of central Wales are dominated by slate, with cliffs like those at Penderi, whose ledges are populated by colonies of kittiwakes, auks or gulls. But the low crumbling slabs of boulder-clay between Aberaeron and Llanrhystud were deposited by ice-sheets whose retreat also left five causeways of glacial moraine, or sarns, reaching into the bay. At Ceibwr the cliffs are wicked and black. The rock-scape here is chaotic, confused, faulted and folded, whorled and contorted. The sea is clear enough to see the barnacled rock and black caves yawning beneath its surface, and to watch the translucent compass jellyfish umbrella-gliding by. This is a good place to sit with a picnic and admire the geological chaos.

A Shared Tradition

Coastal settlements along the bay mean you're rarely far from an ice cream. Some settlements are tiny, such as the shingly cove of Borth-y-Gest with its bijou bistros or the terraced Tresaith. Others – such as the cosmopolitan university town of Aberystwyth, the seaside resort of Barmouth or the towns that have grown around a particular export (slate in the case of Porthmadog) – are larger.

But what underpins them all is a powerful maritime tradition that harks back to a time when shoals of herrings were harvested, the sea teemed with brigantines, schooners and sloops, and even small ports such as Aberporth were

The intricate inner workings of the moon jellyfish – the four circles visible in this image – are its reproductive organs.

major ship-building centres. The place that best evokes this seafaring heritage is Cardigan, though with its hinterland of dairy pasture, it's as much agricultural as it is maritime. Nevertheless it was the sailors, anchor manufacturers, coal, culm, corn, flour and salt merchants, lime-burners, rope-makers, sail-makers and ship-builders who made Cardigan the most important port in Wales in the early nineteenth century.

You arrive near the mouth of the Teifi between tin sheds and garages, where green weed clings to the quay walls as the tide ebbs. Warehouses that once stored wine, tobacco and salt still stand tall at the bridge, and the river, smelling salty and fresh, laps at the muddy banks.

A slew of beaches ring the bay. Long drifts of dunes border Ynyslas and Harlech, which is back-dropped by the Rhinogydd Mountains. Others have a pebbly silver charm like Tan-y-Bwlch where Mesolithic hunter-gatherers knapped flint on the banks of the Ystwyth. One of the best is Penbryn. Approaching from coastal hills, the path suddenly becomes peaty and ducks into the wooded Hoffnant Valley, where sounds of the sea are replaced with the chatter of long-tailed tits and the bubbling of a stream. Bare, bright sea-light gives way to the fecund, dappled green of oak and hazel, moss and tall ferns, and the salt-wind to a damp kiss of sweet air. Then, just as suddenly, the path runs to sand and delivers you onto a broad, cliff-hugged white beach, with white foam smashing into a black cave. Take a swim here in the effervescent bottle-green sea, alone except for a cormorant, and looking back to the jungle-like woods and bright white shore, you'll feel you've arrived somewhere almost Jurassic.

It's not all hills and rocks and beach. Cardigan Bay is full of intriguing flatlands. Some of them are saltmarsh, formed by accretions of estuary silt colonised with fleshy stems of marsh samphire and clumps of cord-grass. And Borth has Cors Fochno, an expansive raised peat bog populated by sundews and bog myrtle. A forest was buried here 4,500 years ago beneath a rising sea and dozens of petrified stumps are still visible on the beach at low tide. And then there's the village of Llanon. The coastal plain of Morfa Esgob, or The Bishop's Land, between the village and the sea is divided into strip fields known locally as slangs. Fringed by daisies and fiddle dock, the fields are planted with wheat or beet, their brown, white, green and yellow stripes a dazzle of colour against the sea.

Rivers Calm and Crashing

In the south, rivers such as the Teifi and the Aeron meander green and serenely through lush dairy valleys but you leave them behind in the north when you reach Snowdonia. Here the rivers become swift and stony, tracing a turbulent icy-clear, boulder-strewn passage to the sea. The Mawddach has its gathering of gold-mining hills and the Dwyfor hurries past the grave of Lloyd George. Upriver, pylons straddle the rocky gorge like giants and the water is deep, reflective and tropical-looking, its surface glinting like steel. But seaward, the shifting rivulets are all molten magenta and the fiery sun has lit up one of the pylons like a Christmas tree.

These pylons are just one of many human landmarks along the way, jostling for attention with Pen Dinas hill fort, the medieval church at Mwnt, the fish-traps at Llanon and the Second World War tank-traps at Fairbourne. The remains of Criccieth Castle loom imposingly on a rocky headland. Nearing Aberdaron, you'll pass the ruined manganese mines of Rhiw, once busy and industrial but now abandoned to the hills that drop to the sea and the black-backed gulls and choughs that quarter the air above.

Aberdaron, too, has a rich human heritage, marked by the centuries-old passage of pilgrims bound for the holy island of Bardsey. The tradition of pilgrim hospitality is still alive here and you'll find warmth in the huddle of inns and cafés, braced against the winds and snug between shapely hills. Climb them to see Cardigan Bay spread below you, suffused in

Llandecwyn St Tecwyn is a Victorian church built on the site of a much older one. It has stunning views over the Glaslyn Estuary.

mist – a scene steeped with a sense of arrival but also of imminent departure, to Bardsey perhaps or beyond. Like the tides, we humans are always ebbing and flowing, coming and going, leaving marks on the ever-shifting coastline among the sandbars and sarns, peat-bogs and caves, drumlins and cliffs, while dolphins swim in the bay.

Three Great Walks

CEIBWR TO CARDIGAN (15KM/9 MILES)
This moderately challenging walk takes in some of the most dramatic rocks in the bay, beginning at Ceibwr before ascending the bay's highest cliffs at Pen Yr Afr. The views are spectacular and as you round the Pen Cemaes headland near Poppit Sands you have a good chance of seeing Atlantic grey seals by peering, carefully, to the rocky beaches below.

LLANGRANNOG TO CWMTYDU (9KM/5 MILES)
Starting from the colourful village of Llangrannog, you pass the Ynys Lochtyn headland – a popular feeding place for bottlenose dolphins and harbour porpoises – and join a dramatic stretch of path cut into the hillside. After that it hairpins into tiny Cwmtydu where you can take a lovely wooded route back to Llangrannog, if you want to make it circular.

RHIW TO ABERDARON (10KM/6 MILES)
One of the most remote and peaceful stretches of coast runs from the former manganese mining village of Rhiw through the gentle green farmland and hills of the Llyn before finally arriving in Aberdaron via the lush Daron Valley.

Wildlife Haven
Largely because it's home to the largest school of bottlenose dolphins in Europe, a 1,000 sq km (386 sq mile) section of Cardigan Bay has been designated as a Special Area of Conservation (SAC). The SAC's sandbanks, reefs and sea caves are also rich in marine life, such as harbour porpoises, sand-eels, sprats, honeycomb-worms and herrings, and the populations of mantis shrimps, Atlantic grey seals, and sea and river lampreys are of national importance. Protection is not a straightforward task, however, and the decision by the Welsh Government to reintroduce scallop-dredging has been particularly controversial due to its indiscriminate destruction of the sea bed.

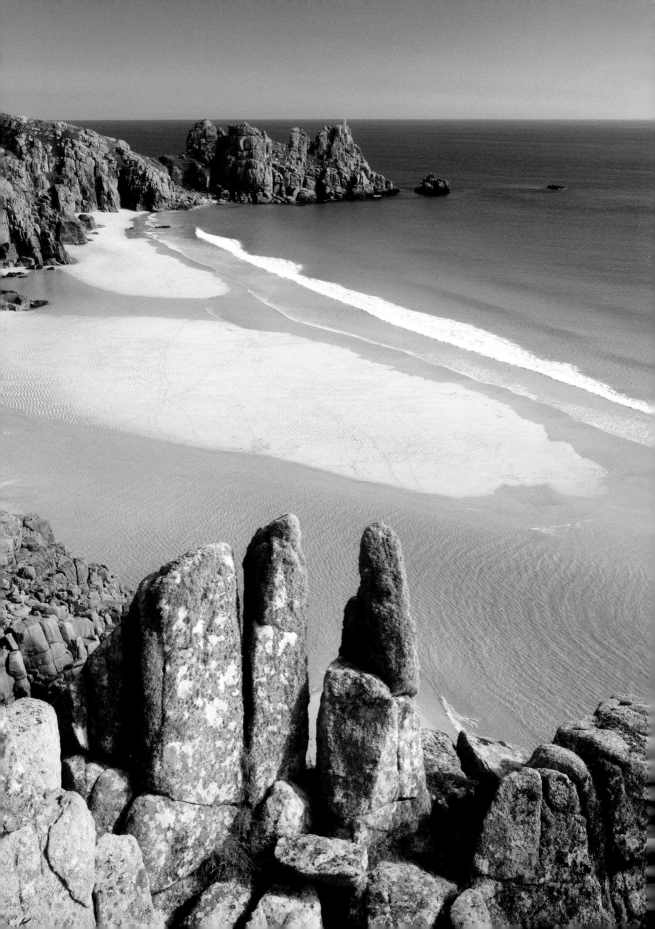

September

This month we are trying to make you feel a little kindlier towards wasps. These picnic-time pests are actually doing us favours: they work as an alternative to chemical pesticides, feeding on aphids and whatever other insects are around, they pollinate crops and flowers, and they may even have inspired the invention of paper. The stripy aggressor that seems determined to sting us is just one of perhaps 200,000 species of wasp, and the smallest insect in the world is the fairyfly wasp, with a body just 0.14mm long and living for only a few days.

Wasps are welcomed at Knepp Farm, where the owners Isabella Tree and Charlie Burrell run Britain's best-known rewilding project. They've stopped farming in the conventional way and have let nature take its course. Meanwhile on every arable farm, September is an anxious time: will the harvest be bountiful, disastrous or somewhere in between?

Hadrian's Wall has imprinted itself on our national mindset for the past 1,800 years: originally a formidable defensive barrier, it stretches for 117km (73 miles) from the Solway Firth to Tyneside. In 2023 it was in the news because of the senseless destruction of the famous lone sycamore tree that dominated a dip in the wall near Hexham. This month, we feature what's left of the emperor's masterpiece in stone.

Wealthier Romans who once lived along the wall were no doubt partial to what they called *Glis glis* – edible dormice which they bred as a delicacy, roasted and dipped in honey. All these years later, far from being delectable these furry little creatures – cousins of our rare hazel dormice – are something of a mini-menace in parts of southern England. There are thousands of them, descendants of a few that escaped from a personal collection.

When I lived on the Chiltern Hills in Buckinghamshire *Glis glis* were uninvited guests in my home and in those of many neighbours. They sneak from surrounding woodlands into lofts and attics, creating fire risks by gnawing at cables and making lots of noise and mess. Because they are protected creatures, pest experts must be called in to remove them. And in my experience as soon as that happens others quickly move in to take their place.

As summer holidays recede, Cornish beaches such as here at
Pedn Vounder, Porthcurno, become havens of quiet once more.

Wasps

Seirian Sumner

Consider the sounds of high summer: the chattering of rooftop starlings, the hum of your neighbour's lawnmower. Listen more closely and you might hear the delicate scratching of a wasp on the wood of your garden shed. Far from being a malicious pest looking to ruin your picnic, this lady (they're all females at this time of year) is completely focused on collecting wood pulp to expand her mother's nest. It's a labour of genetic love – the harder she works, the more wasps her mother's nest will produce, and the more of her genes will be passed on to the next generation.

The wasp in question is the yellowjacket (*Vespula vulgaris*), the black and stripy species you often find yourself swatting away. The reputation of this and a few other species has tarred that of another 200,000. Indeed, wasps are second only to beetles in terms of species numbers and there are thought to be at least 100,000 more waiting to be discovered. Social wasps (that includes our stripy friend) represent less than one per cent of the total wasp species in the world. And most aren't yellow and stripy or fond of picnics.

The vast majority of described wasps are tiny black insects that you'd probably mistake for flies. In fact, the smallest insect in the world is a wasp: the 'fairyfly' is a mere 0.14mm long and only lives for a few days. Despite its size, it plays a vital role in agriculture, as it lays its eggs in the bodies of crop pests, essentially working as an alternative to chemical pesticides.

Pest Controllers

There are many reasons to love (or at least appreciate) wasps, the main one being that they help keep insect, spider and woodlice populations at bay. As predators, they're at the top of the food chain and without them food webs would break down. They're also generalists: wasps will feed on whatever's around. They eat the most abundant pests that we try to control with toxic chemicals – there'd be many more aphids in my garden without wasps. We don't have good data on how much wasps eat, but a single colony is thought to remove somewhere between 0.16–23kg (5oz–50lb) of prey per season. Using a modest estimate, that amounts to about 250,000 aphids by each colony.

Wasps are also pollinators of flowers and crops. Adult wasps don't need much protein (the bugs they prey on are for the developing brood in the nest) but they do need sugar, which they get in the form of nectar from flowers. In the process of finding it, the wasps pick up and transfer pollen from flower to flower. Unlike many bees, wasps don't mind what flowers they visit – as generalist pollinators they're more abundant than bees in degraded or fragmented habitats and so are important 'back-up' pollinators in these areas.

Wasps also have a fascinating social life. A yellowjacket colony is much like that of a honeybee, with a queen supported by a community of workers. It sounds harmonious but look closer and you'll see a veritable *Game of Thrones* in full swing. The parallels with human societies are uncanny: there are specialist work forces, rebellions, policing, leadership contests, undertakers, police, even free-loaders and antisocial thugs. You name it, social wasps have it.

Contingent Loyalty

The lives of social wasps revolve around gene-sharing (or relatedness). Worker wasps are 'self-sacrificers', they have evolved to work rather than reproduce because their genes are passed on through the brood they help rear (their siblings).

But this social contract is only a good deal if their mother is singly mated. Queen wasps only have one mating flight in their lives, but during that time some species mate with several

Wasps love nectar and sweet substances so the sugary, fermenting juice of windfall apples is irresistible to them.

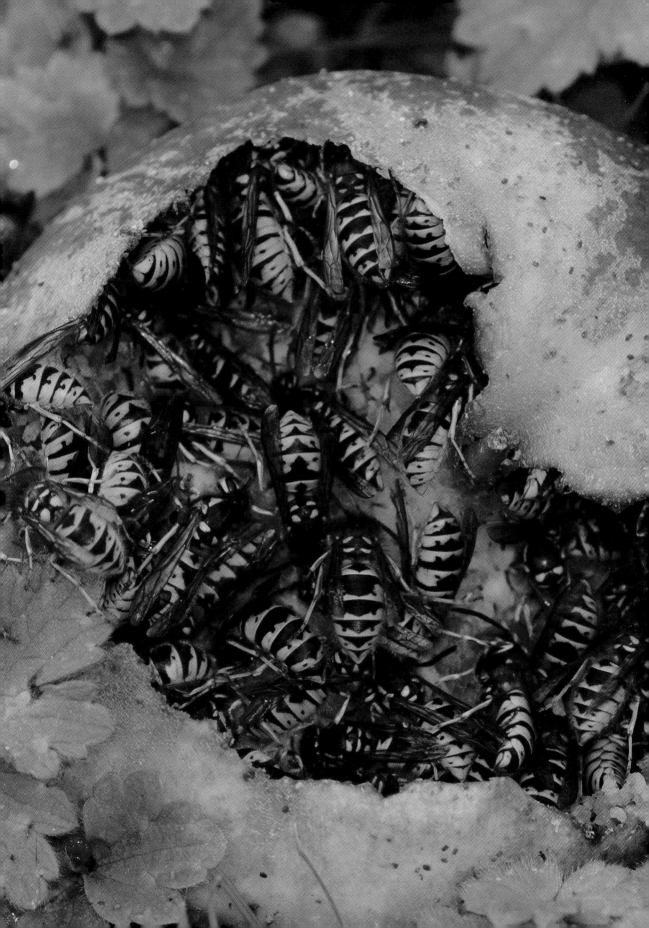

males: they store the sperm in their abdomen and control its release to fertilise the eggs they lay throughout their lives.

Multiple mating means the queen dilutes the relatedness of the workers in her brood and workers end up rearing a mix of half- and full-siblings, which can break the social contract of the colony. In these cases, workers can do better, individually, if they lay their own eggs. And this is when things get messy: sneaky egg laying by workers can cause a colony's cohesion to break down, creating internal battles among the workers. They may be bloodless battles, as no insect blood (haemolymph) is shed, but they're fought by ruthless means: workers that detect another worker's eggs will eat them before they hatch.

But aren't we taught in schools that only queens lay eggs? In fact, workers in almost all Hymenoptera (bee, wasp and ant) colonies can lay eggs. Because of a genetic quirk of the Hymenoptera, females hatch from fertilised eggs and males from unfertilised eggs. Worker wasps have lost the ability to mate, but can still lay male (unfertilised) eggs.

Good for Body and Mind

There are other reasons to admire wasps. For one thing, they may be indirectly responsible for the invention of paper. Around 2,000 years ago a Chinese eunuch called Cai Lun noticed a wasp building a paper nest in his garden. Inspired by what he saw, he started to mulch wood and with it made the first paper. If the story is true, then perhaps we have wasps to thank for much of our rich cultural history and development.

Fast forward to today where exciting research is looking into the potential use of wasp venom as a cancer therapy. An active peptide found in the venom of tropical social wasps selectively destroys cancerous cells by causing their membranes to leak. Wasps may have the potential to save human lives.

A better appreciation of the ecological, economic, medical and cultural services that our stripy friends provide might help us see them in a different light. So next time your picnic is disturbed by black and yellow insects, take a moment to think about their extraordinary world and the contributions they make to our lives before you reach for the swatter.

Wasp Lifecycle

A single-mated queen emerges from hibernation in the early spring. She establishes her nest in a cavity in the ground or a tree, and as she builds each cell, she lays an egg in it.

After about 30 days, her first offspring – the workers – emerge as adults. They're all female at this point. The workers take over the foraging, brood care, nest building and maintenance duties; the queen becomes a stay-at-home egg-laying machine.

After a few days carnivorous larvae will hatch from the newest eggs. The adult workers bring insects back to the nest to feed to the hungry larvae, which offer a sugary reward to the workers, via a process called trophallaxis. The larvae grow over a couple of weeks before they spin their pupal cap and pupate.

Over the next couple of months, the colony will grow, possibly to include thousands of wasps, depending on the species. Once the colony is big enough, the queen will switch to laying a sexual brood: these are males and the sexual females capable of becoming next year's queens.

When the sexual brood emerges, they leave the nest to mate and then find somewhere to hibernate over the winter (lofts are a popular choice). After this point, the nest has served its purpose but the workers are still alive with no brood to feed – this is when they start to bother you.

Key Wasp Species

These are the social wasps that you're most likely to encounter

EUROPEAN HORNET *Vespa crabro*
The European hornet is about twice the size of the other social wasps but despite its looks is unlikely to bother you at picnics. Hornet colonies

have a single queen and around 100 workers. They like to nest in tree cavities or bird boxes.

YELLOW-LEGGED ASIAN HORNET
Vespa velutina
This Asian species is a voracious predator of honeybees that was inadvertently introduced to southern Europe in 2004. It's now widespread in France, Spain, Italy and Belgium, but not the UK, which has an effective extermination protocol for dealing with these invaders. Suspected sightings can be reported using the Asian Hornet Watch app (available for Apple and Android devices) or by emailing details and photos to the Centre for Ecology & Hydrology alertnonnative@ceh.ac.uk.

COMMON/GERMAN WASP
Vespula vulgaris/germanica
These are the wasps most likely to upset your picnic. *V. germanica* tends to be more bad tempered than *V. vulgaris*. These two species are practically identical but you can tell them apart by their facial and thorax markings. Both species have a single queen who produces 6,000 to 10,000 workers. They make football-sized nests in the ground or in roofs and trees.

RED WASP *Vespula rufa*
Red wasps have a distinguishing red tinge on their abdomens. Their nests are smaller and always underground. A single queen will produce around 300 workers. The colony cycle of *V. rufa* is shorter than *V. vulgaris/germanica*, ending in late August.

Dolichovespula SPECIES
There are three species of *Dolichovespula* in the UK. The most common is *Dolichovespula media*. You can tell them from Vespula as they're bigger and have blacker abdomens and are only seen in early or mid-summer. Their new queens leave the nest in early August and thereafter the colony soon winds down.

Avoiding Confrontation
Social wasps only really become a nuisance in late summer. At this time there are no larvae left to feed so instead of hunting for prey the workers turn their attention to sugar (nectar and your picnic). Wasps sting to defend themselves – this is an evolved strategy to combat vertebrate predators at the nest: swatting at them may elicit the same innate collective behaviour. Some wasps' stings trigger the release of an alarm pheromone that attracts more wasps. To minimise the nuisance, try to isolate the first wasp to appear under a glass but don't forget to release her at the end of your picnic.

Ivy flowers continue to produce nectar and pollen deep into autumn, which is a boon for late-flying wasps and other insects.

Goldfinches *Dominic Couzens*

These days goldfinches are a common sight in gardens, noshing up at feeders loaded with seeds, many put out purely for their benefit. But their 'real' life in the countryside is closely bound up with finding clumps of thistles and other related plants, the seeds of which constitute around a third of their annual diet.

At this time of the year it is easily possible, if you can find a suitable patch of weedy, overgrown wasteland, to come across large flocks of goldfinches, known as 'charms', numbering hundreds of birds. And since each goldfinch, with its brilliant yellow wing-bars and three-colour head, is a jewel of a bird even on its own, a large flock of them can be an overwhelming feast for the eyes.

Goldfinches are strongly adapted to obtaining seeds from thistles. Their bills have an unusual musculature that gives as much strength to opening the bill as closing it (most of our jaw strength goes into biting). This means that they can poke right down into the seed-head and then open their bills to prise the bracts open, releasing the seed.

The finches also have strong legs, enabling them to hold on to flowerheads, even when they bend over or are buffeted by the wind. When we see these birds through our kitchen windows, it's easy to forget what specialists they are.

Not all the goldfinches you see in September will have the colourful black, white and red pattern on their heads. Some will be fawn-brown instead. These are the juveniles and, perhaps surprisingly so late in the year, some will not be long fledged. The species' liking for thistle seeds means that the goldfinch often has a very late breeding season. In contrast to most other small birds, the young goldfinch is fed on (mashed) seeds in the nest rather than invertebrates – an indication of its life to come.

A delicate, tweezer-like bill allows the goldfinch to extract tasty morsels from burdock seed heads.

Hazel Dormice *Charlie Elder*

It is dusk, and in the fading light a small mammal has begun foraging amid the outermost branches of a tree. Far too tiny to be mistaken for a squirrel, and yet too high off the ground for mouse, it makes for a surprising sight.

Every now and again it freezes, its golden-brown fur blending with its surroundings and its large dark eyes watching for danger, before it resumes feeding, clambering through the foliage, safely out of reach of predators.

With double-jointed ankles enabling it to get a decent grip when climbing, and a long furry tail aiding balance, this agile woodland dweller is perfectly adapted to an arboreal existence. Indeed, it has been roaming UK forests for thousands of years. However, adults are so seldom encountered out and about in the wild today that one could be forgiven for wondering what on earth one had spotted.

This is the dormouse, arguably the cutest of our creatures. With bright eyes, rounded ears, a cuddlesome hamster-like charm and famously sleepy disposition, this adorable mammal has the kind of appeal that has made it a champion of the conservation cause.

But its secretive lifestyle means it is not easy to see – especially given that numbers have plummeted over the last century, with their distribution now largely restricted to counties in southern England and Wales.

Clever Clogs

Not only are dormice (also known as hazel dormice) active after dark, but they rarely cross open ground and so largely remain out of sight as they explore aerial walkways among the trees, understorey and hedgerows.

One of the first clues that dormice are living in an area is that they leave their clogs lying about – or rather, hazelnut shells that resemble clogs. Dormice lack an intestinal caecum, which means that they are unable to digest cellulose in plants and instead eat pollen, flowers, insects, fruits and nuts. Top of their preferred menu is the hazelnut, which provides a vital food source as the dormice strive to reach an optimum weight in preparation for hibernation. Getting at the nut inside involves gnawing through the broad end, and not only does the discarded hollow shell resemble a wooden clog, but the chiselled hole has a distinctive smooth inner rim.

Nibbled hazelnuts are all very well, but how does one actually stand any chance of seeing such an unobtrusive nocturnal scarcity?

Fortunately, in spring and summer they readily take to nestboxes in which they raise babies (usually one or two litters a year, of about four young) in nests of shredded honeysuckle, leaves and grasses. Dormouse nestboxes are set a metre (3ft) or so off the ground with the entrance hole facing the trunk, though a licence is required to check for the animals' presence as they are specially protected against disturbance.

Softly Softly...

To see a dormouse, consider joining an organised survey, such as those hosted by the People's Trust for Endangered Species (PTES), which runs the National Dormouse Monitoring Programme. You might then be lucky enough to enjoy a close-up view of one of these palm-sized balls of fur.

After inspecting dozens of nestboxes, such as at the charity's Briddlesford Woods reserve on the Isle of Wight, you might finally came across one dormouse curled inside, fast asleep, with its bushy tail wrapped over its paws.

Dormice spend more than half their lives asleep, saving energy on cold days by dropping into a torpor, from which it can take 20 minutes to wake, and hibernating throughout the winter, from October or November to April or May.

Having feasted on autumn's bounty of fruit, nuts and seeds, a hazel dormouse builds a cosy nest to sleep away the winter.

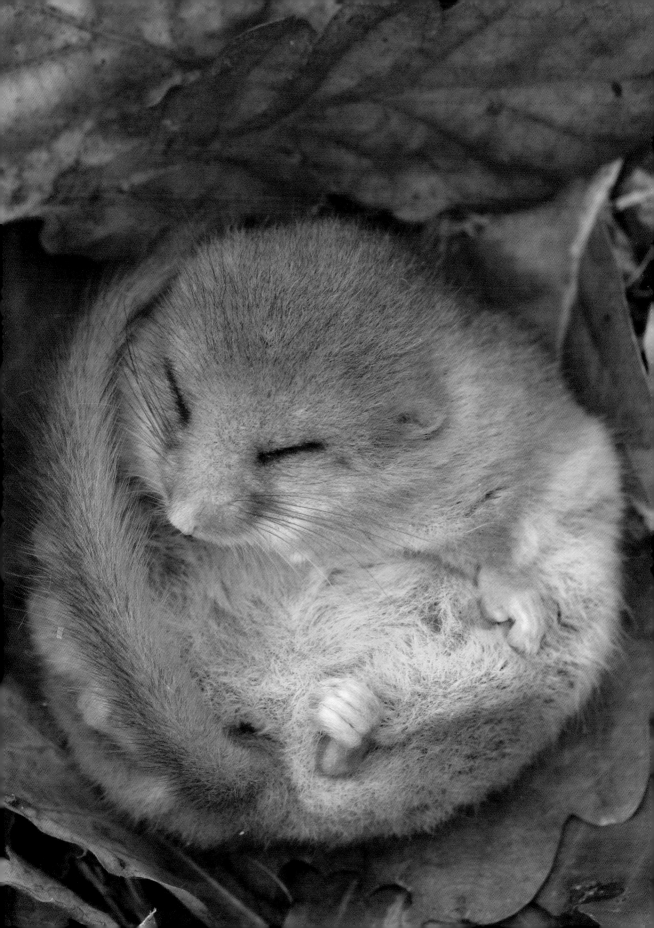

Ian White, the national dormouse officer for PTES, says, 'They're a fabulous native woodland species. People love to see them and have them in the environment – in fact I've never heard a bad word said about them. Their conservation also helps drive beneficial woodland management, because what's good for them is good for a broad range of flora and fauna.'

Low-density Dormice

Dormice tend to live in low densities, even in strongholds (more than 500 nestboxes in the prime 160-hectare (395-acre) Briddlesford Woods nature reserve have been seen to support just a dozen dormice). But they were once far more widespread and common. They don't have many natural predators – although tawny owls, cats and weasels may occasionally kill them, and even wood mice competing for nesting sites can attack dormice when they are in a torpor. Instead, it is the fragmentation and loss of suitable woodland habitat that has caused their UK range to reduce by half over the past 100 years.

Dormice need rich deciduous woods and fat hedgerows for their survival: places of plenty, containing oak and hazel, sweet chestnut, tangles of honeysuckle, brambles and berry-bearing shrubs that can keep them well fed throughout the spring and summer, and plump enough (at least 20g/⅔ ounce) to make it through their hibernation. Favoured old woodlands have a good understorey of interlocking branches, which enable them to get around without having to risk setting foot on the ground.

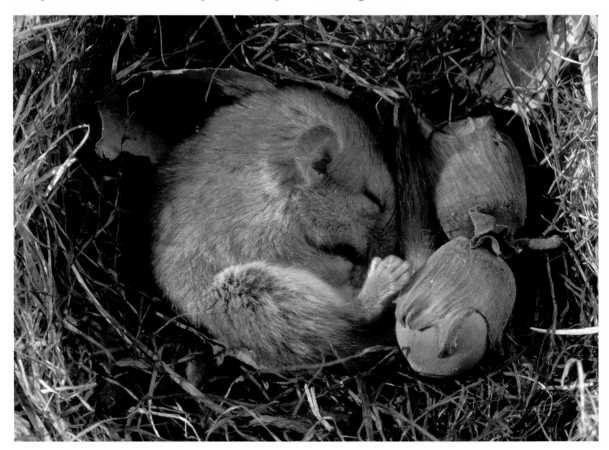

Hazel dormice can go into a state of torpor even outside of hibernation, to conserve energy, for as much as seven months of the year.

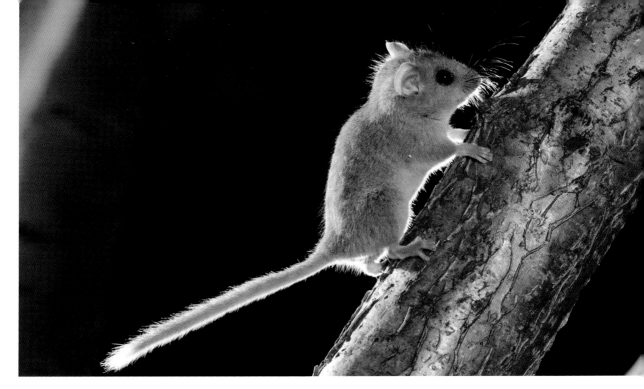

As its name suggests, thickets of hazel coppice offer the perfect blend of shelter, safety and food for the dormouse.

In the right habitat, dormice can thrive and reach the ripe old age of five, comparing well with mice and shrews, which tend to breed fast and die young, few making it through two winters.

Thankfully, the decline of the endearing little dormouse may have slowed, largely due to conservation measures, and they have been successfully reintroduced to a number of former haunts. Good news for all those who like their wildlife with a bit of the 'ahhh' factor…

Dormouse Haven

Coppiced hazel woodland, with tree growth of differing ages and a diverse mix of understorey plants, provides an ideal habitat for dormice.

Coppicing involves cutting trees down to a stump in rotation and harvesting the straight new stems that grow back for a variety of uses, including charcoal production and fencing poles. By injecting a little light and youthful vigour into woodlands, it works wonders for flora and fauna. Flowers such as bluebell, dog violet and wood anemone burst into life, and insects and birds take advantage of new growth and sunlit spaces.

The dwindling of this centuries-old practice has affected everything from nightingales to the Duke of Burgundy butterfly and dormice. But where it still takes place, wildlife flourishes.

Edible Dormouse

Unlike our native hazel dormouse, the larger and bolder edible dormouse is a species of central and southern Europe. It became established in the Chilterns after escaping in 1902 from the private wildlife collection of banker Lionel Walter Rothschild in Tring, Hertfordshire.

It is greyish-brown with a bushy tail, and there may now be as many as 30,000 living in mixed woodland, across a wide area around Tring Park – some even nesting in roof spaces.

The edible dormouse was a table delicacy prized by the ancient Romans. It was fattened in captivity in a terracotta pot called a glirarium, and served roasted with a poppy seed and honey glaze.

Harvest

Jonathan Brown

As the summer draws to a close, the ears of wheat, barley and oats ripen and are ready for harvest. This is the culmination of the arable farmer's year, begun with ploughing and sowing, and has, for millennia, been a time not only of intensive labour but also of high anxiety.

For without granaries filled with dry, good-quality grain, winter food will be scarce and there will be insufficient seed corn to put back into the ground for the next year's crop. So it is no wonder that since cereals were first domesticated in the Neolithic period, harvest time has been invested with ritual and superstition, and today these customs still abound in fields and villages all over the land.

Lord of the Harvest

By tradition, the harvest, brought in with the help of much casual labour, was overseen by the harvest lord, who wore a rush hat entwined with green bindweed and red poppies. It was the lord who set the pace of work and ensured that the crop was cut with long stalks to prevent it being contaminated with weeds. Any labourer unwise enough to trample the corn would be fined by the lord who would use the money for so-called 'trailing beer', to give money to passing strangers and to buy gloves for the reapers, which were especially necessary when the wheat was full of thistles. As the sixteenth-century poet and farmer Thomas Tusser says in his *Five Hundred Points of Good Husbandry*:

> Grant, harvest-lord, more by a penny or two
> To call on his fellows, the better to do;
> Give gloves to thy reapers a largess to crie.
> And daily to loiterers have a good eie.

Scythes were the harvesters' tools, customarily rubbed to charm them into continued sharpness with the juice from wild arum or mouse-ear plants. Work was from dawn, when a horn was blown at the farmhouse door, until dusk – or even later by moonlight if the full, harvest moon was shining brightly. Beer was drunk by the farmer throughout the day (but drunkenness was taboo) and the bond with his labourers was immensely strong at this time.

Each field was cut in a circle, from the outside in, until only two sheaves remained, which were tied together to create a neck or 'mare'. Then the reapers would throw their sickles in unison so that no one individual could be accused of capturing the spirit of the corn living in these final ears. This act, called 'crying the neck' or 'crying the mare', goes back to the days of ancient Egypt and Greece, and any man whose sickle actually cut the knot with one thrust would be awarded a prize. Once the knot was severed, the cry would go up 'I have her'. Then workers would throw their hats in the air and kiss the girls gathered to watch the ceremony. The harvest cart would be loaded and bedecked with flowers, ribbons and branches.

To preserve the spirit of the corn, the final ears were fashioned into corn dollies, brought in on the final load and kept in the farmhouse all winter before being ploughed into the first furrow in spring. Corn dollies or kern babies were originally fashioned into the likeness of Demeter, but were later, as they still are today, woven into a variety of shapes such as chandeliers, horns and horseshoes. They would also be tied or interlaced with red thread to protect the grain against witches' evil. Often, some strands of straw were also shaped into cockerels, birds deemed to be able to protect the corn spirit, and placed at the ends of ricks.

Bringing in the last load, workers would sing:

> Harvest home! Harvest home!
> We've ploughed, we've sowed,
> We've reaped, we've mowed,
> And brought safe home
> Every load.

A healthy field of wheat in Norfolk, ripe for harvesting.

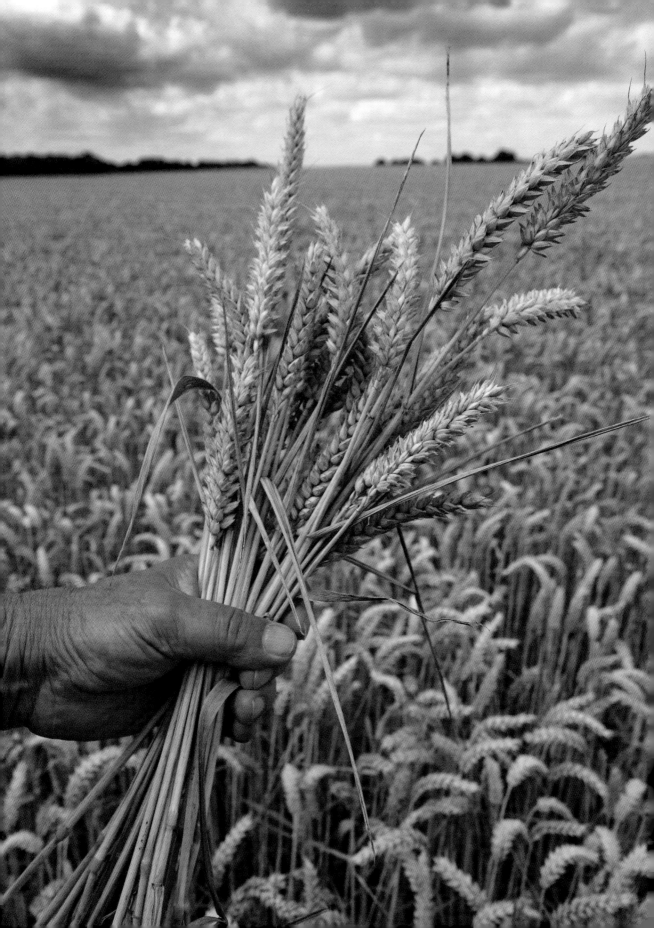

Hedgerow Fruits and Nuts

Adele Nozedar & John Wright

With the lush green herbs of spring long gone and the rather barren months of high summer over, September is the month to go foraging in the hedgerows for berries and other fruits.

ELDERBERRY
These are often ready in late August, but early September is high season. Break off the whole bunch when picking, removing the berries with a fork. Makes the best country wine.

BLACKBERRY
Picking this fruit is the birthright of every child. Don't worry about the fruit-flies or getting covered in juice – it's all part of the fun. Try them in a fool, wine or whisky.

SLOE
Sloe gin is an institution in Dorset. Leave the sloes in the gin for six months before decanting to release the almond flavours in the kernel. Used sloes can be stuffed into game birds.

PLUM
The wild plum is fairly common in hedgerows, but you may have to search out your 'spot'. It comes in three varieties: plum, damson and bullace.

CRAB APPLE
These are best used as the basis of a fruit leather with almost any hedgerow fruit. Adding them to sweet cider can add tannin and acidity, and they make a great country wine.

HAWTHORN
This is the most abundant but most difficult of fruits to use. Stew a kilo of crab apples and haws with a little water. Push through a sieve, stir in sugar and spread for a fruit leather.

Purple sloes and smaller red hawthorns ripen throughout the autumn and are foraged by birds and mammals – and humans.

HAZELNUT
Often seen in hedging or at the edge of woods. The name is from the Anglo-Saxon 'haesel', meaning 'hat', referring to the frilly case that covers half the nut. There are approximately 18 species.

SWEET CHESTNUT
The tree prefers a mild climate, lime-free soil and moisture. Unlike the conker (similar in appearance), the nuts are delicious. Pierce the skins, roast, peel and dip in butter and salt.

ACORN
Also known as the oaknut, acorn species vary in shape and size. Oak trees grow in woods as well as singly or in small groups. All acorns are edible, although tannins make most bitter.

BEECH NUT
Beech trees grow alone and in forests. The tight, prickly shells open in early autumn, dropping their fruits to the ground. The nuts – also known as beech masts – were once fed to pigs.

WALNUT
These non-native nuts are something of a Russian Doll; a smooth, pale-green outer layer covers a further, knobbly shell that gradually hardens. The inner nut resembles two halves of a brain.

HORSE CHESTNUT
Underneath their spiky, green outer case, conkers are glossy brown, round, up to 4cm (1½in) in diameter and have a paler patch on the underside. They are not edible, but make a lovely silky soap.

Standing Stones

Ian Vince

There is something about standing stones that is strangely captivating. Their peculiar, ambiguous form draws your attention first. Many menhirs (an alternative name that translates as 'long stone' in Cornish or Breton) appear as isolated, accusing fingers that do little but point at the sky, lending them an air of mystery. Then there is the extravagant effort required to quarry, transport and erect them, when our ancestors must have had other calls on their time. Finally there is the question of purpose. Are they ancient memorials, avatars of ancestors still at large in the landscape, or did they have a more prosaic function?

Sadly, the thinking that drove our megalithic cultures to do this is lost to us now and we may have to make do with the mystique that remains, along with the consolation that visiting our most interesting stones leads us to corners of Britain that are fascinating in their own right.

Rocks Around the Clock

The stones are part of a wider landscape upon which our ancestors erected stone circles, dolmen, barrows, avenues and other pieces of Neolithic or Bronze Age field furniture. In a few cases, they are found in a small group of other stones forming rows or odd arrangements and for which there is frequently a legend attached.

One of the most bizarre arrangements of stones is at the Mên-an-Tol on Penwith in Cornwall – a holed stone, about 1m (3ft) high, is aligned between two short standing stones, almost certainly not in their original positions. It's thought to be part of a former circle, with the holed stone probably part of a long-forgotten nearby tomb, but in its rearranged form it is associated with a treasury of miracles, from healing rickets to magical fertility rites.

At Rudston in the East Riding of Yorkshire, the Devil was supposed to have thrown a stone at the church and missed, but Rudston Monolith was here long before the church and at 7.6m (25ft) high – Britain's tallest and 40 tonnes in weight – it easily matches its younger cousin in gravitas.

Scotland's tallest, Clach-an-Truiseil (the Stone of Compassion) is a stone's throw from the north-western coast of Lewis in the Western Isles. At 5.8m (19ft) tall it's the sole surviving monolith from a complete circle, of which there is no shortage on Lewis. Its original purpose was surely about making a connection – one that has endured between its builders and the landscape for 5,000 years.

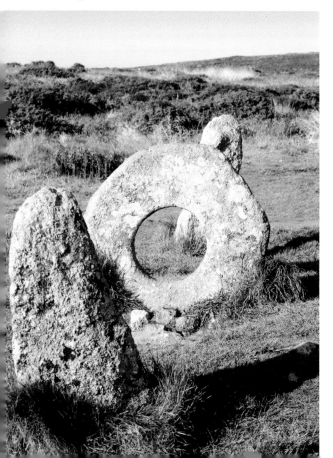

The late Neolithic Men an Tol, near St Just in Cornwall, is thought to have been part of a now disappeared stone circle or an entrance to an old burial chamber.

OPPOSITE: *The Callanish Stones on the Isle of Lewis comprise 13 tall stones and a single 'monolith' in the centre. The stones were erected around 2000 BCE.*

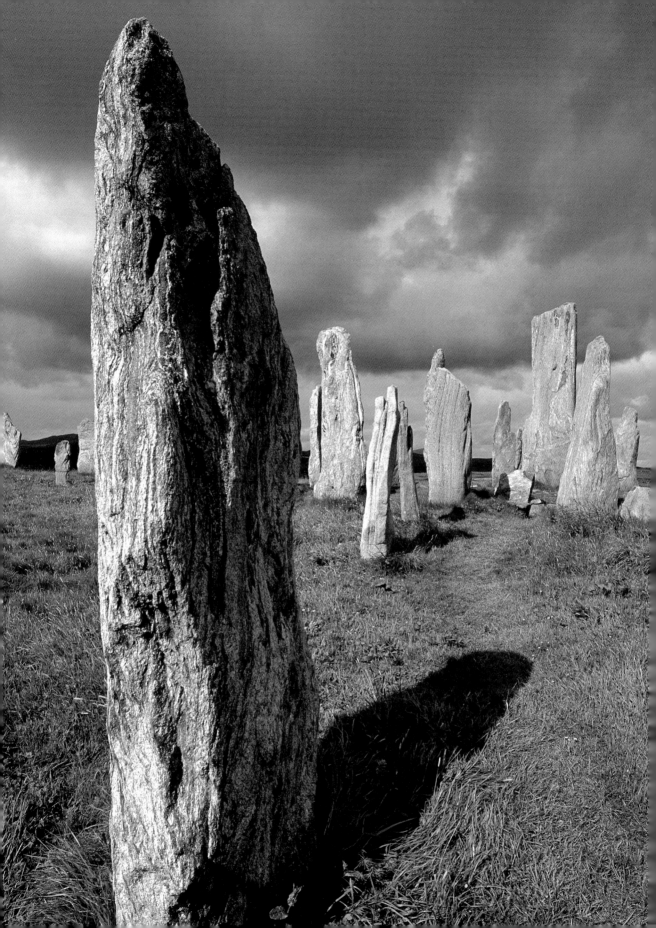

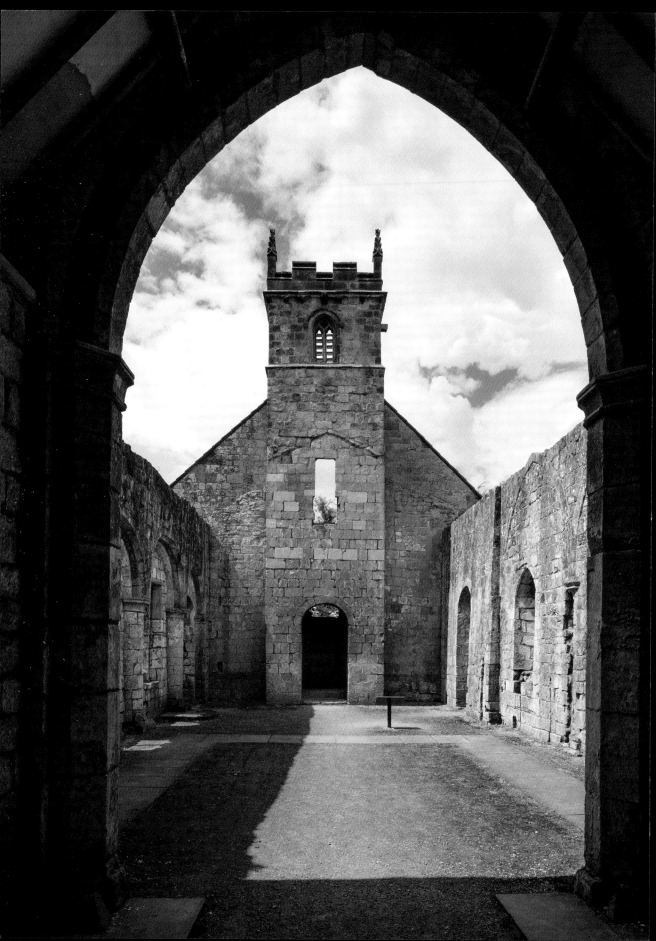

Deserted Medieval Villages

Ian Vince

The eternal peril of its pubs and post offices aside, it's hard not to view the British village as something of an indestructible institution. But it wasn't always such a permanent fixture and the threats villages face now pale in comparison to the menaces of the Middle Ages, when entire communities could be wiped off the map at one person's behest.

The 'Medieval Village' label on OS maps carries the presumption of plague, but the spectre of entire settlements exterminated by the Black Death in the years 1348–1350 is an exaggeration. Magnificent churches, such as St Mary's at Tunstead in Norfolk where work was halted by the Great Mortality – as the plague was known – are better indicators of its effect; villages were weakened and reduced, but not always extinguished.

The real menace of the Middle Ages was the humble sheep. Innocuous and dim as individuals, in farmed flocks their role as woolly bailiffs was well-established before, and for centuries after, the Black Death.

Cistercian monks were among the first to farm sheep on the cleared, enclosed lands of evicted villages. The Cistercian craving for isolation was what destroyed villages such as Cayton and Herleshow in Yorkshire during the twelfth century; both were given to Fountains Abbey in return for the eternal salvation of the villages' noble freeholders, while their tenants suffered the temporal damnation of being forced to move on.

The Black Death would play a part later. With a reduced working population demanding better terms, the manorial lords, perhaps inspired by the Cistercians, filled their lands

The ruined church of St Martin is all that remains of the once-thriving village of Wharram Percy in east Yorkshire.

RIGHT: *Sheep are the only inhabitants left in the ruins of Hirta Village, St Kilda, which was abandoned in the 1930s as life there was no longer sustainable.*

with sheep. Wharram Percy in the Yorkshire Wolds, the most famous of Britain's 3,000 abandoned villages, was enclosed during the late fifteenth/early sixteenth centuries and is typical of the pattern that continued in England for another 300 years. Many later enclosures were for country houses, allowing landscape designers such as 'Capability' Brown to graze on the profits of enclosure in place of the sheep.

In Scotland, the ovine menace appeared during the Highland Clearances of the eighteenth and nineteenth centuries. Some of the most brutal clearances occurred at Boreraig and Suisnish on the shore of Loch Eishort; families were forcibly evicted and their homes burnt down. Geologist Archibald Geikie witnessed the evictions in 1853 and described the dispossessed cortège leaving Suisnish and its grief-laden wail echoing along the strath as a 'prolonged note of desolation'.

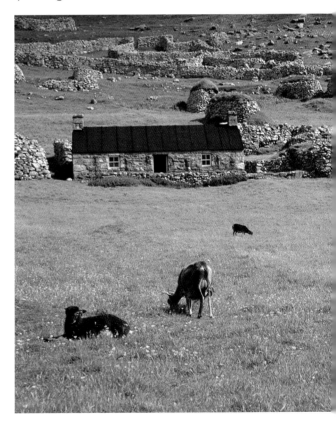

Hadrian's Wall

Fergus Collins

There's a glint of movement in the epic rolling hills to the north. Something… somebody is advancing towards the Wall. From a wind-straffed turret high on a ridge, you feel both exposed to the elements but invulnerable to attack. The Wall stretches across inland cliffs and would take an army to scale.

You needn't have worried anyway as the fidgety movement in the landscape materialises into a lonely post van taking civilisation to the remote farms of Northumberland.

It's hard not to assume that a Roman soldier's life on Hadrian's Wall must have been a lonely, frightening existence but roughly every mile there was a milecastle housing 30–40 soldiers and between each milecastle were two turrets, each housing 5–10 men. So a sentry would only have to walk a couple of hundred yards before he could share a joke with a mate or be warmed by a fire.

A Mental and Physical Barrier

Whether you've visited it or not, this great linear fortification begun in 122CE still imposes itself on everyone's mental map of Britain, even if you only have the most rudimentary idea of how the country is put together. And though it runs entirely through two English counties, it still feels like a barrier between England and Scotland. It has certainly played an important role in defining the two nations through the centuries. In the Roman world, you were either within the Wall and part of the civilised club – or in the twilight zone beyond the limits of the Empire. Modern Scots might argue that the roles have long since been reversed.

Each turret or milecastle had a gate in it where the Roman soldiers controlled entry into the Empire. While their credentials were checked, travellers were penned between two fortified doors with soldiers menacing from above. The prize would be the south door opening – onto more wild countryside it must

be said – but the mind's eye would tell the traveller that this was the promised land.

Though our mental maps might show a wall running from North Sea to Irish, the truth is far from that. There are only fragments left, the best bits running over the craggy countryside between the village of Greenhead and Housesteads fort. Where's the rest of it? That's a long story that becomes clear as you travel along its length.

If you were to walk the Hadrian's Wall Path, a joyous week-long romp from Bowness-on-Solway in the West to Wallsend in Newcastle in the East – you'd find it hard to believe that the Romans extended their wall all the way to the wide saltmarshes of Cumbria. But they did so to keep pirates from raiding what is now Dumfries and Galloway. The Wall here was built from the red sandstone that you'll find in much of nearby Carlisle and it eroded far more quickly than the harder Whin Sill you find further east. Any foundations are now lost under farmland.

Quiet Beginnings

The Solway Firth is the quietest major estuary in this part of the country. There is little industry here, just green expanses loved by waders and wildfowl in winter and grazed by sheep the rest of the year. The villages – Beaumont, Kirkandrews-On-Eden, Burgh by Sands – all rose-covered sandstone and brick cottages, bypassed and bygone.

The only interruption to this estuarine eden is an obelisk, surrounded by metal railings. It marks the spot where Edward I took sick and died in 1307 while attempting to hammer the Scots once more. But perhaps more impressive are the songs of skylarks and yellowhammers – ridiculously common here.

It was Edward I who turned Carlisle into a regional centre. Though it had been a fort on

Walltown Crags has some of the best-preserved sections of Hadrian's Wall, in a wild and remote landscape.

the Roman Wall, Edward I made it a base for his warmongering. Its red walls, castle and fine collection of medieval buildings make it a worthy detour. Like Newcastle at the other end of the Wall, it is miles from any other major city and so has a powerful pride in its own civic identity.

Edward I is inescapable in this part of Cumbria. Following the Wall east out of Carlisle, you will stumble across Lanercost Priory, in the rising hills above the pretty but fading market town of Brampton. Here Edward spent six months in 1306 as his health failed. Hidden signs of his presence remain, from the tiny carving of him and his wife under the eaves to the cuts in the stone by the doorways, where his knights sharpened their swords.

Stone Thieves

Lanercost provides more hints at the whereabouts of the Wall – it is actually built from the Wall's stones. The priory's walls are exactly the same height as the Wall would have been – a daunting 4.5m (15ft). The fact that they created 117km (73 miles) of wall in just five years or so would challenge even our modern technology.

It wasn't just Lanercost that stole stones. Cottages and farmhouses throughout the Northumbrian countryside are built of the Wall's same grey stones. The Wall survives, but not as you'd expect. Wall theft only stopped in the nineteenth century when John Clayton, town clerk of Newcastle, stepped in to buy up land and restore sections of the Wall. It's down to him that anything survives today.

The ridge road above Lanercost takes you into ever more dramatic countryside and it's here that the Wall emerges from the Cumbrian soil. There are turrets studding the roadside, then stretches of Wall and the first major fort, Birdoswald. And it's here that you notice that the Wall is not just about stones. To the south, there is a huge trench, running parallel with the Wall. This is the Vallum. Originally 6m (19ft 7in) wide and 3m (9ft 10in) deep, it designated the military zone that civilians were not to cross. It

would be a world-famous feat of engineering if it weren't so close to the Wall…

From Birdoswald, you enter the heart of Wall country. At Walltown Crags, Cawfields Crags and Steel Rigg you get those famous views of the Wall snaking over distant hills. There is also a series of excavated forts – Housesteads, Chesters and, best of all, Vindolanda. These were the headquarters, and towns grew up around them as traders and others came to service the legionaries' needs.

Vindolanda is perhaps the most interesting of the lot. Set a little to the south of the Wall, it is still being excavated and the brand-new museum provides a poignant insight into life here for both legionaries and the seldom-told stories of the civilians. There is an exquisite garden outside the museum where a small stream tumbles through a red squirrel-haunted woodland. To find out more about the military side of things, head for the Roman Army museum near Greenhead.

If you don't walk along the Wall path here, you'll probably follow the ultra-straight B6318, better known as the Military Road. It was built a good 1,500 years after the Wall by English forces, to put down the rebellious Jacobeans. Sadly, they used stones from the Wall as foundations for their road. Nonetheless, it is perhaps good to know the Wall is still part of the landscape.

South of the Wall

One can overdose on Romans, Walls and history, and yearn to see more wildlife, in which case, make an excursion to the barbarous lands to the north, into the deeply rural valley of the North Tyne to the fringes of the legendary Kielder Forest. At 650 sq km (250 sq miles), it is the largest wooded area in England.

The triangular tips of trees barely pierce the murk here, but if the day is clear, look out for displaying goshawks – Kielder is a haven for this sparrowhawk on steroids.

Black grouse are found nearby in places where moorland meets the woods. There's

a particular hotspot on the MoD land of Otterburn Ranges.

Next head south into the deep valley of the West Allen river and then up onto the foggy North Pennines. Black grouse are virtually guaranteed at the hamlet of Langdon Beck. It's a magnificent drive and this bold landscape seems to have changed little since Roman times.

Langdon Beck is a sunny haven in the hills. The birdlife is astonishing. This is where waders come to breed and every field usually holds lapwings, oystercatchers and redshanks. But black grouse can only be seen early, so set your alarm. This is a region that easily competes with the Lake District Fells or the Yorkshire Dales. Except without the crowds.

Where else in the UK can you find such an epic work of history lying silently in a farmer's field? This quiet region would have once bustled with legionaries, but now it is silent; peaceful. Not everywhere in the UK is becoming busier or more populated.

Border Reivers

Since the Romans built their Wall and created a division, the borderlands between England and Scotland have been contested. While neither country could exert complete control over the region, local chieftains acquired a certain amount of autonomy and this grew to a head in the late Middle Ages and the Tudor period (Stuart in Scotland). One of the means by which the Border families sustained themselves was by raiding – or reiving: rustling each other's cattle and plundering each other's homesteads. Such criminal actions understandably led to grievances and long-running feuds between certain families.

Border families learned to defend themselves by building very distinctive squat fortifications called pele towers, which were designed to withstand short sieges. You can find them in the villages and market towns throughout Cumbria and Northumberland.

Wall Walks

EXPLORE THE WALL – 11KM/7 MILES

Explore one of the finest sections of the Wall ending in Housesteads fort. From Steel Rigg car park follow the Hadrian's Wall National Trail, which runs beside the Wall. You'll pass several turrets and milecastles and a lake called Crag Lough. From Housesteads Fort either catch the Hadrian's Wall bus back to the start or follow the path north of the Wall following signs for the 'Pennine Way' to get a Pict's-eye view of the Wall and crags.

ALLEN BANKS – UP TO 7KM/4 MILES

This wonderful cleft near Bardon Mill holds Northumberland's largest ancient woodland. In spring, bluebells carpet the floor while pied flycatchers haunt the canopy. Otters hunt trout in the river Allen and you should see dippers and kingfishers at any time of year. The path is easy to follow and every step is a delight.

Rewilding (Knepp)

James Fair

A tall white bird with orange-red legs and black wings swishes its long bill through the dry grass, hunting for crickets, frogs or voles.

This rare bird – a white stork – belongs soaring in a thermal over Doñana National Park in southern Spain, and you'd almost certainly come across them in Botswana's Okavango Delta or Zambia's South Luangwa National Park. What was it doing here, on Knepp Estate in West Sussex in the heart of London's commuter belt? The answer? It was a small part of a jigsaw that's been created by the farm's owners, Charlie Burrell and Isabella Tree.

Knepp Estate, its eastern border conveniently located just a few hundred metres from the busy A24 that links London to Worthing, is the UK's most famous example to date of a wildlife conservation practice known as rewilding. Taking their inspiration from a Dutch site called Oostvardersplassen, over a period of some 15 years Charlie and Isabella have stopped farming Knepp in any conventional sense and let nature take its course.

The results have been spectacular, both in the way it looks and in the wildlife they have tempted back. The ghost of a field structure with linear hedges can still be glimpsed amid the overgrown scrub, but the hotchpotch mosaic of trees, shrubs and wildflowers is more reminiscent of the African savannah than an English farm.

Then there's the birdlife. Not just storks – a native species, in fact, that it's hoped will be reintroduced across West Sussex – but turtle doves churring from oak trees and whitethroats and dunnocks singing from almost every available perch, of which there are plenty. It has also become the best place in Britain to see the famed purple emperor butterfly.

Barn owls, kestrels and sparrowhawks patrol rich hunting grounds, while the rare harvest

Impressive white storks are now breeding at Knepp, the first to nest in the UK for some 700 years.

mouse has also found the untamed grasslands to its liking. There are plans to bring beavers back to the area, returning this landscape engineer to the south-east for the first time in hundreds of years.

Creating Wood Pasture

Knepp hosts a safari led by estate ecologist Penny Green who drove a group of conservationists from a local wildlife trust around the estate in an Austrian Pinzgauer all-terrain troop carrier – handy when it's been raining for a few weeks on end, but not quite as necessary when the ground's baked as hard as the South African Karoo.

Hawthorn, blackthorn, bramble, fleabane and sallow – the latter being the food plant for purple emperor caterpillars – now run riot over the estate, but Knepp has also gained a reputation for its Vera oaks. Named for the pioneering conservationist Dr Frans Vera, these oaks demonstrate how trees regenerate in a landscape devoid of top predators, such as wolves or lynx. A protective curtain of brambles stops herbivores stripping the bark from the tree while it's still a vulnerable sapling, and by the time it has grown large enough to shade out the blackberry bush, it won't die if a passing deer stops for a nibble.

As Isabella Tree notes in *Wilding*, her brilliant account of how Knepp came to be, orthodox ecology teaches how Britain was originally closed-canopy woodland from top to tail. 'It is said, before men started swinging stone axes… a squirrel could have run from John O'Groats to Land's End across the tops of trees,' she writes.

But Knepp – and Vera's pet project Oostvardersplassen – works on a different assumption: that herbivores such as aurochs, wild boar, tarpan (Europe's native wild horse, now extinct) and red deer were creating wood pasture out of closed-canopy woodland long before people arrived in Britain. Charlie and

Isabella have brought back these animals, or proxies for them, including longhorn cattle, Tamworth pigs and Exmoor ponies, to create this habitat.

Much has changed in Knepp by the autumn, when the red deer rut. The doves and nightingales have long since departed, and there is none of the hustle and bustle on show seen during the steamy spring. Still, the rut is steamy in a different sense.

In the Southern Block where wilding has been most pronounced, a green woodpecker yaffles nearby, while a group of goldfinches feed on leftover seeds on an old farm track. A pair of jays, wings flashing blue and white, fly into a nearby oak tree, and then comes a throaty, menacing sound, similar to a red deer stag's roar, but also distinctly different – a fallow deer stag, whose rut is supposed to get even tastier than the red's.

One morning, local naturalist and photographer David Plummer headed out before first light, into Knepp's Central Block and its more traditional Repton park-scape. He quickly found a barn owl, post-hopping close to a field where the longhorn cattle have spent the night, then the small herd of Exmoor ponies feeding in open grassland, much as their wild ancestor, the tarpan, might have done 5,000–10,000 years ago. It's more like a prehistoric safari than an African one.

Back in the Southern Block, David found a red stag with a harem of hinds, and a rival waiting in the wings. 'It's been fascinating watching the politics this year,' David says, waiting to see if the interloper would make a move for his hinds. 'One stag's been on top, then another. Last year, one stag became dominant right at the beginning – one big battle and it was all over.' The head stag was on alert, but the newcomer did not push his claim, perhaps – like an ambitious Elizabethan noble – deciding to keep his counsel for now. No point losing your head when there's no chance of a position in court.

An early-morning chill turns into a balmy autumn day, and leggy craneflies flicker in the warmth. They have already mated and are just a few days from completing their life's journey. The stag, too, is also looking to ensure his genes survive into another generation, though unlike the craneflies, he will get another chance next year.

Knepp's Big Winners

RED DEER

After committing to rewilding, Knepp brought back red deer. Along with domesticated herbivores, such as longhorn cattle (which act as substitutes for extinct aurochs) and Tamworth pigs (wild boar), grazing and browsing help drive natural regeneration.

TURTLE DOVES

The gentle churr of the turtle dove – once common in lowland Britain – has disappeared in the past 30–40 years. Knepp is the only place in the country that bucks the declining trend, with numbers increasing from three pairs in 1999 to 16 pairs in 2017.

WHITE STORKS

This dramatic, beautiful wading bird could become a common sight in Knepp and the rest of West Sussex over the next decade. Conservationists hope local communities will volunteer their roofs as nest sites.

PURPLE EMPERORS

The sallow or pussy willow scrub that has proliferated here since Knepp stopped arable farming has been a boon for Britain's second-largest butterfly, the purple emperor. The adult butterflies like Knepp's mature oak trees.

BARN OWLS

Knepp's determination to let wildlife come back under natural processes is slightly compromised when it comes to barn owls: nestboxes have been put up for them throughout the estate. Rough field margins provide ample vole and mouse prey for these silent hunters.

Rewilding in Britain

While Knepp is currently the poster boy of Britain's rewilding movement, there are a number of other projects in development.

In the Lake District, the Wild Ennerdale project is rewilding 4,700 hectares (11,610 acres) of our uplands. Sheep have gone from the fells to be replaced by lower densities of more wildlife-friendly cattle. Other projects include Summit to Sea in mid-Wales, while the Rewilding Britain group has been talking to landowners in Norfolk about a rewilding initiative there.

Rewilding Britain's specialist advisor Alastair Driver says we only need to turn 5 per cent of the country (or about 7 per cent of our farmland) over to rewilding to reverse wildlife declines in the UK. 'We're aiming for one million hectares [2.5 million acres] by 2100,' he says. 'In the uplands, we're looking for significant projects of 10,000 hectares [24,700 acres] or more; in the lowlands, you can demonstrate significant ecosystem changes over 1,000–2,000 hectares [2,470–4,940 acres].'

For the time being, he says, we shouldn't obsess over whether to bring back bears, lynx or wolves, because we're not at that stage yet. 'It is going to take decades, if not centuries, to get anywhere near there,' he says. Instead, we should be thinking of species such as pine martens (which are being brought back to the Forest of Dean), wildcats (the focus of a reintroduction project in Wales) and white-tailed eagles (being reintroduced to the Isle of Wight).

'One of the key principles,' Driver concludes, 'is to treat people and livelihoods as key. It's not about imposing anything on anyone; it's not about stopping farming or forestry. People will do better where rewilding takes place, and it will be seen to be a good thing.'

This 'domestic' Tamworth pig is allowed to live a feral existence on the estate, its rootling and wallowing creating habitats for other creatures.

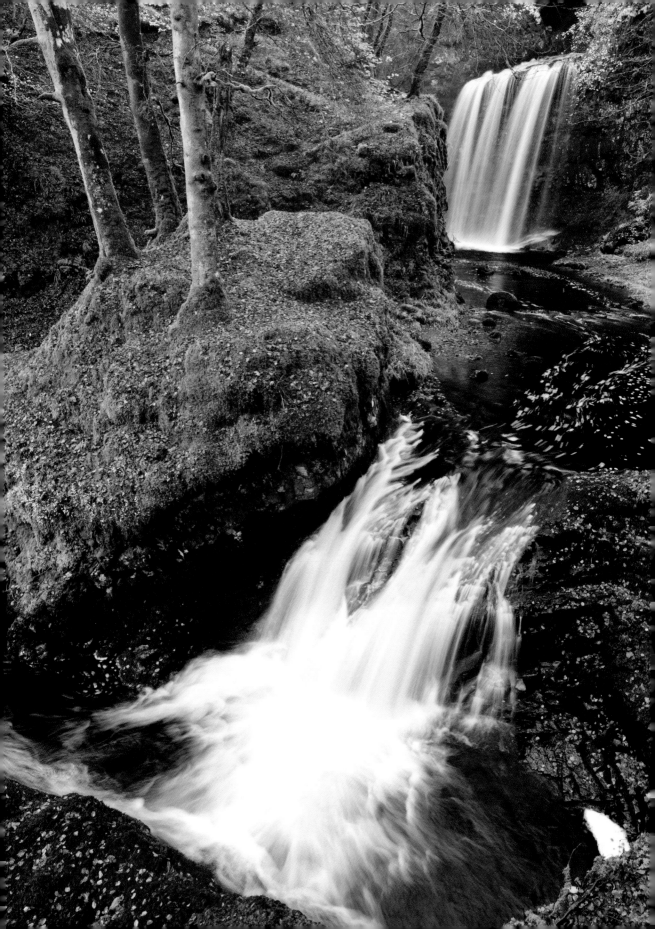

October

The return of the otter to UK rivers is one of the great conservation successes of the past fifty years. When Henry Williamson wrote his much-loved book *Tarka the Otter* in the 1920s (it's never been out of print) they were quite a common sight. But when I met him at his North Devon home in the 1970s he was visibly distressed that their numbers had declined catastrophically. In many counties, otters had become extinct and blame was put on polluted waterways, habitat destruction and hunting. Sadly, Williamson didn't live to see their reversal of fortune, starting in the 1980s: otters became legally protected, hunting was banned and now there are otters in every county – they have even moved into cities like London and Birmingham.

Another member of the weasel family making a comeback is the pine marten, which has been called nature's most adorable assassin. Centuries ago they were everywhere, but now are rare and mostly restricted to Scotland's pine forests. Some have been spotted in Wales and Northern England recently, and numbers, though small, are growing in Gloucestershire's Forest of Dean and the New Forest. They spend most of their time in the trees so are incredibly agile (if they fall they spin round and land on their feet), but hunt mostly on the ground. Their prey includes squirrels – they seem to prefer grey ones to reds, which gives hope that if pine martens keep on increasing so, too, will the reds.

Sometimes when I'm travelling through Britain's more remote areas it's hard to believe we live on one of Earth's most crowded islands. 'Where is everyone?', you wonder, scanning landscapes devoid of any other human presence. The answer, of course, is they are crammed into towns and cities, leaving these huge, empty places to act as nature's green lungs: places like the uplands of England and Wales and the highlands of Scotland.

Nonetheless, human endeavours have left their mark: uplands have been damaged by drainage and peat removal and been overgrazed by sheep while phalanxes of pine dominate large areas of the Highlands. But efforts are under way to return as much as possible of these near wildernesses to the way they used to look.

Autumn rain revives rivers, and waterfalls, such as here in Dalmellington, Ayrshire, cascade vigorously once more.

Mushrooms and Fungi

Kevin Parr

The air is at its most mellow on an autumn morning, softened in a shroud of mist while dew hangs heavy in the cobwebs. The sun will rise, when it can be bothered, but its energy is spent after the summer and it eases sleepily into the day, casting long, hazy shadows and just a gentle warmth.

The hedgerows are laden with berries; elder, black and dew – while sloes, hips and haws stand proud among the withered leaves. Beneath the fallen leaves, millions of strands of mycelium are hard at work, breaking down the leaves and throwing up their fruits of reproduction – mushrooms. And though some will appear throughout the year, autumn is when it gets serious.

Mushroom hunting is best done in the early morning unless storms are crashing in off the Atlantic. The forest is so much more welcoming when the air is still and you can hear every acorn fall, every roe deer hoofstep.

Picking mushrooms is a chancy business. There are plenty of fungi in this country that can make you very poorly or even kill, so don't so much as touch a mushroom unless you know what it is, and carefully check through your haul when you get home, just in case overexuberance saw an unwanted interloper sneak into the basket.

It is a rewarding pastime, though, and the beginner could do worse than buy a copy of *Mushrooms* in the *River Cottage Handbook* range, not least for author John Wright's wonderful turn of phrase. Heed his advice carefully, though – particularly when he suggests you refer to at least one other book than his own. You can never be too careful.

Five Fine Fungi to Forage

HEDGEHOG *Hydnum repandum*
From above, the irregularly shaped, off-white leathery cap is hard to spot, but turn one over and the key characteristic is revealed. Beneath the firm cap are little spines, which give the mushroom its name. Often found in rings, so if you find one, there will probably be more. The mushroom is best cooked in a pan with butter for at least 10 minutes.

GIANT PUFFBALL *Calvatia gigantean*
Unmistakable when fully grown, these fungi can grow bigger than a football. Slice them thick and cook in bacon fat and black pepper. They are not common, though, so be sure to leave more than you harvest. Smaller but more common varieties of puffball are also edible, but beware earthballs, which are black inside.

CHANTERELLE *Cantharellus cibarius*
One of the most sought-after mushrooms, the egg yolk-yellow chanterelle typically grows among moss on the forest floor and is versatile in the kitchen. It tastes good and looks good after cooking, too. It is similar in appearance to the rare, but poisonous, jack o'lantern (*Omphalotus illudens*), so caution is required.

PARASOL *Macrolepiota procera*
Has a round, scaly, cream-coloured cap measuring up to 30cm (1ft) in diameter with a bump in the centre; a distinct 'snakeskin' stipe (stem) and a movable ring. The cap is best coated in breadcrumbs and fried. Also look for the smaller shaggy parasol (*Chlorophylum rhacodes*), but don't confuse either with poisonous dapperlings when small.

CEP *Boletus edulis*
Has stunning flavour, but can be difficult to distinguish from other Boletus so some care should be taken. Most Boletus are edible, but lack the cep's 'bread roll' cap, which has a pale edge and gives the mushroom its common name, penny-bun. Known as *porcini* in Italy.

Once you get your eye in, chanterelles seem to glow from the leaf litter on the woodland floor.

Moorlands

Andrew Griffiths

Most people's experiences of moorland come from looking out of a car window over what seems a bleak, inhospitable landscape. If the weather is good, you might see across the tussocks of grass to the purple edge of the flowering heather. If the weather is poor, the thick, grey cloud descends to envelop you.

But there is more to the moor's story. The dark strips on far hillsides, for instance, are a sign of human activity. Reminiscent of the marks left by a plaster ripped off bare skin, they are actually where heather has been burnt, possibly for managing a grouse moor.

Or perhaps an area of peat is bare, parched, crumbling and cracked – another sign of human activity, where the land has been drained and overgrazed by sheep farmers encouraged by an agricultural policy that subsidised the draining of moorland in the 1960s and '70s. This is far from a natural environment. It has been managed – or mismanaged – for centuries and has now reached crisis point. Despite the moors' hard visage, a real fragility lies just below the surface. And none has suffered more than the South Pennines area of the Peak District – the 'Dark Peak'.

The partnership Moors for the Future (MFTF) has spent the past couple of decades working to repair the damage. 'We're in a unique position in that the level of degradation that has occurred in the Dark Peak and South Pennines is far above anything that's happened to upland blanket peat anywhere else in the country,' says Chris Dean, head of MFTF's programme delivery.

The Peak District has become so degraded because it is surrounded by Manchester, Leeds and Sheffield, some of the most densely populated cities in the country. These were great centres of the industrial revolution, powered by the burning of coal. The resultant smoke found its way over the Dark Peak and fell into the moorland with the rain. 'Whichever way the wind was blowing, there would be coal smoke shed on the Peak District,' says Dean.

Hard-working Land

To understand why pollution wreaked such havoc on moorland ecosystems, you need to know how the blanket bog that forms them works. The key component is the bog-forming plant, sphagnum. This plant absorbs carbon dioxide (CO_2) from the atmosphere, which it does so efficiently that, if all the Peak District's blanket bogs could be restored, it would take the annual planting of 15,000 broadleaf trees to soak up the same amount of CO_2.

The reason for this efficiency is that peat has two layers: a top layer of living sphagnum that captures CO_2 and lower layers of spent sphagnum that make up the waterlogged peat, but which decay slowly due to a lack of oxygen.

But sphagnum moss doesn't like sulphur or acidic environments and the coal smoke blown in from the cities brought in sulphur by the bucket load, along with heavy metal pollutants. It led to the creation of a sphagnum 'stew' that was as acidic as lemon juice. Thus another incentive to prevent the further erosion of peat is to keep toxic elements buried on the moors rather than seeping into our drinking water.

Once the sphagnum is gone, the peat dries out, and can all too easily fall victim to summer wildfire. This kills more vegetation, which leaves more peat uncovered, and so the cycle continues. So rather than act as an efficient CO_2 sink, it then releases the trapped carbon into the atmosphere, adding to the problem of global warming rather than mitigating it.

Since 2003, MFTF has been working to restore vegetation to these vast tracts of bare peat. The process begins with a temporary cover of fast-growing grass, after which other moorland species, such as heather, are introduced. These raise the water table by blocking drainage gullies and produce the right conditions for reintroducing sphagnum.

Rushes and mosses dominate the starkly beautiful uplands of the Cairngorms.

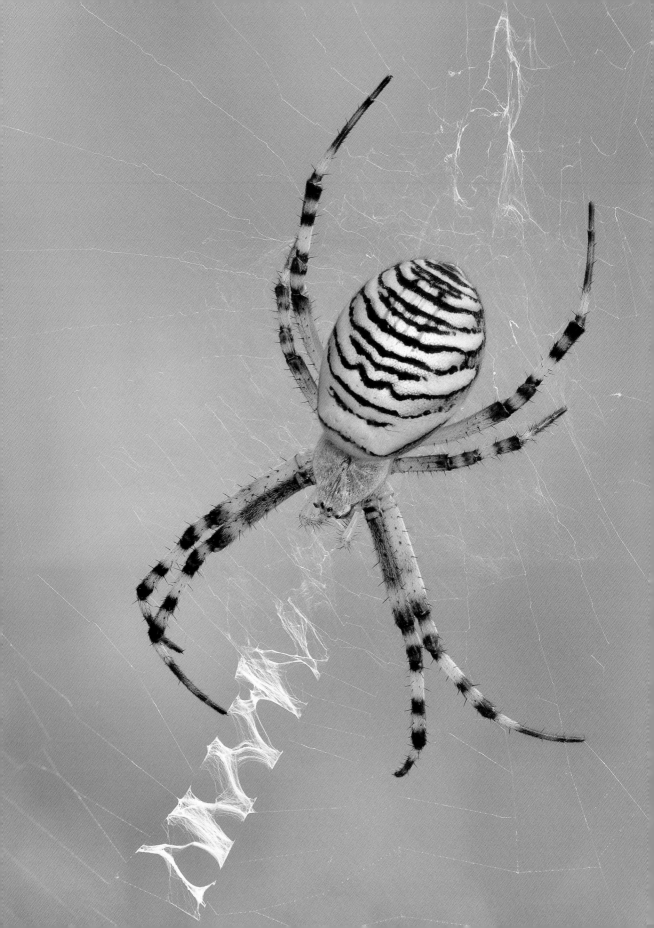

Spiders

Richard Jones

Autumn is a good time to appreciate spiders, when they reach full maturity towards the end of their commonly one-year life cycles.

Common Spider Species

GARDEN OR DIADEM SPIDER
Araneus diadematus
Named for the diadem on its back (a pale circle and four radiating gleams), this has many colour forms including brown, yellow-green and orange. It spins spiral webs along hedges and between tall stems.

FOUR-SPOT ORB-WEAVER *Araneus quadratus*
Britain's largest spider is plumper, broader, rounder than the garden spider, with four indented dimples on its abdomen, usually outlined with four white spots. Makes webs in long grass and dense shrubs.

BRIDGE ORB-WEAVER *Larinioides sclopetarius*
Elegantly marked, this has velvety grey-and-white colouring (brown hints sometimes) and an undulating white line down each side of its abdomen. Its webs are over water on bridges, lock gates and wharves.

WATER SPIDER *Argyroneta aquatica*
Britain's only subaquatic spider is reddish brown and grey, streaked, but appears silver because of an air bubble over its abdomen. It makes an air-filled silk-stranded diving bell in pond and stream weeds.

FALSE WIDOW *Steatoda nobilis*
Glossy black, sometimes with pale crescent on front of abdomen; male has pale mottled

The huge, brightly patterned wasp spider spins its webs in meadows to catch grasshoppers.

RIGHT: Britain's heaviest spider, the four-spot orb weaver builds its web close to the ground to trap jumping insects.

fleur-de-lis mark on back of abdomen. It makes a scaffold web in sheds and can give a painful nip if picked up. So don't.

WALNUT ORB-WEAVER *Nuctenea umbratica*
Glossy dark-brown above, fawn at edges, separated by undulating pale line on each side of abdomen. Broad and flattened, it hides in cracks in fenceposts or under tree bark by day and spins web at night.

WASP SPIDER *Argiope bruennichi*
Unmistakable, massive, barred black-and-yellow female; the male is smaller, narrower with orange abdomen. Its low web in long grass has a broad vertical stripe of fuzzy white silk. Grasshopper predator.

RAFT SPIDER *Dolomedes fimbriatus*
Huge and dark chocolate brown, this is edged with two contrasting yellow-white stripes down sides of abdomen; legs are paler. Common in lowland wetlands, fens and boggy upland moors, it walks on water.

GIANT HOUSE SPIDER *Tegenaria gigantea*
In browns and greys, its abdomen chevron-marked, very long legs. It makes an untidy web with tubular retreat behind furniture or loose skirting, but also under logs and in hollow trees – its original habitat.

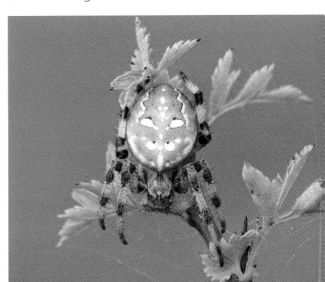

Deer

Fergus Collins

Britain's deer populations are expanding, yet most of us see them rarely as they are secretive woodland dwellers. During the autumn deer rut, they are much more noticeable due to their need to mate. Here's our guide to the six deer species found in the British countryside.

RED DEER *Cervus elaphus*
The UK's largest land mammal, with stags up to 140cm (4ft 7in) at the shoulder. Its high, branched antlers gain more tines with age and its reddish-brown summer coat turns grey in winter. The red deer prefers woodland in England and southern Scotland but has adapted to living on open moors.

SIKA DEER *Cervus nippon*
Up to 95cm (3ft) at the shoulder, the sika is reddish-brown with spots in summer, but the spots recede in winter. Its antlers are similar to red deer but smaller. Introduced from the Far East in the nineteenth century, small populations are now found in England, Scotland and Northern Ireland.

FALLOW DEER *Cervus dama*
Up to 95cm (3ft) at the shoulder, the fallow is our only deer with palmate/plate-like antlers.

A male fallow deer and his harem of females with a couple of juvenile bucks at the Holkham Estate in Norfolk.

It has a distinctive spotted coat and white rump outlined with a black horseshoe. Brought to Britain in Roman times, it is now widespread in England and Wales; patchy in Scotland.

ROE DEER *Capreolus capreolus*
Up to 65cm (2ft 2in) at the shoulder, the roe is small and elegant with a reddish summer coat that turns grey-brown in winter. It has short, rough antlers. It is widespread in forests across England and Scotland and increasing in Wales. May be seen feeding in open fields.

CHINESE WATER DEER *Hydropotes inermis*
Small, up to 55cm (1ft 9in) at the shoulder, this deer has fang-like tusks and not antlers. The buck emits a distinctive whistle during the rut. Originally from China, escapees from parks have fostered wild populations in eastern England. It prefers reedbeds, river shores and fenland.

MUNTJAC *Muntiacus reevesi*
Our smallest deer, just 50cm (1ft 8in) at the shoulder, the muntjac is russet in summer, grey-brown in winter with single antlers. Unlike other deer, it breeds all year round. Introduced from China in the twentieth century; now widespread in the south. It emits an eerie barking call.

OPPOSITE: *Introduced in 1860, sika favour heathlands and conifer woodland, with scattered but growing populations in Scotland, Cumbria and Dorset.*

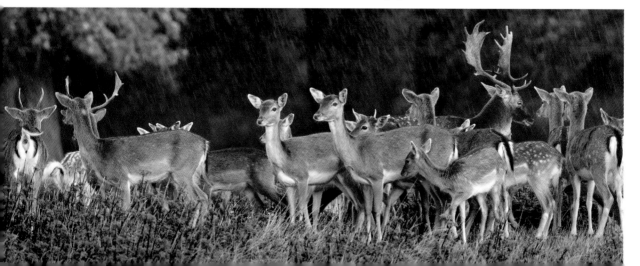

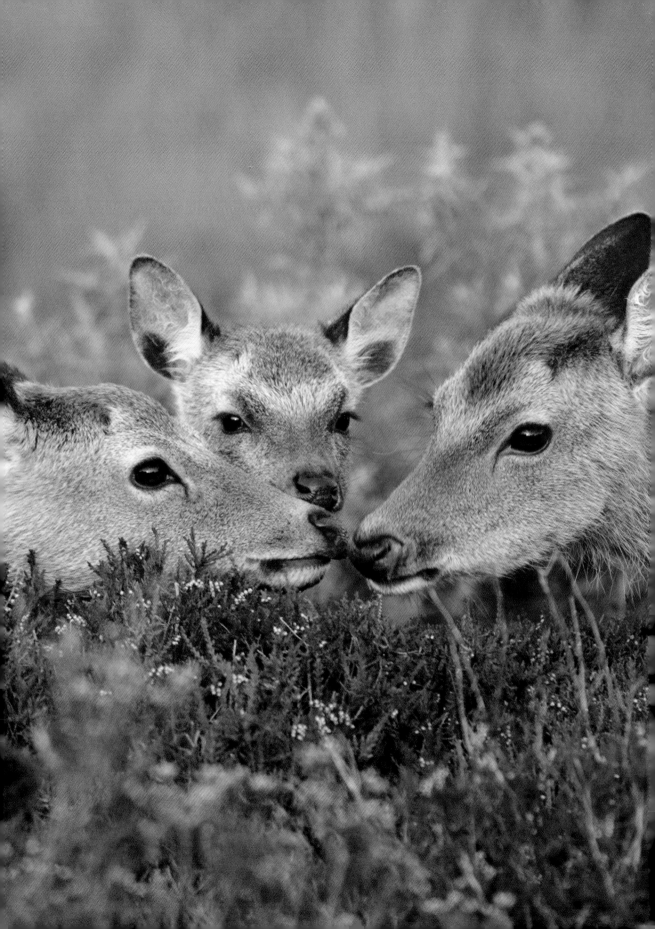

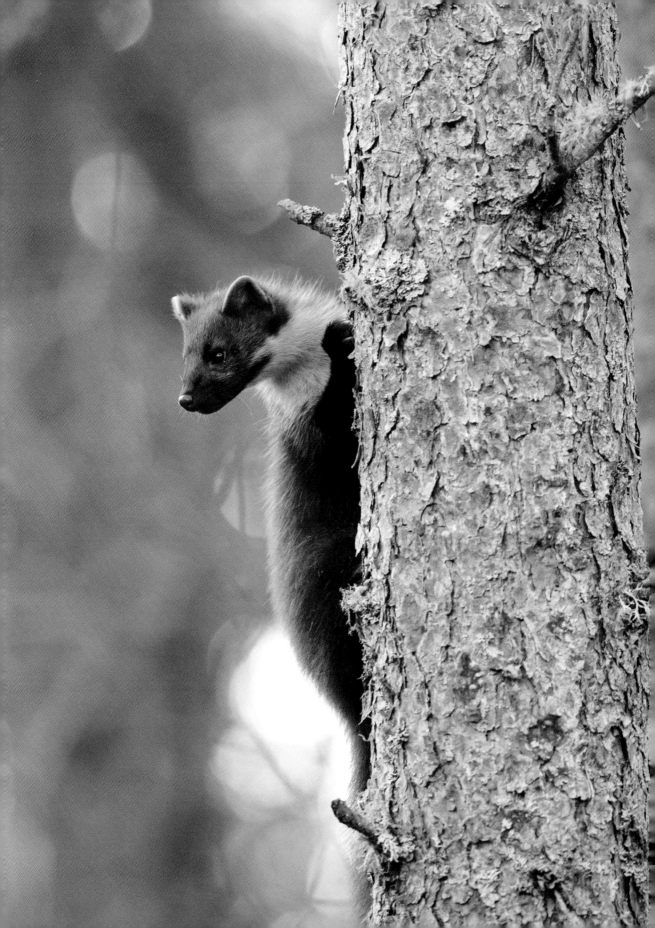

Pine Martens

Julie Brominicks

The woodland feeding station camera reveals a glossy, chestnut animal. It pauses, sniffs the air and arches its back, before springing lightly on to large paws. A pine marten!

This glimpse of the pine marten is precious: the species is Britain's second-rarest carnivore – only wildcats are more scarce.

It's hard to believe that pine martens were once Britain's second most abundant carnivore, after the weasel. In the Mesolithic Age (9,000 to 4,300BCE), an estimated 147,000 of them thrived in the wild wood that covered the land.

Over centuries, their forest homes were cut down in vast tracts, and they were hunted by humans. As early as the sixth century, pine martens were trapped for fur. Later, they were considered a pest; omnivorous and opportunistic, they would take valuable game and poultry. In the nineteenth century, when grouse shooting became fashionable, gamekeepers would cull any predators they could. Already scarce after centuries of deforestation, pine martens were almost obliterated.

Some respite came in the early twentieth century, after new taxes on the wealthy led to a reduction in gamekeepers. After the Second World War there was more woodland, too, offering pine martens a suitable habitat to move into. Finally, in 1988, the Wildlife Act gave pine martens legal protection for the first time.

In the Scottish Highlands and Ireland, pine marten populations began to recover. Yet in England and Wales there was still little sign of them. Possibly the remaining populations were just too small to expand. Enter the Vincent Wildlife Trust (VWT). After years of research, the mammal research and conservation charity concluded that the marten communities in England and Wales would not recover without help, in the form of reintroduction of animals into the area.

The agile pine marten is an avid hunter of squirrels – especially greys.

Support for the idea was bolstered by reports from Ireland showing that where pine martens thrived, grey squirrel numbers dropped significantly. This was good news to the forestry industry, as greys allegedly cause £20m-worth of damage annually to young trees. And with greys more scarce, the beloved reds are more likely to thrive. Legislation was secured and over the next few years a number of animals were released in Wales.

What is a Pine Marten

Pine martens are mustelids – their relatives include badgers, weasels, polecats and otters. They make dens, raise young and travel in trees, but hunt on open ground. Their omnivorous, seasonal diet is dominated by voles but includes rodents, pigeons, grey squirrels, eggs, invertebrates, berries, fruit, honey and carrion.

They typically live for around 15 years. Breeding rates are slow; most do not mate successfully until the age of three. Typically three kits are born in spring and disperse in autumn, although the mother may tolerate them on her territory over winter. Otherwise, adults are solitary, though territories can overlap with those of the opposite sex to facilitate breeding.

Territories range from 3,300 hectares (8,100 acres) in the upland spruce monoculture of Galloway Forest to 42 hectares (100 acres) in the lowland woodland of County Clare, benefited by an absence of polecats, with which martens compete, and a scarcity of foxes, which kill them.

Roughly cat-size, they mark their territory with scent glands and almost aromatic scats. Flexible ankles, long, robust limbs and large feet aid climbing, and large tails help them balance. A light body weight enhances speed and agility but limits insulation, tempered in the den by a warm bushy tail and improved in winter by a fluffy coat.

Mammal Burrows

Richard Jones

A burrow is more than just a hole in the ground – it is warmth, shelter, safety from predators, and a place to raise a family. Usually dug in dry ground, with at least some scrub cover, they can be awkward to locate unless given away by a large spoil heap. Burrows are normally dug horizontally, so need a bank or ridge in which to start the excavation, though the tunnel may then veer downwards. Exact shape and dimensions depend on soil type, underlying rock or root obstacles, and age.

Burrows to Look Out For

BADGER
The sett (or set) is usually a massive earthwork, with one or more main chambers buried up to 3m (10ft) into the ground and a large mound of excavated soil piled up around the main entrance. There tend to be multiple exits hidden deeper in the undergrowth, and a latrine of small square holes will be close by.

FOX
Not a strong digger despite his Roald Dahl incarnation, Mr Fox will excavate an earth in loose sandy soil or adapt rabbit or badger holes elsewhere, closing up all but one entrance.

He's been known to set up home under garden sheds, beneath fallen trees or inside a deep dense thicket of scrub.

HARE
Hares have no burrow, but create a semi-permanent abode in a rough scrape or hollow in undulating ground, against a rock or in a large grass tussock. The site is often chosen to give a view for danger. Hares are said to make one or two long leaps when leaving or returning, to confound scent-tracking predators.

RABBIT
A female will dig a small breeding burrow of about 1m (3ft) deep to give birth, closing up the entrance each time she leaves to feed. Otherwise, rabbits live in large interconnected warrens in a loose colony. The warrens have many entrances but a panicked rabbit will bolt for its 'home' hole rather than the closest entrance.

OTTER
Always near water, the otter's holt can be dug up to 10m (33ft) into a stream bank, under overhanging tree roots, in hollow trees or in piles of reed refuse. Their aquatic homes have both underwater and above-ground exits. Some say that otters dig deeper holts when they know they are actively hunted.

MOUSE OR VOLE
Little rodents like small, secretive holes up to 1m (3ft) into soil but often make do with a cover of loose leaf litter and a nesting chamber underneath. These homemakers sometimes build larders full of stored seeds, and their old abandoned nests are frequently reused by discerning bumblebees.

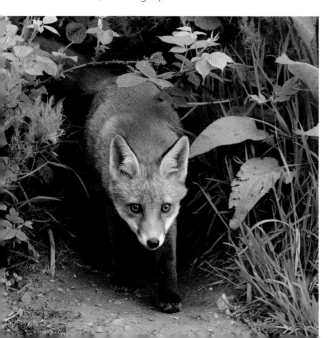

A fox cub emerges from his den, a hole hidden deep in the base of a hedgerow.

OPPOSITE: *A large badger sett may be home to up to 15 animals and with as many as 40 entrances.*

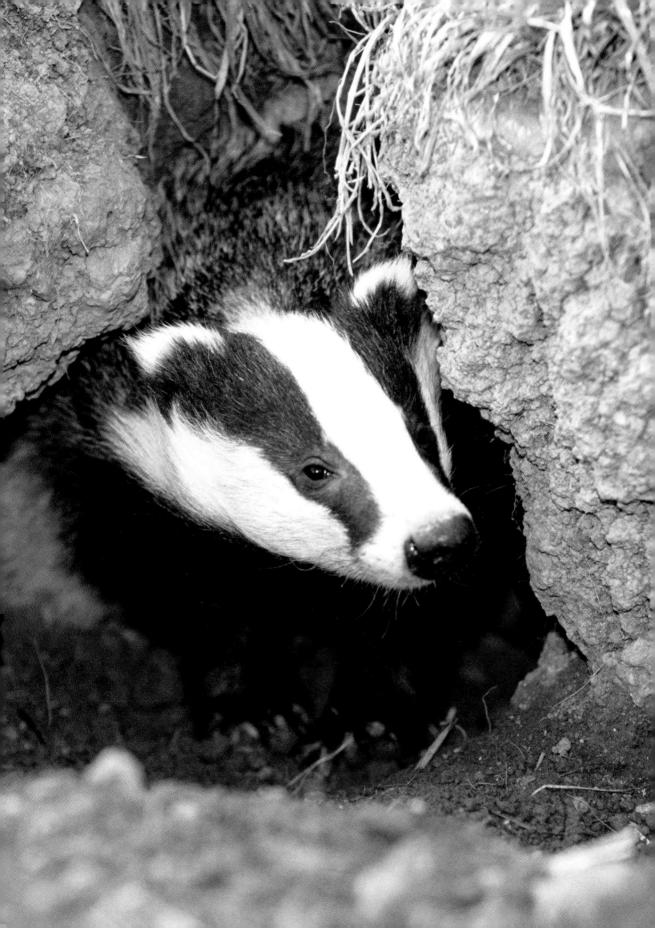

Pumpkins

Vernon Harwood

How does that old advertising slogan go? The future's bright – the future's orange. Well, for many enterprising farmers that's certainly the case, but rather than investing in mobile phones, they've found a market in growing pumpkins.

Shops are awash with the brightly coloured crop every autumn in a way that was unthinkable 20 years ago, when the long, misty months between the end of the summer holidays and the Christmas break were punctuated only by Guy Fawkes Night. But in the 1990s, America's Halloween traditions began to take off in Britain. Along with spooky outfits and trick or treating, the trend for pumpkin carving really gathered pace.

Of course, there's nothing new about jack-o'-lanterns – we've been carving them from vegetables for centuries – but in recent years the American influence has seen their popularity escalate. According to legend, the custom began with the carving of turnips. When Irish immigrants arrived in the New World, there was a distinct lack of turnips, so instead they used pumpkins.

But there's more to pumpkins than just a cheap way to make a scary lantern. Brits have developed a taste for them, too. The fleshy 'insides' are cropping up in all sorts of imaginative dishes – not just the famous pumpkin pie, but also soup, stew, lasagne, ice cream, pizza and even pâté. A few years ago, Matt Baker made pumpkin pâté when the *Countryfile* programme visited Slindon in Sussex. It's a small community not far from Arundel, but every autumn its annual pumpkin festival is a magnet for thousands of visitors from all over the world. The highlight is an impressive mural made up of hundreds of pumpkins and all sorts of colourful veg.

Pumpkins ready for harvest in late October, Norfolk. It is estimated that 23 million pumpkins are grown in the UK each year.

Slindon's rival for the title of Britain's pumpkin capital has to be the Lincolnshire town of Spalding. Already renowned for its bulb production, the area is also home to Europe's largest commercial pumpkin grower, which produces more than three million for sale in the UK and overseas. Not surprisingly, it's led to Spalding staging its own pumpkin festival with stalls, entertainment and a parade of carved pumpkins, followed by a firework display.

Freaky Fruit

Now pumpkins might look like vegetables but they're actually fruit. Technically a type of squash, they belong to the same family of plants as the cucumber. Although they're about 90 per cent water, pumpkins are a great source of potassium, iron and vitamins A, C and E. There are around 500 varieties worldwide in a range of colours including white, blue and green.

Planted in late spring, the UK pumpkin harvest runs from the beginning of September until the end of October. But in the last two weeks the race is on, because after Halloween demand disappears quicker than Cinderella's coach at midnight.

That's no easy feat, because harvesting them is extremely labour intensive. So while it's great news for seasonal staff, who can ensure several weeks of work in the fields, the cost of employing pickers (and supermarket demand for high volume at low cost) means a smaller margin for the farmer.

So what should you look for when you choose your pumpkin? Always go for a heavy one without any soft spots or blemishes. Another good tip is to pick one with at least a 5cm (2in) stem. That's because the shorter the stem, the sooner it will shrivel. But most importantly, enjoy your pumpkin, whether it's for eating – or scaring the neighbours!

Quince

Richard Aslan

You could be forgiven for mistaking a quince for a pear, especially one of the golden-skinned, chubby sort, like a Starking or a Comice. They are of a roughly similar size and both dangle from gnarled, shade-giving trees. The traditional habit of scattering quince trees among those bearing other fruits would only add to the potential confusion. Bite into one, however, and the difference is quickly apparent. While a ripe pear bursts with sweetness and tumbles juice down your chin, all but the very ripest of quinces is hard enough to make your jaws ache and has a flavour to make you wince. In Turkish, its extreme sourness is referenced in the saying '*ayvayi yemek*' – meaning 'eat a quince' – a rather forthright way of explaining the outcome of any unfortunate situation that would best be avoided.

Not Good Raw

While some claim to enjoy gnawing on raw quince, this fruit is best enjoyed cooked or preserved. Its unique flavour and hint of pink make an interesting addition to any apple pie. While pears make bland jam, quince preserve is flavoursome. In the Middle Ages, quinces were boiled to form a thick purée that was poured into animal-shaped moulds. This survives today in Spain as *membrillo*. In Iran, quinces are added to meat dishes for a sour fruity note, reminiscent of medieval European cuisine.

Both fruits are members of the Rosaceae family, which is found in every part of the globe and which takes in other fruits including apricots, plums, cherries, raspberries, strawberries and almonds, as well as roses. The subgrouping Maleae, from the Latin *malum*, is restricted to the milder climates of the northern hemisphere and contains apples, pears, quinces and hawthorns among others.

Though these fruits are redolent of English country gardens, both are among the oldest of cultivated fruits. Some theories place the genesis of the pear in the mountains of China, where they were valued commodities along the trade routes west into central Asia and Europe.

Quinces have been around for even longer – since at least the time of the ancient Mesopotamians. As historical documents are notoriously vague on detail, this might mean that the 'apples' in the Garden of Eden, and the fruit offered to Aphrodite by Paris, were in fact 'golden apples' – another name for the quince.

Membrillo Recipe

Pronounced mem-BREE-yo, this floral and fragrant quince paste is a traditional Spanish favourite. Serve it with equal-sized squares of manchego cheese in a combination known as *Romeo y Julieta*. It makes an easy dessert, or a great addition to a buffet lunch.

- 1.5kg (3lb 4oz) quinces
- 1 vanilla pod
- caster sugar (for amount see below)
- 1 large lemon

Scrub, core, peel and slice the quinces. Cover with water in a large pan. Split the vanilla pod and add to the pot along with the lemon juice and zest. Boil for 30–60 minutes until the quinces are very soft, then drain. Fish out the vanilla pods and scrape the seeds into the fruit mixture. Weigh the drained quinces and measure the same weight of caster sugar. Blend the fruit with a hand-held blender until very smooth, then return to the pan with the sugar and boil for 60–100 minutes until thick and deep ruby in colour. Pour the paste onto a greased baking tray, cover with parchment paper and refrigerate overnight to set. Or bake the paste on a low oven for an hour to speed up the process. When set and firm, cut into squares.

Pear-shaped, quinces are golden in colour, hard yet highly aromatic – the scent suggestive of ripe pears and apples.

Tarka the Otter

Jack Watkins

'Twilight over meadow and water, the eve-star shining above the hill, and Old Nog the heron crying kra-a-ark! as his slow dark wings carried him down to the estuary.' So reads the atmospheric opening line of the much-loved nature story *Tarka the Otter*. When Henry Williamson's tale was first published, the novelist John Galsworthy hailed its author as 'the finest and most intimate living interpreter of the drama of wild life'. TE Lawrence, who became a friend of Williamson, wrote that it had kept him 'sizzling with joy for three weeks'. Even an ailing Thomas Hardy approved.

But it was the public that delivered the ultimate verdict, delighting in the saga of Tarka's 'joyful water-life and death in the two rivers', the Taw and the Torridge, of remotest Devon. They made it an instant favourite, and it has been endlessly republished, never out of print, and even adapted as a feature film.

Years before TV documentaries brought nature so graphically into living rooms, Williamson's taut prose conveyed an otter's-eye view of life in all its raw, brutal and often terrifying reality. Decades before concern about the natural world had taken root, the work touched a nerve.

Exploring North Devon

Williamson moved to the isolated Devon village of Georgeham in 1921, after several restless years following the trenches of the Great War. Determined to make a living from country writing, he'd kept a nature diary from boyhood, and was soon familiar with the wild cliffs and moors of north Devon. Although his response to wildlife was not scholarly or academic, Williamson's empathy with nature seems to have been total.

Tarka was several years in the making, and Williamson would later tell how, in 1921, a stranger had arrived at his cottage asking for help rescuing an orphaned otter cub. Williamson brought it home, where his cat acted as foster mother. The otter learned to respond to Williamson's call, and joined him on his evening strolls. One time, however, the otter got caught in a rabbit snare, and when Williamson freed him, ran off.

Still, the seeds of a book were sown. Williamson was so keen to be exact that he claimed to have rewritten the manuscript 17 times. Critics, he conceded, might have been right when they said the result was too tightly packed: 'Yet I enjoyed it all. I knew the prose was straight, clean and true – facts you know. It is all here in Devon if you just happen to see and hear or smell it.'

Nostalgia

Today, Tarka can be read with nostalgia for wildlife or country scenes we'd now consider rare or special – corncrakes, bittern and snipe, a woodlark singing 'his wistful falling song over the bracken', foxgloves on the hillsides, or bundles of hazel drying in a wood clearing for the thatcher. It would be wrong to read it as a conservationist tract, however, for otters in the 1920s were still abundant in most counties, and would only begin to decline seriously from the late 1950s, with the use of organochlorine insecticides and new river management.

Still, Williamson's meticulous detailing of otters' playful, curious and adventurous natures had elevated their profile. And along with his brilliant representations of animal sounds – the otters' playful 'hu-ee-ic!', the 'skirr-rr' of barn owls, and 'cur-lee-eek!' of curlews – his ability to convey the elements and landscape ensured its timelessness as a literary masterpiece. From incidentals such as blackthorns 'creaking' in the wind, to the roaring, foaming river that sweeps Tarka along in joyous reverie, or the bleak estuary in a winter freeze, he created images that linger long in the memory.

Tarka the Otter gives readers a unique insight into the seldom-seen lives of these elegant aquatic mammals.

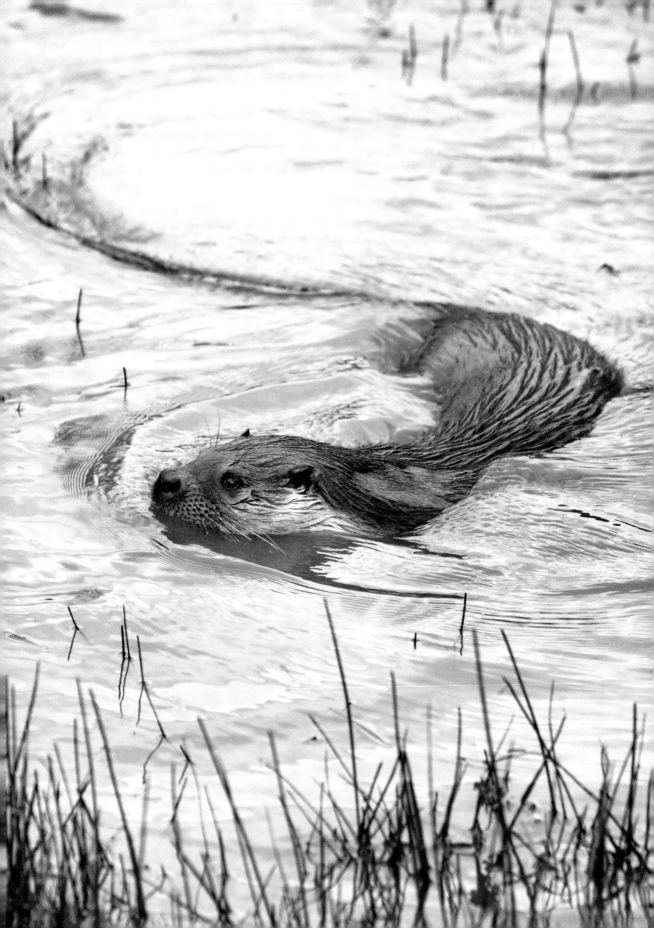

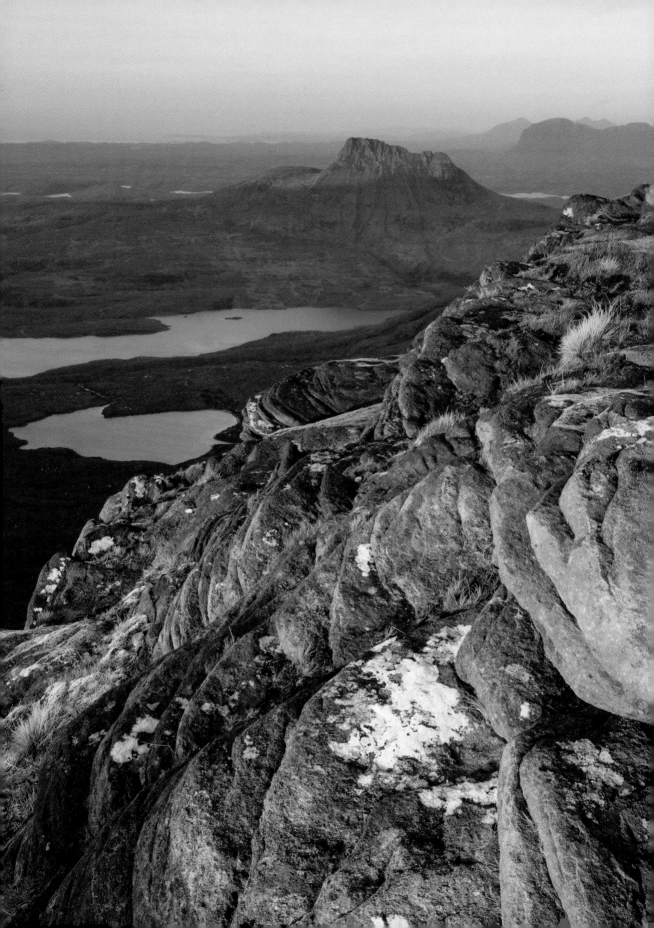

Northwest Highlands

Cameron McNeish

The pull of the west – a rather abstract notion that draws us towards the shimmering seas and whatever lies beyond them. Add the element of 'northness' and you discover a magical blend personified in many ways by the North West Highlands of Scotland, a land of torn and shredded coastlines, highly individualistic mountains, and some of the oldest rocks in the world. This is the ragged, wild edge of Europe, and the finest time of the year to visit is the autumn.

Why? First, for the bronze, gold and ochre earth tones, which contrast so well with the blue of the sky or the dark rolling storm clouds. Then there's the roaring of rutting red deer stags, primeval and raw – a sound that no other British mammal quite matches. And on a more practical note, the midges and the tourists have largely vanished. So as the season begins to fade gently towards winter, head north in search of adventure.

This journey threads together unforgettable mountains, magnificent lochs and a blend of trails. It begins in Ullapool and ends at Cape Wrath, the most north-westerly point on the Scottish mainland.

On the Road

The Norse named Ullapool when they came south to Scotland and recognised its sheltered position on Loch Broom as an ideal place for seafarers. Today, Ullapool is an important ferry port – a bustling portal to the Western Isles and the North West Highlands' largest town.

From Ullapool drive north, revelling in the tawny autumn colours of the land. Excitement builds around Ardmair Bay. This is a special landscape formed by the effects of the geological feature known as the Moine Thrust Belt, a 200km (120-mile) line that crosses

The distinctive profile of the mountain Stac Pollaidh and the wild land of peaks, moors and lochs known as Assynt.

Scotland from Skye to Loch Eriboll on the north coast. West of this ancient frontier, the mountains are individual, stark and contrasting. Their Torridonian sandstone forms a wondrous array of shapes, the result of millions of years of erosion. It's no wonder this whole area has been designated as the North West Highlands Geopark, the first in Scotland.

To experience the most dramatic impression of this scenery, leave the main road and follow the winding route west to Achnahaird. Just beyond the Brae of Achnahaird, look back at the isolated mountain shapes that form the horizon – beyond the russet shades of bracken lie the hills of Coigach, Stac Pollaidh, Cul Beag and Cul Mor, Suilven, Canisp and Quinag. You'll be gazing at some of the most dramatic mountains in Scotland.

Stac Pollaidh is the most visitor-friendly. It rises on the southern fringes of Assynt and could be described as the 'perfect miniature'. On first viewing, its primeval shape makes you gasp in astonishment. Rising from the ochreous moorland, it thrusts its jagged crest into the sky with a cocky bravado.

A footpath encircles the hill at about half-height before a subsidiary path lifts you up to a pass which is usually the high point for most folk. To stand on the true summit, to the west of the bealach (or pass), calls for an exposed and rocky scramble. Most folk are happy enough to sit among the rocky pinnacles of this narrow saddle to eat their lunch. There, they soak up the views of the wonderful maze of rock and water known as Inverpollaidh, a region of lochs and heathery hummocks clenched between Stac Pollaidh and the long ridge of Suilven in the north.

From Inverpollaidh you can float along a rosary of lochans (small lochs) to reach lovely Loch Sionascaig, with its ragged coastline and green islands. Camp on its shore and you can watch otters play in one of the nearby pools while red deer stags roar their seasonal challenge.

The road rises beyond Loch Assynt and climbs over a high pass between Glas Bheinn and a multi-topped mountain called Quinag. From the tiny hamlet of Kylesku, the first glimpse of Quinag can be intimidating. On dour autumn days she can look distinctly menacing, with steep, barrel-shaped buttresses of terraced rock. This is the territory of the golden eagle and, increasingly, the massive white-tailed eagle; look carefully and you might just catch the scything flight of a peregrine falcon diving on some unsuspecting prey.

The hamlet of Kylesku, and its excellent hotel, lies where three lochs meet. It's a stunning location, particularly in its autumn raiment, and the slim curve of Kylesku Bridge links it to north-west Sutherland, where no visit is complete without a walk or bike ride to Sandwood Bay.

The landscape here is pockmarked with lochans and it is the land of the great northern diver. The bird's wild and melancholy cry embodies the spirit of these northern parts. It's an eerie sound, particularly in the half-light of an autumn gloaming.

The End of the Road

Twenty or so kilometres (12 miles) north of Sandwood Bay lies the Cape Wrath lighthouse, home to John and Kay Ure. This remarkable couple run the UK's most remote tearoom, the Ozone Café, in one of the renovated lighthouse buildings.

Despite its isolation, this remote corner of the UK is the focus for much of the tourism in the area. From April until October, a tiny ferry operates from Keoldale near Durness, carrying passengers over the beautiful Kyle of Durness.

A small loch or lochan shelters beneath the peak of Quinag – where golden eagles often make their home.

Loch Lurgainn and the mountain of Cul Beag viewed from the summit of Stac Pollaidh at sunrise.

Once ashore, the passengers are taken 20km (12 miles) by minibus to Cape Wrath, where they can spend an hour enjoying the cliff-girt scenery or savouring Kay Ure's wonderful home baking.

The Ures enjoy the kind of lifestyle that many would aspire to but few could cope with. It is not without uncertainty: a few years ago John took Kay to their boat, which was moored in the Kyle of Durness. She was going to Durness for a Christmas shopping excursion to Inverness. It was 19 December.

By the time Kay returned to Durness with her Christmas turkey, heavy snow and gale-force winds had made it impossible for her to complete her journey to the Cape. She didn't get home until the third week in January. The only bonus was that the turkey had stayed frozen the entire time.

It's easy to focus on the difficulties and potential hardships of living in such an isolated place as Cape Wrath, but there are benefits too. 'We don't suffer from loneliness,' John says. 'We have each other, we have the dogs, there's usually a walker or two about and in the summer the minibus keeps us busy with tourists.

'I can sit here and watch the fin whales and dolphins. The deer come at night to graze. I breathe what almost feels like pure oxygen. I wouldn't go back to the city for anything.'

And the name of the café? Where does that come from? 'We named it after the wafts of fresh ozone that drift down from Greenland from time to time. It smells a bit like newly mown grass, pure fresh oxygen.' And there can't be many places in the UK where you can have the privilege of smelling that. The Scottish Northwest Highlands boasts such purity in abundance.

November

One of the most popular features on *Countryfile* has always been the weather forecast and I know the duty meteorologists take special pride in it – they even switch from smart to casual clothes to deliver the details. For everyone who is out and about in the countryside it's vital to know what the weather will bring. In farming, fishing and other outdoor industries, livelihoods – even lives – can depend on it.

Over the years, improving technology has made these forecasts ever more accurate, and when I set off to locations I pack the appropriate clothing and am always glad I did. But when I interviewed Gavin Pretor-Pinney, founder of the wonderfully named Cloud Appreciation Society, he said we must read the sky to find out what the weather will be in our immediate vicinity in the next minutes or hours. Here are clues on how to do just that.

It's more than just bad weather that can stop you reaching the Dorset village of Tyneham. The only road is closed when red flags are flying because Tyneham is dangerous – it's part of the Army 's Lulworth firing range with live shells flying everywhere. Check beforehand online, as I did, to make sure it's safe to visit.

The villagers were moved out in 1943 because the area was needed for military manoeuvres and, despite promises, they have never been allowed back because it still is. One gets an eerie feeling wandering round this deserted village that was no different from thousands of other small rural communities until the needs of warfare led to it being forcibly abandoned and frozen in time.

But closing Tyneham and the rest of the 2,800-hectare (7,000-acre) firing range to human habitation has been good news for rare wildlife species such as sand lizards and smooth snakes. They are undisturbed (unless the shells land too close!), and even white-tailed eagles, reintroduced this century on the south coast, have been seen checking the place out.

November marks the start of the frosts that can damage many plants, but not the humble kale. During a mini-ice age in the middle of the last millennium, kale thrived and today chefs say they prefer kale that's picked after a frost because it tastes sweeter.

Looking up into a canopy of beech trees, leaves turning bronze-gold as autumn progresses.

Oak Apples

Richard Jones

Among the naked twigs of oak trees, strange bobbles are now revealed by the falling leaves. Dubbed 'oak apples' or 'marbles' by a puzzled medieval populace, their production by the tree was a mystery for centuries. But this bemusement did not stop country people harvesting and exploiting them – high in tannins, the apples were used for making brown dyes and writing inks.

These are 'galls', abnormal growths on a plant's leaves, stems or roots, and although these 'apples' are made by the oak tree, they are under the control of tiny insect larvae living inside them. The adult gall wasps are as small as ants. When they lay an egg into the oak bud, they also inject special growth chemicals that cause the plant tissues to multiply and swell. When it hatches, the maggot continues to produce these distorting compounds, creating its own protective shell and an abundant food source within.

Here are some you might see on your next walk in the woods…

OAK APPLE *Biorhiza pallida*
These uneven, roughly spherical balls, are up to 4.5cm (1¾in) across and soft, creamy pink or green when fresh in May, but hardening to dull brown in autumn. There are usually several holes showing where the adult gall wasps exited; slice one open to reveal the remains of the larval chambers inside.

OAK MARBLE *Andricus kollari*
This is a hard, brown, woody, marble-sized ball, around 20mm (¾in) in diameter, perfectly round, but with a few small nodules on the surface. One hole reveals where the gall-causer emerged as an adult, while many smaller holes show where other gall-squatter insects have been feeding, too. A clever way to count the many holes is to stick a pin in each and count the pins as you go.

KNOPPER *Andricus quercuscalicis*
Look among the fallen leaves, under the trees, for the knopper, a gall made on the acorn. A twisted irregular ridged mass, about 20mm (¾in) across, sometimes completely obscuring the acorn (caused by several galls knitted together). It is sticky, reddish green on the tree in early summer, but by now is crusty brown. Knopper galls can outnumber 'normal' ungalled acorns, and when they first appeared in Britain in the 1960s and 70s, there were worries for future oak fecundity.

Gall wasp larvae secrete a chemical that changes the oak tree's normal defensive systems and a gall forms, protecting the larvae.

OPPOSITE: Oak galls usually resemble marbles but can take on a variety of shapes depending on conditions.

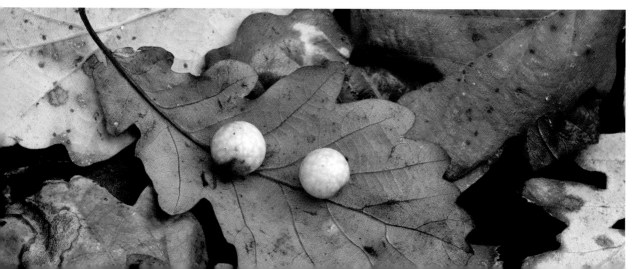

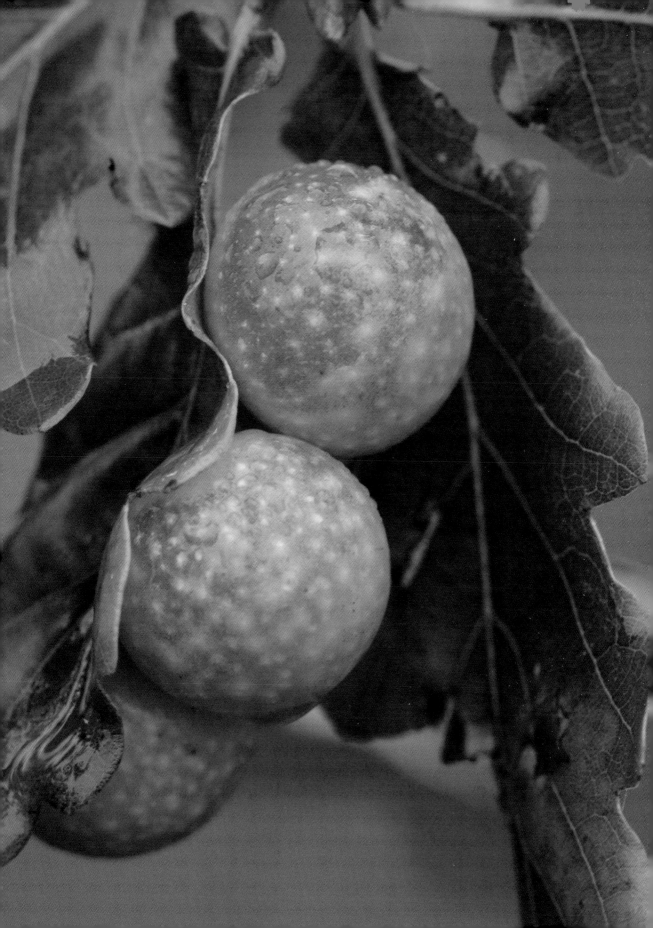

Lichens

Richard Jones

Lichens are not plants, but bizarre, poorly understood organisms in a mutual co-operation: half fungus, half alga, and sometimes home to cyanobacteria too. The alga or cyanobacterium produces simple sugars from photosynthesis and the fungus creates a structural matrix, the thallus, in which to house its powerhouse 'guest'. The thallus absorbs water from the atmosphere so lichens can grow on extreme, virtually water-free substrates, such as bare rock, tree trunks and stone walls. They can also survive severe desiccation by becoming metabolically inactive.

A Guide to the Most Common Species

GOLD LICHEN *Caloplaca flavescens*
Bright yellow lines, it fades to orange or lemon with elongated radiating lobes. Grows in rounded encrustations to 10cm (4in) across, with a central area resembling crazy paving. Apothecia (fruit body) are darker orange, 1.5mm (a tiny fraction of an inch) across. Found on walls, limestone and gravestones.

WHITE LICHEN *Diploicia canescens*
Pale grey to brilliant white, rounded or irregular-ovals to 6cm (2¼in) with long, overlapping lobes at the margins. The centre breaks out in powdery pale greenish white floury soralia (reproductive structures), 1–5mm. Found on trees, walls and rocks in lowland England and Wales, coastal Scotland and Ireland.

MAP LICHEN *Rhizocarpon geographicum*
Strong yellow-to-pale-green encrusted rosette, up to 15cm (6in) in diameter, with a distinctive crackled appearance and small (1–3mm across) black apothecia scattered all over. An upland species, found on exposed hard granite and silica rock, it's common in Scotland and Wales, more scattered in England and Ireland.

Beautiful lichens on a beech tree trunk. The presence of lichens is a good indicator of clean air.

OAK MOSS *Evernia prunastri*
Thallus-forming, bushy, branching, strap-like tufts of pale greenish-grey clusters with miniature antlers hanging down. The underside is paler, sometimes almost white. It grows on the bark of broad-leaved trees, and is particularly obvious on twigs and small stems, giving a mossy appearance. Found throughout the British Isles.

BLACK-SPOT LICHEN *Physcia aipolia*
Black-spot is pale green or bluish grey with a loosely folded and encrusting rosette up to 6cm (2in) across. Spotted liberally with grey-dusted blackberry-jam-tart apothecia, 2–3cm (1in) in diameter. It grows on tree trunks, branches, logs and stumps throughout the British Isles.

HANDWRITING LICHEN *Graphis scripta*
Large, pale-green or cream encrustations. It is smooth, but etched all over with small, regularly spaced black hieroglyph-like marks (slit apothecia) that are wrinkled, curved and often branching. Under a lens, the margins seem to be raised. Found on tree bark, especially in partial shade, throughout the UK.

CUP LICHEN *Cladonia fimbriata*
The cup lichen has an irregular, overlapping, pale-green leaf-like thallus forming dense mats from which trumpet-shaped fruiting bodies (30–40mm /*c.* 1½in high) erupt. It is found growing on the ground and on tree roots and logs throughout the British Isles. One of the most commonly collected lichens.

LEAF LICHEN *Peltigera membranacea*
Large, folded, pale grey-brown body of thin but broad leaf-shaped bracts forming large clusters to 40cm (16in) across. The undersides are ribbed with branching vein-like ridges. Its fruiting trumpets with grey stalks are tipped bright orange like damp matches. Widespread across the British Isles, especially in the west and north.

Fish of Fast Streams

Kevin Parr

It's a good time of year to watch salmon leaping up our fast-flowing rivers. But what other species are lurking there?

Six Fast-stream Fish

SALMON PARR *Salmo salar*
The juvenile salmon have a sleek body, forked tail and fingerprint-shaped 'parr spots'. They remain in freshwater for up to four years before becoming smolts and migrating to the sea.

BROWN TROUT *Salmo trutta*
Synonymous with well-oxygenated, fast-flowing water, the brown trout is one of our most familiar fish and a favourite quarry for anglers. The buttery flanks are spotted black and red.

STONE LOACH *Barbatula barbatula*
The lithe, eel-like stone loach is a small, barbuled fish that rarely exceeds 10cm (4in) in length. The flanks and fins are delicately

Large pectoral fins enable bullheads to hold their position in fast-flowing water.

patterned, with lines and spots that help hide its form on the stream bed.

BROOK LAMPREY *Lampetra planeri*
The brook lamprey spends most of its life in larvae form, buried in the sediment at the bottom of the stream with only its mouth protruding. It changes into adult form to breed, after which it dies.

BULLHEAD *Cottus gobio*
Also known as the miller's thumb due to its gnarled appearance, the bullhead has a large head, wide mouth, tapered body and fan-like pectoral fins. The eggs are guarded by the male until they hatch.

MINNOW *Phoxinus phoxinus*
Minnows often occur in large numbers, shoaling in slacks and margins where they are targeted by kingfishers and herons. The belly and lower fins of the male turn bright red as it prepares to breed.

OPPOSITE: *Salmon wait for rain to swell rivers and streams to make it easier to leap waterfalls and weirs.*

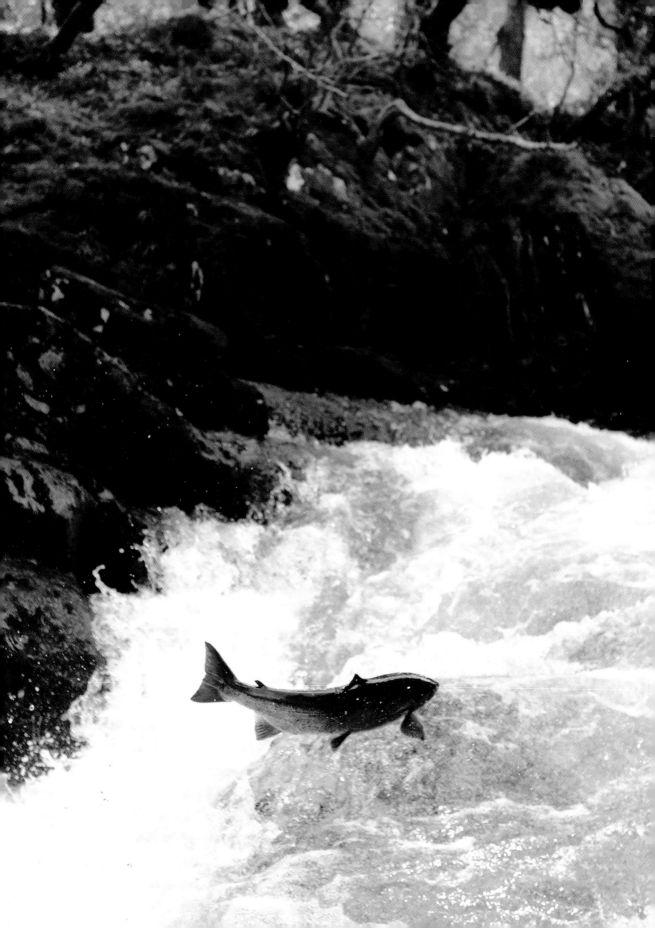

Weather Lore

Ruth Binney

The weather matters to most people, and has always done so, but it is most important to farmers, fishermen, sailors and others whose livelihoods – and even their lives – can depend on correct forecasts. So it is hardly surprising that, for centuries, people have been trying to predict the weather by looking at the sky, and at the way plants and animals behave. The oldest of all weather sayings were recorded on Babylonian tablets in the twelfth century BC, while foremost among ancient Greek forecasters was the physician and poet Aratus, who penned an early version of 'red sky at night…'

Day to day, signs that the weather is changing can almost invariably be predicted by alterations in the clouds. In the mid-nineteenth century, when forecasting was beginning to become more reliable, Admiral Robert Fitzroy, who made huge advances in scientific meteorology, produced this typical observation: 'After fine, clear weather, the first signs in the sky of a coming change are usually light streaks, curls, wisps or mottled patches of white distant clouds, which increase and are followed by an overcasting of murky vapour that grows into cloudiness…' He was accurately describing the change from cirrocumulus to the nimbostratus clouds that inevitably bring rain.

All True – Or Nearly So

Of all the old weather sayings, the best known and most reliable whenever the weather comes from the west is still 'Red sky at night, shepherd's (or sailor's) delight, red sky in the morning, shepherd's warning'. The explanation is that colours in the sky come from dust and moisture that split and scatter sunlight. At the beginning and end of each day, when sunlight travels farthest to reach the Earth, the 'long' red, orange and yellow rays of the spectrum are scattered least, and are most visible. If, as the sun sets, the sky glows a rosy pink, dry air is approaching from the west. In the morning, because the sun rises in the east, a fiery red sunrise reflects the water particles of a weather system that has just passed and indicates that a storm system may be moving in.

When the weather approaches from the west, it is also true that 'if there be a rainbow in the eve it will rain and leave'. This works because a rainbow is visible only if the sun is behind you, so the bow is in the east. Thus, if there is enough sunshine to create a bow then the weather will be clearing from the west. However, 'if the sun in red should set, the next day surely will be wet' is a valid prediction because high moisture levels disperse light to create the livid yellow or reddish-orange clouds. These look quite different from the benign pink ones heralding a fine dawn.

Simply looking at clouds can lead to accurate weather predictions. 'Mackerel sky and mares' tails make lofty ships carry low sails' works because these formations indicate deteriorating weather and are a signal for ships to take down their sails to prevent damage. A mackerel sky, named for its likeness to the fish's skin, is a type of cirrocumulus cloud that forms when there is significant moisture in the troposphere (about 25km/15 miles above sea level), often as a rain-bearing depression approaches; the gaps are made by choppy winds. Mares' tails – clouds with up-tipped ends like the tails of galloping horses – are created in cirrus clouds by high winds.

Equally accurate is the observation that Goat's hair clouds forebode wind. Like shortened mares' tails, these form at very high altitudes, and most readily as a warm front approaches. When they thicken, they change into nimbostratus, which almost inevitably means rain. 'The deeper the cloud the harder it showers' is a reliable forecast based on the link between heavy rainfall and towering cumulonimbus clouds, created when the air

Mackerel skies are a forerunner of rain and poorer weather generally.

A red sky at sunset, here over the New Forest, indicates higher pressure and better weather coming in from the west.

is deeply unstable. The base of each cloud is usually dark, and the top either wispy or flattened into an anvil shape. From such clouds, hard showers easily develop into full-scale thunderstorms.

Even at night, clouds can be used to predict the weather. 'Ring round the moon, snow soon' can often be true. In winter, a pale halo around the moon, with red on the inside, may last only a few minutes, but if it persists, it will reveal rainbow colours that fluctuate as millions of ice crystals swirl within moisture-laden cirrostratus clouds and are split by sunlight from below the horizon. If the cloud then thickens and lowers, snow – or rain – is almost certain. If it snows, the saying 'if the snowflakes increase in size, a thaw will follow' is generally correct simply because snowflakes tend to be larger at higher temperatures.

Signs of Nature

Some plants and animals can be remarkably good weather forecasters, as in the saying 'if the ladybird hibernates, the winter will be harsh'. For more than a decade, zoologist Michael Majerus of Cambridge University has studied orange ladybirds (those with 16 white spots on orange bodies). He found that if the ladybirds spend the winter nestling in sheltered positions, such as tree crevices, and at least 1m (3ft 3in) above ground, then the winter will be mild. But if they hibernate among dead, dry leaves it will be harsh. To date, this has proved a totally accurate forecast.

Almost equally good is 'when the glow-worm lights her lamp, the air is always damp', since healthy glow-worms always prefer moisture-rich locations. Bees, too, are remarkably sensitive to humidity, and it is correct that 'a bee was never caught in a shower' simply because bees will take shelter before rain sets in. Bees can also judge wind direction and strength, and adjust their behaviour accordingly, even timing their swarming to avoid storms.

Arachnids are also accurate forecasters, as in 'spiders fall from their cobwebs before it rains'. Even if they do not actually fall, spiders certainly take shelter when it rains, but are more likely to indicate what is in store by their web fixings; when rain or wind are likely, these are always short. Bird behaviour has long been studied in relation to the weather, and the belief that 'when swallows fly low, rain is on the way' is true to the extent that when pressure falls and the air is full of moisture, insects descend much nearer to the ground, as do the swallows pursuing them.

'When the scarlet pimpernel closes, it's going to rain' is an old and accurate prediction, although the scarlet pimpernel flower always shuts its petals by 2pm and keeps them so until 8am. If the petals open fully in the morning, a fine day is due. But if they stay closed in the morning, it is likely to remain cloudy, but it won't necessarily rain.

With the winter solstice comes 'as the days lengthen the cold strengthens', a correct conclusion because, in northern latitudes, the sea continues to cool after 21 December. Because the sea cools and heats more slowly than the land, British weather generally continues to get colder through January and into February.

Even the look and smell of the countryside can predict the weather. That 'springs rise against rain' is a phenomenon associated with a fall in air pressure, which happens when rain is due. As a result, water and gases are released from underground so a dry spring can suddenly gush with water, a phenomenon known as 'earth sweat'. Similarly, reduction in pressure can cause foul air to escape from the crevices in rocks, as miners will testify. In extreme cases, this can create a sound like insects buzzing.

So, armed with all this weather lore, can you do a better job of predicting the weather than the *Countryfile* weather forecaster?

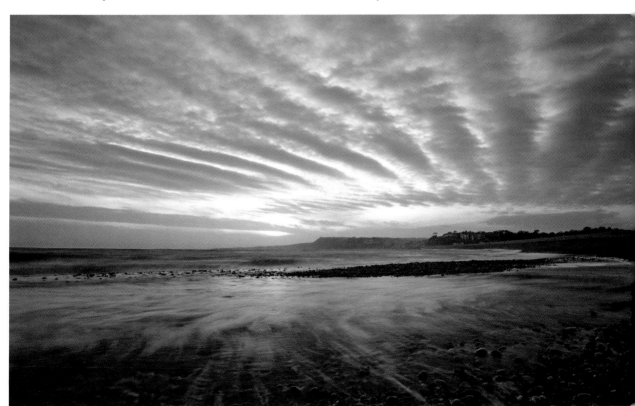

Streaky cirrus clouds appear in fair weather but may indicate storms are on their way.

Wind Farms

Julie Brominicks

Snowdonia is wild and high. Trees thrive in the valleys but on exposed slopes they are twisted and bent. Rain clouds gather above purple peaks, where the wind shrieks, and over the gullies, where it moans.

Small farms are dotted about the hills. They produce lamb, mutton and beef – the slopes are too steep and the soil too thin to grow crops. Farmers dig stones from the soil and build them into walls. And recently, on a modest scale, they have begun to farm the wind.

There are no wind farms in the Snowdonia National Park, just solitary wind turbines belonging to individual farms. They're small, standing just 10–20m (30–60ft) high, and produce five to 10 kilowatts of energy, compared with the 100m (330ft)-tall, 2.5-megawatt turbines used in the UK's commercial wind farms. National Park guidelines stipulate that the turbines are painted slate-grey to match the hills and the clouds, and must not stand proud of the skyline. Each farm's turbine is discreet among the barns and stony slopes.

Wind Farmers

Among those taking advantage of wind power are three farmers within the Snowdonia National Park. Dilwyn Pughe's wind turbine produces more electricity than he uses at Rhiwogof Farm. In the foothills of the Cadair Idris mountain, Rhiwogof faces precipitous crags and overlooks Tal-y-llyn lake. Pencoed mountain, which the Pughe family has farmed for over a hundred years, soars above the farm, dwarfing their turbine. 'People have been very supportive,' says Dilwyn. 'There were questions in the beginning because people had visions of big ugly things but this is very different. It does make a bit of noise when it turns the pitch of the blades to slow itself down, but if it's that windy, you can only hear the wind.'

Hoyle Bank wind farm is located off the coast of Flintshire, North Wales, and was built in 2003.

At Esgairgyfela Farm, a few kilometres further south, three-year-old Cadi enjoys watching her grandparents' wind turbine spinning. Her grandmother Meinir Owen says it's very soothing. Meinir's husband Dewi is used to the wind. It races over his fields and over the River Dyfi below that meanders its way through the estuary sands. To the Owens, the turbine looks as if it has always been there. 'When people come up here we ask if they noticed our wind turbine, and they always say no.'

Bird's Rock and the aqueous blue Dysynni Valley hills are overlooked by Rhyd-y-Criw organic farm a few kilometres to the north, which has also had a turbine installed. Third-generation farmer Alwyn Roberts has always admired wind turbines. 'I love the idea of something that can create energy out of nothing', he says. But he didn't install one just because he likes them. The technology had to be proven and the economics had to make sense.

Small family farms have been encouraged to diversify to make ends meet. Some provide holiday accommodation or workshop space; others run courses. But money can take a long time to trickle in and diversification often requires extra work. 'We already work full-time. When renewable energy came along, we saw a way of making an income that didn't require any labour from us and doesn't use up valuable space,' says Alwyn.

The turbines are connected to the National Grid so when the wind isn't blowing, the farms buy in electricity as normal. When the wind picks up, the electricity they generate is used on the farm. Surplus electricity is sold to the National Grid at a guaranteed rate, called a Feed-in Tariff. The farmers also benefit from lower electricity bills. The feed-in tariff lessens the financial risk of the installation cost and halves the pay-back period to six to nine years.

Herefordshire Perry

Clare Hargreaves

In the ancient orchards of Herefordshire, a quiet straw-coloured revolution is taking place. Its name is perry. The tipple isn't new of course – it's been made in the UK since the Norman Conquest, and achieved commercial success in the 1950s in the form of Babycham. But in the 1970s and 80s the drink fell out of favour and perry became the preserve of growers in a few small agricultural communities.

Recently though, the resurgence of interest in craft ciders, often using single-variety fruits, has had a knock-on effect on perry's popularity. In Herefordshire and its neighbouring counties, growers have been reviving historic orchards and planting new ones with old local varieties with intoxicating names such as Dead Boy, Blakeney Red and Flakey Bark.

One perry maker who has been achieving impressive results is James Marsden, whose orchard, in the village of Much Marcle, is believed to date back to 1785. James made his first perry in 1994 and hasn't looked back. He's even turned his unique Gregg's Pit pear into a very drinkable single-variety perry.

'You only get great perry if you have great pears,' says James. 'They must be perry pears, not dessert pears, which lack the tannins and acidity that give good perry its flavour.' The very best perry pears, he claims, are rooted in the soils of Herefordshire, Worcestershire and Gloucestershire. 'They say you don't get good perry unless you have a view of May Hill,' he laughs, nodding towards the hill in the distance.

Tasting the Tipple

A shed in James's back garden houses state-of-the-art stainless-steel barrels in which last year's brew is gently fermenting. Their modernity stands in stark contrast to the ancient stone bed press outside where in

Perry pears are different to eating pears. The trees can live up to 300 years and have been grown in the UK since the Roman times.

autumn the ripe pears are pressed to extract their juice. This is stored in the barrels and the wild yeast works its magic until early summer, when fermentation slows and the perry is ready.

Down the road, near Ross on Wye, Mike Johnson makes equally authentic perry at Broome Farm, where his family have been growing apples and pears since the 1930s. They used to sell their fruit to cider-makers Bulmers, but one year orders dried up so Mike tried his hand at making perry instead. Having caught the bug, he planted 27 different pear varieties, many of which he turns into single-variety perries, fermented in old whisky barrels. It's not a hobby for the impatient though: many trees take 15 to 20 years to produce pears. 'We've got one tree that's just got its first crop after 25 years,' he laughs.

There are others too, such as Paul Stephens, at Newton Court farm near Leominster, who started making perry and cider in 2000 as a way of diversifying, and Denis Gwatkin, who brews perry using pears from his orchards in the Golden Valley.

They all agree that craft perry should not be confused with the industrially made drink that's frequently – and some say misleadingly – called pear cider. Traditional perries contain 100 per cent juice, whereas industrial ones contain added sugar and water, are usually made from dessert pears, and are fermented for weeks rather than months.

Traditional perries can have differing alcohol content year to year, depending on the weather. 'The sun provides the sugars, which are broken down by the natural yeasts during fermentation, so the alcoholic content depends on how sunny it's been that year,' says James.

Although available nationwide, Herefordshire perry is still sold largely within the county. If you need an excuse to visit, a glass of well-chilled perry is a fine one indeed.

Kale

Richard Aslan

While a lot has changed in our kitchens since the Middle Ages, one vegetable has stood the test of time. Long gone is the highly spiced cuisine favoured by the medieval nobility, rich in sweet and sour flavour combinations. And there can't be too many pantries about still stocking the old staples of almond milk and verjuice, an acidic brew made with unripe grapes or crabapples. Modern favourites such as potatoes and tomatoes were yet to journey across the Atlantic, while current luxuries, such as oceanic fish, were salted, pickled and smoked to be served at the meanest of tables in times of scarcity. Even bread would have been all but unrecognisable in form and ingredients. When so much has changed, why has kale, the best-loved medieval vegetable, remained a firm favourite?

The huge popularity of kale in the Middle Ages might have something to do with its ability to thrive in colder temperatures. Between the fourteenth and nineteenth centuries, Europe shivered under the Little Ice Age, a 500-year-long cold snap that saw average temperatures plummeting. In this age of winter fairs on frozen rivers and snowfall from October to May, viticulture disappeared from British shores and the more delicate crops withered. People had no choice but to rely on hardier species for sustenance, and kale was chief among them.

Not only does this tough vegetable survive throughout winter, many chefs and gardeners will only harvest it after it has endured a stiff frost, claiming it tastes sweeter.

Kale is a member of the Brassica family and closely related to wild cabbages. Like cabbages, its leaves come in dark green or varying shades of purple, but instead of forming a compact head, they grow outwards from the stem. It is this characteristic that gives kale, collard greens and spring greens their botanical name acephala, or 'headless'. The Middle English word 'cole', from which kale derives, referred to all kinds of cabbages and greens. Variants of the word appear in coleslaw and cauliflower, and the same root also turns up in Spanish *col*, French *chou*, German *kohl*, Norwegian *kål* and Italian *cavolo* – all meaning cabbage.

Kale's number one position was eventually eclipsed, but its unique flavour and high nutritional value have meant that this winter favourite has been rediscovered by successive generations. It's not just its potent cocktail of vitamins, micronutrients and antioxidants that gives kale superpowers, but also its ability to resist even the coldest weather.

Stamppot Boerenkool

This Dutch winter warmer is traditionally made with *rookworst* sausage, but it is almost as delicious without.

- 500g (1lb 1oz) kale, chopped and washed
- 1kg (2lb 2oz) potatoes
- 50g (2oz) butter
- 2 medium onions, diced
- Vegetable stock cube
- Salt and pepper to taste
- 2 tbsp vinegar

Peel and chop the potatoes, then place in a pan. Cover with water and add stock cube. Place the chopped kale (and *rookworst*, if using) on top. Do not stir. Cover, bring to the boil, then simmer until the potatoes are soft. In a pan, fry the onions in oil over a low heat until they start to caramelise. Strain the liquid from the potatoes and kale and set aside. Mash to a smooth consistency. Add the cooking stock a little at a time until the mixture is soft, then add the fried onion. Season and serve piping hot.

Kale has four times the vitamin C content of spinach and is seen as a superfood by nutritionists.

Ghost Village

Ian Vince

Set back from the sea and secreted in the Dorset countryside between ridges of vertiginous hills, there is something of Conan Doyle's *The Lost World* – a land that time forgot – about the deserted village of Tyneham.

Notwithstanding the fossilised delights of Purbeck and its Jurassic Coast, the lost world that Tyneham calls to mind, with its limestone ruins and dry-stone walling, is a much more domestic affair than Conan Doyle's. It is the world we all think of when we read Edward Thomas or hear the first strains of 'Barwick Green' at the top of The Archers. It is Britain – specifically, England – between the wars or just after, a world long gone, a postcard from a Laurie Lee novel, all woodcuts and haystacks and slanting sun.

The only way in is over an impressive hog's back – a ridgeway of chalk, which snakes like the spine of a colossal sauropod, dipping and rising for 24km (15 miles) from Ballard Down near Swanage to Lulworth in the west. From the top of Povington Hill, an exhilarating view of a deep, largely deserted and verdant valley opens before you. At its centre lies a demure church that is partly obscured by trees and a large car park that, unfortunately, is not. The valley runs east–west behind the coastline, which it meets at Worbarrow Bay with its eponymous Tout, a hummock of headland, a lookout, almost severed from the cliff line. It's a place that would have delighted Conan Doyle for its footprints of dinosaurs imprinted in the rocks.

The War Effort

Unlike deserted villages elsewhere – consumed by bubonic plague or levelled by an avaricious Georgian squire intent on sheep farming or emparkment – Tyneham, along with all its surrounding hamlets and farmsteads, made it all the way into the twentieth century. When it was commandeered by the British Army during the last years of the Second World War for D-Day training, assurances were made that the villagers – who were given just a month to leave before being evicted the week before Christmas 1943 – would be allowed back at the end of the war. Despite the promises, the occupants of Tyneham never returned.

The villagers' loss is incalculable and threads itself through every thought you have in Tyneham. The squire enjoyed compensation of course, but the tenants only received the value of their garden produce and alternative accommodation, mostly in nearby Wareham. Nearly half of the front page of the *Western Gazette* for 3 December 1943 is taken up with lineage ads, auctions of livestock and equipment, and the effects of 15 farms. A total of 3,000 hectares (7,300 acres) of Dorset were fenced off by the War Department, but when peace came, the Government stalled, the Army found the area invaluable, and time wore on.

Campaigns were launched to win back the village, but in 1948 it was lost to a compulsory purchase order. It went the same way as most of the other requisitioned ranges such as Imber on Salisbury Plain or the Stanford Battle Area in Norfolk's Breckland.

For all those associations with loss, however, Tyneham, like Salisbury Plain and Breckland, has gained something: a sense of wilderness unusual in modern Britain, untainted by contemporary environmental woes. There has been no intensive agriculture and the landscape has not been warped by road building and its fussy filing system of white lines, parking bays and signs that caution at every turn.

The ghost village of Tyneham slowly falling into ruin since it was commandeered by the British army in 1943.

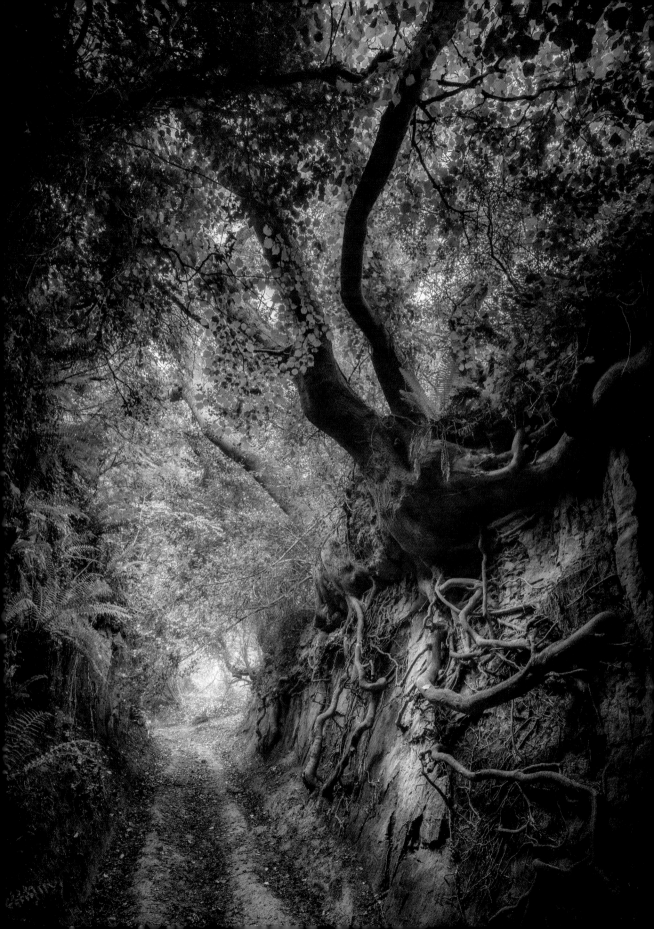

Green Lanes and Holloways

Ian Vince

Of all the various roads and paths that snake their way through the countryside, it's interesting to note that some ways are invested with a little more romance than others; these are the green lanes and holloways.

While 'green lane' is a catch-all for many different kinds of unsurfaced rural road or path – such as an old drove, a coffin road or a ridgeway – a holloway is a more specific term. It describes a sunken green lane, a track that has been worn down by the passage of thousands of feet, cartwheels and hooves over hundreds of years, even millennia. With the loosened soil subsequently washed away by the next downpour, the course of a holloway will often become more pronounced on the side of a hill because of the extra energy imparted by the surface water run-off.

Holloways are common in lowland Britain, with the greensands of the southern counties – Wiltshire, the Weald and the Chilterns – being particularly suited for their formation, as is the old red sandstone of the Wye and Usk valleys. The new red sandstone of south and east Devon has splendid, deep lanes on its slopes.

Tree Cover

Over time, as they are inscribed ever more deeply and the level of the lane lowers, they become more sheltered and trees arch over, creating a womb-like tunnel, an enclosed place of natural safety. So safe, indeed, that it's only around this time of the year that the walls of foliage have died back enough to get into some old lanes, long-since abandoned by changing patterns of passage over the land, bypassed in favour of a better route.

Where holloways have fallen into disuse for longer periods, they can be discovered anew – many centuries after they were last followed – by tell-tale shallow linear grooves

Hell Lane in south Dorset once thronged with heavy carts carrying stone from local quarries.

through fields or woodland, though check that it's not a short stretch of forgotten park pale or a defensive ditch, both of which will be accompanied by a bank above the natural ground level.

Unique Atmosphere

Holloways have their own atmosphere, an unexpected quality that cannot be explained away purely in terms of the local topography or geology. As ancient routes, they are the perfect expressions of collective will; tracks that share a common origin with desire lines – those unpaved shortcuts that urban planners never anticipated. As travelling long distances was more difficult in the past, the reasons were more keenly felt; every footstep has meaning on a pilgrimage and the burdens shouldered on a well-used coffin road were more than the purely physical.

The Halnaker Tree Tunnel near Chichester in West Sussex follows the course of a Roman road.

Lych Gates

Ian Vince

In a month that starts with All Hallows and All Souls, two opening feast days of November that sift and grade the dearly departed for salvation – first the saints and then the ain'ts – it's natural to look at the earthly, temporal end of the process. After all, before anybody gets to pray for your soul, there's the matter of getting into the churchyard.

Lych gates, which acquired their name from the Saxon word for corpse, stand at the threshold of all thresholds, the entrance to God's acre. Although many were built before 1549 – Beckenham and Boughton Monchelsea in Kent are dated to the thirteenth and fifteenth centuries, respectively – it became a requirement of the Book of Common Prayer

The 'lych' in lychgate comes from the Old English word for 'body' because these roofed entrances to cemeteries were used to house biers before funeral services began.

that priests 'metyng the corpse at the church style' should commence the service there. This encouraged construction of lych gates to keep everybody (and every body) dry.

As if hiding their true and gruesome purpose, lych gates often have a charming gingerbread cottage appeal. They are commonly built from stout timbers and capped by a pleasing doll's house roof. But the gate at Long Compton church in Warwickshire is the peak of picturesque; an entire seventeenth-century thatched cottage, minus most of its ground floor, the last surviving of an old row demolished in the 1920s, functions as the churchyard's gate.

Other designs are grander. The gate at St Peter's church in Carmarthen is a vaulted Victorian gothic creation in red sandstone, which competes for attention with the lime-rendered tower of Wales's largest parish church. Sometimes, as at the church of St Germanus, Rame, in southeast Cornwall, the gate appears to be a funereal dual carriageway, complete with a 1.8m (6ft-long central reservation (the bier or lych stone to park the deceased on), while benches on either side were provided for the pallbearers, who may have had to walk long distances to church.

Corpse ways to outlying areas of the parish were part of an extensive funereal topography, especially in upland Britain. In Derbyshire, before Coton-in-the-Elms had its own church, bodies were carried 2km (1½ miles) along Procession Way to Lullington for burial. The mourners passed under a curve of tree boughs known as the Devil's Arches on their journey. In Devon, a long-distance footpath – the Lich Way – follows a 20km (12-mile)-long corpse road over the moor to the church at Lydford and, this being Dartmoor, there are tales of spectral monks walking the trail on moonlit nights.

Every lych gate has its own character, such as here at All Saints Church, Edingthorpe, Norfolk.

Forest of Dean

Joe Pontin

On a misty morning in autumn, the hush broken only by the cry of a buzzard above a canopy of golden beech leaves, it's hard to imagine a more tranquil place than the Forest of Dean.

At this time of year, these rolling woodlands light up like a furnace, making it one of Britain's most spectacular places to visit for autumn colour. Oakwoods turn yellow and russet. Stands of larches, Britain's only deciduous conifer, turn a diaphanous pale gold; crimson rowans and scarlet cherry trees weave their way through bright patches of yellow field maples and giant golden chestnuts.

Amid this glowing tapestry of colour, wildlife teems. Goshawks wheel above oak woods, eyeing squirrels gathering acorns. Crossbills feed on larch cones. Wild boar forage among fallen chestnuts; the forest sustains Britain's largest population at 400-plus, descended from animals escaped from a nearby boar farm a decade or so ago. Then there are bats: Europe's biggest concentration of greater and lesser horseshoes. With all this thriving wildlife, it's hard to grasp how transformed these woods are.

A Forest Born, and Reborn

Somehow we expect our ancient forests to be immune from change. 'We have this notion a forest is forever, but it isn't,' says Kevin Stannard, the Forest of Dean's deputy surveyor. 'The Forest of Dean is a brilliant example of a landscape that has changed and evolved out of man's decisions – political decisions.'

One thousand years ago, the Dean was a royal hunting forest, and it's still owned by the Crown. But from the seventeenth century, the mineral extraction that began with the Romans really took off. Ambitious men came to exploit the area's precious minerals – especially coal and iron ore. The Crown benefited in lucrative levies.

The resulting near free-for-all almost wiped out the forest forever. By 1676, barely a tree was left standing: much had been felled to make charcoal for smelting iron. (The Dean may be an ancient forest, but its oldest trees date back 'only' 300 years or so.) Legislation at last protected the trees of the Dean and a programme of replanting began. A second wave of planting around 1830 bequeathed the Machen oaks – named after the forest's deputy surveyor Edward Machen – that now populate swathes of woodland such as that at Nagshead. They were meant to provide the Admiralty with timber for wooden ships but in the end were never needed, because metal hulled vessels superseded them. The oaks were packed together in numbers to encourage tall, straight growth – not unlike later conifer plantations. Then the weaker trees were thinned out. So even the tall oaks you see in the Dean now are shaped by man.

Meanwhile, the advance of industry continued into the twentieth century. When Britain emerged, depleted and exhausted, from the Second World War, the Forestry Commission – now custodians of the forest – began a new wave of plantings, mostly huge tracts of fast-growing conifers such as larch, Norway spruce and Douglas fir.

Diverse Woodlands

This history gives the woodlands of the Forest of Dean their huge variety. Each has its own distinct atmosphere and ecology. There are dark scented blankets of conifers; airy oakwoods; shady pockets of yew, moss and mushrooms; vaulted beechwoods. But the traditional makeup is threatened and the solution may be in new plantings that once more change the face of the forest. Kevin's team is looking at hickory, and the spectacular tulip tree, a tall, straight species that bears a cascade of creamy blossoms in spring.

Puzzlewood in the Forest of Dean is riven by moss-covered gullies and pits known as 'scowles'.

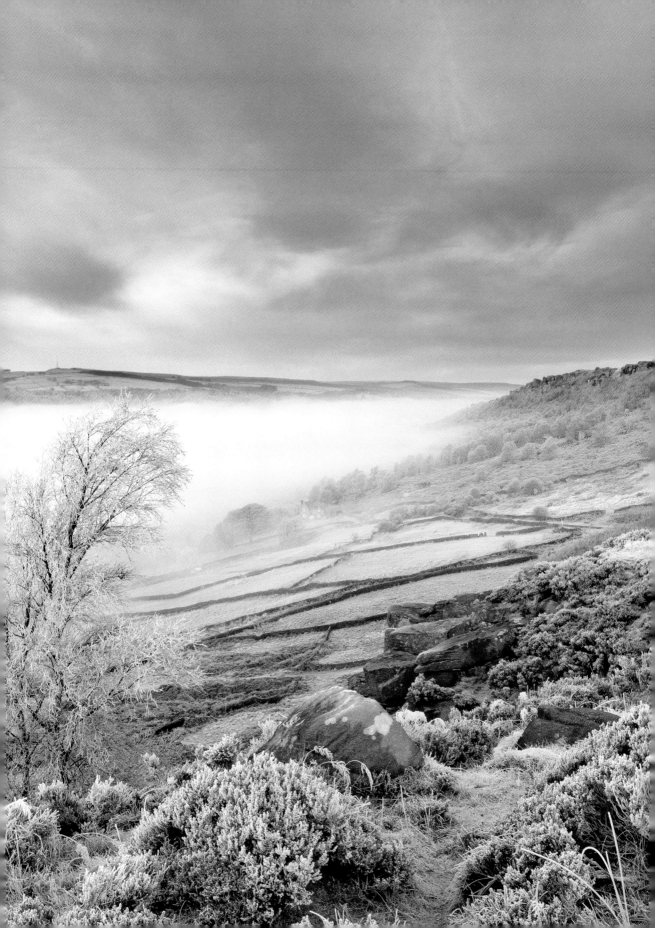

December

I n our final chapter we take December walks through two of England's most popular yet radically different landscapes – the Lake District with its snow-capped peaks and grey waters and the gentler Cotswolds, all rolling hills and honey-coloured stone – at the time of year when you are least likely to see large numbers of other walkers.

If you follow our footsteps you will probably spot festive symbols of this Christmas month along the way: holly, ivy and mistletoe, each with a fascinating botanical background and place in our social history. Take, for example, the reason why holly bushes are often found near houses. Ancient belief was that they acted as lightning conductors and modern science has since proved this to be true – their prickles do indeed attract lightning bolts.

By early December harvesting will be over for another seasonal symbol, the Christmas tree, and varieties like Nordmann fir, Norway spruce and Douglas fir are ready for sale. They can take up to 10 years to grow and around 8 million are sold every December.

None of them are native conifers and I learned how the Douglas fir came to the UK when, of all things, I was leading a *Countryfile* ramble in aid of BBC Children in Need in the grounds of Scone Castle in Perthshire. David Douglas worked there two centuries ago and became the Indiana Jones of plant collectors, travelling through the unexplored wilds of North America and bringing home more than 240 species of plants and trees including, in 1824, lupins, and seeds of the fir tree that bears his name.

He discovered so many other species of conifer (among them the sitka spruce which is now the commonest in the UK) that he wrote home: 'You will begin to think I manufacture pines at my leisure.' Hardly leisure – his life was filled with discovery and adventure, dodging non-too-friendly native Americans and nearly drowning when his canoe capsized, all the while searching for species he had never seen before.

As I sat on the massive lower branch of his original Douglas fir tree at Scone Castle, it occurred to me that it was this man's discoveries that helped dramatically change the look of our gardens and countryside – around half of Britain's woodlands are now conifer.

Frost embalms the craggy escarpment of Curbar Edge in the
Dark Peak of the Peak District National Park.

Holly and Ivy

Mark Hillsdon

While firs and conifers take most of the attention at Christmas, and mistletoe adds a touch of mystery, the humble holly tree, and its woodland neighbour the ivy, are often taken for granted. Yet, these ubiquitous evergreens, with their berries and shiny leaves, are as Christmassy as it comes.

Holly is a sturdy and robust tree. Over the centuries it has become a potent symbol of winter and steeped in the traditions and rituals of the countryside. The Holly King was said to rule over the wood until the winter solstice, when control was wrested back by the Oak King, who would rule for the next six months. Holly was also revered by farmers, who considered it bad luck to cut one down, which is why lone, gnarled trees often punctuate fields and farmland.

Holly has dominated our hedgerows too, offering a hardy barrier to livestock. It often remained uncut, soaring about the layered hedge to form a tall, spiky barrier that stopped prowling witches, who were said to traverse the countryside by walking along the tops of hedgerows. The tree was also planted close to houses to ward off goblins and evil fairies, and to act as a lightning conductor, a quality that scientists have recently proved to be true, with the leaves' prickles acting as tiny conductors.

Holly was often seen as a powerful fertility symbol, because although it is dioecious – meaning that individual trees are either male or female – it is only the latter that bears any berries.

The Victorians popularised holly on Christmas cards and in carols, but people had been bringing it into their homes on Christmas Eve for hundreds of years, as it protected the house from evil spirits. Christian symbolism has also picked up on the tree, linking the prickly leaves to Christ's crown of thorns, and the berries to droplets of his blood.

Extremely hardy, ivy can survive heavy frost and snow, providing shelter for small creatures within its miniature canopy.

OPPOSITE: *What could be more Christmassy than a robin foraging for holly berries?*

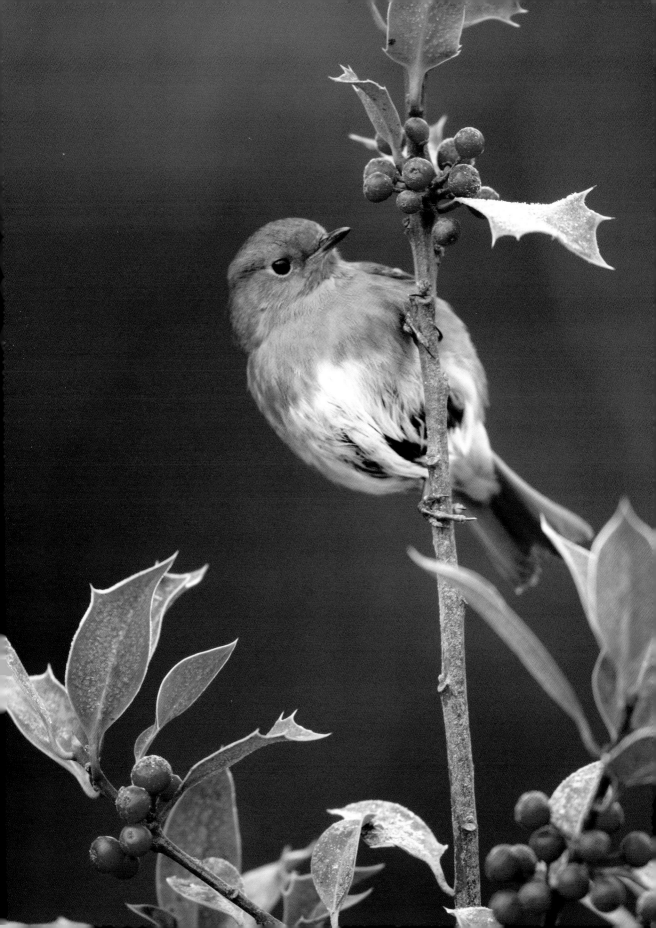

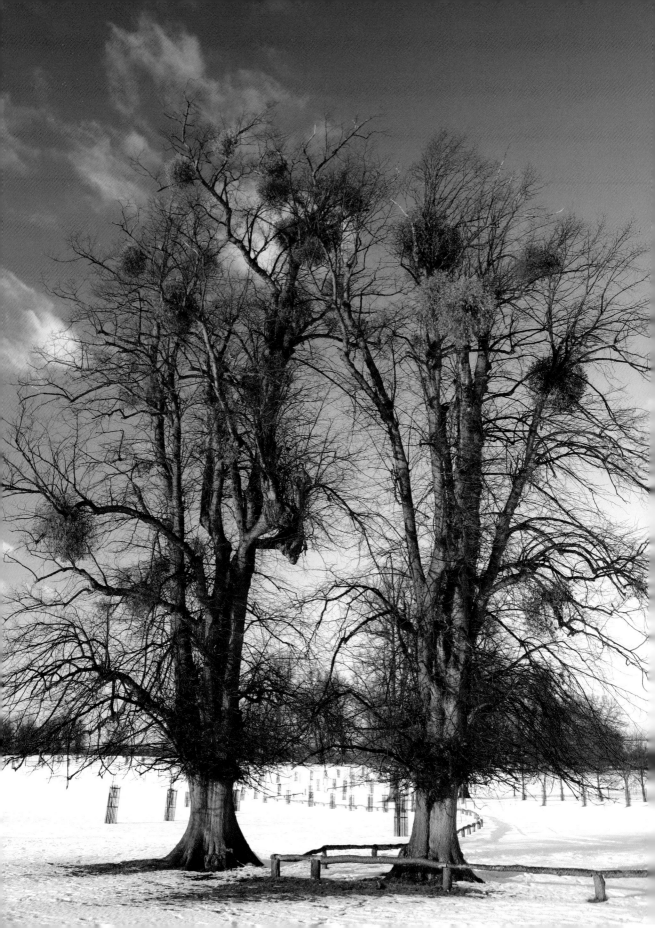

Mistletoe

Jonathan Briggs

For thousands of years, mistletoe has been used in midwinter festivities. In nearly every European culture, mistletoe figures in legends and customs. In many of these ancient tales, this evergreen plant is a symbol of ongoing life, fertility and protection through the otherwise leafless winter months.

The European white-berried species *Viscum album* is the true mistletoe of legend – and what a lot of legends there are. It isn't just that it is evergreen. It is a true parasite, rooted inside the branches of its hosts. And it has a unique branching pattern, with a distinctive, wishbone-shaped leaf pair. Most unusually, there are those pearly white berries in midwinter. Long after other plants' seeds and fruits have matured, these develop into translucent spheres that almost glow in the low winter sun.

How Mistletoe Makes its Home High Up in Trees

As a parasite, mistletoe cannot grow independently – it must grow on and in host trees. Technically, it is a hemi-parasite, since it has green leaves that photosynthesise, so the host could be just a surrogate root system. But that would be an oversimplification – the detailed host–parasite biology is more complex.

Not all trees are suitable hosts; most mistletoe parasitises apples, limes, willows and poplars. It grows from seeds, one per berry, which are spread by particular birds, including mistle thrushes and blackcaps. These excrete or wipe the sticky seeds on to a branch, only digesting the berry pulp. The word mistletoe derives from this – from Anglo-Saxon words meaning 'dung on a stick'.

Seeds germinate in late winter, sending out one or two tiny green shoots that bend round to contact the host bark, penetrating very slightly, only as far as the host's cambial

Trees can become festooned in mistletoe – which becomes obvious when the leaves have fallen.

(growth) cells. The seedling's cells trick these host cells into letting them connect to the host vascular system. Early growth is slow but, after a couple of years, a mistletoe plant will emerge. Too many mistletoes on one tree affect tree health, so it's best to control numbers when possible. Mistletoe itself is host to several specialist insects, including a moth whose larvae overwinter inside mistletoe leaves, various sap-sucking bugs and a rather pretty mistletoe weevil.

How Mistletoe is Harvested

Most mistletoe plants are cut from apple trees, which are more accessible than those growing high up on limes or poplars. Only the female plants have berries, so the male plants are less desirable. The most valued sprigs are those with berries and the brightest green leaves.

Cutting is done with long-handled cutters or, as the plants are brittle, snapping by hand. Some branches are left for subsequent years. A good harvester will also cut some male sprigs to keep a gender balance in the tree. Once cut, the stems will last for weeks if kept outside but will wither in a heated room. Mistletoe leaves and berries are poisonous to eat, but there is no risk from handling them.

Blame it on a Mistletoe Kiss

Mistletoe kissing traditions reaffirm the concept of it as a fertility symbol and the many associations with friendship and luck. It even, by hanging at face-height, endorses an ancient druidic requirement to keep it off the ground.

It was perhaps just a local custom at one time, practised in areas where mistletoe is common, but it was, in effect, nationalised in the Victorian era, one of the many Christmas traditions that became established everywhere with improved communications and prosperity. Kissing under mistletoe, a 'licence to kiss' without conventional constraints, had obvious popular appeal.

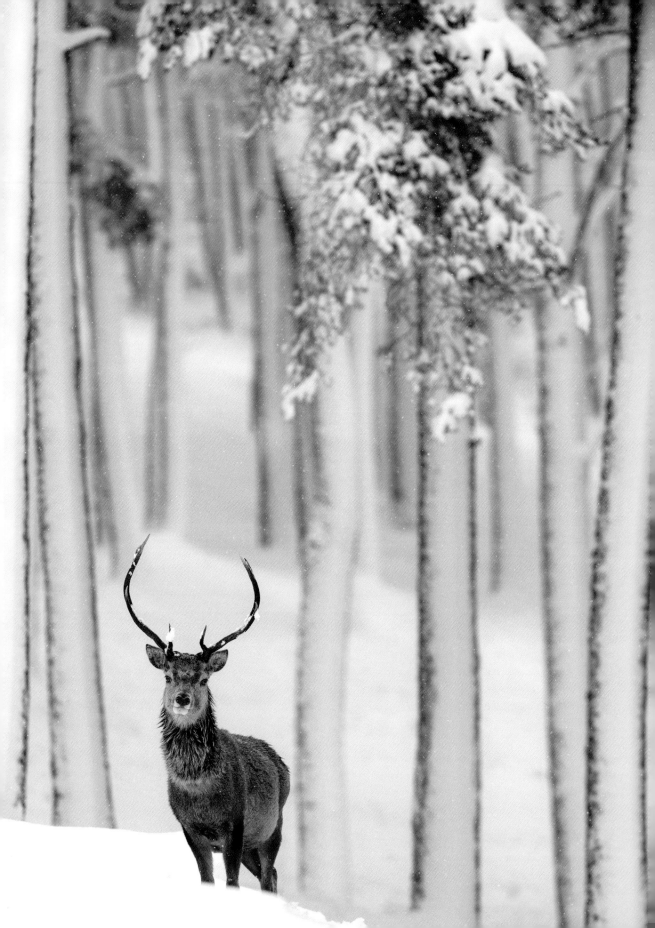

Conifer Forests

Phil Gates

Christmas Eve, and all around the country the centrepiece for celebrations will most likely be a conifer, festooned with fairy lights. Over eight million of these wonderfully fragrant evergreen trees are grown for the Christmas market every year. We have taken them into our hearths and hearts, even though bringing boughs indoors is a relatively recent British tradition, originating in Germany and popularised by Queen Victoria and her German consort Prince Albert.

In the minds of many, that affection for conifers doesn't extend beyond the festive season. In recent decades conifer forestry has often been mired in controversy, thanks to insensitively placed commercial plantings. Many see densely spaced geometrical plantations in much-loved upland landscapes as an abomination. Worse still, confrontations between conservationists, landowners and politicians over commercial forests covering large areas of Flow Country in the far north of Scotland, which involved draining bogs that are critically important habitats for nesting wading birds, endangered wildflowers and rare insects, gave conifer forestry a bad name.

Commercial Success

The UK has only three native conifer species. They are all evergreen trees with needle-shaped leaves, but only one – the Scots pine – bears the woody cones that are typical of the family. The other two – yew and juniper – carry their seeds in fleshy, berry-like structures. Natural conifer forests do not loom as large in our landscape as they do in continental Europe, Russia and North America, due to accidents of climate and the way in which our islands became isolated from the European mainland soon after the end of the last glaciation, but many of the conifer species that form the great evergreen forests of the alpine and boreal regions do flourish in our

A red deer stag finds shelter among the ranks of trees in a Scottish pine forest.

climate. In comparison with native deciduous trees, they grow rapidly and produce straight, commercially valuable timber, often in soil conditions where few native trees thrive.

Non-native conifers have been cultivated in Britain since the sixteenth century, with Norway spruce – the archetypal Christmas tree – being one of the earliest to be imported, from the European Alps sometime around 1500. But it was European larch that really began to transform the landscape. Introduced into Britain from the Austrian Tyrol in 1620, it supplemented the dwindling supply of native oak, first for ship building and later for wooden pit props, shoring-up the roofs of the coal mines that fuelled the industrial revolution.

Throughout the eighteenth and early nineteenth centuries, successive Dukes of Atholl planted 14 million trees covering 4,000 hectares (10,000 acres) of their estates in Perthshire. There is a story, perhaps apocryphal, that, in 1788, such was the 4th Duke's enthusiasm for recreating alpine larch forests on his land, that he once authorised estate workers to scatter larch seed by firing it in canisters from his ceremonial cannons on to inaccessible rock faces.

Throughout the nineteenth century, as intrepid plant collectors, such as Archibald Menzies and David Douglas, trekked westward across North America, they sent back stories and seeds from virgin conifer forest of almost unimaginable grandeur and commercial potential. Douglas fir arrived in 1827 and Sitka spruce in 1831; both would become mainstays of commercial conifer forestry here.

In the twentieth century, two world wars that threatened to cut off imported timber supplies encouraged planting of more fast-growing timber. In the peacetime that followed, governments favoured conifer forestry with generous tax breaks for corporate and celebrity investors, sometimes at the expense of the natural environment.

River in Winter

Kevin Parr

As the days shorten and winter air grows crisp, lowland rivers are beginning to stir – at a time when much of the world seems ready to sleep.

Gone are the leaf-greens and the deep blue of a sunlit sky and instead a river swirls in grey, muddied after rain, finding little to reflect of the world above. Along the banks, dried reed stems rattle beneath the sway of a naked arboreal roof, the branches strewn with debris thrown up by a winter flood. It is a scene that might seem sombre, but there is a vibrancy now that was absent in the summer.

The Dorset Stour is a typical lowland waterway. And rather like a chameleon, it changes its appearance in relation to the landscape through which it flows. From the picturesque, beech-tree splendour of its source at Stourhead, it winds gently and discreetly towards the flat lands of north Dorset where it slows and widens like a man-made drain. Deep, dark water and a flow so slight that it might be tempered by a light upstream breeze. Having slipped through Blandford, the Stour cuts across a swathe of chalk and runs clear over gravel glides, thick fronds of water-crowfoot swinging in the sparkle.

Running Through the Year

In the spring, the Stour reacts to heavy rainfall by spilling angrily over its banks and marooning livestock as it floods the fields. But it's generally muted and tamed through the summer, hemmed in by reed and sedge, the surface smothered by round dollops of water-lily. A trickle of water shrunken beneath high banks and the gentle meander of willow and alder, it snoozes beneath the high summer sun, unhurried and unstirred.

Yet as the water deepens in the autumn, there is a power that demands respect, and a sudden change of mood that can feel almost intimidating. It is as though a river spends the summer months hibernating. Waiting patiently for an opportunity to wake up.

As the air cools, the water follows suit, and as the sun weakens, so the lilypads curl and the reeds brown. Heavy rain will swell the river, flushing out the deadening weeds and changing the nature of the flow. With fewer obstacles to stall it, the river will push with greater purpose, and as autumn cedes to winter so the valley becomes a very different place.

The fish will be tightly shoaled and seeking areas of efficient safety. Creases, where the main current pushes past an area of slacker, more forgiving water, are ideal places to sit. Energy is a precious resource when you are cold-blooded, and fish species such as roach and gudgeon will seek a spot where they can rest quietly while a conveyor belt of potential food items whizzes past their noses.

And wherever the smaller, shoal species swim, larger predators are never far away. Pike and perch lie quietly, waiting for the lowering light of dusk in which to strike surprise, while herons and egrets silently stalk the margins. Kingfishers flash from overhanging branches and otters whisker their way to dinner.

Water Chorus

The sounds of a winter river might seem subdued and stifled by the increased bubble of the water, but if you pause and wait, the natural world will quickly work around you. Gangs of long-tailed tits seep their way through the willows and lesser redpoll beak at the alder cones. Crows and jackdaws squabble across the grey sky, while sunset might bring the echoing 'cronk' of a raven, the screech of a barn owl or the zig-zagged panic of a snipe.

This is a world easily overlooked, but winter is when a river is often at its finest and certainly most expressive. It is moody and temperamental, but also exhilarating, as the mist unfurls in the chill of a December dusk.

Despite heavy snow and ice, the River Whiteadder in Northumberland brings life to the winter countryside.

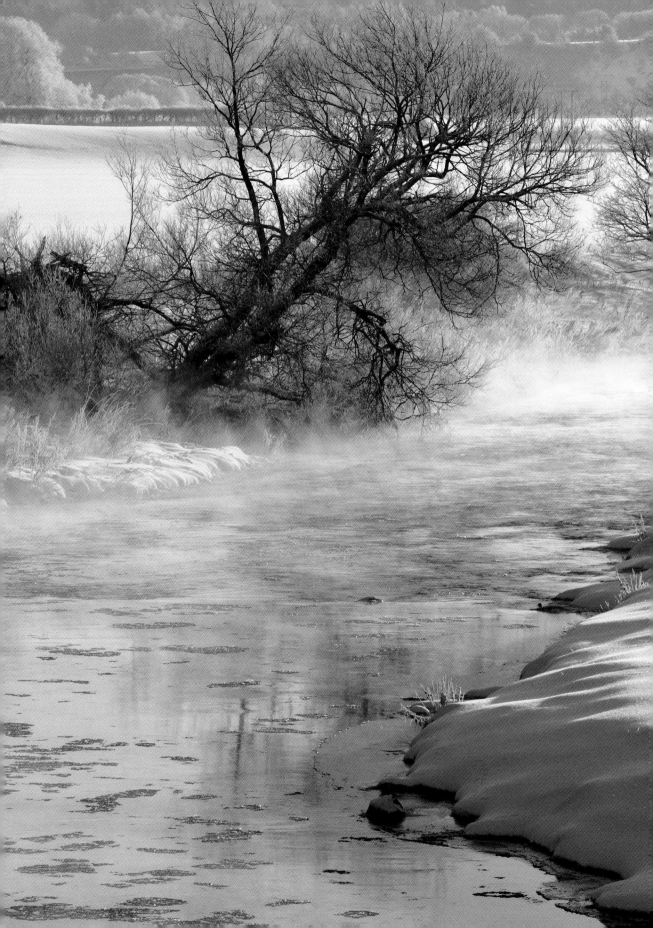

The Lakes in Winter

Neil Coates

The Lake District breathes out in winter. There's tangible relief that another tourist season has ended; a chance for community to again take centre stage from commerciality.

While visitor numbers tumble, everyday life resumes. What can prove a battle in high summer turns into a breeze when snow dusts the heights. It's a time for browsing, reflection and relaxation; a far cry from the hurly-burly of a Lakeland summer. Amble round the yards behind Keswick's Main Street, for example, engaging backwaters bristling with off-beat shops, before taking in the Dog and Gun Inn to reach Derwentwater and one of the most breathtaking low-level views in the Lake District. Crisp winter air magnifies the Derwent Fells above the far shore, hanging tantalisingly just beyond the launch pontoons. Periodic winter boats ply the lake. Cruise down to Brandelhowe and walk the peaceful Cumbria Way through the Jaws of Borrowdale to pretty Grange and secluded Rosthwaite, before hailing the handy local bus back to Keswick.

Set Sail

The main towns and lakes are terrific to explore by boat. While services are more restrictive than in high summer, both Coniston and Windermere still offer the chance to discover the heartland first-hand, without the crowds.

Perhaps the most memorable winter treat, however, is the trip on an Ullswater Steamer. On a still winter's day, this has to be one of England's best journeys, as the ship slinks away from Glenridding past the islets that dot the southern end of the lake, slicing through perfect golden reflections of Place Fell to drop off eager ramblers at secluded Howtown. Here, lonely Martindale beckons, or there's an ultimately satisfying lakeside walk back to Patterdale's logfire-warmed inns, nestling below the snow-mottled ribs of mighty Helvellyn.

Climbing Gentle Peaks

With the highest peaks snowbound, turn your eyes instead to the lower summits, where winter rewards far exceed the effort needed to attain them. Black Crag, for example, tops out at a modest 322m (1,056ft), just an amble from the car parks at beautiful Tarn Hows. With winter's high pressure keeping the skies clear the views are phenomenal: a neck-craning panorama of summits, including England's highest acres atop Scafell Pike.

Further north, find an enchanting walk from tiny Loweswater village up to Mellbreak's 512m (1,676ft) twin-topped summit. With a wintry inversion filling the valleys, a steady ascent escapes the fog, emerging above a quilt of grey and white pierced by hilltops: the stepping-stones of the gods leading to their lofty mountain-top eyries – Red Pike and Haystacks, Fleetwith and Robinson, Helvellyn and Great Gable all gleaming under a watery sun. Simply magnificent.

In Search of Squirrel Nutkin

One of Britain's most endearing mammals is also one of England's most threatened. Red squirrels, native to Britain, are fighting a losing battle with greys, first imported from the USA in 1876. But in the Lake District, a strong rearguard action is being staged.

Beatrix Potter created her beguiling story of Squirrel Nutkin based on reds she saw every day in the woods of Claife Heights, west of Windermere. This is still a good place to look for them, as is nearby Grizedale Forest. The best place in the Lake District, however, is Whinlatter Forest, northwest of Keswick.

Winter is the ideal time to spot them; they don't hibernate and visit feeders placed beside the Squirrel Scurry Trail, which meanders through the woods from the visitor centre.

One of the most-visited spots in the Lake District in summer, Tarn Hows can be a peaceful haven in the cooler months.

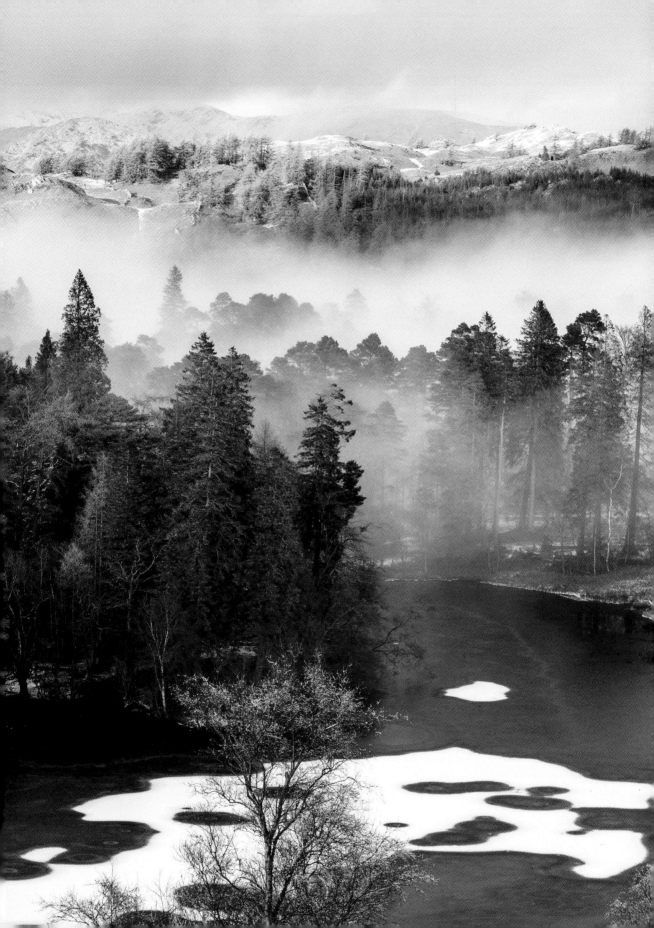

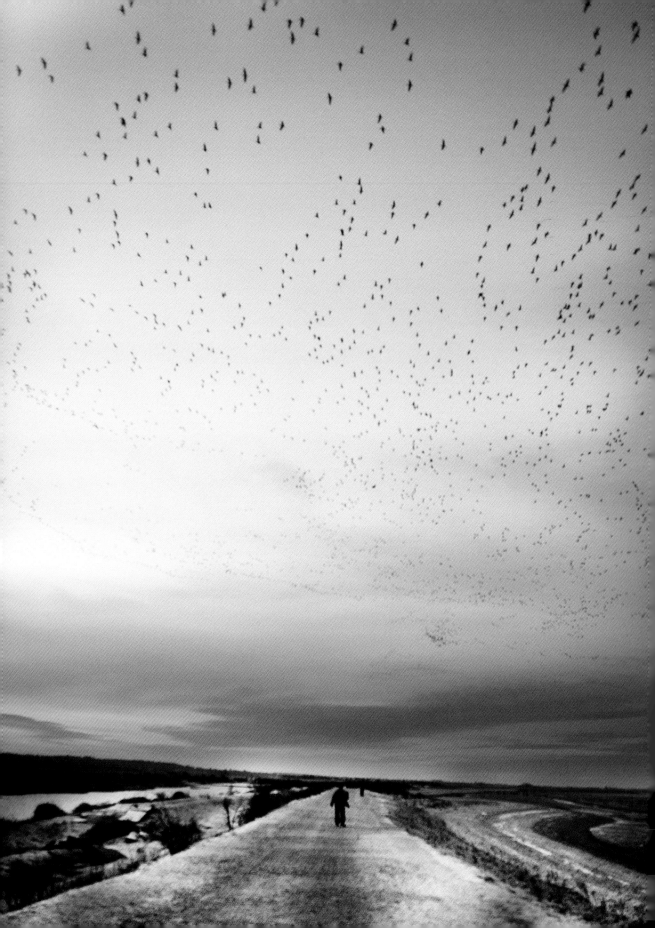

Wild Geese

Stephen Moss

A misty winter dawn on the north Norfolk coast is the perfect place to witness one of our greatest wildlife spectacles.

You'll hear them long before you see them. Quietly at first, they begin to utter their echoing calls; and as one starts, others join in, until a crescendo of sound begins to build. There are thousands upon thousands of pink-footed geese, waking after spending the night huddled together for safety against the cold and predators, on these misty marshes.

Suddenly, the wall of sound changes key, and a moment later the birds take off as one, rising from the ground like a vast blanket being lifted and shaken. The sound rises with them too: higher-pitched, less strident and more musical than the calls of other geese.

Struck Dumb

As the first glint of December sun breaks the horizon, they turn and head inland. They will spend the day there, feeding on potatoes or sugar beet before returning at dusk, to roost.

But why so many? And why, apart from Canada and feral greylag geese, are they only here in the autumn and winter months, leaving in spring? Surprisingly, they come here to take advantage of the mild winter climate. Britain has a very benevolent climate compared with the places where these birds breed: Scandinavia, Iceland, the Norwegian island of Spitsbergen and Arctic Canada.

In winter, virtually nothing can survive there, so each autumn geese head down to the UK to find plentiful supplies of food. As a result, the UK ranks with the Netherlands as the most important place for geese in Europe, supporting up to 90 per cent of all the world's pink-footed geese, and important numbers of several other species.

The honking and bugling of thousands of pink-footed geese as they head inland at dawn to feed is one of Norfolk's greatest wild experiences.

Goose Species Found in the UK

PINK-FOOTED GOOSE *Anser brachyrhynchus*
A dark-headed, long-necked goose, with pale markings across its back and a short, delicate pink bill with a black tip.

BRENT GOOSE *Branta bernicla*
Our smallest goose, only about the size of a mallard. Mainly blackish-brown in colour, with a distinctive white collar. Dark-bellied birds from Siberia winter in the south and east; pale-bellied birds from Canada winter in Ireland.

BARNACLE GOOSE *Branta leucopsis*
Similar to the brent goose, though has a white face and throat. Upperparts grey, underparts are paler, with a black neck and crown. Found mainly in northern Britain in winter.

SNOW GOOSE *Anser caerulescens*
Don't confuse with white domesticated geese and escaped individuals from waterfowl collections. Wild snow geese are usually seen in the Western Isles, in flocks of other geese.

BEAN GOOSE *Anser fabalis*
A rare goose, very similar to pink-footed – indeed the two were considered to be the same species until fairly recently. A regular flock spends the winter in east Norfolk; others can be found in Scotland.

WHITE-FRONTED GOOSE *Anser albifrons*
A medium-sized, rather attractive 'grey' goose with dark barring on its belly, and an obvious patch of white on its face. Winters widely in eastern and southern Britain.

CANADA GOOSE *Branta canadensis*
Our commonest goose, found on lakes, rivers and park ponds throughout England and Wales. Easily identified by its large size, and distinctive black neck with a white face-patch.

Winter Thrushes

Stephen Moss

With the onset of autumn, vast squadrons have been crossing the Atlantic Ocean and the North Sea. They travel under cover of darkness; the only clue to their presence a squeak or a harsh chatter in the night sky as they cross open country and even fly over city centres.

As dawn breaks they land; in fields and hedgerows, along country lanes and in our gardens. Hungry from their long flight, they begin to feed, stripping the lush red berries from the bushes until they can eat no more.

The identity of this invading army? Our winter thrushes, the redwing and fieldfare – two of the most beautiful and fascinating of all Britain's birds. Although they breed far to the north and east, they spend half the year with us. In some parts of the countryside they are among the commonest of winter birds.

If the weather stays mild, the best way to see these attractive winter thrushes is to drive, cycle or walk along a country lane and look into muddy fields, where flocks gather to feed on earthworms. Check out hedgerows, too – especially those laden with fruit such as sloes or haws. The two species are easily told apart: redwings are small, compact and dark; while fieldfares are large, long-tailed and bulky in appearance.

Take a really good look through binoculars at the fieldfare's chestnut back, grey head and yellowish front with its black, arrow-like markings. And marvel at the miniature beauty of the redwing: our smallest thrush, barely bigger than a skylark. Darker than the song thrush, it sports a creamy stripe above each eye, and the orange-red patches on its flanks that give the species its name.

Meet the Family

Redwings and fieldfares are two of Britain's six native species of thrush. Of the other four, three – the song thrush, mistle thrush and blackbird – are widespread, found in urban, suburban and rural areas all over lowland Britain. The fourth, the ring ouzel, is an upland specialist – its old name, mountain blackbird, summing up its habitat and appearance. It is also a migrant, leaving Britain in September or October and returning in March and April.

Now, in the middle of winter, Britain's ring ouzels are sunning themselves in southern Spain or Morocco. But our three resident species are still quite easy to see, especially if you have a large garden with fallen fruit – blackbirds, in particular, love windfall apples. Mistle thrushes are more commonly found in parkland with large trees, but you may also see them defending a berry bush against all-comers – often quite aggressively. Song thrushes, the smallest of the trio, are more mobile, often making short-distance winter movements, with those in southern Britain heading west to Ireland.

National Treasures

Because of their beauty, song, and preference for living alongside us in our towns, villages and countryside, thrushes have permeated our consciousness more than almost any other group of British birds. But the fact that our four resident species have all fallen in numbers over the past few decades should make us pause for thought. For if these adaptable birds cannot survive in modern Britain, what hope is there for more specialised species?

A winter's day without the sight of a blackbird or redwing, a spring morning without the sound of the song thrush, or an autumn evening without clouds of fieldfares would be little short of a tragedy. We can only hope that the recent upturn in the fortunes of the song thrush signals the turning of a corner, and that these delightful birds will continue to enchant us for many centuries to come.

Fieldfares migrate to the UK in the winter to feast on our winter berries, like these hawthorn berries in Warwickshire.

Stars and Dark Sky Parks

Rachael Oakden

An astronomer is pointing to a creamy swirl surrounded by shimmering stars in the black sky above Kielder Water in Northumberland, on the edge of Europe's largest Dark Sky Park. 'The Milky Way,' he declares. 'Until Galileo turned his telescope on it and revealed that it was made up of billions of stars, people thought it was a cloud.' We now know that this disc-shaped galaxy – our galaxy – measures 100,000 light years across.

As the sky turns denim blue, the first star becomes visible, followed quickly by another, then another, appearing out of the emptiness like distant, silent popcorn. The first star is called Vega, and the other bright dots are Deneb and Altair. These three stars make up what's called the Summer Triangle.

Soon the familiar Plough appears on the horizon, and by following a line upwards from its two westernmost stars, you can also find Polaris, the North Star.

Next, look for Cassiopeia, recognisable as a big 'W' on its side. It's supposed to be a queen sitting on her throne. Now if you look at Deneb again, you can see it is part of a big cross. That's Cygnus, the swan. The Milky Way runs right through it, and as it gets darker it will become more visible.

Another astronomer arrvies, and as the two swap stories – frequent sleepless nights in minus double digits, stargazing colleagues sent delirious by the cold – and mind-boggling statistics, it's clear why their family-friendly stargazing events are great fun even when the stars remain invisible. 'Our sun is 150 million kilometres (93 million miles) away and it takes eight minutes for its light to get to Earth, yet there are stars out there whose light takes 600 million years to reach us.'

The Stars Return

Looking up again, the Summer Triangle is higher in the sky now because the Earth has rotated by a few hours, and next to Cygnus, the faintest smudge of cloudy whiteness marks the first appearance of the Milky Way.

Suddenly a streak of orange burns across the sky. A shooting star – a fireball: a piece of matter, about the size of a pea, that's bumped into our atmosphere and vapourised.

The clearing sky fills with mythical creatures and characters: Delphinus (the dolphin), Perseus and, just above the horizon, a tiny teardrop of a star cluster known as Pleiades (the Seven Sisters). Its distant, delicate beauty makes it the most captivating sight of the evening, with one exception: one of the most longed-for prizes of a proper dark sky.

The elongated blur of lightness is so distant that, in tonight's sky, it can be seen only using peripheral vision (the corners of our eyes are most sensitive to light). The Andromeda galaxy, two and a half million light years away, is the furthest thing that it's possible to see with the naked eye.

Dark Sky Parks

Dark Sky Parks are designated by the International Dark-Sky Association (IDA) as being low enough in light pollution to allow the viewing of exceptionally starry skies. Northumberland National Park and Kielder Water and Forest Park (one dark sky park comprising two parks) and Galloway Forest Park in Scotland are some of the best.

Britain's national parks also include six IDA-designated Dark Sky Reserves – larger and less remote places that minimise light pollution and protect the nocturnal environment: Exmoor, Bannau Brycheiniog (formerly Brecon Beacons), Moore's Reserve in the South Downs, Snowdonia (Eryri), North York Moors and Yorkshire Dales.

Other great stargazing spots in the UK include the Ennerdale valley in west Cumbria and Kelling Heath in North Norfolk.

Parts of Bannau Brycheiniog National Park are a designated Dark Skies Preserve – where you can still witness a night sky full of stars.

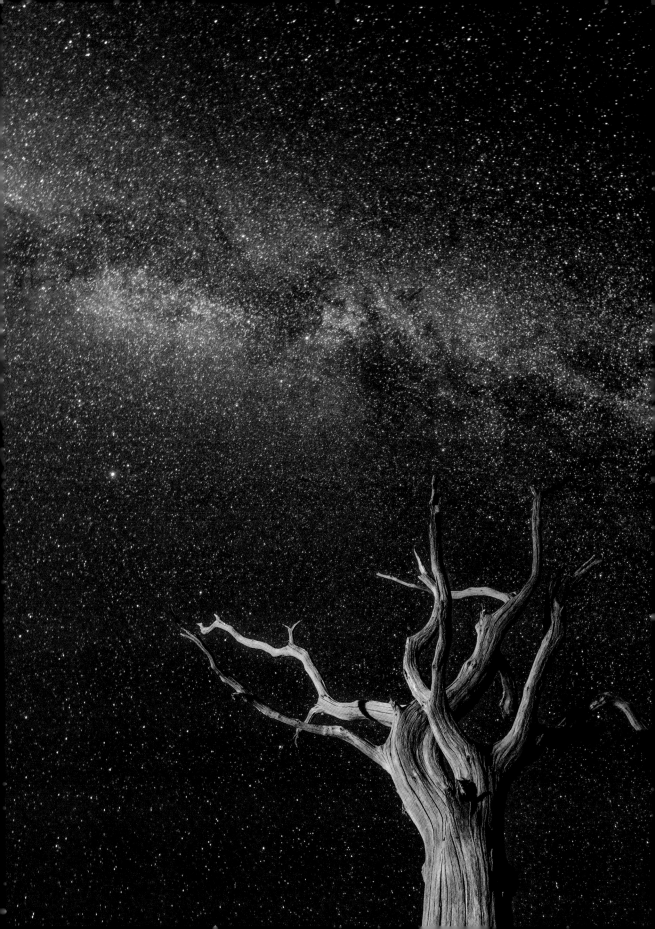

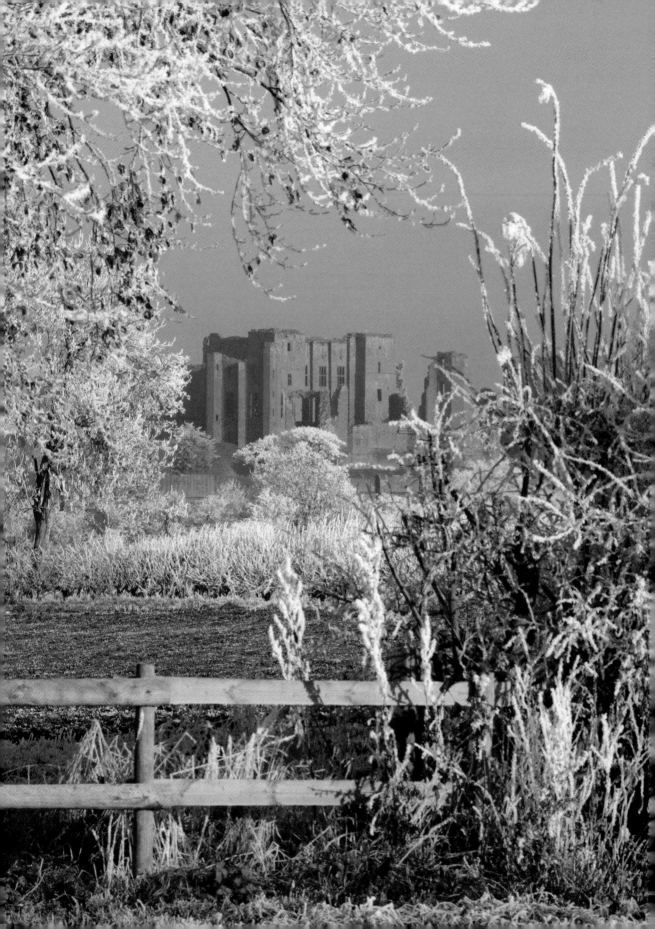

Park Pales

Ian Vince

A familiar label, a park pale – as rendered in Old English blackletter on Ordnance Survey maps – marks the ditch and bank that formed the boundary of a medieval deer park.

The word 'pale' originally referred to the stakes used to fence out a portion of land. Later it came to mean 'boundary'; hence the phrase 'beyond the pale'.

The surviving 'park pales' you see marked on the map often still define areas of woodland pasture. Banks may be several metres wide. Some were once surmounted by a wooden palisade; others by stone walling, the remains of which can still be found now, centuries later. The ditch that once ran inside the bank is usually less distinct.

The park pales' design allowed deer to bound into the park, but prevented them from leaping out again, making the deer park like a huge, terrestrial lobster pot, harvesting meat for the aristocratic table.

It's a fitting feature to investigate during the season of high-octane food, not least because in the low-fat, calorie-counted twenty-first century, Christmas dinner is the closest most of us get to a proper medieval banquet. In those days a Christmas feast was likely to include venison, while the most kindly of lords might give their servants deer offal – or numbles – for baking into a numble pie.

The model on which the ornamental parks of the eighteenth century were based, the medieval deer park is a tradition dating back to the Norman Conquest, or earlier. William the Conqueror, who was crowned as King of England on Christmas Day, 1066, famously created 36 royal forests in the 21 years of his reign, reflecting his enthusiasm for the chase. At first, keeping and hunting deer was exclusively the reserve of royalty, but licences

The medieval Park Pale at Kenilworth Castle in Warwickshire is encircled by an earthwork that can still be seen today.

from the king gave aristocrats and senior churchmen the right to hunt on their lands, and a mania for making deer parks took hold. The remains of one such park – first recorded in 1291, but almost certainly older – can be seen on the eastern side of Lyndhurst in the New Forest, where the pale is 9m (30ft) wide and its bank more than 1m (3ft) high. Another park pale is associated with Kenilworth Castle and Pleasance – Henry V's manor house in Warwickshire – while the most outstanding example in Scotland is at Fettercairn in Aberdeenshire, where 14km (8 miles) of pale around the King's Deer Park may even pre-date the Norman conquest of England.

The frequent occurrence of the park pale on modern maps is a reflection of their ubiquity in medieval landscapes; deer parks covered as much as two per cent of England at the start of the fourteenth century and had a political importance to match. While there was no shortage of deer parks, there were shortages of deer because noble huntsmen were rather good at killing their trapped quarry, often quicker than they could be restocked by hapless deer bounding over the pale. With his large royal forests, the king could send deer to his more co-operative and influential lords.

The remains of a medieval ditch and bank system that would have been topped with a paling fence can be seen at Lyndhurst Old Park in the New Forest.

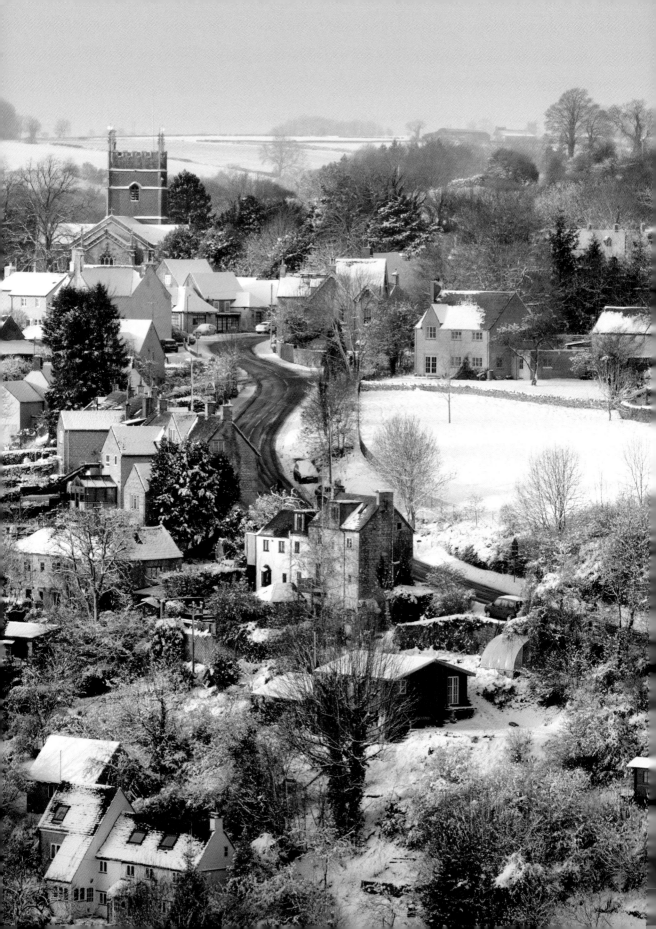

Christmas Cotswolds

Anthony Burton

It's a crisp winter day in the Cotswolds, with snow on the ground and enough keenness in the wind to keep you moving briskly along over the hills, through a landscape seemingly forgotten by the modern world.

Near the end of the walk, you reach the edge of the escarpment and there's time to pause and admire the magnificent view – and also to anticipate the other pleasures that lie just ahead. Below is the village, a comforting huddle of mellow stone houses and cottages. It's time to head downhill to the village inn, get a drink and relax before a crackling log fire. What more could you ask from a winter's day?

The Boom Times

You could think of the Cotswolds as a slice of Christmas cake. Beneath the surface is a great wedge of limestone that rises gently from the clays of Oxfordshire and Northamptonshire in the east to reach a height of around 300m (1,000ft), before dropping away in the west to a great escarpment that runs along the edge of the Vale of Evesham and the Severn valley.

Because of the nature of the land it has always been hard to grow crops, but it is ideal for grazing sheep, especially the local breed, whose fine and abundant fleece earned it the title 'Cotswold Lion'. Its wool was so prized that merchants came from all over Europe to buy it; market towns such as Cirencester and Chipping Campden prospered and the local clothiers and merchants grew rich.

The wealth created from wool gave the settlements of the area their unique character. Even a small town such as Northleach can boast a magnificent church with an ornate porch that would not look out of place in a cathedral. There were other endowments too, such as the charming almshouses at Wotton-under-Edge, built in 1632. And, of course, the

The historic village of Horsley in Gloucestershire is beautiful to visit in winter.

wealthy built fine houses for themselves. Each town also has its spacious inns, such as the Lygon Arms in Broadway and the Falcon Hotel, Painswick, which had to be provided for the visitors who came to buy the wool.

Spectacular Winter Walks

There is another good reason to visit the area apart from its architectural glories: the landscape – or, one should say, landscapes, for different areas have different characters. The eastern side is not obviously hilly, but a place of wide-open spaces, which is why in winter the snow can whip across the land to fill up lanes and roads. One of the most popular upland areas is Minchinhampton. This is a large plateau and genuine common, where cattle still graze on unfenced pasture. Walkers wander where they please, from one side to the other, or on the edge of the escarpment, which on a good day gives views to the Welsh hills.

For many of us, the best walking of all is near the edge of the escarpment, where you find the richest variety of scenery. One of the finest views in the north of the area can be had by walking up the escarpment to Broadway Tower, a magnificent folly built at the beginning of the nineteenth century: the direct route is steep, following the Cotswold Way, but it is possible to follow a gentler route to the west. Another popular area is Leckhampton Hill above Cheltenham. Here, the edge is marked by a series of limestone outcrops, including the Devil's Chimney.

One other feature of the escarpment adds to the pleasure of a winter walk: the beech woodland. Even without leaves the trees have a majesty all their own and act as effective windbreaks on a day when there is an icy east wind blowing. And when you feel like warming up, there is always a friendly pub with a fire and good local fare and beer. A happy combination that can be found all over the Cotswolds.

Credits

Text

Images

January

February

March

April

May

June

161 Mike Read / naturepl.com

July

162 Ross Hoddinott / naturepl.
com
165 Ross Hoddinott / naturepl.
com
166 Ross Hoddinott / naturepl.
com
168 Mike Read / naturepl.com
169 Ashley Cooper / naturepl.com
170 Ross Hoddinott / naturepl.
com
171 Nick Upton / naturepl.com
173 Ross Hoddinott / naturepl.
com
174 Laurie Campbell / naturepl.
com
176 Nick Turner / naturepl.com
179 Gary K Smith / naturepl.com
180 Philippe Clement / naturepl.
com
182 Arcaid Images / Alamy
183 Washington Imaging / Alamy
185 Guy Edwardes / naturepl.com
186 Nick Turner / naturepl.com
189 Csaba Peterdi / Alamy

August

190 Nick Upton / naturepl.com
193 Paul Harris / 2020VISION /
naturepl.com
194 Phil Savoie / naturepl.com
197 Rod Williams / naturepl.com
199 Alex Mustard / naturepl.com
200 Alex Mustard / naturepl.com
201 Lewis Jefferies / naturepl.com
202 Terry Whittaker / naturepl.
com
204 Terry Whittaker / naturepl.
com
205 Terry Whittaker / naturepl.
com
207 John Waters / naturepl.com
209 Chris Gomersall /
2020VISION / naturepl.com
210 Mike Kipling Photography /
Alamy

211 travelib history / Alamy
213 Graham Eaton / naturepl.com
215 Graham Eaton / naturepl.com

September

216 Guy Edwardes / naturepl.com
219 Colin Varndell / naturepl.com
221 Nick Upton / naturepl.com
222 Ernie Janes / naturepl.com
225 Danny Green / naturepl.com
226 George McCarthy / naturepl.
com
227 Terry Whittaker / 2020VISION
/ naturepl.com
229 Ernie Janes / naturepl.com
230 Colin Varndell / naturepl.com
232 Ashley Cooper / naturepl.com
233 Grant Dixon / Hedgehog
House / Minden Pictures /
naturepl.com
234 Mike Kipling Photography /
Alamy
235 Colin Monteath / Minden
Pictures / naturepl.com
237 Nick Turner / naturepl.com
240 Nick Upton / naturepl.com
243 Stephen Dalton / naturepl.
com

October

244 Niall Benvie / naturepl.com
247 Nick Upton / naturepl.com
249 Mark Hamblin / 2020VISION /
naturepl.com
250 Andy Sands / naturepl.com
251 David Kjaer / naturepl.com
252 Ernie Janes / naturepl.com
253 Andrew Parkinson / naturepl.
com
254 Terry Whittaker / 2020VISION
/ naturepl.com
256 Andy Rouse / naturepl.com
257 Colin Seddon / naturepl.com
258 Ernie Janes / naturepl.com
261 Klein & Hubert / naturepl.com
263 Alex Hyde / naturepl.com
264 SCOTLAND: The Big Picture /
naturepl.com

266 SCOTLAND: The Big Picture /
naturepl.com
267 SCOTLAND: The Big Picture /
naturepl.com

November

268 Alex Hyde / naturepl.com
270 Robert Thompson / naturepl.
com
271 Paul Hobson / naturepl.com
272 Niall Benvie / naturepl.com
274 Paul Hobson / naturepl.com
275 Mike Potts / naturepl.com
277 Ashley Cooper / naturepl.com
278 Mike Read / naturepl.com
279 Matthew Maran / naturepl.
com
280 Graham Eaton / naturepl.com
282 Ashley Cooper / Avalon /
TopFoto / naturepl.com
285 Ernie Janes / naturepl.com
286 David Chapman / Alamy
288 Guy Edwardes / naturepl.com
289 Adrian Davies / naturepl.com
290 TopFoto / naturepl.com
291 Jim Laws / Avalon / TopFoto /
naturepl.com
293 John Waters / naturepl.com

December

294 Ben Hall / 2020VISION /
naturepl.com
296 Ross Hoddinott / naturepl.
com
297 Dave Bevan / naturepl.com
298 Dave Porter / Alamy
300 Mark Hamblin / naturepl.com
303 Laurie Campbell / naturepl.
com
305 Ashley Cooper / naturepl.com
306 David Tipling / 2020VISION /
naturepl.com
309 Mike Wilkes / naturepl.com
311 Phil Savoie / naturepl.com
312 John Cancalosi / naturepl.
com
313 Mike Read / naturepl.com
314 Nick Turner / naturepl.com

William Collins
An imprint of HarperCollins*Publishers*
1 London Bridge Street
London SE1 9GF

WilliamCollinsBooks.com

HarperCollins*Publishers*
Macken House
39/40 Mayor Street Upper
Dublin 1
D01 C9W8
Ireland

First published in Great Britain in 2024 by William Collins

1

ISBN 978-0-00-852933-8

Designed and typeset by D & N Publishing, Baydon, Wiltshire
Picture research by Laura Barwick

Printed and bound by GPS Group in Bosnia and Herzegovina

MIX
Paper | Supporting responsible forestry
FSC™ C007454

This book contains FSC™ certified paper and other controlled sources to ensure responsible forest management.

For more information visit: www.harpercollins.co.uk/green